Apple Aperture 3

6mg

Apple Aperture 3

Ken McMahon Nik Rawlinson

Focal Press

AMSTERDAM • BOSTON • HEIDELBERG • LONDON • NEW YORK • OXFORD PARIS • SAN DIEGO • SAN FRANCISCO • SINGAPORE • SYDNEY • TOKYO Focal Press is an imprint of Elsevier Focal Press is an imprint of Elsevier The Boulevard, Langford Lane, Kidlington, Oxford, OX5 1GB, UK 30 Corporate Drive, Suite 400, Burlington, MA 01803, USA

First published 2010

Copyright © 2010 Ken McMahon and Nik Rawlinson. Elsevier Ltd. All rights reserved.

The rights of Ken McMahon and Nik Rawlinson to be identified as the authors of this work has been asserted in accordance with the Copyright, Designs and Patents Act 1988

No part of this publication may be reproduced or transmitted in any form or by any means, electronic or mechanical, including photocopying, recording, or any information storage and retrieval system, without permission in writing from the publisher. Details on how to seek permission, further information about the Publisher's permissions policies and our arrangement with organizations such as the Copyright Clearance Center and the Copyright Licensing Agency, can be found at our website: www.elsevier.com/permissions

This book and the individual contributions contained in it are protected under copyright by the Publisher (other than as may be noted herein).

Notices

Knowledge and best practice in this field are constantly changing. As new research and experience broaden our understanding, changes in research methods, professional practices, or medical treatment may become necessary.

Practitioners and researchers must always rely on their own experience and knowledge in evaluating and using any information, methods, compounds, or experiments described herein. In using such information or methods they should be mindful of their own safety and the safety of others, including parties for whom they have a professional responsibility.

To the fullest extent of the law, neither the Publisher nor the authors, contributors, or editors, assume any liability for any injury and/or damage to persons or property as a matter of products liability, negligence or otherwise, or from any use or operation of any methods, products, instructions, or ideas contained in the material herein.

British Library Cataloguing in Publication Data

McMahon, Ken.

Apple Aperture 3: a workflow guide for digital photographers. 1. Aperture (Computer file) 2. Photography–Digital techniques. I. Title II. Rawlinson, Nik. 775-dc22

//J-uczz

Library of Congress Control Number: 2010928085

ISBN: 978-0-240-52178-7

For information on all Focal Press publications visit our website at focalpress.com

Printed and bound in the United States

10 11 12 11 10 9 8 7 6 5 4 3 2 1

Working together to grow libraries in developing countries www.elsevier.com | www.bookaid.org | www.sabre.org ELSEVIER BOOK AID International Sabre Foundation

Contents

Introduction	xiii
Chapter 1: Camera Raw	1
Introduction	1
What is Camera Raw?	2
Raw Support	2
The Pros and Cons of a Raw Workflow	4
Benefits	5
Disadvantages	б
From Raw to RGB	7
How Sensor Data are Captured and Stored	9
In-Camera Processing and the Aperture Alternatives	9
Demosaicing and Color Space Conversion	9
Tonal Mapping	10
White Balance	14
Noise Reduction and Sharpening	
Raw Fine Tuning in Aperture	
Which Decoder?	17
Boost	
Sharpening	
Moiré and Chromatic Aberration	
DNG	
Using DNG Converter	21
Unsupported Raw Formats	23
Chapter 2: How Aperture Works	
The Aperture Workspace	27
How Aperture Stores Your Images	
Digital Masters and Versions	
Browsing and Organizing Images	
Library Inspector	
Browser	
Toolbar	
Control Bar and Keyword Controls	
Navigating Your Photos Using the Control Bar	
Rating and Sorting Images with the Control Bar	41

Selecting and Displaying Images Using the Viewer Toolbar	43
Full Screen and Dual-Screen Mode	47
Adjustments and Metadata Inspectors	48
Adding and Editing Views in the Metadata Panel	
Organizing Images	51
Folders	51
Projects	52
Masters and Versions	52
Stacks	52
Workspace Layouts	53
Standard Workspace Layout	53
Swapping and Rotating Workspaces	55
Ratings and Keywords	
Adjustments and Filters	58
Overlays	
Head-Up Displays (HUDs)	60
Filter HUD	61
Inspector HUD	63
Lift and Stamp HUD	63
Metadata Overlays	66
Using Aperture for the First Time	66
Customizing Aperture	67
Exporting Shortcut Presets	69
Managing Color	69
Setting Your Preferences	71
Chapter 3: Managing Your Images	73
Adding Images to Your Library	
Importing from Your Camera	
Sort Your Images Before Import	
Choosing Where To Store Your Images	
Creating Filename Presets	
Completing the Import Workflow	
Creating Metadata Presets	
Importing Your Pictures	
Importing from Other Sources	
Importing Without the Dialog	
Renaming Files	
Backing Up Raw Files	

Backup and Time Machine	86
Managing Vaults	88
Creating Your First Vault	89
Maintaining Your Vaults	91
Restoring Your Library from a Vault	92
Transferring Your Library to a New Mac	92
Moving Libraries	94
Splitting Up Your Library	. 95
Moving Referenced Images	97
Managing Your Referenced Images	97
Consolidating Your Masters	99
Hard Disk Management	100
Smart Folders	101
Burn Folders	103
Folder Actions	104
Launching Automator and Accessing Aperture's Actions	104
Building an Aperture Workflow	105
Chapter 4: Working with Metadata	111
Introduction	111
Rating Images	112
Arranging the Workspace	112
Using the Keyboard	112
Using the Mouse	113
Comparing Images	114
Adding IPTC Metadata	114
Using the Metadata Inspector	116
Using the Lift and Stamp HUD	116
Using Metadata Views	116
Creating Metadata Views	117
Creating Metadata Presets	118
Batch Operations	120
Changing the Time	121
Adding Metadata on Import	121
Keywords Overview	122
Keyword Strategy	122
Adding Keywords Using the Metadata Inspector	124
Adding Keywords Using the Keyword HUD	124
Adding Keywords Using the Control Bar	126

Contents

Removing Keywords 12	7
Creating and Editing Preset Groups12	8
Displaying Metadata on Images 12	9
Viewer and Browser Sets 12	9
Sorting and Searching 13	1
Search Tools	2
The Search Field and Search Field Pop-Up Menu 13	2
The Filter HUD 13	2
Searching by Rating	3
Text Searching	3
Keyword Searching	4
All or Any	5
Searching by Date	6
Searching by Other Criteria	7
Using Multiple Search Criteria	8
Multiple Text Searching	9
Saving Search Results	1
Chapter 5: Adjusting Images14	3
Introduction14	3
The Adjustments Inspector14	4
The Adjustments HUD	5
The Adjustments HUD Adjustment by Adjustment	6
The Histogram	6
Raw Fine Tuning14	7
White Balance	7
Exposure	8
Enhance	0
Highlights & Shadows15	2
Levels	4
Color	4
Other Adjustments	8
Red-Eye Correction	8
Spot & Patch and Retouch15	9
Crop and Straighten and Flip16	2
Chromatic Aberration	3
Vignette and Devignette	4
Black & White, Color Monochrome and Sepia Tone	6
Noise Reduction	6

Sorting Your Images	228
Rating and Picking Your Photos Using Comparisons	229
Edit Your Photos	231
Output Your Photos	231
Back up, Back up and Back up Again	232
Light Tables	232
Performing Sorts and Edits from a Light Table	235
Stacking	236
Versions and Version Sets	238
Automatically Created Versions	239
Manually Created Versions	240
Chapter 7: Working with Other Applications	241
Introduction	
Importing your iPhoto Library	
Importing Individual Images or Albums	
Previews	
Moving from Adobe Bridge and Adobe Camera Raw	
Aperture and Adobe Bridge	
Aperture and Adobe Camera Raw	
Migrating your Library	
Metadata	
Bridge and Camera Raw Metadata	
XMP sidecar files	
DNG Conversion	
Aperture and Adobe Photoshop Lightroom	
Aperture and Adobe Photoshop	
New Masters	
Workflow Considerations	
Plug-ins	
How Edit Plug-ins Work	
Aperture, Plug-ins and External Editing	
Nik Software – Viveza 2	
PictureCode – Noise Ninja	
Tiffen – Tiffen Dfx	
Digital Film Tools – Light!	
Image Trends – Fisheye-Hemi, ShineOff and PearlyWhites	
Using Aperture from Other Applications	
Preview Preferences	267

iPhoto 268	
iTunes 268	
iWork Applications 269	
Mail 271	
Photoshop 272	
InDesign 272	
Chapter 8: Output275	
Exporting 275	
Defining Your Own Export Settings 277	
Protecting Your Exported Images 278	
Color Management 279	
Defining Export Names and Destinations	
Exporting Metadata 283	
Export Plug-ins	
Working with Two Macs and Two Libraries 286	
Publishing Your Photos Online	
MobileMe Galleries 287	
Web Pages 291	
Web Journals 296	
Producing Books 298	
Printing	
Common Features in the Printing Dialogs	
Managing Color or Not	
Slideshows	
Adjusting Slideshow Settings 310	
Creating a Bespoke Slideshow 313	
Slideshow Music	
Slideshows Beyond Aperture 316	
Controlling Playback	

ndex	. 319	

Introduction

This book tells you what you need to know to get the most from Aperture 3, Apple's Pro advanced photo editing and management application. If you're reading this, it's fair to assume you either already own Aperture 3 or are thinking about buying it.

If the latter is the case and you're serious about your photography, you really do need software to help you organize, edit and archive your digital images. In our view, Aperture 3 provides by far and away the best means of doing that. Other than to say that, we're not here to persuade you.

With new features like Faces, Places and advanced slideshows with iPhoto slideshow themes, Aperture 3 is now more accessible and has much more to offer those who are serious about their photography but don't make a living from it.

For both pro and amateur photographers alike, new brush-based adjustments and quick fix adjustment presets make it possible to carry out the bulk of your photo editing within Aperture without the need to round-trip files to Photoshop or other editing applications.

Aperture's tools for organizing images condense potentially tedious and time-consuming tasks like rating, captioning, copyright labelling and keyword tagging down to a five minute routine when you upload a card of photos to your Mac. With that done, producing contact sheets, Web Galleries and photo books for clients, family and friends is just a short step away.

OK, so it looks like we are here to persuade you after all.

How you use Aperture 3 is very much up to you. You can make use of individual features like Raw conversion, Adjustment presets, or apply metadata and export images as RGB files, create Web Galleries or upload them to photo sharing sites. But Aperture was designed to sit at the heart of your image editing workflow and to be involved in every aspect of what happens to your images after you've pressed the shutter release. That's where this book comes in.

In *Apple Aperture 3* we have tried to show you not just what Aperture is capable of, but the best way to go about individual editing tasks and how to integrate them into an enjoyable and productive way of working.

Aperture can store your images in its internal Library, or can leave them on your hard drive like other files and reference them, but which way is best for you and why? Aperture provides several Sharpening tools, but what's the difference between them, which should you use, and when? How can you speed up the task of applying keyword tags to images? And what about color management in Aperture?

As well as providing answers to these and many other questions, we've tried to show how all of this fits together into an effective image processing workflow. This is reflected within the structure of the book, which starts with a chapter on Camera Raw files and their processing, and then covers how Aperture works, managing images, working with metadata, making image adjustments, and finally how to output images, as well as within the content of each chapter itself. Chapter 6 – Aperture workflow – provides an example of real-life workflow strategy from import to output.

Whether you're a pro photographer or a publishing professional looking to integrate Aperture more fully into a production environment, are stepping up from iPhoto and feel in need of some guidance, or are new to Aperture and want a comprehensive introduction to every aspect of the application, we're confident you'll find what you're looking for in these pages.

> Ken McMahon Nik Rawlinson May 2010

Camera Raw

Introduction

First and foremost, Aperture is a Raw converter. You can use it to organize, annotate, edit and output TIFF, JPEG and other RGB file formats and it does a great job, but this is to ignore its most useful function.

Aperture's Raw decoder is designed to help you squeeze the last ounce of quality from your digital images. From the Raw Fine Tuning controls that allow you to influence how Aperture's decoder interprets the data in your Camera Raw files, to the tonal adjustments that allow you to recover apparently lost highlight and shadow detail, Aperture's tools are designed primarily to work with Camera Raw files.

Knowing what Camera Raw files are, how they differ from RGB file formats like TIFF, JPEG and PSD, and how Camera Raw data are produced and stored will influence every aspect of your digital imaging workflow – from your choice of exposure to how and when you apply Sharpening to your images.

In this chapter we begin by taking a look at what Camera Raw is and the advantages and disadvantages of adopting a Raw digital imaging workflow. If you're not currently shooting Raw, and aren't sure that it's for you, this information may help you come to a decision.

Apple Aperture 3. DOI: 10.1016/B978-0-240-52178-7.10001-5 Copyright © 2010 Elsevier Ltd. All rights of reproduction, in any form, reserved.

ISO 200 F Presets *		20 70mm nts - 1
RAW Fine Tuning	I	5 Ø.
Camera: Canon	EOS 20D	
Boost:		
Hue Boost:		· 0.50 ·
Sharpening:		(+ 0.50+)
Edges:		(+ 0.18 »)
Moire: O		
Radius:		····· (* 4.00 +)
Mauta	o Noise Comp	ensation
White Balance		n 0 .
(Temp:	0	- 5314 K +
• Exposure		(Auto) h &.
Exposure:		
Recovery: O		(* 0.0 >)
Black Point:		(* 3.0 +)
Brightness:		- 0.0 -
T Enhance		n 0 .
Contrast:		
Definition: O		
		- 1.0 -)

FIG. 1.1 The Raw Fine Tuning adjustment on Aperture's Adjustments Inspector.

Following that we take a fairly technical look at how imaging sensors record the data in a scene and how that information is stored in a Camera Raw file. It's not essential to know this, but it will help you make shooting and editing decisions that produce the best possible final image quality.

The second half of the chapter deals specifically with the Adjustment controls found in the Raw Fine Tuning adjustment of Aperture's Adjustments Inspector (Fig. 1.1). These are only available when working with Camera Raw files and determine how Aperture's Raw decoder interprets Raw data to produce an RGB image ready for further editing. If you're new to Aperture you might want to fast forward to Chapter 2 to familiarize yourself with the workspace and how Aperture works with images and Versions before returning here.

The chapter ends with an explanation of Adobe's DNG Raw format and the advantages it offers in an Aperture-based Raw workflow.

What is Camera Raw?

The first thing to understand about Camera Raw is that it is not one file format, but many. Camera Raw formats are proprietary, developed by camera manufacturers to best handle the data produced by individual models. Hence, the Raw file format produced by Canon's EOS 1D Mark IV will differ from that produced by the Nikon D3S and even from other Canon dSLRs.

Though there are some important differences, Raw is just another file format, like JPEG or TIFF. The major difference is that Raw files contain unprocessed data from the camera sensor. Before Raw data can be viewed as an RGB image they have to undergo a number of processes. If you shoot in an RGB format, such as TIFF or JPEG, this processing is done in the camera. If you shoot Raw, it's done by Raw decoder software like that used in Aperture.

Raw Support

The proprietary nature of camera Raw formats has a number of important implications for the photographer whose livelihood may depend on the integrity of and future access to a library of images.

In practical terms, your ability to view and manipulate Raw files from your camera depends upon the availability of software which is able to read those files. Camera manufacturers usually supply a software utility for this purpose and, as well as MacOs X and Aperture, an increasing number of applications developed by third-party vendors now support a wide range of proprietary Raw formats. Apple maintains a list of Camera Raw formats supported by Aperture 2 on its website at http://www.apple.com/aperture/specs/raw.html (Fig. 1.2)

		echnical Specifications - RAV	V Support	
http://www.apple.com/apert	And the second			Google
			Lookaround Cornwal Subscribe Google Re	ader Shorten with bit.ly
with a loss Statewide a list	Boskmarks 4	Translate + 🔄 Autofili •		
AD * 🔮 Share * 🗭 info 👘	avorites 🚻 Stamplers Topls *			
pec. +				
deline and the second second second				and an and a state of the state
Store	Mac iPod	Phone iPad	iTunes Support Q Search	
Aperture 3	What's New What is Ac	erture? In Action How T	o Resources Tech Specs	
				Carlosoft,
Wide Support fo	or RAW Formats from Le	ading Camoras	Wikon	
		-		
	RAW formats from more than 150			
camera backs. (Note th	at models marked with an asterisk	require Aperture 2 or		
later with Mac OS X v10	4.11 Tiger or Mac OS X v10.5.2 Le	opard or later: models		
	ks require Aperture 3 or later.) Ap			
	es. 1 Shoot JPEG? Using Aperture, yo		States I all	
images from virtually a		a can import pred		
nonges trotti vircoany a	orginal cameras.			7
Canon	Hasselblad	Nikon	a an an a	
 EOS 1D 	 CF-22* 	= D1	1 1 1 1 1 1 1 1 1 1 1 1 1 1 1 1 1 1 1	
 EOS 1D Mark II 	 CF-39* 	= D1X		
 EOS 10 Mark BN 	 CFV-16" 	 D1H 	Panasonic	
 EOS LD Mark III 	 H30~31* 	 D2H 	 DMC-LC1 	
* EOS 10s	 H3D-31H* 	 D2Hs 	 Lumix DMC-FZ50 	
 EOS 1Ds Mark II 	 H308-50** 	 D2X 	 Lumix DMC-G1** 	
 EOS 1Ds Mark 8i* 		 D2Xs 	 Lumix DMC-GF1** 	
 EOS 1D Mark IV* 	Kodak	• D3*	 Lumix DMC-GH1** 	
= EOS SD	 DCS Pro SLR/n* 	 D3s* 	 Lamix DMC-L1 	
 EOS SD Mark II* 		 D3X* 	 Lumis DMC-LX1 	
 EQS 7D 	Konica Minolta	* D40	 Lumix DMC-LX2 	
 EOS 10D 	 DIMAGE A1 	 D40x 	 Lumix DMC-LX3** 	
	 DIMAGE A2 	DS0		
 EOS 20D 				
 EOS 30D 	 Maoxum SD 	 D60* 	Pentax	
	 Maxxum SD Maxxum 7D 	 D60* D70 	Pentax * tst D * tst DL	

FIG. 1.2 You'll find a list of all the Raw formats supported by Aperture at http://www.apple.com/aperture/specs/raw.html.

Raw file formats tend to adapt and change in order to keep pace with hardware developments. So when a camera manufacturer releases a new model it's possible that the Raw file format will differ in some respect or other from that used on previous models.

The practical consequences of this are two-fold. Firstly, it means that if you buy a newly released camera model and shoot Raw with it, you may not be able to import those files to Aperture, or any other third-party application, until they are able to provide support for it. Given the proprietary nature of Raw formats, this process can take time. In the meantime you may be forced to rely on the manufacturer's software to read and convert Raw files into a format that your software can handle.

A second, more long-term issue concerns image archiving. Given the pace of change of digital hardware, it's not unlikely that in the course of, say, the next decade, you'll own and use a variety of cameras, each with its own flavor of Camera Raw file format. At the end of that period, and for the foreseeable future beyond, it would be reassuring to know that you could rely on the availability of software to allow you to open and manipulate those images the way you can today.

Regrettably, if past history is anything to go by, this is by no means a certainty. Camera manufacturers, software companies, hardware platforms and operating systems come and go. Even assuming they are still around in 20 years' time, how likely is it they will be willing to support a format for a camera that nobody has used for decades? There are, however, ways in which you can future-proof your images from this risk. Simply by importing your photos to Aperture you are providing one means of defense. It's fair to assume that Aperture's library and vault backup files will continue to be readable by future versions of the program. Another means of ensuring future readability of your Raw files is to convert them to Adobe's published 'digital negative' DNG format. This option is discussed in greater detail later in this chapter.

FIG. 1.3 Support for new Camera Raw formats is provided in the MacOs operating system. Owners of recently introduced digital cameras like the Canon EOS-1D Mark IV will need Aperture 3 to handle their Raw image file format. Other cameras that require Aperture 3 include Nikon's D3 and D3s, the Olympus E3, Sony's Alpha dSLR range and the Hasselblad CF line of digital camera backs. You can get a full list at http://www. apple.com/aperture/specs/raw.html.

The Pros and Cons of a Raw Workflow

More and more, professional photographers are realizing the benefits of shooting Raw, as opposed to TIFF or JPEG. The fact that many dSLRs provide the option of saving both types of file from a single shot gives you the option of producing a Raw file 'just in case'. It may be that your usual workflow involves very little image processing, that subjects aren't difficult from an exposure point of view and that 8-bit JPEGs provide good quality images.

In such situations you might think of Raw files as an insurance policy to fall back on should the lighting turn out to have been problematic, or the White Balance off. You can correct RGB files in these circumstances, but Raw files will provide you with more options and generate a better quality end result.

There is, of course, a downside to shooting Raw. The files are bigger than JPEGs, take longer to write and, if you're not using Aperture, you may have to introduce at least one extra processing stage to your workflow. On balance though, we'd argue the advantages heavily outweigh the disadvantages. If you're still undecided, the following might convince you one way or the other (Fig. 1.4).

900		364CANON		(
			Q	
Back View	Action			Search
DEVICES	Name	Date Modified	Size	Kind
@ iDisk	IMG_6409.CR2	Today, 13:57	8 MB	Canon Camera Raw file
Macintosh HD	MG_6409.JPG	Today, 13:57	1.2 MB	Adobe Photoshop JPEG file
Lacie 75Gb ▲	MG_6409.dng	Today, 14:58	7.5 MB	Digital Negative file
SHARED				
PLACES				
Desktop 🔻			 	
		3 items, 939.3 MB available		

FIG. 1.4 These three files are all from the same image shot in Raw with JPEG mode on a Canon EOS 20D. The Raw file comes in at 8MB with the JPEG occupying only 1.2MB. The third file was produced from the .CR2 file using Adobe DNG converter with lossless compression selected.

Benefits

Overall Quality

In a well-exposed image with a full range of tones that requires no processing the differences between, say, a 16-bit TIFF produced by your camera and one produced using Aperture's Raw converter would probably be marginal. This is probably the only situation in which there is little advantage to be gained from shooting Raw, but probably not one that occurs all that regularly for most photographers.

Bit Depth

Camera Raw files use the full number of bits (usually up to 14) available in the image data. If you shoot JPEGs, this is downsampled to 8 and the camera, not you, makes the decision about how to effectively use those bits to represent the tonal levels in the image. For some images this can result in the irre-trievable loss of highlight and/or shadow detail.

No Compression

Camera Raw files are not usually compressed; if they are, a lossless algorithm is employed. JPEG compression, even at the highest quality settings, removes a lot of data from your images, which can severely limit what you are able to achieve in post-processing.

Increased Latitude

Latitude describes the exposure characteristics of film emulsions or digital sensors in terms of their ability to cope with a range of light levels. When the range of light levels (called the dynamic range) in a subject is within that capable of being recorded by the film or sensor, latitude provides an indication of the degree to which the image can be over or underexposed while still producing acceptable results (i.e. details in the highlights and shadows).

In a Raw workflow, your images have greater latitude than if you're working with RGB files. By using Aperture's Exposure, Levels, and Highlight and Shadow tools, you can ensure that the critical tonal regions receive the most bits. In practice, this means you can pull detail from apparently blown highlights and, to a lesser degree, rescue shadow detail and produce a robust image capable of withstanding further pixel manipulation.

Future Improvements

Currently, Aperture's Raw converter does an excellent job of producing high quality RGB files from Camera Raw data, even in relatively inexperienced hands. Future releases will no doubt improve on this, making it possible for you to revisit you archived library and produce even better images for your 2050 retrospective.

Disadvantages

More to Do

In many digital imaging workflows, Raw images introduce an extra processing stage as they must be converted to RGB files before they can be used, for example, printed, added to a Web Page or undergo further editing. Because Aperture treats all files as master images, and stores Versions and their edits and adjustments internally, there is in fact little difference between working with Raw files and JPEGs or TIFFs.

Bigger Files

Raw files are bigger than JPEGs and this has consequences all the way down the line. It takes longer to write Raw files to a data card in the camera with the obvious consequences for action photography. Raw files will take up more hard disk space and, because of the necessity to generate an RGB TIFF if you want to edit the image in Photoshop, it's necessary to produce duplicates. On the upside, because Aperture handles all adjustments to the original Raw master on the fly, there's no need to keep several edited versions of images.

Proprietary, Closed Formats

As we've seen, Raw is not one format but encompasses many different proprietary file formats. This carries a risk in terms of the availability of future support for existing Camera Raw formats.

From Raw to RGB

Raw files contain information about brightness values recorded by each photosite on the camera sensor. These data are analyzed and referenced according to their position on a grid to determine the color value of each image pixel (see 'How Sensor Data is Captured and Stored' on page 9).

This process, called demosaicing, determines the color of pixels in the data matrix depending on their position and the color of neighboring pixels. The resultant image is then color calibrated according to the camera's White Balance settings, Saturation is determined and the image may be sharpened. Finally, the image color space is assigned and, if you are shooting JPEGs, the file is compressed.

Some of what happens during this process is determined by your camera settings. Most dSLRs provide 'parameter' sets which apply manufacturer- or user-defined presets for all of these settings (Fig. 1.5).

FIG. 1.5 dSLR parameter settings provide in-camera control over some aspects of Raw processing.

By setting your camera to shoot in Raw mode, you are effectively bypassing this in-camera processing of the sensor data. This means that before you can view the files, you have to process the data yourself and this is where the huge advantage of working with Raw files becomes clear.

When Raw image data is processed in the camera to produce a JPEG or a TIFF file, decisions are made about how the data is interpreted – some of the data are even discarded. The camera's processing algorithms are designed to produce the best results under all possible conditions, but your camera can't tell if the image it is processing is correctly exposed, if the scene before it contained a full range of tones, or whether the shadow detail is more important to you than the highlights. By delaying processing of the Raw file until you've seen the image you can decide for yourself how best to interpret the data to produce a robust RGB file.

You can, of course, manipulate tones and colors and make other changes to an 8-bit TIFF or JPEG file processed by your camera, but these edits are destructive. Even minor Levels adjustments in Photoshop can produce tonal discontinuities and exaggerate noise. Such changes applied to Raw files don't always carry the same penalties, because you are working with much more of the image data to begin with and interpreting this to produce a clean RGB file (Fig. 1.6).

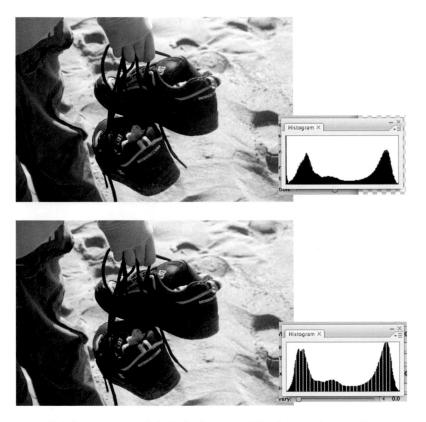

FIG. 1.6 Both of these images have had a Levels adjustment applied to darken the shadows and increase image contrast. Both images are from the same original Carnera Raw file. For the top image, the Carnera Raw master was Levels adjusted in Aperture and the image was opened in Photoshop as a 16-bit PSD. Despite the Levels adjustment, the Photoshop histogram is smooth and shows no discontinuities. The bottom image was opened unadjusted in Photoshop, also as a 16-bit PSD, then downsampled to 8 bits per channel using Image > Mode > 8 Bits/Channel. It was then given a Levels adjustment in Photoshop similar to the one given to the top image. Because there is less information in this image, the adjustment has produced discontinuities in the histogram. In severe cases these will appear as posterization, or banding.

Raw files are much more robust and able to tolerate much greater tonal manipulation than 8-bit RGB files. Whereas the top image still has sufficient information to undergo further editing, further adjustments to the bottom file will likely result in visible posterization, noise and other artifacts.

How Sensor Data are Captured and Stored

A sensor consists of a grid, or 'array', of individual photodiode receptors which convert the light that falls on them into an electrical voltage. The voltage varies in direct proportion to the amount of light and is converted into a number by an analog-to-digital converter.

Image sensors don't detect or measure color, only light, or 'luminance', which is represented digitally as a grayscale value. The color information is provided by a 'color filter array' consisting of red, green and blue cells placed over the sensor.

As we know from the trichromatic theory of color reproduction, all colors can be composed from the three primaries – red, green and blue. Although each pixel in the sensor array measures only one primary color, the 'missing' two components for each pixel are interpolated by analysis of neighboring pixel values in a process known as demosaicing.

It is these grayscale data, along with some metadata, that are stored in the Camera Raw file. Among other things, the metadata include the Camera's White Balance setting but, if you are shooting Raw, this information is simply recorded; it's not applied to the data to create an RGB image.

In-Camera Processing and the Aperture Alternatives

By taking a look at how captured sensor data are processed to produce an RGB image file, you can better understand how to use Aperture's adjustment controls to squeeze the utmost quality form your Raw files.

Demosaicing and Color Space Conversion

As we've seen, Camera sensors produce only luminance information, which is initially recorded as grayscale values. By making use of a colored grid, or color filter array, placed over the sensor, the correct color value for each image pixel can be determined by a process called demosaicing.

The most common type of array in use is the Bayer pattern, which alternates lines of red/green and blue/green cells – there are twice as many green cells as red or blue because the human eye is more sensitive to that portion of the visible spectrum. To determine the correct value for a given pixel the demosaicing algorithm assesses the value of both that pixel and its neighbors (Fig. 1.7).

This is one process that Aperture doesn't give you much control over. It happens automatically using profiles which tell Aperture about the color characteristics (e.g. the type of filter array used) of the camera used to create the Raw file.

Apple Aperture 3

FIG. 1.7 A color filter array placed over the camera's image sensor filters light to transmit only red, green or blue at specific sensor locations. By analyzing the luminance values of a single sensor location and its neighbors, the color of individual pixels is determined. This process is known as demosaicing.

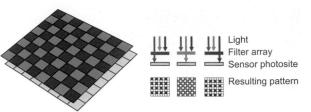

Color filter array sensor

You do, however, have the option to influence the result using controls in the Raw Fine Tuning area of Aperture's Adjustment Inspector. These include Boost, Hue Boost, Sharpening, Moiré and Auto Noise Compensation. Note that if you are using Aperture 2 these tools are only available if you are using the Version 2 decoder. See the 'Raw Fine Tuning in Aperture' section later in the chapter for more detail on using these adjustments.

In their default positions, all of these are set to produce optimal results for the given camera profile; you may, however, be able to achieve better results through experimentation on individual images. If you find something that works well you can save it as a preset by selecting Save as Preset from the action menu.

Tonal Mapping

If you want to produce the best possible quality images from your Raw files, understanding how digital cameras record tonal data and how to safely manipulate those data will underpin virtually every adjustment you make to a digital photo from here on in.

The human eye doesn't see light in a linear fashion. That is to say, if twice as much light enters your eye it doesn't appear twice as bright. It's this non-linearity of response that enables us to see so well in such a wide range of conditions – from a dimly lit room to bright sunshine. One other thing that's important to know about the human eye is that it is much more sensitive to shadow detail than it is to highlights. You can differentiate more tones in a dark scene than you can in a light one (Figs 1.8 and 1.9).

Film responds to light in a similar non-linear fashion and if you plot a curve of this response with input along the x-axis and output on the y-axis you get a gamma curve which describes it (Fig. 1.10). Although film stock characteristics vary, the general appearance of a film gamma curve is S-shaped like that in Fig. 1.11.

Unlike our eyes and photochemical emulsions, digital sensors have a linear response with a gamma of 1. Their gamma curve is a 45 degree straight diagonal line.

FIG. 1.8 The way digital camera sensors record light.

FIG. 1.9 The way the human eye perceives light.

FIG. 1.10 Linear gamma curve.

FIG. 1.11 Gamma curve for a typical film emulsion.

Digital cameras typically use 12 bits per pixel to record tonal information in a Raw image file. Those bits are allocated across the range of tones that the sensor is capable of recording, from the darkest black to the lightest white, providing 4096 (2¹²) discrete levels. Assuming your camera is capable of recording a dynamic range of six stops, which is typical for a modern dSLR, you might expect that one-sixth of the available bits is allocated to each stop so that the darkest and the brightest levels contain equal amounts of data. This isn't the case.

In fact, half of the levels (2048), are used to record the brightest stop, leaving 2048 for the remaining five stops. Half of these (1024) are devoted to the next stop, half of the remainder (512) to the next and so on down to the darkest stop, which gets 64 levels (Fig. 1.12).

Do you see the problem? The shadow details, to which our eyes are most sensitive, are recorded using the least amount of data and therefore the fewest grayscale levels. This has important consequences for how you shoot Raw images, how you convert them to RGB files, and how you make tonal and color adjustments.

As we've seen, adjustments to Raw images don't carry the same consequences for data loss and image degradation as with RGB image files. That doesn't mean your changes won't affect image quality. There wouldn't be any point in working with Raw files if you couldn't achieve quality improvements, but you can also make things worse if you're not careful.

Clearly, if the shadow regions of an image are recorded using relatively few levels, manipulation of those levels is likely to cause problems. Any adjustment that stretches the histogram to the right, moving data from the

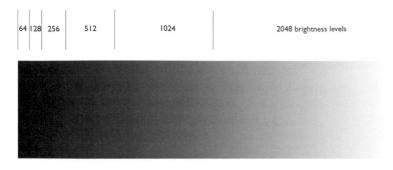

FIG. 1.12 This diagram shows how data are allocated to represent the brightness levels in a 12-bit image. Half of all the image data is used to represent the brightest stop. Half of the remainder is allocated to the next stop, and so on. While the brightest stop gets 2048 brightness levels, the darkest gets only 64. This has significant implications both for exposure settings when shooting and tonal adjustments of shadow detail in Raw images.

shadows to the midtones, for example Levels or Highlights and Shadows, carries the risk of introducing image artifacts such as posterization or noise.

You're only likely to need to make such adjustments with images that are underexposed, where the histogram is bunched up on the left. So it clearly pays to avoid underexposure. The generally accepted rule when shooting Raw is to set your exposure so that the highlights are as close to blowing out without actually doing so. In doing this you ensure that tonal detail is recorded using all of the available bits.

Let's suppose you shoot a subject and subsequently discover the histogram is bunched on the left with no pixels visible on the right-hand side, in the area normally occupied by the brightest stop of image detail (Fig. 1.13). Effectively you've sacrificed half of your camera's capacity to record tonal detail before you've even started processing the image. Not a good start.

When you come to making image Adjustments in Chapter 5, you'll discover that the histogram is your best guide when determining what controls to adjust and how far to go with them. Likewise, when you are shooting Raw, the camera histogram is your best guide to determining whether your exposure settings are providing you with the most data-rich image it's possible to obtain and one which provides the best opportunity for processing into a high quality RGB file.

It can often be difficult to determine from a camera histogram at exactly what point image highlights are blown beyond recovery. For one thing, the displayed histogram is adjusted to a non-linear gamma so doesn't tell you the whole story and can exaggerate highlight clipping. For another,

Aperture is quite good at recovering lost highlight detail so a small amount of clipping at the right side of the histogram isn't necessarily the end of the world and, in any case, is preferable to losing shadow detail from the other end (Fig. 1.14).

FIG. 1.13 If your histograms look like this, you're wasting most of your camera's ability to record tonal information.

FIG. 1.14 Camera histograms show the data for a gammaadjusted image and can exaggerate highlight clipping which, in any case, can easily be recovered in Aperture. A small degree of highlight clipping is infinitely preferable to underexposure.

White Balance

The White Balance setting on a digital camera makes a qualitative assessment of the lighting conditions in the scene being photographed and interprets the data so that white areas in the scene appear white in the image and other colors are accurately reproduced.

You can tell the camera about the ambient lighting conditions by using a White Balance preset, such as 'Daylight' or 'Tungsten' or by setting a specific color temperature. By using the automatic White Balance setting you can let the camera determine the color temperature of the ambient light, or you can set the White Balance more accurately by using a custom White Balance setting and taking a reading from a neutral surface, such as a white wall or neutral gray card, in the scene you are about to photograph.

If you're not shooting Raw it's important to get the White Balance right, because inaccuracies will need to be corrected (Fig. 1.15) and such corrections to pixel values are destructive and result in a loss, albeit marginal, in image quality.

When shooting Raw, White Balance is less of an issue. In fact, it's not an issue at all because, as the Raw image data haven't been colorimetrically interpreted, the White Balance hasn't yet been determined – you can do that in Aperture.

In practice, this makes the Camera's White Balance setting more or less irrelevant. Probably the best option is to leave it set to automatic. Aperture will use the camera's White Balance setting to make the initial conversion so that the image can be displayed and this is what will appear in the White Balance section on the Adjustment Inspector.

It's important to understand that this White Balance isn't 'fixed' as it is for RGB files. The White Balance information from the file metadata is applied to the Raw image to produce what you see on the screen. You can drag the slider to set any White Balance you want and this is effectively the same as setting the White Balance in the camera.

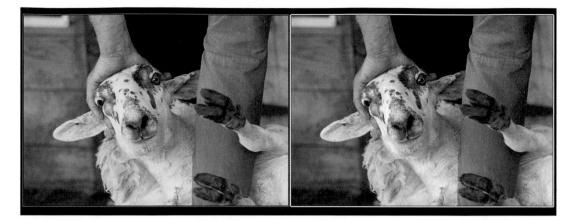

FIG. 1.15 The image on the left has been shot with the camera White Balance incorrectly set for artificial light. Using Aperture's White Balance adjustment you can correct for this by indicating the approximate color temperature of the lighting conditions in the scene (or simply judging the result visually). Because the White Balance adjustment occurs prior to conversion of the raw data, it's exactly the same as if you'd set the correct White Balance on the camera. This is not the case with RGB files, which will suffer a loss in image quality as a result of such a color correction.

Noise Reduction and Sharpening

Noise reduction in the camera is a proprietary process developed by the camera manufacturer to reduce image noise. Light falling on a camera sensor produces an electrical charge which is amplified before being converted to a number by an analog-to-digital (A/D) converter.

Analog systems such as this are subject to noise – a component of the signal that is generated by the circuitry and which, if you like, pollutes the pure signal. Noise in digital images is often compared to film grain and, just as faster films exhibit more graininess, digital images shot at a higher ISO rating display more noise (largely as a consequence of analog signal amplification resulting in a lower signal-to-noise (s/n) ratio). Visible noise can also be generated by long exposure settings.

Camera manufacturers implement noise reduction algorithms to deal with the noise characteristics of sensors at given ISO settings. Aperture's Auto Noise Compensation is an on or off control that performs a similar function (Fig. 1.16) and also removes so-called hot and cold image pixels caused by camera sensor faults.

Additionally, the Noise Reduction adjustment can be applied in varying degrees depending on the amount of correction required. See Chapter 5 for more details on how to use it.

The demosaicing process produces slightly soft images, and noise reduction tends to exaggerate this softness. To redress the balance and produce images with acceptably well-defined edges, in-camera Sharpening is usually

subsequently applied. Aperture's Raw Fine Tuning provides a Sharpening adjustment with two settings – Sharpening and Edges.

Most digital sharpening tools work by enhancing contrast in edge detail and this tool is no exception. The Sharpening control determines how much the edge contrast is increased and the Radius slider defines the edge boundary – it tells Aperture how far to look either side of a given pixel to detect a change in contrast.

Raw Fine Tuning in Aperture

The Raw Fine Tuning adjustment at the top of Aperture's Adjustments HUD (head-up display) provides some user control over how images are decoded, and this can be used to adjust the appearance of decoded images to a degree.

Which Decoder?

Aperture 3 has a new Raw decoder which is an improvement on the decoder used in earlier versions of the program and includes changes to noise reduction, color rendering and detail. If you're new to Aperture you don't really need to worry about this – providing Aperture 3 supports your camera's Raw file format the Raw decoder will optimize its settings for your files.

If, however, you're upgrading from an earlier version of Aperture, your images will previously have been decoded using an earlier version of the Raw decoder. For some cameras Aperture 3 automatically uses the most recent decoder to process images, but for some older cameras Aperture 3 will continue to work with the old decoder originally used to process the images, unless you tell it otherwise.

Unless you have good reasons for not doing so (for example you may want to maintain the appearance of existing images in your Aperture library), you should update all of your images to use the most recent version of the Aperture Raw decoder. If you select an image that uses an earlier version of the decoder the message 'This photo was adjusted using an earlier version of Apple's RAW processing' appears above the Raw Fine Tuning adjustment. Clicking the Reprocess button reprocesses the selected image using the Aperture 3 Raw decoder (Fig. 1.17).

If you have a large number of images that require reprocessing, you'll probably find it more convenient to do it project-by-project, rather than en masse, as reprocessing a large number of images can take a long time. To find all of the images in your Aperture library that use an earlier version of the Raw decoder, first select Photos in the Library Inspector and then click the Filter HUD button (Fig. 1.18) and select File Type from the Add rule pull-down menu. Set File Type is Raw and then choose Adjustments from the Add rule pull-down menu and set it so it doesn't include Raw Decode Version 3.0. Make sure both checkboxes for the new rules are checked and the Browser will now display all images in your Aperture library that do not use the Version 3 decoder. Now you can select any images you want to update and click the Reprocess button on the Adjustments Inspector.

Boost

Hue Boost

The Hue Boost slider is used to maintain the hue values in an image as the contrast is increased. Higher Hue Boost settings cause color in the image

FIG. 1.17 Images imported using earlier versions of Aperture may require reprocessing using the Version 3 Raw decoder.

FIG. 1.18 You can use the Filter HUD to locate images processed using legacy Versions of the Raw decoder.

Filter: Photos		Mercel.
All 🗧 of the following that match 🕴 🗖 Stack picks only	Add Rule	-
Rating: is greater than or equal to 🗧 📩 👘 Unrated		
Flagged: Yes :		
🖱 Color Label: 👔 🐨 🗧 💿 💿 💿 🌑 👁 👁 👁		
Text: Includes + Q+	Sec. 10	
🗮 Keywords		
🗹 File Type: is 🕴 RAW 🛊		
Adjustments: does not include + Raw Decode Version 3.0 +		
New Album With Current Im	ages 0	

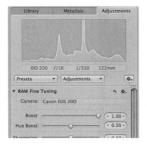

FIG. 1.19 This is what the Adjustments Inspector looks like for images using the Version 3 Raw decoder. to shift more as the Boost slider is increased. At lower Hue Boost settings, Boost has less of an effect on color values in the image. In practice, high Hue Boost settings work well for images with saturated primary and secondary colors, like flowers. You can use lower Hue Boost settings to maintain natural skin tones in portraits.

The defaults for Boost and Hue Boost settings are 1.0 and 0.5 respectively. This doesn't mean that the same settings are applied to all images; 1.0 is the recommended amount of boost for the Camera Raw format of the selected image. You can reduce this, but not increase it (Figs 1.20 and 1.21).

Reducing the Boost is often a good first step in recovering highlight detail in overexposed images or those with a high dynamic range. See Chapter 5 for more details of how to go about this.

FIG. 1.20 The Version on the left has the default Boost adjustment of 1.0; on the right this has been reduced to 0.5. For most images the default Boost setting produces excellent results.

FIG. 1.21 Both of these Versions have a Boost setting of 1.0. The Version on the left has a Hue Boost setting of 0; the one on the right has a Hue Boost setting of 1. The difference is marginal, but most noticeable in the yellows and greens.

Sharpening

Next on the Raw Fine Tuning adjustment are two sliders which control Sharpening. Aperture has other Sharpening adjustments but those on the Raw Fine Tuning adjustment are designed specifically to compensate for softening of the image, which occurs as a result of the demosaicing process (see 'Demosaicing and Color Space Conversion', on page 9).

Like the other Raw Fine Tuning adjustments, Sharpening is applied on the basis of the camera model characteristics – different Sharpening parameters will be applied, for example, to images from a Nikon D3 than to those from a Canon EOS-1D Mark IV.

The Sharpening slider controls the amount, or intensity, of Sharpening and the Edges slider defines the largest group of pixels which, for sharpening purposes, constitute an edge. As you drag the Edges slider to the right, more of the image is sharpened.

Sharpening has a very minimal impact on the image compared with Aperture's Edge Sharpen adjustment. See Figure 5.32 in Chapter 5 for a comparison of an image with the default Sharpening settings applied and no Sharpening. You'll also find a more detailed discussion of Sharpening in general.

Given that it has such a marginal effect, you might be tempted to turn Sharpening off altogether. In our view this isn't a good idea. For most images the best option is to leave Sharpening on its default setting and use Edge Sharpen later in your workflow to sharpen images in preparation for output.

Moiré and Chromatic Aberration

The Moiré adjustment and its associated Radius slider are used to reduce the effects of Moiré interference patterns and fringing caused by chromatic aberration in lenses.

Moiré patterns will be familiar to anyone who has experience of commercial printing, where they commonly occur as a result of interference between fine image detail and halftone reproduction screens. In cameras they are similarly brought on by interference between the color array and repeating fine image detail.

Chromatic aberration is a lens fault where light of different wavelengths is focused in different planes. It results in a colored fringe, usually purple, around backlit objects. In good quality lenses, chromatic aberration is rarely present, but it is difficult to eliminate in ultra-wide-angle lenses and can often be seen in images from digital compacts.

To reduce Moiré or fringing, drag both sliders to the extreme right to apply the maximum amount of Moiré at the largest radius setting – 1.00 and 25 respectively. Reduce the Moiré until the effect starts to reappear, then increase it just enough to eliminate it. Finally, do the same with the Radius slider, reducing it until the Moiré pattern starts to reappear in areas of the image and adjusting back up to the minimum setting required to eliminate the effect.

To be brutally honest, the Moiré adjustment never was very effective, so don't be surprised if your efforts to remove colored fringing using Moiré aren't all that successful (Fig. 1.22). Fortunately, Aperture 3 now has a dedicated Chromatic Aberration adjustment, which is explained in more detail in Chapter 5.

DNG

DNG is a Raw format published by Adobe in the hope of creating a single, industry-standard Raw format as an alternative to the multitude of proprietary Raw formats currently in existence.

One advantage of this for developers of software that works with Camera Raw files is that it would not be necessary to add support for new formats each time a new camera model is released. And owners of those new cameras would not have to wait for their image management and editing applications to add support so they can start using them with images from their new hardware.

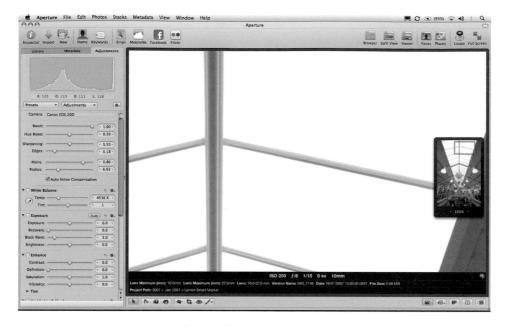

FIG. 1.22 Aperture's Moiré adjustment isn't the most effective tool for removing Chromatic Aberration. Alongside a whole range of new adjustments, Aperture 3 includes a Chromatic Aberration adjustment which does a much better job.

Although some camera manufacturers, such as Hasselblad, Leica, Ricoh and Samsung, produce models which can write Raw files in DNG format, most manufacturers continue to use proprietary Camera Raw formats. But you don't need a camera that writes DNG files in order to be able to use it in your Raw workflow. Adobe's DNG converter application converts files from a wide range of Camera Raw formats into DNG.

There are a number of advantages to converting your Raw files to DNG. We've already talked about the risks of archiving images in a proprietary unpublished format and the problems inherent in adding software support for new formats as they become available. As well as standardizing on a single format for all of the images you produce in future, regardless of hardware developments, DNG files can contain embedded IPTC metadata; they can also provide a vehicle for migrating images that have had metadata added in applications other than Aperture. See Chapter 7 for more details on how to migrate images from Adobe Bridge to Aperture using DNG Converter.

Using DNG Converter

DNG Converter is a free download available from www.adobe.com/products/ dng/(Fig. 1.23). All the conversion options are provided from a single panel

divided into four numbered sections. The first two of these are used to select the images you want to convert and specify a destination folder and file naming options.

Specify a separate location for the converted DNG files. Depending on your archival requirements you may want to archive the original Raw files to a removable or separate disk.

Panel 3 provides file renaming options. In most cases, the default settings, which keep the original filenames and append a .dng suffix are fine. If required, you can always rename the files on import to Aperture.

Panel 4 displays the conversion preferences, which determine the kind of DNG file produced. Click the Change Preferences button to open the Preferences dialog box (Fig. 1.24). These conversion settings have been greatly simplified from earlier versions of the program. DNG files created with the default compatibility setting of Camera Raw 5.4 and later will be readable by Aperture 3. If you're using an earlier version of Aperture, or want your DNG files to be readable by other applications, you may need to choose a different setting – use trial and error to determine the most recent setting that will work with your chosen application.

The JPEG Preview pop-up menu sets the size of the JPEG preview. If you checked the 'Use embedded JPEG from camera when possible' box in the Previews pane of the Aperture Preferences window, this is the preview that

	Adobe Digital Negativ	ve Conver	ter	Adobe
O Se	lect the images to convert			
63	Select Folder) /Work in	n Progress/522	1 Aperture 3/	
6	Include images containe			
0.0			olders	
U Se	lect location to save converted			
600	Save in Same Location 🗘			
-	Select Folder) /Work in	n Progress/522	1 Aperture 3/	
	Preserve subfolders			
D Se	lect name for converted images	5		
	Name example: MyDocument.de	ng		
	Document Name	+		¢ +
		+		
	Begin numbering:			
	File extension: .dng	•		
O Pr	eferences			
	Compatibility: Camera Raw 5.4 a IPEG Preview: Medium Size	and later	Change Preferen	

Preferences					
Compatibility -					
Compatibility:	Camera Raw 5	.4 and later	\$		
CS4) and la	e will be readable b ter, and Lightroom adable by earlier ver	2.4 and later. The I	ONG file will		
Preview					
JPEG Preview:	Medium Size	÷			
Original Raw Fi	le				
Embed Orig	ginal Raw File				
creates a la	entire non-DNG ra rger DNG file, but it ater if needed.				

FIG. 1.23 Adobe DNG Converter.

FIG. 1.24 DNG Converter Preferences.

Aperture will use. Otherwise, or if you choose none, Aperture will create its own preview.

DNG Converter provides the option of embedding the original Raw image file in the DNG file you are about to create. This is an archival option which provides for the extraction and retrieval of the original Raw file should you require it. It is, if you like, a 'belt and braces' option. The only drawback is that it increases the size of the DNG file considerably. Though it doesn't provide the convenience of co-location, a more workable option might be to archive your Raw originals separately. Embedded Raw files can be extracted from DNGs using the Extract button.

Unsupported Raw Formats

As mentioned earlier in this chapter, one of the drawbacks of shooting Raw is that when new camera models are released software developers can take some time to implement support for the new camera Raw format. Apple is no exception and if you buy a recent model SLR you may find yourself in the position of not being able to process Raw files from it for some time (Fig. 1.25).

Apple regularly produces Raw updates for MacOs to include popular new dSLR and compact cameras that shoot Raw, but what do you do in the

FIG. 1.25 You'll most likely have a wait on your hands before Aperture (and other Raw conversion applications) gets around to supporting Raw formats from new camera models...

meantime? The simplest solution is to set your camera to record both a Raw file and a JPEG at the highest resolution and best quality settings (nearly all recent dSLRs have Raw + JPEG settings) and import both images into Aperture.

When you select the folder containing both Raw and JPEG files, the Aperture Import panel provides a number of options for importing either the Raw and JPEG files, or both. You can choose to import Raw + JPEG image pairs with the JPEG file as the master, in which case the image pair is displayed in the Browser with a J badge, indicating it is a Raw + JPEG image pair with the

	= 🔟 🗐 Ap	ril 02		earch
V DEVICES	Name		Date Mod	ified
Ken McMah.	IMG_0	633.JPG	Monday,	12 April 2010
Macintosh H	IMC O	634.CR2	Monday,	12 April 2010
Mister T 🛋	IMC O	634.JPG	Monday,	12 April 2010
in wiscer i _	MG_0	635.CR2	Monday,	12 April 2010
PLACES	IMG_0	635.JPG	Monday,	12 April 2010
🔜 Desktop	IMG_0	636.CR2	Monday,	12 April 2010
Applications	IMG_0	636.JPG	Monday,	12 April 2010
Documents	IMG_0	637.CR2	Monday,	12 April 2010
.docx	IMG_0	637.JPG	Monday,	12 April 2010
	IMG_0	638.CR2	Monday,	12 April 2010
	IMG_0	638.JPG	Monday,	12 April 2010
	IMG 0	639.CR2	Monday,	12 April 2010
			CONTRACTOR OF STATE	13 4-1 2010
	and the second sec	639.JPG	Monday,	12 April 2010
		640 CP2	Monday	12 April 2010
	Import Folders As:	Folders and Projects	Monday	감독가 관계 전화 경험을 얻는 것을 가지 않는 것을 가지 않는 것을 가지 않는 것을 가지 않는 것을 수 없다.
		640 CP2	Monday	감독가 관계 전화 경험을 얻는 것을 가지 않는 것을 가지 않는 것을 가지 않는 것을 가지 않는 것을 수 없다.
	Import Folders As:	Folders and Projects	Monday ¢	감독가 관계 전화 경험을 얻는 것을 가지 않는 것을 가지 않는 것을 가지 않는 것을 가지 않는 것을 수 없다.
	Import Folders As:	Folders and Projects	Monday ¢	감독가 관계 전화 경험을 얻는 것을 가지 않는 것을 가지 않는 것을 가지 않는 것을 가지 않는 것을 수 없다.
	Import Folders As:	Folders and Projects In their current location Move files Copy files	Monday ¢	감독가 관계 전화 경험을 얻는 것을 가지 않는 것을 가지 않는 것을 가지 않는 것을 가지 않는 것을 수 없다.
	Import Folders As: Store Files:	Folders and Projects In their current location Move files Copy files Do not import duplicates	Monday	감독가 관계 전화 경험을 얻는 것을 가지 않는 것을 가지 않는 것을 가지 않는 것을 가지 않는 것을 수 없다.
	Import Folders As: Store Files: Subfolders:	Folders and Projects In their current location Move files Copy files Do not import duplicates	Monday	감독가 관계 전화 경험을 얻는 것을 가지 않는 것을 가지 않는 것을 가지 않는 것을 가지 않는 것을 수 없다.
	Import Folders As: Store Files: Subfolders: Folder Text:	Folders and Projects In their current location Move files Copy files Do not import duplicates None Master File Name	Monday	감독가 관계 전화 경험을 얻는 것을 가지 않는 것을 가지 않는 것을 가지 않는 것을 가지 않는 것을 수 없다.
	Import Folders As: Store Files: Subfolders: Folder Text: Version Name:	Folders and Projects In their current location Move files Copy files Do not import duplicates None Master File Name Both (JPEG as Master)	Monday	감독가 관계 전화 경험을 얻는 것을 가지 않는 것을 가지 않는 것을 가지 않는 것을 가지 않는 것을 수 없다.
	Import Folders As: Store Files: Subfolders: Folder Text: Version Name: Name Text	Folders and Projects In their current location Move files Copy files Do not import duplicates None Master File Name Both (JPEC as Master) Both (RAW as Master)	Monday	감독가 관계 전화 경험을 얻는 것을 가지 않는 것을 가지 않는 것을 가지 않는 것을 가지 않는 것을 수 없다.
	Import Folders As: Store Files: Subfolders: Folder Text: Version Name:	Folders and Projects In their current location Move files Copy files Do not import duplicates None Master File Name Both (JPEG as Master) Both (RAW as Master)	Monday	감독가 관계 전화 경험을 얻는 것을 가지 않는 것을 가지 않는 것을 가지 않는 것을 가지 않는 것을 수 없다.

FIG. 1.26 Aperture's ability to import Raw + JPEG image pairs can provide a useful workaround in the interim.

JPEG as the master. When Aperture eventually provides support for your camera's Raw file format, you can set the Raw file as the master by selecting Set Raw as Master from the Photos menu. An alternative approach would be to select Both (separate Masters) from the Raw + JPEG pop-up menu in the Import panel (Fig. 1.26). Then you could simply delete the JPEGs when they were no longer required.

How Aperture Works

The Aperture Workspace

Aperture is part of Apple's 'Pro' application line-up, where it sits beside Final Cut Studio, Logic and Shake. As such, it sports the distinctive dark interface that Apple uses for these products, and works best on high resolution displays, as it adopts a smaller on-screen font and a range of complex panels and palettes. It's even better when spread across two screens, where the management and editing workspaces will be separated out from each other and your pictures will have room to breathe.

When it upgraded the application to Version 3, Apple made it clear that it was a suitable next step for anyone who does most of their photo management through iPhoto, its consumer editing application. Not only did it switch to a white box, like iPhoto, but the interface had an overhaul, with the introduction of friendlier icons, direct posting to Facebook and Flickr, and the Places and Faces features of iPhoto.

The interface is split into resizable areas dedicated to specific tasks, such as Project management, image editing, photo browsing, and viewing at larger sizes. Each one is contained within the Aperture application interface, rather than spun off as a separate panel as things are in Photoshop. This follows the methods used in Final Cut Studio, iTunes and iPhoto. There are exceptions, however, in the form of Head-Up Displays (HUDs) and the innovative Full Screen mode, which has now been supplemented by a Full Screen Browser for better management of your photo collections, particularly on smaller-screened computers like the MacBook. When running in full screen, Aperture hides its rigid gray interface and instead adopts a black background to better show off your photos (Fig. 2.1), while a strip at the top of the interface displays your various tools. The HUDs, meanwhile, are semi-transparent dialogs that overlay the main interface and allow you to perform a range of tasks, which includes assigning keywords and editing colors and exposure. They can be used in regular and Full Screen modes.

In its regular layout, Aperture's three most obvious palettes are the Library Inspector, the Viewer and the Browser. By default these sit to the left, top and bottom of the display respectively. The Adjustments and Metadata panels sit behind the Library panel and you can switch between them either by clicking the tabs at the top of the pane or tapping **W** to cycle through all three.

Supplementary to these are the toolbar and control bar. The toolbar sits at the very top of the screen, just below the OS X menu bar, and handles image imports, creating books, galleries, slideshows and so on, emailing your

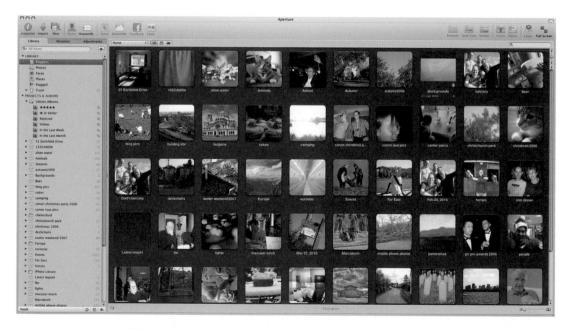

FIG. 2.1 The Aperture interface follows the design of Apple's Pro apps, with a darker background, smaller font and distinctive panels inside a unified interface. Here we are using Browser mode, which displays the images inside our various libraries, each of which is listed in the Library inspector to the left.

photos, invoking the loupe, applying keywords to your files, posting to photo sharing sites and filtering the contents of your current project according to the settings in Faces and Places.

The control bar, invoked by tapping **D**, sits at the very bottom of the screen. It handles the way in which your images are displayed in the Viewer and – if you've called up the relevant dialogs – provides for an easy way to rate pictures, add keywords (**Shift D**) and skip through your Library.

Everyone will use Aperture in a different way, and while some will never step out of the regular interface layout, others will spend all of their time working in full screen. Aperture 3 sports a new full screen Browser, which supplements the existing Full Screen editing mode. Tap 🕞 to switch back and forth between Full Screen and the regular windowed mode.

To use the full screen Browser, click Projects at the top of the Library Inspector and then tap **(F)**. Your projects are laid out in piles on a black background. Rolling your mouse across them lets you preview their contents, and double-clicking opens the Project for working on.

In Full Screen mode it is particularly beneficial to have a good working knowledge of Aperture's keyboard shortcuts, as this will allow you to work without constantly revealing the hidden toolbars and menus that sit at the top and bottom of the screen.

In this chapter we will examine each element of the Aperture interface in detail, walking you through the various options open to power users and explaining how to use each to best effect. We'll also point out those essential keyboard shortcuts wherever they apply.

First, though, we'll take you through how Aperture stores your images. A thorough understanding of its filing system goes a long way to helping understand how it applies edits and adjustments to your files.

How Aperture Stores Your Images

Aperture stores all of your images in its Library. Under the hood, this is a complex collection of folders, subfolders, packaged files and original images, accompanied by thumbnails, previews and metadata files describing how they should be organized and what changes you have made to them.

At a system level – on your hard drive – your images are organized in a complex series of embedded folders hidden inside a package in your Pictures folder called Aperture Library (Fig. 2.2). Double-clicking this will open Aperture, but right-clicking and selecting Show Package Contents will open it up for inspection. While there is no harm in taking a look at what it contains, you should resist the temptation to fiddle with its contents, as doing so could cause irreparable damage to your photo Library, and you risk losing some or all of your images.

	E * # · O	Q		
P DEVICES	Name	A Date Modified	Size	Kind
Disk iDisk	Aperture.aplib	Today, 16:04		Folder
Macintosh HD	ApertureData.xml	Today, 15:54	17.2 MB	Text document
Datavol 1	Attachments	18 February 2010 15:14		Folder
MyBook	🔹 🔻 📖 Database	Today, 17:11		Folder
	Albums	Today, 16:04		Folder
SHARED	🕒 BigBlobs.apdb	Today, 17:11	48.5 MB	Document
Ion-mc002911	BigBlobs.apdb-journal	Today, 17:11	16 KB	Document
thomson	DataModelVersion.plist	Today, 16:04	4 KB	XML Property Lis
PLACES	🕒 Faces.db	Today, 17:10	40.6 MB	Document
MacUser 1	Folders	Today, 15:38		Folder
MacUser 2	💾 History.apdb	Today, 17:12	30.3 MB	Document
Desktop	💾 History.apdb-journal	Today, 17:12	29 KB	Document
1 nikrawlinson	🕒 ImageProxies.apdb	Today, 17:10	7.6 MB	Document
Applications	🗋 Keywords.plist	8 March 2010 17:40	45 KB	XML Property Lis
Documents	🗋 KeywordSets.plist	23 February 2010 12:35	16 KB	XML Property Lis
MacUser	Library.apdb	Today, 17:12	55.6 MB	Document
Movies	Library.apdb-journal	Today, 17:12	33 KB	Document
Music	Places	Today, 15:40		Folder
00	Properties.apdb	Today, 17:12	216.5 MB	Document
Pictures	Properties.apdb-journal	Today, 17:12	37 KB	Document
iiii web	Vaults	17 March 2010 08:01		Folder
images images	Versions	23 February 2010 15:57		Folder
Dropbox	🕒 Info.plist	28 February 2010 10:52	4 KB	XML Property Lis
SEARCH FOR	▶ 🚞 Masks	23 February 2010 12:21		Folder
	Masters	Today, 17:10		Folder
	Previews	23 February 2010 15:58		Folder
	Thumbnails	8 March 2010 17:40		Folder

FIG. 2.2 Any images you import into Aperture directly are stored in its Library, a packaged folder than can be explored through the Finder. Never tamper with the contents or you could irreparably damage your collection.

Within this package you'll see a series of subfolders. These are the roots of an extensive folder tree that contains not only your images but also any new versions you have made by editing and attaching any metadata. Should you suffer an irrevocable failure of some kind, you will be able to retrieve your original images from these folders. They are organized by date in a folder called Masters, with year, month and date folders inside it.

Fortunately all of this is hidden inside Aperture itself, which makes a thorough understanding of the Library's underlying directory structure unnecessary. All images are organized in the Library panel and selected in the Browser, which presents lists or thumbnails of files below the main editing window, the Viewer, or in Full Screen mode (Fig. 2.3).

The precise subdivisions of your images are up to you. If you want, you can have a single large Project containing everything you've ever imported, although this would be barely any easier to navigate than the on-disk file structure. Instead, you should use Projects to split your photos by assignment or subject – say, France, Jill's Wedding, and so on – with albums inside each one to further categorize the contents – such as Lyon, Paris, Marseilles, and Dress, Cake, Ceremony in the examples above. Supplementary to these are Light Tables, used to help sort and filter your images, Web Galleries, Pages and Journals used to publish them online, and Books.

Above your Projects are Aperture's 'Smart' folders. These are automatically populated when you import images into Projects elsewhere in the application, and then start to rate them, and you can add your own Smart Folders to further automate your photo management. With the pre-defined Smart Folders you have immediate access to the very best images across all categories by clicking on the automatically-maintained five-star group in the Library. This will help when it comes to maintaining a portfolio of your best work. The default Smart Albums will also identify images imported in the last week or month, videos that appear in your Library and any images you have rejected.

The Projects entry at the very top of the Library Inspector shows thumbnail views of every Project you have created in the application. Rolling your mouse across them from left to right or right to left flicks through all of the images they contain, allowing you to quickly preview their contents, so helping you distinguish between similarly-named Projects (Italy 2008 and Italy 2009, for example).

We'll explore these subdivisions in greater detail in the pages that follow.

Digital Masters and Versions

Every photo you import into Aperture is a Digital Master. Regardless of its format, it is considered sacred within the application and will never be touched by any of the editing tools at your disposal. Even cropped images still exist in their original format in the directory structure we described above, so that should you suffer a serious drive corruption, after which Aperture can no longer open your Library itself, you can still go back in and manually copy out the images yourself. This assumes, of course, that the drive hasn't failed, in which case you may need to employ the services of expensive data recovery specialists.

When you use the Adjustments panel to edit an image for the first time, Aperture creates what it calls a Version. It will then show a small numeric icon in the corner of the original showing how many Versions (including the master) it now holds in its Library. Digital masters and their Versions are organized into Stacks, which can be expanded and contracted by clicking on the afore-mentioned icon, called the Stack button. Stacks are covered in depth, starting on page 236 (Fig. 2.4).

FIG. 2.4 Whenever you make an adjustment to a Digital Master, Aperture creates a new Version. This sports a numeric badge, which shows how many versions of the picture exist in your library.

FIG. 2.3 The Library Inspector organizes not only Projects, but also Folders, Albums, Smart Albums and the products you make with your images, such as Web Pages, Galleries, Journals and Books.

Browsing and Organizing Images

Images are edited in the Viewer and organized in the Browser. The Browser is a collection of thumbnails or image names, which can either take over the whole of your screen or share the screen space with the Viewer, allowing you to work on several images in quick succession by editing them in the Viewer and then clicking in the Browser strip to move to the next one.

Press V to cycle through the various interface modes – Browser Only, Split View or Viewer. When viewing thumbnails in Browser Only mode the size of the thumbnail is set using the slider at the bottom of the interface. Stacks, meanwhile, are outlined in a darker gray border that groups related images together.

In the List view, where the thumbnails are swapped for a more conventional file listing (also showing metadata such as ratings, labels, aperture, shutter speed and so on), Versions are organized within a folder that takes the name of the original image. It doesn't look like a folder, since it also sports the Digital Master's shooting metadata, but a disclosure triangle in the left-hand margin betrays its true purpose, and in this respect it works just like Folders in the Finder.

If you have already made some edits to a photo and want to make another copy so you can try an alternative set of adjustments, you have two options. We will copy the currently selected Version and all of its adjustments to a new Version in the Stack, allowing you to pick up further adjustments from the point you have already reached without doing further edits to what could already be a perfectly tweaked Version. Ge, meanwhile, creates a fresh copy of the original untouched image, allowing you to start making adjustments from scratch, giving you two distinct Versions that you can then go on to compare side by side. Whichever you choose, the resulting copy will be added to the current Stack.

Versions can be treated in exactly the same way as masters; you can print, copy, duplicate and export them. They can be rated separately from the original, you can have as many subsequent editions as you like, and you can use any one of them, or indeed several editions of the same master, in a single Book, Gallery, Light Table, Web Page or Journal.

Library Inspector

The Library Inspector is where you will do most of your organization. It shows top-level Folders, Projects, and the products you're making with your images, such as Light Tables, Galleries and Books. It doesn't show individual images as these are organized through the Browser, which sits below or to one side of the Viewer.

The Library Inspector is pre-filled with Smart Folders that organize your images by rating or data, to which you can add your own Projects, Albums, Smart Albums, Books, Light Tables, Web Galleries, Web Journals and Web Pages.

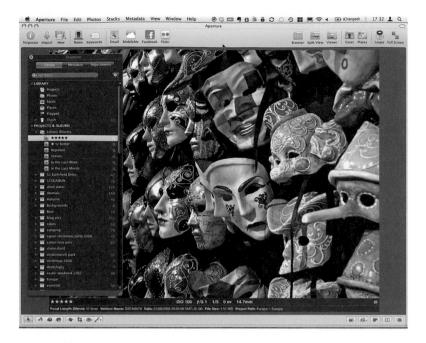

FIG. 2.5 Many elements of the Aperture interface are duplicated in the form of HUDs, including the Inspector, containing the Library, Metadata and Adjustments panels.

The combined Library, Metadata and Adjustments panel can be quickly hidden and revealed by clicking the Inspector button on the main toolbar or using the keyboard shortcut **1**. This is particularly useful when working on a small screen, such as that on a 13-inch MacBook. In this instance, the same collection of Inspector panels can be used through a HUD, called up by tapping **(f)** with an image selected (Fig. 2.5).

Browser

The Browser is the panel through which you organize your photos and files. It works in tandem with the Library Inspector and shows the images displayed inside each Project, Web Album, Folder, and so on (Fig. 2.6a and b). It is invoked by clicking the Browser button on the toolbar, or by pressing **V** to cycle through the various view modes.

The Browser can display your images in two ways: either as thumbnails organized in a grid formation (*CIP* (*C*)), or as a list of files (*CIP* (*L*)) accompanied by supplementary metadata showing key attributes including aperture, shutter speed, creation date and focal length. You can sort on any of these attributes by clicking the header above each column. Clicking a selected column header for a second time reverses the sorting order. So, clicking the ISO column once will sort your images in order of increasing

Apple Aperture 3

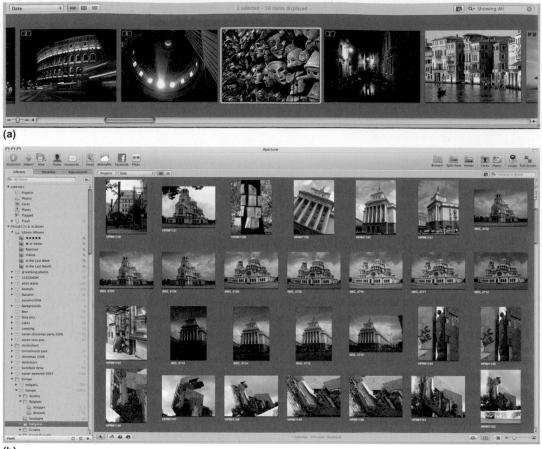

(b)

FIG. 2.6 The Browser usually appears as a strip running across the bottom of the interface, below the Viewer (a). However, it can also be maximized to occupy the majority of the screen for those occasions when organization and management are more important than adjustments and editing (b).

sensitivity – say, from 100 ISO to 1600 ISO – while tapping it for a second time would sort them in order of decreasing sensitivity. Depending how you use this feature, it could let you quickly identify underexposed or grainy images, depending on which end of the scale is uppermost.

Dragging the slider at the bottom of the screen adjusts the size of the thumbnails displayed in any Browser view, allowing you to get the best of both worlds by selecting the List view and maximizing the thumbnails. The results won't be as large as they are in the grid view, but they are perfectly serviceable.

New in Aperture 3 is the full screen Browser, which presents your Folders and Projects in a more appealing manner. It is invoked by tapping (a) from the Browser view.

A toolbar running across the top of the interface lets you perform rudimentary edits, such as Red-Eye Correction, Cropping, Straightening and Rating, as well as opening up the Loupe. Below this are the Browser navigation tabs. The backward-facing Projects button takes you back to the projects overview, which presents your images in Stacks organized by project. To the right of this is a breadcrumb trail that lets you skip straight to a specific Folder, Project or Album without having to work your way back up and then down the directory tree.

Double-clicking an image in the full screen Browser opens it for editing. Double-clicking again on the opened image returns you to the Browser.

Toolbar

The toolbar runs across the top of the Aperture interface, just as it does in Word, Excel, Finder windows in Mac OS X and in most mainstream applications. Its importance has been greatly reduced over successive updates to Aperture, for while it was once used to open and close panels, rotate, crop and straighten images, fix red-eye and apply selective patches to your work, it has benefited from a radical slimming down and now focuses on core features (Fig. 2.7). In Aperture 3 it has been redesigned, with more friendly icons and new one-click publishing to social networks like Facebook and Flickr.

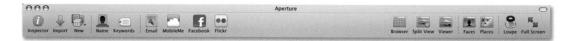

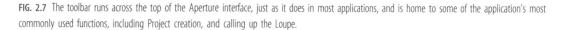

The first icon on the toolbar – Inspector – hides and shows the combined Library, Metadata and Adjustments panel on the left of the interface. It has the same function as the keyboard shortcut **1**. The blue arrow to the right of this opens the Import tool to add photos to your Library. Technically you could do the same by inserting a media card into an attached reader or connecting a camera (assuming you have Mac OS X set to treat Aperture as the default application for handling incoming photos), but by manually invoking the Import tool you can also add images from internal or external drives and network stores.

Controlling Image Imports

If you would rather not have Aperture pop up every time you insert a memory card, perhaps because you'd rather store your images in iPhoto or save them directly to a backed-up network drive, its auto appearance can be disabled in the operating system. It will then be up to you to manually invoke the Import command in whichever application you choose.

To disable Aperture's automatic appearance, or activate it if iPhoto or another application appears each time you insert a card or connect a camera, open Aperture's Preferences (**H**), and click on the Import tab. Here, change the drop-down menu beside the line 'When camera is connected, open:' to either Aperture, 'No application' or an alternative piece of software, as appropriate (Fig. 2.8).

FIG. 2.8 Control what happens when you plug in a camera or insert a card into a media reader by specifying whether Aperture, an alternative or no application at all should launch.

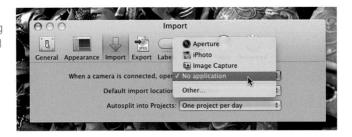

The New button is used for creating Projects, Folders, Albums, Smart Albums and either printed or online products, such as Books and Journals. The relative importance of the Projects, Folders, Albums and Smart Albums is clear from the fact that they have keyboard equivalents (**H N**, **Shift H N**, **H (**) and **Shift (H**) respectively), whereas the others do not. Why? Because they are used for organizing your images and so relate to everything you do. The others are creation actions, and so will apply to only a selection of images. As ever, it's worth getting familiar with these shortcuts as they are excellent timesavers.

Equally useful are the shortcuts that duplicate the toolbar's View and Full Screen buttons: View through the three options in the View menu, switching between Browser Only (just your thumbnails or file list), Viewer Only (just the selected image) and a mixture of the two. To devote the whole of your screen to your images or the Browser, tap rolick the toolbar's Full Screen button. This fades away the Aperture interface and switches to a black background, allowing you to focus all of your attention on the image or images in hand (Fig. 2.9).

Some parts of the toolbar are merely reorganized: the Keywords button, for example, brings up the keywords HUD, allowing you to assign tags to your images, and has simply been moved from the opposite end of the toolbar. However, there are also a number of new buttons on the toolbar in

FIG. 2.9 Aperture's Full Screen mode lets you devote every available pixel to the task of editing your photos. The filmstrip at the bottom of the screen, and the toolbar at the top can both be set to automatically slide off the screen as your mouse moves away from them.

Aperture 3. The first is Name, which detects the faces in an image and asks you to assign a name to each one. These are then used to catalog the people to whom they relate in the Faces Library. Also new are upload buttons for posting images from your Library to Facebook and Flickr. Both of these services have to be set up to access your accounts.

Two further additions appear on the right-hand side of the toolbar. These are Faces and Places, and have been inspired by equivalent tools in iPhoto. Faces uses Apple's own face recognition technology to identify people who appear in your photos. When you have named them in a couple of images, it will then try to automatically identify them in other pictures in your Library. Clicking Faces when you have a Project or Folder open will show just the faces of people that appear in that collection. Clicking it in the Library Inspector, however, displays all faces from all images in your Library.

Likewise, clicking Places in the Library Inspector brings up a Google Map showing all of the places in which you have shot photos, but clicking it on the toolbar when you have a Project or Folder open shows just the locations featured in those active photos. Apple Aperture 3

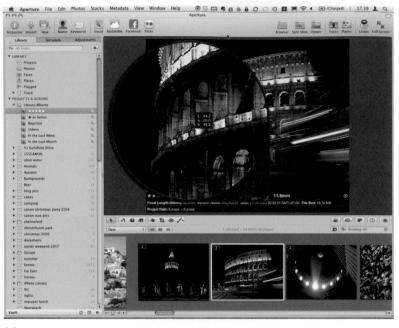

(a)

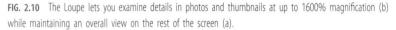

The Loupe, the toolbar's penultimate feature, is one of Aperture's most radical tools. It lets you examine an open image at up to 1600% magnification or, if you drag it over your thumbnails, view parts of them at higher zoom levels without fully opening them. More usefully, it will optionally display a crosshair at the center of its lens, detailing the individual color values of the center-most pixel.

Dragging the Loupe around by its gray border is somewhat imprecise, so Apple has provided a second, more accurate way to position this tool. Click and hold in the center of its lens and you'll see that a thick white circle will shrink down to the mouse point. Drag this to its new position and let go to have the Loupe zoom the circle until it fills the tool's full frame.

The Loupe can sometimes be restrictive, so tapping **Z** at any time toggles the selected image between fitting in the Viewer, and zooming to 100% magnification.

It's unlikely you'll fit the whole image on screen at this level, in which case you'll have to drag it around. This is done by mousing over the thumbnail view of the image to the right. This will pop out, allowing you to drag around a white rectangle to select the view you want to use. For a more direct approach, you can also click and hold on the image and drag.

The Zoom tool can be combined with other view modes. Tapping 2 while in three-up view, for example, will show all three images at 100% zoom, which is an excellent way to compare particular parts of different versions of a Digital Master (Fig. 2.11). Unfortunately, there is no way to line up images displayed in this way so a certain amount of manual nudging will have to take place to position the same area in view in each window; however, holding down the Shift key while dragging one of the images will pan all of them at once.

FIG. 2.11 Using the Zoom tool with several images opened side by side lets you compare fine details on each one when making your initial judgments.

If you have been using Aperture since its first appearance, you may find the new slimmed-down toolbar to be rather too svelte for your needs. Likewise, if there are a small handful of tasks that you perform on a regular basis that aren't represented in its default state, then you may feel that the toolbar is more form than function. In this case, you can customize it by right-clicking on any blank area of the toolbar and choosing Customize Toolbar... then dragging optional elements onto the bar itself. To reset it after making changes, drag the default set back onto the bar and it will replace any additions you have made.

Control Bar and Keyword Controls

The control bar exists to help you organize your workspace more efficiently, and has just a few features that impact directly on your images. As such, it's a bit of an oddity. It's hidden by default, but revealed (and subsequently rehidden) by tapping **()**, which when combined with shift will also show and hide the Keywords tool, allowing you to quickly add pre-defined keywords to your images to make searching more efficient. It sits at the bottom of the screen.

The control bar lets you mange your journey through the images in your current project and, like most of the other features in the application, can be bypassed once you've taken the time to learn some simple keyboard shortcuts.

Once you can work without reference to the control bar, your productivity will increase exponentially, and so it is fortunate that in all cases Apple has chosen logical keyboard shortcuts to represent each function performed by the different parts of the bar. If you are to learn the 'mouse-less' operation of just one part of Aperture, make it this one.

Navigating Your Photos Using the Control Bar

The two simplest buttons on the control bar are the white forwards and backwards arrows. These move one step in either direction through the images in the currently selected Project, Folder, Album or Smart Album, even if the Browser is hidden.

Combining these buttons with *Shift*, **S** and **H** lets you use them in a more intelligent way to view and compare several images at once. Here, switching from clicking the buttons to using the **S** and **S** cursor keys on your keyboard pays dividends.

Shift and Shift keeps the current image selected and adds the next or previous picture to the selection, displaying them side by side in the Viewer. Making further movements in either direction adds further images to the collection shown in the Viewer. Displaying several images side by side in this way lets you make adjustments to any one of them while comparing it to others in the collection, so easing the task of matching colors, brightness and simulated exposure across multiple related images.

The image in any selection of this sort to which Aperture will apply any adjustments you make has a fat white border. Letting go of the Shift key and using the arrow keys to move back and forth through the selection will move this border, and so change the image to which the adjustments will be applied.

However, some features apply across all selected images at once. Notable among them are changes to the metadata and star ratings. Using 🖨 and 🖨 to increase and decrease ratings while you have multiple images selected at one time in this way will apply the changes to every image in the selection. The changes are relative to their existing rating, so if you have one unrated image, one rated 2 and one rated 5, and then tap 🖨 once, the unrated image will be given one star and the two-star image would have its rating increased to three, but the five-star image would see its rating unchanged as it was already rated as high as possible.

The inverse is also true. Tapping instead of would have decreased every image's existing rating by one star, so that the unrated star was rejected. It would then appear in the Rejected Smart Album at the top of the Library Inspector.

You can compare your images in a similar way, which we'll explore later.

Rating and Sorting Images with the Control Bar

The Rating and Sorting controls are among the control bar's most complex tools. This is because Apple has managed to cram an enormous number of features into each one using a series of combined modifiers. Fortunately the system is logical and regular throughout each one, so if you'd prefer to learn how to perform the same tasks on the keyboard, rather than using the mouse, you need learn only four shortcuts, plus their five modifiers.

Rating images should be your first task after they are imported. It helps you quickly sort the good from the average, and the average from the bad, and then concentrate your efforts on only the best material from any session.

Ratings run on a scale of one to five, and are applied using the numbers 1 to 5 on the keyboard. They can also be applied comparatively using the green and red up and down buttons on the control bar, which respectively increase and decrease a picture's rating from its current setting. The same can be achieved on the keyboard using \cong (or + on the numeric keypad) to increase the rating, and \bigoplus to reduce it, while combining these with the Control key will increase or decrease the rating of the image by one point and then the selection will move on to the next image in the Browser or selected range. Images can be rejected outright using the control bar's red cross, and given a five-star rating using the green tick or, on the keyboard, using *()* on the numeric keypad (if you have one) and *()* on the keyboard; once rated they appear in the appropriate Smart Folder at the top of the Library Inspector.

Rating is often done in a linear fashion, where we move backwards and forwards through the photos from our latest shoot and rate them in turn. Each is thus rated before you have seen what comes next, and so you can often find that the next picture is better than the one you have just rated. Combining *Shift* rather than *ett1* with , *f* or will apply a rating change to your current image and simultaneously remove the rating applied to the previous one, while holding *Shift ett1* and using the relevant rating increment command will perform three tasks at once. First, it will clear the previous image rating; second, it will increment the rating of the current image either up or down; and third, it will enable moving on to the next.

This is an effective, but slightly messy way to work. You should always be rating images from a shoot on the basis of how they compare with the other images taken at the same time, and this is best done when comparing them side by side.

This is done in Compare mode. Tap $\$ $\$ to switch the primary Viewer to this mode and then select the first image to which you'd like to compare the other by hitting *Return*. Your picture will shift to one side of the Viewer and take on a green border. You can now click or move through other photos in your Library using the arrow keys, or mouse and see each one lined up against the reference shot. Using the standard ratings keys outlined above you can then mark each image against the reference shot, but at the same time increase or decrease the reference shot rating by holding down the modifier $\$, so while $\$ would increase the rating of the currently selected image (outlined in white), $\$ $\$ would increase that of the reference shot against which you are comparing everything (outlined in green). $\$ $\$ and $\$ on its own would perform their respective functions in the same way.

When you have finished comparing your images, **H** *Return* takes you back out of Compare mode. The most recently selected image will take center stage, and can then be used as a reference point for future comparison by immediately hitting *Return* again.

So, the modifiers you need to remember are *Shift*, *ctrl*, *C* and *C*. Combine them with *t* and *c* to step through your ratings, and the *l* and *C* slashes, and you have a total of 20 rating functions at your fingertips.

	Solo	with <i>ctrl</i>	with 💽	with <i>Shift</i>	with <i>ctrl Shift</i>
Ø	Increase rating	Increase rating, move to next	Increase comparison image rating	Increase image rating, clear previous image rating	Increase image rating, clear previous image rating, move to next image
8	Decrease rating	Decrease rating, move to next	Decrease comparison image rating	Decrease image rating, clear previous image rating	Decrease image rating, clear previous image rating, move to next image
	Reject image	Reject image, move to next	Reject comparison image	Reject image, clear previous image rating	Reject image, clear previous image rating, move to next image
0	Approve image	Approve image, move to next	Approve comparison image	Approve image, clear previous image rating	Approve image, clear previous image rating, move to next image

Selecting and Displaying Images Using the Viewer Toolbar

The Viewer toolbar sits just below the main area for displaying your images. Its only editing tool is a rotation device: all other functions relate to metadata or the control of your display (Fig. 2.12).

The first tool of which you'll make any use is the Rotation tool. Its icon is a skewed rectangle with a curved arrow beside it. Clicking this with an image selected will rotate the image counter-clockwise by 90 degrees; doing the same while holding *Shift* will reverse the direction and rotate by a quarter turn clockwise.

You can achieve the same thing with the **(**) and **(**) keyboard buttons respectively or, if you want to rotate several images in quick succession, use the Rotation tool, invoked by tapping **(**). This changes the cursor to resemble the button's icon, allowing you to click on several images in succession and have each one rotate. Clicking several times obviously rotates them by 90 degrees each time, by default counter-clockwise. Somewhat confusingly, Apple has chosen to use the **(S)** key as the modifier for the

FIG. 2.12 The Viewer toolbar performs some basic edits to your images, but is best used to organize the way in which they are displayed in the Viewer.

Rotation button; this means that if you want to rotate in a clockwise direction you hold this while clicking, rather than holding *Shifi* as you do when using the Rotate button.

To leave the Rotate tool, click the Selection Tool button – the first button on the bar – or tap (\mathbf{A}) .

This tool is followed immediately by the Metadata Lift and Stamp tools, which we will cover in the HUDs section (see page 60).

Editing Tools

The precise make-up of the Viewer toolbar will depend on the mode in which you are using it. If you have the Browser view active, showing only thumbnails of your images or a file list with attached metadata, you will not see any editing tools. However, if you are in Viewer or Split mode, you will also be presented with four editing buttons covering, from left to right, Straightening, Cropping, Red-Eye Removal and Brushes.

Straighten is a deceptively powerful and easy to use tool. Selecting it and then clicking and holding on your image overlays it with a grid against which you can judge the skew of items in your photo (the most important of which, of course, is the horizon). Keep the mouse button held down and drag on your image until those items line up with the horizontal or vertical lines on the grid and then release it to fix the skew. Aperture will intelligently resize the image as you perform this dragging action to ensure that you don't drag empty areas of the image into the frame. It is much quicker and easier to perform than in rival applications.

Crop does exactly what its name suggests, but because the crop is performed as a metadata instruction that simply tells Aperture how much of the image to show and where the corners should fall, it is entirely non-destructive. You don't actually lop off any of your image at any time, meaning that if you make a mistake or later need it to fit within a different space you can retrieve the cropped off sections.

The Red-Eye tool performs just one function: it removes the unattractive red spot that appears in people's eyes in some photos when the flash bounces off the back of the subject's retina and back through the front of the eye, being tinted with the passing blood as it goes.

Obviously Aperture cannot detect the size of the blood spot in your images, and so a Radius slider lets you enlarge and reduce it as appropriate. Clicking on each of the red eyes in the image then applies a correction to them, blackening off the center of the eye to reduce the amount of red showing through. The exact amount of correction applied is controlled by the Red-Eye Correction brick in the Adjustments Inspector. If the Adjustments Inspector is not visible, click its tab in the left-hand inspector group or press to cycle through the various Inspector tabs.

The last of the image adjustment tools is the Brushes button, which drops down the expanded list of adjustment brushes built into Aperture 3. Previously the only brush available was for skin smoothing, but that has now been joined by 14 new brushes that handle everything from lightening selective areas of your image to applying a vignette.

You may question why you would want to apply a vignette using a brush rather than as an effect that encroaches equally on all areas of your images, but it can be useful when applying the same amount of vignette to the landscape as the sky in a pastoral scene would lose detail in the lower half of the image.

All adjustment brushes have tweakable brush sizes and softness and can be set to detect edges so that you don't accidentally paint adjustments into unintended areas. The HUD that controls them also lets you apply an overlay so that you can see where you have painted on an adjustment if your settings are too subtle to detect. The effect can also be restricted to just the shadows, midtones or highlights if, for example, you wanted to avoid dodging your highlights for fear of burning them out entirely. As with the Red-Eye Correction tool, the intensity of the effect is controlled by a brick in the Adjustments Inspector.

Adjustments brushes are covered in more detail in Chapter 5 'Adjusting Images' (see page 143).

To the right of the Viewer toolbar are the buttons that control how your display behaves. The first is the Zoom button, which switches back and forth between 100% zoom and fitting the whole of your image within the image window. The same effect can be achieved by repeatedly tapping **Z**.

Beside this, the Metadata Overlay menu selects what information will be shown as you interact with your images. This is split into sections for the Viewer and Browser with matching functions in each section. Metadata are shown and hidden in the Viewer by tapping **()**, and in the Browser by tapping **()**. A further option on this menu to show metadata tooltips, which appear as you hover over an image in either Viewer or Browser mode, is invoked by tapping **()**.

Aperture has a default metadata set that it shows you, including ISO, *f*-stop, shutter speed, focal length and exposure compensation, but you can tailor it to your own specific requirements using the shortcut **(H) (J)**, which gives you access to the full set of Exif metadata attached to your images, and supplementary data generated by Aperture itself, such as whether an image has been printed, emailed, exported or made into a book.

To the right of the Metadata menu, you'll see a negative strip – the Show Master button (shortcut **M**). This switches back and forth between the Version you're working on and the Digital Master from which it was created, effectively removing all of your adjustments to give you a quick view of the original to see whether your work is having the effect you want.

To the right of the Metadata menu you'll find Primary Only, which has no shortcut, and Quick Preview (shortcut **P**).

Primary Only restricts the number of images you'll work on when you have selected several at once. By dragging a selection around several images in a Browser, or \mathfrak{B} - or \mathfrak{S} - or \mathfrak{S} - clicking more than one, you can move several images into the Viewer at one time. In this way you can batch-develop them simultaneously, applying adjustments across the whole selection rather than just one at a time. However, while this is perfect for initial editing, where you may need to correct a color cast or exposure problem across a whole session of photos, it is no good for making individual tweaks that would fix problems in just one photo.

To save you from deselecting all of your chosen images, making the change to the one in question and then reselecting, toggling Primary Only means your edits will apply only to the image in your selection sporting a thicker white border. This is known – as the name might suggest – as the primary image.

You can change the primary image in a selected group by clicking it with the mouse – in either the Browser or the Viewer – or by moving the border selection around using the cursor keys (Fig. 2.13).

FIG. 2.13 When comparing images, the reference photo is always indicated by a green border. This will be pinned open and compared against a sequence of images from the Browser, each of which is bordered in white. Once your change has been made you can go back to editing the primary photo as part of a group by switching off the toggle again.

Quick Preview (shortcut P) temporarily ignores the original files that make up your Digital Masters and Versions, and instead reads only the compressed JPEG previews stored beside each one in the Library package. These are of a lower quality, but they also take up less space on disk, and so load more quickly. This lets you skip through a large collection of images quickly, while displaying each of them in the Viewer rather than just the Browser. You should not make adjustments in this mode, but it is fine for applying metadata changes. To warn you that you are using this mode, Aperture displays a Quick Preview line below the image in the Viewer, and highlights its selection in the Browser with a yellow background (Fig. 2.14)

FIG. 2.14 When working in Quick Preview mode, Aperture applies a yellow border to your image, in both the Viewer and the Browser, and details the mode on the Viewer toolbar, to warn you that it is emulating your output device on screen.

That is the last of the buttons that control the way Aperture displays and selects your images. You'll soon realize that these features will be among the most often used in the application, and so it pays to learn their shortcuts early on, to save you excessive 'mousing' time.

Full Screen and Dual-Screen Mode

Aperture comes into its own when given room to breathe. While it's happy running on a MacBook or MacBook Pro for quick-and-dirty photo selections on the road – particularly with the new full screen Browser – you'll work faster and more productively with two screens, or at the very least a large wide display you can devote entirely to the application.

Switching to Full Screen mode removes most of the toolbars and control panels, and maximizes your image on-screen. In Browser mode, your thumbnails take over the whole screen, with just a narrow toolbar strip running across the top of the display. Double-clicking an image in this mode opens it full screen for editing. Double-clicking again returns you to the Browser.

When editing in full screen, the Browser becomes a bar at the bottom of the screen that can be set either to display permanently, with the image above

resizing so that none of it is obscured, or be hidden at the bottom of the screen and only pop up when you move your mouse down to it.

The Browser becomes a thumbnail-based strip running along the bottom of the display, which can be set to automatically hide using *ctr f*. If set to hide, it will reappear when you move the mouse to the bottom of the screen, at which point the image will shrink to remain fully visible.

Likewise, by default the toolbar at the top of the screen remains visible at all times, but can be set to auto hide by moving the slider on the furthest right of the bar – the toggle for 'Always show toolbar'.

Adjustments and Metadata Inspectors

The Adjustments and Metadata Inspectors sit behind the Library panel. They differ slightly from the Library panel in that while that pane focuses purely on management, the Adjustments and Metadata Inspectors fundamentally change a Version of the file (although never your Digital Master). Obviously you can't see any changes you make to the metadata, unless you're looking at them in the Inspector itself, but any changes you make here are written to the file and used by the application to control how they are used and filed. They also form the basis of filtering decisions made by Smart Folders.

The Adjustments Inspector

The Adjustments Inspector can be displayed either within the unified Aperture interface, or as an HUD. It is split into sections, which can be expanded and collapsed using disclosure triangles so that you can focus on only the edits you need to make. You'll notice that whenever you make an adjustment the checkbox beside that part of the Adjustments Inspector's name – say, Exposure, Levels or Enhance, for example – will be ticked. By clearing the box you can quickly remove the adjustment and so reset your image. You can also undo the adjustment, but leave that part of the panel active, by clicking the backward-curling undo arrow to the right of its name (Fig. 2.15).

If you find you apply the same change several times across multiple Projects, it makes sense to save it as a preset. This way you can come back to it every time you need to use it, and be sure that you are always applying the adjustment at the same level. This would be particularly useful in a studio environment where you are unable to block out all of the available natural light. In a situation such as this, the color temperature will change over the course of the day – even with studio lighting in place – and you may want to create a series of presets to account for these changes throughout the course of the day. Each one would be given a plain English name, like morning light correction, afternoon light correction and evening light correction.

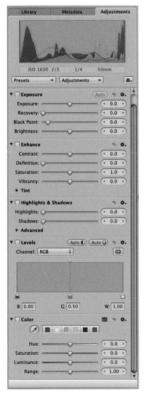

FIG. 2.15 The Adjustments Inspector lets you apply non-destructive edits to your photos. Each one is applied photo-wide, and can be removed by clearing the checkbox beside each section's name. Presets are created by making your adjustment and then opening the Presets drop-down menu just below the histogram at the top of the Adjustments Inspector. Here you'll find an option for 'Save as preset...'. Click it and you can give your preset a name, selectively remove applied adjustments by clicking the '-' button to the right of each one and organize it into an existing or new group. Whenever you want to apply it in the future, open the Presets menu and you will find your saved Adjustment preset stored alongside any others you have created, and the defaults that ship with the application (Fig. 2.16).

FIG. 2.16 If you find yourself applying the same adjustments to several images, you can save your settings as a preset to ensure that you make the same tweak every time you edit a photo taken under the same conditions.

(a)

FIGS 2.17 Several components of the Adjustments Inspector have standard and expanded views (b). A classic example is the color component, which caters for regular and advanced needs (a).

Some panes on the Adjustments Inspector have three levels of disclosure: fully closed; their default state; and an extended version that gives you access to a wider range of adjustments. The Color pane is a prime example. By default it gives you access to Hue, Saturation, Luminance and Range sliders, with an eyedropper for sampling from the active image and buttons for the principal subtractive and additive colors (red, green, blue, cyan, magenta and yellow). However, clicking the Switch to Expanded View button, to the left of the curled undo arrow (it looks like a grid with colored cells to the left and gray to the right) reveals a far more extensive dialog, giving you simultaneous access to the Hue, Saturation, Luminance and Range sliders for every primary tone side by side, to save you clicking back and forth between them (Figs 2.17 (a) and (b)).

The Adjustments panel is also where you'll crop, fix red-eye and straighten your images. These panes, along with up to 19 others, are hidden by default, but can be added to the Adjustments panel through the menu on the

Adjustments button just below the histogram. Be aware, though, that whenever you add a new pane to the Inspector it is automatically activated and applied to your image, even though you won't actually have made any changes. Therefore, if you open a new pane when you have a Digital Master selected in the Browser, Aperture will automatically create a new Version.

All of these panes are replicated in the HUD version of the Adjustments Inspector.

The Metadata Inspector

The Metadata Inspector displays everything Aperture knows about your images. This is the information used to file and filter your assets, and to assign rights and captions when output. Some of it is generated automatically based on the attributes of the photo, other parts are written by your camera at the time of capture, and the remainder is input by yourself, either at the point of importing the pictures into your Library, or over time as you work with them.

As with other panels in Aperture, its views can be extensively customized, allowing you to cycle through a large quantity of information in a relatively small area.

The options available here – called views – can be streamlined by deleting those you don't use through the drop-down menu below the LCD-style camera read-out at the top of the Inspector. You can add your own views using the same menu.

Adding and Editing Views in the Metadata Panel

Click the views drop-down and select Edit... at the bottom of the list, then use the Cog menu at the bottom of the dialog to select New View. Each view needs a name that will appear in the pop-up menu and let you switch between it and other views shipped with the application. Your own views will appear at the bottom of the menu by default, but you can rearrange them through the Manage option on the shortcut menu.

Once you have named your view, you can start choosing which attributes are displayed whenever that view is selected by checking the boxes within the Metadata Fields to the right of the Views menu. These are split into various common sections, defined by the keywords, EXIF, IPTC, Aperture, Audio/ Video and Photo Usage. This View building dialog no longer displays live data as it did in Aperture 2 (Fig. 2.18).

To remove a tag from the view, simply uncheck the box beside its name. To finish editing the view, click the OK button at the bottom of the panel.

The same principle applies to editing existing views. Click on its name in the Metadata Views side of the panel, and then use the disclosure triangles to expand the categories on the right. This lets you uncheck those fields that you do not want to include in the finished view.

Metadata Views	Metadata Fields
Metadata Views Ceneral Name Only Caption Only Common data Name & Ratings Name & Caption Ratings Caption & Cedits File Info Photo Info EXIF Info NIK's favourite metadata	Metadata Fields
Oscar's photos Contact Sheet	EXIF Version
GPS	Exposure Mode Exposure Program Firmware

FIG. 2.18 A lot of the metadata attached to your photos is written by your camera at the point you took the picture. This records shooting conditions and camera settings, and is completely searchable.

Organizing Images

Aperture uses Folders, Albums, Smart Albums and Projects for organizing your images, and it's not immediately clear how each works; the differences are subtle (Fig. 2.19).

Folders

Folders work in exactly the same way as they do in the Finder, and look like the Mac OS X equivalent. They are blue tabbed containers for the other files and collections in your Aperture Library. They are a grouping device used to contain Albums, Smart Albums, other Folders and Projects. Think of them as handy dividers, or bookmarks that let you skip to a particular collection.

Their use is to keep related work together, and to allow you to collapse long lists of elements so that they take up less space in the Library Inspector. They are your only navigational tool – as opposed to search and indexing tool – so maximize their potential by employing subfolders inside main Folders; for example, a Europe Folder containing Folders or Projects for Hungary, Spain and France; subfolders for Paris, Lyon and Marseilles inside France, and further subfolders for architecture, churches and people inside the Paris Folder. You can now expand and contract each one, thus navigating through your Folder structure without having the Library Inspector so long that it scrolls off the bottom of the screen.

Although there is no image count beside a Folder in the Library Inspector, clicking one will always show the contents of every element it contains, so if you couldn't remember whether you'd put Notre Dame cathedral in the Parisian Architecture or Churches Folder, clicking on Paris would show you the contents of both, along with those pictures filed inside the People Folder.

FIG. 2.19 The Library Inspector is home to far more than just Projects, as it is also the place where you create and organize Folders, Smart Folders, Albums, Books, Light Tables, Web Galleries, Web Pages and Web Journals. Clicking France would show you all pictures filed under Paris, Lyon or Marseilles, regardless of how far down they were buried within any further subfolders, while clicking on Europe would show all pictures from the three named countries, the cities within them and the Folders, Albums, Smart Albums and Projects within.

Folders may look like dumb containers but – used wisely – they are actually powerful filtering tools.

Projects

Projects are the containers of your images and the work you are doing on them. Such work could include Web Galleries, Contact Sheets, Light Tables or Books. The closest equivalent elsewhere on the Mac would be a directory in the Finder, which can lead to some confusion with folders in Aperture which, as we have seen, work in a slightly different way.

Masters and Versions

Your Projects will contain two types of image, and neither is defined by the format in which it is shot. Known as Digital Masters and Versions, the latter is a copy of your original – the Digital Master – to which you have made some edits.

Regardless of the changes you make to the images in your Projects, Aperture will always preserve your originals. This allows you to experiment and refine your results to an infinite degree, safe in the knowledge that should you take things one step too far you can roll back to the original picture.

Digital Masters are effectively the negatives from which all successive images are developed. Every time you edit a picture, Aperture creates a copy and applies the changes to that.

Select a Digital Master and apply changes using the Adjustments panel or HUD and you'll see a copy appear beside it, with a small number in the corner of the original showing how many Versions now exist, including the Digital Master. This derivative image is called a Version.

Stacks

You can have an unlimited number of Versions of any Digital Master, and by default they will be organized into Stacks. This is Aperture's way of keeping things tidy by piling up images so your workspace doesn't get too cluttered. In the Grid view they will be displayed side by side, but by switching to the List view you'll see that an icon of the original is shown, alongside which there is a disclosure triangle. Clicking this reveals the Digital Master and any Versions inside, with each Version given a number (Fig. 2.20).

Each master or Version can be exported individually, and selecting more than one at a time lets you compare them side by side in the Viewer.

IM0_0000	.0	313	1/00	Uev	100 000	
V MG_0089	10	<i>f</i> /5	1/60	0 ev	ISO 800	
IMG_0090	¤ 10	f/5	1/60	0 ev	ISO 800	
IMG_0090 - Version 2	¤ 10	f/5	1/60	0 ev	ISO 800	
IMG_0091	10	f/5	1/125	0 ev	ISO 800	
IMG_0092	10	f/5	1/320	-1 ev	ISO 800	
No and and	-	fin r	21540	0.111	150 000	

FIG. 2.20 Versions are organized into Stacks, helping you to relate derivative images to their originals. In the List view each Stack looks like a folder, accompanied by a disclosure triangle.

Images can also be stacked automatically on the basis of how quickly they were taken in succession. Anyone with a dSLR will know how easy it is to take several pictures in quick succession with a single press of the shutter. The chances are these are very similar editions of the same scene – perhaps dogs chasing a ball, athletes jumping hurdles or kids blowing out birthday candles – and the chances are you'll only want the one image out of ten that captures the moment you were after.

By organizing them into Stacks, Aperture lets you keep the whole sequence in one place, without having them fanned out across your workspace, thus saving space.

Workspace Layouts

Aperture is a great saver of screen space. However, it really flourishes when given room to breathe, and the ideal Aperture set-up is a dual-screen environment, where you can keep the main organizational guts of the application – the File Manager, Library Inspector, and Adjustment and Metadata panels – on a secondary screen off to one side, and have the image on which you are working maximized on the primary display directly in front of you.

Standard Workspace Layout

There are three primary interface layouts: Browser Only, Viewer Only and Split (previously called Browser & Viewer). Split is the default, and you can cycle through all three modes by tapping **V**, or clicking their icons on the toolbar (Fig. 2.21).

Browser Only and Viewer Only modes

Browser Only uses all of the space to the right of the Library Inspector to browse images in any selected Folders, Albums or Projects (or the whole screen if the Inspector is hidden or you have invoked full screen by tapping). It's primarily used for getting an overview of the images in use, and not for editing, since the images will usually be rendered too small for you to see what you're doing without using the Loupe or increasing the magnification, which negates the benefit of being able to see more files in one place.

Once you have identified the image with which you want to work, you should maximize the Viewer to give your chosen image prominence as you make your adjustments. You can do this by double-clicking the image, pressing **V** to cycle to the Viewer mode, or clicking Viewer on the toolbar.

Apple Aperture 3

(b)

FIG. 2.21 Aperture offers three view modes to suit your specific organizational and editing needs.

The full screen Browser is a headline feature in Aperture 3. It is invoked by switching to Browser mode and then tapping **F** on the keyboard. This takes away your toolbars and Inspectors and makes best use of your available screen space to display a catalog of your images. It is particularly effective when working on smaller screens, such as that found on a MacBook. Doubleclicking images likewise opens them in Full Screen mode, and doubleclicking again returns you to the Browser view. A breadcrumb trail at the top of the interface lets you move directly to other Projects and Folders in your Library without stepping out of this mode.

Swapping and Rotating Workspaces

When not working in Full Screen mode, workspaces can be turned through 90 degrees with Shift W, and flipped with 🗨 W. Rotating them puts the Browser and Viewer windows side by side rather than above and below, while swapping them does exactly what the name suggests, putting the Browser pane to the right and the Viewer pane in the center. If you use 💽 🚺 to flip the display when in the more conventional mode of Viewer top and Browser strip bottom, you will put the Browser at the top and the Viewer below. The Library Inspector never moves in either of these operations, but a rotated layout of three columns rather than one column (the Library Inspector) and two horizontal windows for the Viewer and Browser is better suited to single-screen use, as it allows portraitoriented images more room to breathe (Figs 2.22 (a) and (b)).

Apple Aperture 3

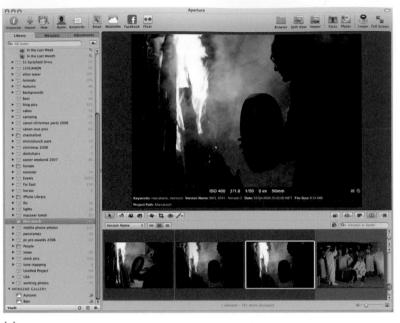

(a)

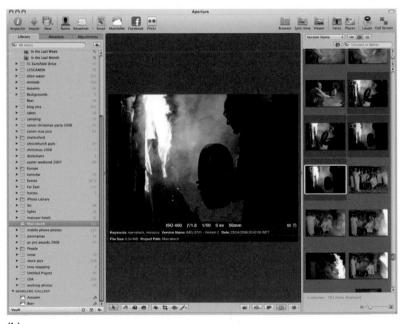

(b)

56

Ratings and Keywords

The key to good management is an effective index. Attaching keywords to your images means you can easily search across all Albums, Projects, Books, Light Tables and Web Galleries, and pull out every matching image. In extensive Libraries this can be a real timesaver, and when combined with ratings you can further refine your results to show only the best in each class.

Ratings can be applied or changed quickly by selecting an image in the Browser's grid or list and using the number keys **1** to **5**. Pressing **0** will remove any existing rating and **9** will reject an image. Ratings can also be applied in an abstract, rather than absolute, manner by increments. Tapping **a** increases an image's current rating (unless it already stands at 5), while **b** takes it down one point.

Keywords, too, can be applied using hotkeys on the keyboard. The Keyword Viewer (Shift D) sits at the bottom of the Aperture interface and is split into seven logical sections: people, photo descriptors, stock categories, snap-shots, wedding (details), wedding (prep) and wedding. Each contains a set of buttons that apply associated keywords to the selected image. So people contains man, woman, couple, adults, for example, while wedding (prep) includes hair, flowers, makeup and decorations (Fig. 2.23).

You can add your own sections and buttons by selecting Edit Buttons... from the menu in the bottom right-hand corner. This opens a panel with three panes: one for your button sets, one for their component buttons and one showing the keywords you have already applied to your images when importing them.

Start a new set by clicking the + below the first pane and give it a name. Next, drag corresponding entries from the Keywords Library, far right, into the Contents pane in the center. This adds each one to the new section you have just created. If you haven't yet imported any images using one of the keywords you want, add a new one to the Library using the Add Keyword and Add Subordinate Keyword buttons below the Keywords Library pane. The former creates a top-level keyword, such as birthday, into which you'd add entries such as cake, candles, presents and games using the latter.

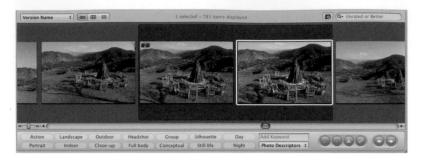

FIG. 2.23 Keywords can be applied by using keyboard shortcuts, but are also available through the keyword toolbar at the foot of the Aperture interface.

Adjustments and Filters

The Adjustments Inspector is where you'll do the most of your work. It consists of collapsible panels that can be checked on and off to quickly roll back changes.

Apart from exceptions like Red-Eye Removal, Dodge and Burn, and anything applied using an adjustment brush, Aperture works on a whole-picture basis, relying on you to have shot a well-balanced image in the first place without excessively burnt-out or deeply-shadowed areas that you'll need to recover later.

The Adjustments Inspector is split into sections, each of which is mirrored on the Adjustments HUD. Each section deals with a different kind of adjustment. You can add extra Adjustment bricks by selecting them from the Adjustments drop-down menu below the histogram. Those with spots beside their name are already in use. To remove an Adjustment brick, click the cog icon towards its right-hand edge and select either 'Remove this adjustment' or 'Remove from default set', as appropriate (Fig. 2.24).

The Cog menu at the top of the Adjustments Inspector allows you to show and hide the value of the color over which your mouse is positioned, and hide or reveal camera and color information.

From here you can also select your color value options (RGB, Lab, CMYK, HSB or HSL), the number of pixels it will take into account when assessing a value (blocks of 1×1 , 3×3 , 5×5 or 7×7), and what the histogram should show (luminance by default, but optionally RGB, or just the individual red, green and blue channels).

Using Adjustment Bricks within the Inspector

Whenever you make a change in one of the adjustment bricks, it is activated with a small tick appearing beside the section name. Unchecking this box removes the adjustment. In this way, it is best to think of edits made in

FIG. 2.24 Features missing from the Adjustments Inspector? Not a problem – tailor its look and feel to your specific needs.

Aperture like adjustment layers in Photoshop, although here their range is far wider, even covering such potentially destructive edits as crops and rotations.

Overlays

The various data associated with your images are, for the most part, hidden when the Adjustments and Filters or Metadata panels are closed. What is left is restricted to star ratings, flags and version counts in the Browser, and just a rating in the Viewer, all of which overlays the images of thumbnails to which they refer.

There are times when you will want more detailed data, in which case you'll expand them with Shift Y and Shift U for the data in the Viewer and Browser respectively. While expanding the Browser data means you lose the filename and so can concentrate fully on your thumbnails, in the Viewer you end up with a broad survey of the shooting conditions for each image. This spans aperture, shutter speed and exposure compensation: actual- and 35mm-equivalent focal length, applied keywords, Version name, image date and rating. Combined, they allow you to close a lot of the head-up displays on which this information is found (Fig. 2.25).

And that's where we're heading next.

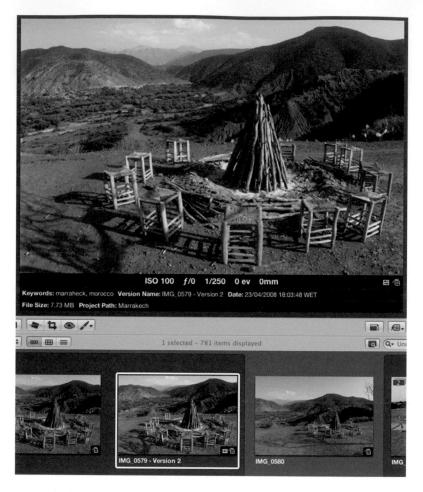

FIG. 2.25 Use shortcuts to temporarily expose more of the metadata attached to your images within the Viewer itself.

Head-Up Displays (HUDs)

As we have already explained, Aperture really gives your photos the opportunity to breathe. On a suitably equipped Mac, it is perfectly happy working across two monitors, devoting one to the organizational workspace, and the other to a Full Screen view of your photos so that you can edit them with the best view possible.

However, even on a single-screen Mac, or a portable such as a MacBook, you can do much to maximize your working space while keeping every tool handy, thanks to its extensive use of head-up displays – or, in Apple parlance, HUDs.

These are floating, semi-opaque Versions of the key panels, allowing you to bring them into and out of view when required, and still see your work through them. They take their name from the displays projected onto cockpit windshields in fighter aircraft.

They are common across many Apple applications, and even break out of the professional application line-up; HUDs are also found in Pages, its consumer word processor, and iPhoto.

Some panels always work as HUDs, regardless of your view mode, while others appear in this form only when you're working in full screen. The Keywords HUD (Shift (H)), for example, only ever appears as a floating panel, whatever your screen mode, because it duplicates features already found on the interface proper. By appearing in the applications in two incarnations it is more accessible, and can be shown even when the main keywords interface is closed or inaccessible. It presents a list of keywords already applied to images in your Library so that you can then apply them with a single click to whichever photo is presently selected (Fig. 2.26). The first time you use it, you'll find that it already includes a range of pre-defined keywords relating to weddings, stock photography and so on. You can add to these in exactly the same way as described on page 57 using the Add Keyword and Add Subordinate Keyword buttons at the bottom of the HUD, and likewise delete existing entries using the Remove Keyword button to the right. This is explained in more detail in Chapter 4.

The Filter panel is also always shown as an HUD. It is invoked by clicking the button beside the search box at the top of the screen when set to Browser mode or the image strip when set to Split View, and appears as a pop-up that can be torn off and floated out on its own. This allows you to create Smart Albums, and gives you a live preview of the results as you define each query's search criteria.

The Inspector HUD, containing the Library, Metadata and Adjustments panels (shortcut **ff**) exactly mirrors the panel shown in the regular interface.

Filter HUD

With so much metadata at its disposal, Aperture makes short work of keeping your photos in order. It relies heavily on the data you input to do this, as you feed it keywords, correct time zones on import, apply copyright information and assign bylines to your work. Then, once it sits inside Aperture, you organize it into Projects and Folders, make Adjustments and build them into products for output. All of this is passive, but every action tells Aperture a little more about your assets, and adds to the extensive database of metadata it uses to keep things in order. By combining them with the data supplied by your camera about its settings and the shooting conditions it encountered, you'll soon have access to a comprehensive profile of every image on your system.

FIG. 2.26 The Keywords HUD organizes keywords already applied to your images, and lets you remove or add new ones. Keywords can also be organized into sub-groups for better organization on the keywords toolbar. FIG. 2.27 The Filter HUD lets you quickly sort your images thanks to its understanding of the metadata that already exists in your library.

8 Filter: Marrakech	-
All + of the following that match + Stack picks only Add Re	ule 🔻
🗹 Rating: is greater than or equal to 💠 🍐 👘 👘 Unrated	
Elagged: Yes :	
🕾 Color Label: 👔 🌩 🍥 🔍 🔍 🗶 🜑 🜑 🜑	
Text: includes + Q-	
Ceywords	
New Smart Album New Album With Current Images	•-

The Filter HUD gives you access to all of these data when performing complex searches of your Library (Fig. 2.27). It uses your currently selected Project or Folder as its starting point, so pick your initial location before showing it by clicking the Filter button, on the right-hand side of the Browser toolbar or at the top of the screen in Browser mode. In both cases, it is beside the search box, and its icon is a window with a magnifier above it. To perform a system-wide search of all of your images, select Photos at the top of the Library Inspector as your starting point.

The palette that pops up is notionally attached to the toolbar, but can be torn off and repositioned anywhere on screen. It is a table of variable fields for rating, dates (calendar), keywords, import sessions and other user-definable categories, and lets you specify whether results should match some or all of your search criteria to qualify for inclusion in the Smart Folder it will create. Used in combination, these various attributes should be enough to let you strip down your Library to a single image if you wanted.

To use any search variable in the Filter HUD, fill the checkbox beside its name and then use the pop-up menus and data grids that appear to specify your requirements. Most of these dialogs are pre-populated with data from your Library, allowing you to simply click further checkboxes to narrow down the range of images it captures, as for several terms you would be unlikely to remember the valid terms yourself. While you might remember some of the keywords you have used, it is highly unlikely you would remember all of the import sessions you used to import your assets into your Library.

Each section of the Filter HUD uses plain-English commands, so the calendar section gives you the option of trimming down to exact dates, regardless of what was taken on that day (if anything), or instead choosing that the date should not be one on which you took no photos, and also not be the dates selected using the calendar below.

You can select ranges by holding *Shift* when clicking the opposite extremes of a selection, and several disparate variables by using the **(X)** key. If you later want to deselect them, click again, and to deactivate a complete section, remove the tick from the selection's checkbox.

Aperture will maintain a live preview of the results of your Filter queries in the Browser window. Once these show what you were aiming for, it's time to either save or use the results using the buttons at the bottom of the HUD. The New Album with Current Images button does just what its name suggests, but the shortcut button beside it gives you access to Aperture's Light Table, Book, Album, Slideshow and Web Publishing features, using the results as the source material.

Inspector HUD

The Inspector HUD works in exactly the same way as the Inspector panel in the main interface. It is hidden and revealed using the keyboard shortcut and is functionally identical to the regular Adjustments, Metadata and Library Inspectors in the main interface.

Opening and closing sections in this HUD performs the same action – simultaneously – in the regular equivalent found in the main Aperture interface, as you can see if you keep both open at the same time. Collapsing and expanding panels, and moving sliders in the Adjustments panel will be mirrored, regardless of the version of the Inspector in which you're working, and the same is true of the Library Inspector. The only panel on which it doesn't work is Metadata, allowing you to show, say, General metadata in the Inspector, and more extensive EXIF Info in the HUD.

The real point of having a HUD that mirrors one built into the main interface, though, is that you can either close the primary interface, or switch it to something else, allowing you to display both the Metadata and Adjustments panels at once, for example, in the main Aperture interface and the HUD.

Lift and Stamp HUD

The Lift and Stamp HUD is like a sophisticated clipboard, along the same lines as that used in Word, Numbers or Photoshop. However, rather than holding plain text or parts of an image you're working on, it is used to transport data between different images to save you from applying them manually yourself. That data includes all metadata and adjustments applied to your image from the point it was imported into Aperture, including the keywords applied when you imported it. Rotations are not lifted, for a very obvious reason: while most cameras will now record whether a photo was taken in portrait or landscape orientation and write this data to the image file, it's not a universal capability. As such, you may need to rotate some images in your Library but not others. If this rotation data was recorded when you lifted adjustments data from your images, and the data was then stamped onto a range of other images, you may find yourself having to spin them back one by one.

The HUD is opened either by using the Lift and Stamp tools on the top of the Browser, or through its entry on the Window menu. We'd recommend leaving it closed until you start using the tools, as it's otherwise redundant (Fig. 2.28).

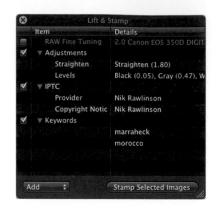

FIG. 2.28 The Lift and Stamp HUD acts as a sophisticated clipboard, used to transport metadata and adjustments from one image to another. Each field copied to it can be individually disabled, or deleted altogether.

To transfer data from one image to another using Lift and Stamp, either select your source image and press **(H) (C)** or press the lift button on the Viewer's toolbar. It's third from the left, and sports the icon of a luggage tag with an upwards-pointing arrow coming out of it. Alternatively, press **(O)** to select the Lift tool and directly lift the data. This will change the cursor to an upwards-pointing arrow, and clicking with this on any image will copy the metadata and applied adjustments and drop them onto the Lift and Stamp HUD.

Each class of data is separated out, so that keywords sit apart from adjustments, and IPTC data are hived off in a section of their own. Each data set is stored in a collapsible section that is expanded using a disclosure triangle to show what it contains.

If you were to then apply these data to another image, they would be pasted in its entirety, which saves you a lot of time in performing the same edits or filing tasks on multiple photos one by one. However, there are many occasions when you will not want to drop the data wholesale. In these instances, you can temporarily disable them by unchecking the tick box beside each one. This will disable all of the data in that section, so if you have captured three adjustments in lifting the metadata from an image, unchecking the adjustments box means none of them will be applied to any other images when the data are stamped. You can be more selective about the range of data that are or are not stamped by instead expanding each data section using the disclosure triangles, and then clicking on each individual entry within, and pressing the Backspace key to remove them. Note that none of these disabling and deletion measures has any effect on the original image from which the metadata was lifted. To remove the attributes from there you'll have to resort to the Adjustments and Metadata Inspectors.

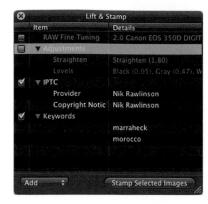

FIG. 2.29 Here, we have deselected the Adjustments section of the lifted data so that it will not be applied to other images once it is stamped.

Once you have filtered the lifted data down to just the attributes that you want to apply to other images in the Library, you will take one of two courses of action. If you lifted the data by pressing (2) to select the Lift tool and used the up-pointing arrow, you'll have noticed that as soon as you copied the data the arrow flipped to point down. Using this to click on any other image in your Library – even in a different Project – will apply the checked and active metadata displayed in the Lift and Stamp HUD (Fig. 2.29).

If you collected the metadata by clicking the Lift button or the **(H) Shift (C)** shortcut, select the image to which you'd like to apply the edited metadata and click the Stamp button (next to lift), press the shortcut **(H) Shift (V)** to stamp immediately, or use **Shift (O)** to invoke the Stamp tool without stamping so that you can go on to stamp elsewhere. Once the tool is selected in this latter manner, it remains active, allowing you to apply the data to several disparate images in your Library. If all of the images to which you want to apply the data sit beside each other, you can select them by clickdragging across them or **Shift** clicking a selection range and then using the Stamp Selected Images button on the HUD.

The captured metadata will remain active in the HUD even when it has been closed, allowing you to go on and apply it to further images without your screen being cluttered up by a redundant panel you no longer need, but will reopen every time you use any of the shortcuts or buttons to capture new data.

Before closing it, then, take note of the pop-up menu in the lower left corner of the HUD that switches between Add and Replace. When set to Replace, any new data captured using the Lift tool will overwrite what already exists in the HUD. Set to Add, the new data will be appended to what you have already gathered.

Lift and Stamp is a deceptively powerful tool, which will greatly speed and simplify your workflow, whether in processing adjustments as a batch to

meet particular requirements, or in updating an existing filing system to meet changing requirements.

Metadata Overlays

It's not technically a HUD, as you can't interact with it, but the metadata overlay for your images is well worth investigating – particularly if you often work in Grid or Filmstrip mode and therefore don't have access to all of the data shown in the Browser's List view. Toggle it on and off by tapping and, when active, move your mouse over the thumbnails to see key metadata shown on a semi-transparent overlay. It also works with images shown in the Viewer, so is an easy way of differentiating between two very similar images when displayed side by side.

Using Aperture for the First Time

Aperture is built from the ground up for photographers, not computer technicians, and Apple has gone a long way to make it easy to understand and non-threatening. Even first-time users should be up and running in minutes, and will be pleasantly surprised by the amount of hand-holding on offer, making Aperture's workflow a more intuitive, productive one than that offered by Photoshop.

Mac OS X's unified media Browser lets you use any photo managed by an Apple application – iPhoto or Aperture – in any compatible application, so you can view your Libraries in office tools like Keynote and Pages, or use them as desktop backgrounds or screen savers. By providing third-party developers with hooks into this system, Apple also allows these Libraries to appear in applications developed externally, such as RapidWeaver, so it's no surprise that Aperture and iPhoto themselves can also happily exchange assets between themselves. As described elsewhere (see page 268), this lets you use your photos to create products that are not available to each application, using iPhoto assets in Aperture to produce the more advanced Web Pages not available in iPhoto, and Aperture assets in iPhoto to produce a calendar.

However, there remain good reasons not to import your iPhoto library into Aperture including, not least, the fact that by maintaining a separate iPhoto library you can use this for more personal projects, and save cluttering up your Aperture library with family photos.

We have covered importing your photos extensively elsewhere (page 73), so won't repeat that here, but you should bear in mind that as you are starting from scratch with a brand new Aperture library, you are in an enviable position. Here you can lay the foundations for a well-thought-out filing system designed from day 1 to make your assets as easy to find and use as possible. You should pay particular attention to the metadata fields in the Import dialog, accurately adjust the time offset if you were shooting in a different time zone and hadn't reset your camera's clock, and choose an appropriate folder structure and name for each project as it is imported.

Bear in mind at this point that there is no obligation to import all of the images in a folder, camera or memory card at once; use Mac OS X's usual selection tools – *Shift*-clicking to select a range or **S** clicking to select non-contiguous images – to specify the ones that should be imported. Once you have made a selection, check the tick box on just one to select the whole group. Likewise, use the Check All and Uncheck All buttons at the top of the import dialog to select and deselect whole groups.

Aperture will go about importing your images. The speed at which it can do this depends on the speed of your system, the speed of your interface (USB 1 or USB 2 makes a big difference) and the number of other applications you have running at the same time. Aperture isn't just copying your images from the memory media to your hard drive – it is also building a series of JPEG previews in the background, which will let you preview your work more quickly.

If you want to track its progress you can do so through the Activity Monitor (Window > Show Activity), which displays the progress of every function the software conducts, not just when importing, but as you perform your work inside the application.

Customizing Aperture

Now that you have imported your first batch of photos, it's time to start thinking about how Aperture works, and whether this is right for you. The application is designed to be used by both the mouse and keyboard simultaneously, and you will benefit greatly if you take the time to learn at least those shortcuts that you'll use most often. However, these can be confusing if they are different to those used by any of your other most commonly used applications.

In this instance you may want to tailor which keys are used and what they do. This is done through the Aperture > Commands > Customize... menu option, which opens an on-screen representation of the keyboard, with the various functions highlighted. Click through the various keys on the onscreen keyboard using your mouse to see what they do in the Key Detail pane below right, and use the Command List pane below left to drill down on the key combination subsets and the modifier keys at the top of the interface to see how each function changes when combined with (#3, Shift), (South) (option) and *ctri* (Fig. 2.30).

Aperture is rightly protective of the default set of key combinations, which are the ones used throughout this book. It won't let you define your own without first creating a complete copy of the originals. Use the pop-up menu at the top of the Command Editor dialog to duplicate the existing

efault		Command X Shift	Option X Contr	- 10					9.		
are F1	F2	R R R R R	F3 F10 F11	F12	FI	FN	FIS				
* 1 * 2 *	2.			•			•	22			
20 - a · M	•	· R · T · Y · D · I · O ·	• • • • •	•	12			2	8		100
and box 2 A	5	D* F* G* H* J* K* L*		•				1.	5.	6	
17 D Z	1x	· · · · · · · · · ·	· [·]	Q		. •			2.		Г
anter Tarter	comme	Elector .	command aption	critici	1.1				•		
emmand List		Command	A Modifiers Ke		Key Detail		bnemm				L
All Aperture Comman		Add Black & White Adjustment	^ M	41	No Modif	ter .					
All Aperture Comman		Add Blur Quick Brush	~ M	i	No Modif	ser se					
All Aperture Comman Main Menu Comman	ds	Add Blur Quick Brush Add Burn Quick Brush	^ W	Ó	No Modif						
All Aperture Comman Main Menu Comman Adjustment Presets	ts ©	Add Blur Quick Brush Add Burn Quick Brush Add Chromatic Aberration Adjustment		Ó	Ne Modi	×					
All Aperture Comman Main Menu Comman	5 0 0	Add Blur Quick Brush Add Burn Quick Brush Add Chromatic Aberration Adjustment Add Color Adjustment	^ M ^ C	Ó	No Modif	X 12					
All Aperture Comman Main Menu Comman Adjustment Presets Adjustments	ts ©	Add Blur Quick Brush Add Burn Quick Brush Add Chromatic Aberration Adjustment		Ô		* * 7					
All Aperture Comman Main Menu Comman Adjustment Presets Adjustments Browser	ts 0000	Add Burn Quick Rrush Add Chromasic Aberration Adjustment Add Color Adjustment Add Color Adjustment Add Color Machemote Adjustment Add Corpa Adjustment Add Corpa Adjustment		Ó	4	× 2 2					
All Aperture Comman Main Menu Comman Adjustment Presets Adjustments Browser Interface	50000	Add Bur Quick Brush Add Burn Quick Brush Add Chronatic Abertation Adjustment Add Color Adjustment Add Color Monotrone Adjustment Add Const Adjustment Add Const Adjustment Add Curves Adjustment		Ó	2	8 2 7 8					
All Aperture Comman Main Menu Comman Adjustment Presets Adjustments Browser Interface Metadata	ts 0000	Add Bur Quick Brush Add Chromaic Abersation Adjustment Add Chromaic Abersation Adjustment Add Chromauch Adjustment Add Chron Adjustment Add Chron Adjustment Add Chron Adjustment Add Chron Adjustment		Ó	1	2 2 2 2 2 2 2 2 2 2 2 2 2 2 2 2 2 2 2					
All Aperture Comman Main Menu Comman Adjustment Presets Adjustments Browser Interface Metadata Tools	50000	Add Bur Clack Brush Add Burn Clack Brush Add Chronatic Alternation Adjustment Add Clack Monochrone Adjustment Add Clack Monochrone Adjustment Add Clark Monochrone Adjustment Add Clark Adjustment Add Clark Adjustment Add Clark Adjustment Add Clark Adjustment		Ó	1	2 X X Y Y Y Y Y Y Y Y Y Y Y Y Y Y Y Y Y					
All Aperture Comman Main Menu Comman Adjustment Presets Adjustments Browser Interface Metadata Tools	50000	Add Bur Quick Brush Add Burn Quick Brush Add Chonnaic Aberration Adjustment Add Color Monochrome Adjustment Add Color Monochrome Adjustment Add Color Monochrome Adjustment Add Color Monochrome Add Color Adjustment Add Dorfen Stand, Quick Brush Add Dorfen Stand, Quick Brush Add Dorfen Stand, Karsh		Ó		20 X X X ~ 7 0 X					
All Aperture Comman Main Menu Comman Adjustment Presets Adjustments Browser Interface Metadata Tools	50000	Add Bur Clack Brush Add Clark Brush Add Chronatic Alternation Adjustment Add Clark Ministerent Add Clark Monochrone Adjustment Add Clark Ministerent Add Clark Adjustment Add Clark Adjustment Add Clark Adjustment Add Devignet Adjustment Add Devignet Adjustment Add Devignet Adjustment		Ó		1 2 2 2 2 2 2 2 2 2 2 2 2 2 2 2 2 2 2 2					
All Aperture Comman Main Menu Comman Adjustment Presets Adjustments Browser Interface Metadata Tools	50000	Add Bur Quick Brush Add Burn Quick Brush Add Chonnaic Aberration Adjustment Add Color Monochrome Adjustment Add Color Monochrome Adjustment Add Color Monochrome Adjustment Add Color Monochrome Add Color Adjustment Add Dorfen Stand, Quick Brush Add Dorfen Stand, Quick Brush Add Dorfen Stand, Karsh		·0		第一7 2 2 第二第一7 2 2 第二第二7 2 2 第二第二7 2 2 第二第二7 2 2 2 第二第二7 2 2 3					

FIG. 2.30 Use the keyboard customization features to specify combinations that more closely match the way you are used to working in other applications on your Mac. Aperture will be careful not to let you overwrite core combinations used by the operating system, and will warn you if you are going to overwrite any of its own.

set, giving it a name of your own, and then set about defining your own (Fig. 2.31).

Do this by picking the option to which you want to assign a shortcut from the Command List on the left of the dialog and then press the key combination you want to use. Start with the shortcut keys – \mathfrak{R} , *Shift*, \mathfrak{N} and *otto* – and watch the on-screen keyboard as you press them. The keys will change color as you add more keys to the combination to show whether that combination is already in use. If you ignore it, you'll see a warning, either forbidding you from using it if it's assigned to a system command, such as \mathfrak{R} (\mathfrak{M}) for closing windows and \mathfrak{R}) for opening Preferences, or overwriting it if it's only used by Aperture, such as \mathfrak{N} (\mathfrak{F}) for sending an image by email.

Please	enter a ner	w name	for the	command	i set:	
Backup	keyboard s	hortcuts				
					Cancel	Ок
T	1.	T	• 1	• 1 •	Ia	•

FIG. 2.31 Before you can specify your own keyboard shortcuts, you must make a duplicate set of the default combination to save you from destroying what is already in place.

Exporting Shortcut Presets

Once you have set up your preferred shortcuts, you can export the settings for use on other Aperture installations. This is useful if you have installed the application on more than one Mac – perhaps because you have both a notebook installation for use in the field and a desktop edition for editing in the studio – you use it in two applications, or you want to roll out a standardized, tweaked edition of the application across several Macs in a creative environment.

Click the pop-up menu and pick Export... from the options. Give your presets a name and pick a location, and Aperture will save a binary presets file with the extension .apcommands. To import this on a different Mac, pick Aperture > Commands > Import...

You can then switch between your installed customization and the defaults by choosing from your local menu in the Aperture > Commands > Default... fly-out, or your imported settings from the bottom of the menu.

Managing Color

Photos, in whatever medium, are merely representations of light and color in a scene. To get the most out of Aperture, therefore, it is critical that you set it up to best reproduce these tones on-screen, and when outputting your work.

Mac OS X manages color using ColorSync, a utility that translates the colors captured and displayed by components of your set-up – including cameras, monitors and printers – so that they can be universally understood. This is important because not all devices can display the same range of colors, and so a certain amount of interpretation has to take place to simulate some tones on those devices with a narrower color gamut. Further, what one printer thinks is pure red may vary widely from another, and still more dramatically from the pure red of a pixel on your display, or a photosite sensor in your camera.

Without color management, you could have no confidence that the adjustments made to your images in Aperture would be accurately represented in a Photo Book, on a Web Page, or in the output from your home or office inkjet printer.

Every device attached to your Mac should therefore include a color profile, which defines the range of colors it can handle. You can see the installed profiles by opening Applications > Utilities > ColorSync Utility. Clicking through them will display their relative abilities, which will vary widely. Contrast the abilities of your display, found by expanding the Computer and Displays sections using the disclosure triangles, with that of your printer, found in the Other section – again hidden by a disclosure triangle. If you are using a consumer Mac with an integrated display, such as a MacBook, you may be surprised at how many more colors your printer can handle, even if it's

FIG. 2.32 ColorSync Utility manages color translation between various applications and hardware devices attached to your Mac. Here, we are comparing the relative color gamuts of a screen and a printer.

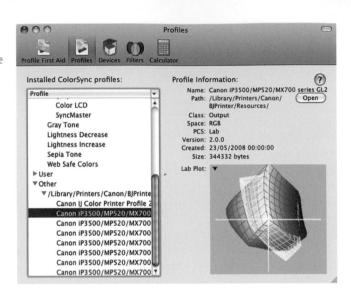

a consumer inkjet. In the grab (Fig. 2.32), we have held the gamut of our printer for comparison by clicking the downward-pointing arrow in its profile graph and picking Hold for Comparison, and then clicked back to the profile for our screen (Color LCD under displays). The printer's profile is the colored graph which, as you'll see, is far wider than the ghosted white profile representing the gamut available to our display, shown behind it. This means that our printer can reproduce a wider range of tones right across the spectrum than can our screen, and so rather than using pure tones our screen will have to work hard to interpolate a wide variety of colors so that it can approximate – as closely as possible – the results you will see when you come to print.

ColorSync handles this approximation by using a neutral third profile as a conduit for this color information, in the same way that native English and Italian speakers may use German as a lingua franca if neither understands the other's native tongue.

These generic profiles span the usual range of Lab, CMYK and RGB colorspaces, and Mac OS X needs to be told how these generic profiles differ from those of your output devices. Investing in an inexpensive calibration tool such as Pantone's Huey, which includes a sensor to affix to your display during the calibration process, should therefore be considered a minimal first step. More expensive and extensive alternatives are also available.

Regardless of the price of the tool you choose, the process of calibrating your monitor is very similar in all instances. The bundled software will display a range of pure colors on your screen, and you position the optical sensor over them. This samples the colors produced and compares what it sees with what it knows the software to be producing, using any variations it detects to build a profile that will be used to correct the display.

However, monitors change over time, and their performance can be affected by age, temperature and a range of other environmental factors. While performing a one-off calibration when you first start using Aperture pays dividends, frequent retesting is therefore required if you want to rely on your display long-term.

Setting Your Preferences

You should now work your way through Aperture's Preferences dialog (E), setting up the application to work however is best for you. In its default state it is configured in the way that Apple considers to be most beneficial to the greatest number of users, after extensive focus group testing. However, it won't suit all tastes. Many users will find a black background in the Browser lets them more clearly focus on their work; the same goes for the Viewer.

Both of these run on a scale from black to white set using sliders on the Preferences Appearances tab, where you can also specify whether adjusted images should sport identifying icons and Stack count badges (Fig. 2.33).

The Export tab is best left as it is for the time being, as these settings can be adjusted as and when needed using other parts of the application at the times when you are exporting your files. Setting them now would be to second-guess your future needs. Making the changes as and when they crop up means you should be able to make more accurate, relevant choices.

The Web tab, which we cover in more detail on page 291, will only show useful data if you are signed up for Apple's £59 a year MobileMe service. If you are, then it's worth changing the Gallery publishing setting to hourly, daily or weekly, so that changes you make to published Galleries will automatically be reflected on your site without you having to manually republish them yourself. From here you can also upgrade your MobileMe Web Space.

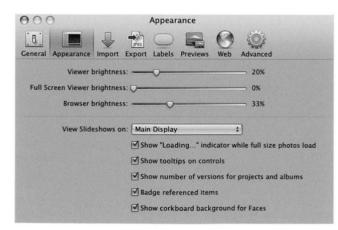

FIG. 2.33 Use the Appearance tab in Aperture's Preferences to specify the background color of the Viewer and Browser. Many users will find they have less distraction and are better able to concentrate on their images when these are both set to black.

The Previews tab controls how Aperture goes about generating JPEG equivalents of your images inside its Library package. Using these, speeds up Aperture's operation by giving it less demanding files to open when scrolling through your Library in the Browser. You should only uncheck the box for creating these at the time of creating new Projects if you have a very good reason, as doing it then – when the images are imported into the system – is passive, and takes place in the background.

By now Aperture is ready for daily use. Over time you will continue to hone it to meet your own specific needs, as you can never know from day 1 precisely how you will use it. You can now import the remainder of your images into its Library, ready for use in future creative Projects.

Managing Your Images

Adding Images to Your Library

There are two primary ways to get your images into Aperture – either directly from your camera or memory card, or from an attached drive or folder on your Mac. We will cover cameras and memory cards here, and move on to internal and external drives in the following section.

Whatever your source, photos are always added to the Aperture Library using the Import dialog. This may appear automatically when you connect your camera – if you have Mac OS X set to do that – but if not, it can be activated using the Import button on the toolbar.

The setting that controls whether or not it appears every time your Mac detects that a camera or card has been connected is found in Preferences ((**)) or through Image Capture, the utility that manages cameras and scanners at the system level. This is found in the Applications folder (Figs 3.1 and 3.2).

The Import dialog is split into three key sections, and has been greatly simplified in Aperture 3. When launched, it slides down your Library Inspector pane to show the various sources above. The central window

Apple Aperture 3. DOI: 10.1016/B978-0-240-52178-7.10003-9 Copyright © 2010 Elsevier Ltd. All rights of reproduction, in any form reserved.

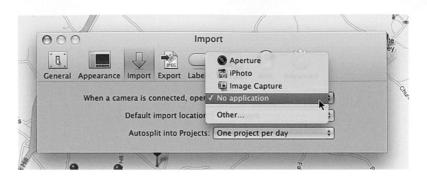

FIG. 3.1 Use Aperture's Preferences dialog to specify what should happen when a camera is connected to your computer. Select Aperture in the pop-up beside 'When a camera is connected, open.' to automatically launch the Import dialog.

000		Image Capture			
* DEVICES	Name	A Date	File Size	Aperture	Depth
Untitled	DSC00313.JPG	11/24/2009 12:18:22	4 MB	f/2.8	8
MassStorage,	DSC00314.JPG	11/24/2009 12:18:27	4.3 MB	f/2.8	8
Meeester Nik	DSC00315.JPG	11/24/2009 12:18:50	4.2 MB	f/2.8	8
E Bidetooth	DSC00316.JPG	11/24/2009 12:19:34	3.9 MB	f/2.8	8
	DSC00317.JPG	11/24/2009 12:19:40	4 MB	f/2.8	8
	DSC00318.JPG	11/24/2009 12:20:06	4.3 MB	f/2.8	8
	DSC00319.JPG	11/24/2009 12:53:25	4.4 MB	f/2.8	8
	DSC00320.JPG	11/24/2009 12:54:25	4.3 MB	f/5.8	8
	DSC00321.JPG	11/24/2009 12:54:32	4 MB	f/5.8	8
Untitled	DSC00322.JPG	11/24/2009 12:54:39	3.9 MB	f/5.8	8
Connecting this camera o	DSC00323.JPG	11/24/2009 12:54:44	4 MB	f/5.8	8
iPhoto *	- (e la constantina de l)+
Aperture Image Capture		ictures	Import		port All
AutoImporter		1 of 320 selected		0	
Other		and when the state	1		

FIG. 3.2 Image capture gives you great control over how your images are imported and where they are stored. It also works with local and network-connected scanners.

shows the images in the chosen location, and if you are importing images from a hard drive rather than a media card, a panel below this lets you navigate through the various Folders and Directories on the drive. Finally, the Import Settings panel on the right-hand side lets you choose what happens to your images while they are being imported.

This last panel is especially flexible, and lets you save a lot of time by automating common tasks, such as choosing whether to import Raw or JPEG images (or both) from cameras that shoot the two together, rename files as they are imported to comply with your specific cataloguing system, what to exclude from the import (audio attachments, videos and so on) and even where to simultaneously back up the images and which AppleScripts to run. This last option is particularly powerful, making short work of, for example, shrinking down images for use on the Web while at the same time importing the full-size editions into your Aperture Library.

Exactly what shows in this Import Settings panel is controlled by the dropdown menu that appears above it. Check and uncheck the options found here to tailor it to your own specific requirements.

Importing from Your Camera

Cameras organize their images into Folders, usually defined by the number of photos they have captured since they were new. Each Folder is usually restricted to holding just 100 images, and so a day-long shoot can often end up split across several Folders. Even if you have taken less than 100 images, you can still sometimes find that they are split across more than one Folder. This is because your camera may have taken, say, 3690 images in all time. If you then take a further 50 images in one session, the first 10 would be filed in one Folder, and a new folder would be created for the other 40 shots in the session (Fig. 3.3).

Aperture's Import From Camera dialog ignores these artificial subdivisions and instead presents you with a single grouping of all of your photos. Aperture is compatible with almost all current digital cameras, so it is unlikely that you will be unable to access your photos in this way, and even if you have trouble now, the chances are that in time your camera will eventually become compatible, as Aperture draws its Raw processing tools from the operating system, and so OS updates filter through to the application.

Raw format files are simply a dump of all of the data gathered by the sensor of your camera. These data have not been edited or refined in any way, and so although metadata such as your ISO setting, shutter speed and exposure compensation are also recorded, only physical attributes such as the length of time the shutter was open will have any affect on the image. This leaves you free to change the other settings once you get them into Aperture.

Some cameras offer to shoot JPEG and Raw files together. This consumes more space on your memory card, but can save time when importing into Aperture, as it will use the JPEGs as the preview images that it initially displays in the Browser pane, rather than creating them from scratch at the point of import. It is up to you to decide, therefore, whether import speed or shooting capacity is of primary importance, while bearing in mind that as both options create previews passively, in the background, the impact on your workflow will be minimal.

By default, Aperture will select all of the images on your card or in your source Folder for import. You can uncheck them all using the button above

		٩		
DEVICES	Name A	Date mounieu	Size	Kind
🖾 iDisk		22 November 2009 18:00		Folder
EOS_DIGITAL	228CANON	22 November 2009 18:00		Folder
Macintosh HD	IMG_2883.CR2	25 November 2009 12:35	7.2 MB	Canonaw file
Datavol 1	IMG_2885.CR2	25 November 2009 12:35	7 MB	Canonaw file
MyBook :	MG_2886.CR2	25 November 2009 12:35	7.1 MB	Canonaw file
SHARED	IMG_2887.CR2	25 November 2009 12:36	7.2 MB	Canonaw file
	IMG_2888.CR2	25 November 2009 12:36	7.1 MB	Canonaw file
PLACES	IMG_2889.CR2	25 November 2009 12:36	7.6 MB	Canonaw file
MacUser 1	IMG_2890.CR2	25 November 2009 12:36	7.5 MB	Canonaw file
MacUser 2	IMG_2891.CR2	25 November 2009 12:36	7 MB	Canonaw file
Desktop	IMG_2892.CR2	25 November 2009 12:37	7.5 MB	Canonaw file
1 nikrawlinson	IMG_2893.CR2	25 November 2009 12:37	7.5 MB	Canonaw file
Applications	IMG_2894.CR2	25 November 2009 12:38	7.3 MB	Canonaw file
Documents	IMG_2895.CR2	25 November 2009 12:38	6.8 MB	Canonaw file
MacUser	IMG_2896.CR2	25 November 2009 12:38	6.8 MB	Canonaw file
Movies	IMG_2897.CR2	25 November 2009 12:38	6.8 MB	Canonaw file
Music	IMG_2898.CR2	25 November 2009 12:38	6.8 MB	Canonaw file
Pictures	MG_2899.CR2	25 November 2009 12:38	6.9 MB	Canonaw file
	IMG_2900.CR2	25 November 2009 12:39	7.2 MB	Canonaw file
web	* 🚞 229CANON	25 November 2009 12:39		Folder
images	IMG_2901.CR2	25 November 2009 12:39	7.3 MB	Canonaw file
Dropbox	IMG_2902.CR2	25 November 2009 12:40	7.1 MB	Canonaw file
SEARCH FOR	IMG_2903.CR2	25 November 2009 13:57	6.7 MB	Canonaw file
	IMG_2904.CR2	25 November 2009 13:57	6.7 MB	Canonaw file
	IMG_2905.CR2	25 November 2009 13:57	6.7 MB	Canonaw file
	IMG_2906.CR2	25 November 2009 13:57	6.7 MB	Canonaw file
	IMG_2907.CR2	25 November 2009 13:57	6.7 MB	Canonaw file
	IMG_2908.CR2	25 November 2009 13:57	6.7 MB	Canonaw file
	IMG_2909.CR2	25 November 2009 13:57	6.7 MB	Canonaw file
	IMG_2910.CR2	25 November 2009 13:57	7.1 MB	Canonaw file
	IMG_2911.CR2	25 November 2009 13:57	7.1 MB	Canonaw file
	IMG_2912.CR2	25 November 2009 13:57	6.8 MB	Canonaw file

FIG. 3.3 Digital cameras maintain a strict filing system, splitting up images into different Folders depending on their sequence number. This number is counted from the time when the camera was first manufactured, with most models creating a new Folder for every 100 images shot.

the thumbnail previews, and then select only the ones you want to bring into your Library by individually checking the tick boxes below them. If you want to import a large number of consecutive images, select the first one and then hold **Shiff** while clicking on the last. Checking the tick box on any one of the selected images will then check or unckeck them all as appropriate. You then click the Import Checked button at the bottom of the screen.

Sort Your Images Before Import

You may think that Aperture's Import dialog looks similar to the Browser, and it does. That's no mere coincidence. Although it deals with images that don't yet exist in your Library, it still gives you access to many of the same sorting and organizing tools as the Browser does for those you have already imported.

At the bottom of the dialog is a facsimile of the Browser toolbar, allowing you to switch between Grid and List views and then sort by name, date or file size in either ascending or descending order by clicking the column headers in the List view. A slider lets you vary the size of each thumbnail.

You can choose, if you want, to start stacking your images at this point so that they are already stacked when they appear in the Library for easier management of similar photos. Select the images you want to stack and either right-click then pick Stack, or use the shortcut \mathfrak{B} \mathfrak{K} . If you would rather have them automatically stacked on the basis of the gap between each one being taken, use \mathfrak{B} \mathfrak{L} \mathfrak{A} and drag the slider or click the arrows on the head-up display that appears to specify the timeframe within which stacked images should have been taken (Fig. 3.4).

Choosing Where To Store Your Images

Whenever you import an image to the Library from another location on your Mac or network, you have the option of adding it to your local Aperture Library, or leaving it in its original location. Your choice will largely depend on how the image is used. If you work alone, then there is no problem with moving it to your local drive, but users on a network should be careful here, as changing its location could make it unavailable to others on the network.

You can, however, change the location of your Aperture Library. By default it is stored on your local hard drive in the Pictures Folder (~/Pictures/Aperture Library.apLibrary). To change this click Aperture > Preferences... and in the General section, click the Change button and navigate to a new location. Note that if you do this, you'll then have to re-launch the application. You can have several different Libraries set up for each copy of Aperture and switch between them using the Switch to Library option on the File menu.

The option to move your files at the point of import, leave them where they are or move them to another Folder is found in the Import Settings sldebar. Your options are In the Aperture Library, In their Current Location, Pictures, Desktop and Choose.... The latter option is the most flexible, allowing you to store your images in a standalone format anywhere on your hard drive, rather than in the complex Directory structure inside the Aperture Library package. Pictures and Desktop speak for themselves, although we would strongly advise against storing photos on the desktop. This part of the Mac OS X interface is intended only as a transport area, or for hosting a very small number of frequently used files, Folders or links to applications. For maximum system efficiency – and maximum personal productivity – it should remain as clutter-free as possible.

Images stored anywhere other than in your Aperture Library are called referenced images (Fig. 3.5), because the application has to look elsewhere to get the full resolution photos to work on. When importing images, but leaving them in their original location or saving them anywhere other than inside the application itself, Aperture merely creates references to and thumbnails of the originals, and so it's imperative that the original is also available whenever you want to make edits.

FIG. 3.4 Use the time-based slider called up by Stacks > Auto Stack, or the shortcut (HB - N - A). The Stacks are determined by the interval between each photo, on a scale of 1 to 60 seconds. Moving the slider to the extreme left - '0' turns off automatic stacking. FIG. 3.5 Although most users will want to keep their images within the Aperture Library, and hence benefit from the access this gives to backing up using Vaults, you can also store them elsewhere on your hard drive. Photos stored in this way are known as Referenced images.

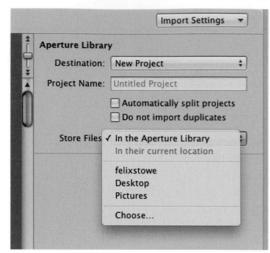

You should also ensure that you have a suitable backup system in place to protect your referenced images, as they can't be stored in Vaults, Aperture's own internal backup spaces. As such, any serious system failure or a hardware fault that impacts on an external drive holding your referenced images will make them unavailable for use in Aperture. This is a serious issue, as they are used as the basis of Versions stored within your Library. As Versions don't actually exist in image format but are, rather, data files telling the application what changes to apply to a Digital Master in order to render each one, they would effectively be lost at the same time as your originals, leaving you with no assets at all. For more information on implementing an effective backup routine, see page 86.

Even if you choose to store the images in your Aperture Library, or in another folder on your Mac, the originals remain exactly as they are. Aperture will never delete them unless you specifically tell it to, with any originals simply copied – not moved – from one media or location to another.

Should you choose not to import your images into the Aperture Library, but store them elsewhere on your system, you will obviously need to specify where and how they should be filed.

Creating Filename Presets

If you want to have your image files renamed as they are imported into Aperture, you need to set up a file naming preset. This can be done either through the menus (Aperture > Presets > File naming...) or by opening the Rename Files brick in the Import Settings Inspector and picking Edit...

Aperture ships with nine filename presets in place, but you can create an almost unlimited number of variations by dragging 16 different elements

into the Format box. The elements include Version and master filenames, current time and date, creation time and date, counters and index numbers and, perhaps most useful of all, the option to create a custom name.

The custom name must be set at the point of creating the preset, or else Aperture will interpret it as incomplete, and it will not be available for use in the Export dialog. However, you can go back and change it at any time if you find that your needs change at a later point.

The other variable that accepts user input at the point of creation is Counter. In this instance the input isn't compulsory, but it does let you specify an initial value and how many digits should be included in the counter. Note that this digit length isn't a maximum beyond which the numbers will be capped (so no more than 999 for a three-digit length or 9999 for four) but the number of digits that will be included in every filename. So pick 6 and even your first digit will be assigned 000001, along with any other variables you specify (Fig. 3.6).

You can split your filename into more manageable parts by inserting spaces and other special characters such as hyphens between the constituent parts. However, there are a number of reserved characters that cannot be used in filenames. The forward slash (/) is one, as this is used as a Directory separator, and you won't be able to enter it when creating your preset. However, you can enter a colon (:), although again this should be avoided as it is conventionally assigned to marking out drives by many operating systems. When the file is saved out, Aperture substitutes it for a forbidden forward slash.

Depending on the file type and which application is designated to open it, this could cause the file to self-replicate every time it is accessed. A PNG export including this character opened up in Preview, for example, will do just this, littering its Folder, or the desktop if that's where it is saved, with one duplicate edition for each opening. Another quirk permitted by Aperture, but

Preset Name	Furnalis	Courses Namel Internal		
Custom Name with Index	Example:	[Custom Name] [Name]1		
Nik's naming standard	Format:	(Custom Name) (Version Name) (Index #)		
Custom Name with Index (no spaces)		Customize the format by dragging elements below into		
Version Name		the text above. You can also edit the text above to add		
Version Name and Date/Time		or remove characters such as spaces.		
Version Name with Sequence				
Version Name with Index	Indudes			
Image Date/Time	Include:	Version Name Image Date Current Date		
Custom Name with Counter		(Master File Name) (Image Time) (Current Time		
Custom name		Custom Name Image Year Current Year		
		Index # Image Month Current Month		
		Sequence # Image Day Current Day		
		Counter		
		Custom Name:		
		Incrementing counter starting at: 1		
		# of digits: Auto ‡		

FIG. 3.6 The File Name Preset Creation tool works in a similar way to the tool for defining Folder name presets, but gives you access to fewer punctuation marks, and adds in sequential tools, such as Sequence number, which will specify the number of the image and where it appears in the overall collection — for example 117 of 203. which should be avoided, is the use of a full stop at the start of a preset filename. Do this and your exported file will never appear, as it is an indicator used to denote a hidden file. The export will take place, and the file will be saved exactly where you said it should, but you'll never see it without using FTP software, changing your system settings or rooting around with Terminal.

Completing the Import Workflow

The Import Settings Inspector defines a logical workflow for adding photos to your Library, and it is best to take a top-down approach to the panel, as regardless of the order in which you add new bricks, Aperture will always arrange them in one set top-down list. Once your file names have been defined, we come to time stamping and metadata, both of which are key to effective file management within the application.

The modern photographer is no longer confined to a studio. Location assignments, reportage and international photojournalism have long called for a mobile freelance workforce, and who has time to be resetting their camera clock every time they arrive on site?

Using the Time Adjustment feature, you can have Aperture take care of this for you. Leave your camera set to your local time zone – or GMT/UTC for simplicity – and specify on each import the zone in which the photos were taken. Aperture understands the time relationships between key world cities, allowing you to select your camera time zone and assignment location geographically, rather than chronologically. Do this and it will make the necessary changes to the metadata of the imported Digital Masters without any further intervention on your part (Fig. 3.7).

By now you have reached perhaps the most important step in importing your photos: adding metadata. This works on a batch basis, adding the same variables to all of the images you import in one session. You should therefore only specify data that apply to every image in your selection, and then further personalize them once they have been safely stored or referenced in your Library.

Aperture ships with a range of pre-defined metadata sets, but the Import dialog is interested only in your own presets. If you have not yet created any of your own, you can do so by picking Edit... from this menu.

Creating Metadata Presets

A lot of the metadata that you apply to your images will be identical from photo to photo: your byline will always be the same; your copyright notice will only change once a year; and you may use a common set of keywords across several images because you specialize in one particular area or type of photography.

			Import Se	ttings
	Ê	Aperture Librar	у	
	<u></u>	Destination:	New Project	
	(A =			
1 P		Project Name:	Untitled Project	
H	W []		Automatically split	
0316.JP	G	Store Files:	In the Aperture Libra	ry
		Time Zone		
1	2.36	Camera Time:	Europe/London	
		Actual Time	/ Europe/London	
1.10	4		Africa	
			America	
-			Antarctica	
0320.JP	G		Arctic	•
			Asia	
Az	ores (GMT+	00:00	Atlantic	
Be	rmuda (ADT)	Australia	•
Ca	nary (GMT+	01:00)	Brazil	•
Ca	pe Verde (G	MT-01:00)	Canada	•
Fa	eroe (GMT+	01:00)	Europe	•
Jar	Mayen (GM	T+02:00)	Indian	•
Ma	deira (GMT	+01:00)	Japan	
Re	ykjavik (GM	D N	Pacific	
		(GMT-02:00)	US	
	Helena (GM		GMT	
Sta	anley (GMT-	03:00)	UTC	
Stor Bar	10.004	Contraction of the local division of the	UIL	

FIG. 3.7 Aperture is time zone aware, allowing you to leave your camera's clock set to your home time zone, and change the date and time stamps on your images at the point of import by picking the name of the country or city in which the images were taken from the Actual Time Zone drop-down menu.

Rather than having to type all of these details anew each time you import a fresh set of photos, therefore, Aperture lets you define them just once as sets and then add them by picking the appropriate set from the pop-up Metadata menu. You can define as many sets as you need, which allows you to duplicate a great deal of common information in all of your presets, and adjust only those parts that vary between clients or shoots. In this way you can precisely tailor the data you pass on to each client, providing them just what they need, without either overburdening them, or leaving any blanks.

Open the Metadata Presets brick from the Import Settings drop-down menu and pick Edit... . Create a new preset using the Cog button at the bottom of the panel, giving it a meaningful name. You then use the various metadata fields to define common data that should be applied to every image imported using that preset. Obviously you should be careful what you enter here, as not all of the fields will be relevant to all images. For example, while Creator, email address and website are unique to you and should be applied to all of your images, date created will only be relevant to images shot on one particular date, and so no data should be entered in this field for a preset that you intend to use for more than one job.

Progress through the various metadata sections, checking the boxes of the variables you want to include. You can clear out individual fields at the

FIG. 3.8 Setting up a Metadata preset cuts the amount of time you'll spend tweaking photos with similar themes when you come to import them into Aperture.

900	Metadata
Preset Name	
Nik Rawlinson	IPTC Status
Nik's copyright	Title:
Oscar's contact details	Job identifier:
	Instructions:
	Provider: Nik Rawlinson
	Source:
	Copyright: 2011 Nik Rawlinson. All Rights Reserved.
	Usage Terms:
	Aperture
	Rating: x
	Flag: 101
	Custom Fields
	iPhoto Roll:
	IPTC Legacy
	Action Advised:
	Audio Duration:
	Audio Outcue:
	Audio Sampling Rate:
0.	(Cancel) OK

point of import, but it saves a lot of work in the long term to define accurate metadata sets at this point that you know you can rely on in the future.

Obviously not all metadata variables can be edited in this way, as any that already exist will have been set by the camera and so are immutable facts, rather than judgment calls on your part. These can be included in a Metadata view so that you can call them up at a later point to examine a specific range of data in one place, but including them in a preset is unnecessary as they will already be imported with your images anyway. In the interests of speed, therefore, they should be excluded at this point.

Click OK to save your Metadata list as a preset (Fig. 3.8).

Once your preset has been saved, you will return to the Import dialog and will see that there are two radio buttons between the pop-up menu and the fields themselves to either append or replace the data that already apply to your photos. Their functions speak for themselves, but you should be careful when choosing between them. Appending data can lead to bloat, where a lot of insignificant information is attached to your files. However, replacing existing data can lead to existing key facts being lost.

Importing Your Pictures

By now you have reached the end of the import workflow, and all that remains is to bring your images into your Library by clicking the Import button at the bottom of the Import dialog. Aperture will either copy your pictures into its Library package, or reference them within the Library. Whichever route you choose, it will also go about creating JPEG previews for use in the Browser windows to speed up its operation, although as this happens in the background, the only thing you will know about it is if you try to quit the application before it's finished and see a warning. To monitor its progress, open the Activity window (Window > Show Activity).

Importing from Other Sources

Images can also be imported from a Folder, stored either locally on your hard drive, or on any networked drive. The principle is the same as importing from a memory card, except that it requires a little more manual intervention.

Aperture can handle a wide range of image formats, including GIF, JPEG, JPEG2000, PNG, Photoshop PSD, Digital Negative (DNG) files, TIFF and Raw. This latter option will not be available for all cameras, since each manufacturer maintains its own Raw format, but Aperture keeps up with the leading manufacturers, including Canon, Nikon and Pentax. Apple maintains a list of supported cameras at apple.com/aperture/specs/raw.html, and there's a chance that even if your camera is not supported right now, it would be in the near future, as it frequently adds to the range when it updates the operating system. Bear in mind that some manufacturers give their cameras different names in different territories. This is usually an internal marketing convention derived through research that shows which name would perform best in different territories. A prime example is the Canon EOS 350D, which took this numeric name in Europe, was the Digital Rebel XT in the USA, and in Japan masqueraded under the title EOS Kiss Digital N. Each has - ostensibly the same specification, but because the naming convention is included in the files used to decode the Raw data, using mismatched Raw definitions will not work. You should therefore only ever assume that your camera will work flawlessly when the title of your specific model of the camera is included in the range of Raw-parsing updates delivered by Mac OS X's Software Update.

Assuming your camera is supported, then any Raw files you have saved onto a drive can be imported as quickly and easily from here as they can from a memory card.

Importing Without the Dialog

If your images already exist on your system – whether internally or on an attached external drive – then it is possible to bypass the Import dialog altogether when adding images to the Library, by selecting an existing Project (or creating a new one with **(B) (N)**) and dragging the images to it from a Mac OS X Finder window. Aperture will then run through the regular import routine itself, saving you the time of working through the process step by step. They will be imported into a new untitled Project within your selected folder.

This is a speedy shortcut, but it has one very significant disadvantage: bypassing the Import dialog means you won't have applied any user-defined

metadata to your images, and so they will only carry with them information about your camera, settings and shooting conditions. They will not have any keywords attached, any captions, copyright notices, rights information or credits, and so these must be added manually at a later point. For single Folders of images, therefore, using drag and drop to import them into your Library can actually be a false economy.

If you are importing several Folders, though, it can pay significant dividends – particularly if you are setting up Aperture for the very first time. Over several years of use, you may have built up a significant collection of images elsewhere on your Mac – say, for example, your Pictures folder. Importing these using the Import dialog would be a time-consuming affair, which by necessity would have to be done in stages, with a new Project created for each group, and Albums created within these for individual sub-sections. In an instance such as this, you may want to import existing Folders as Projects in their own right (Fig. 3.9).

Aperture will recognize each Folder's name and use this to create an identically named folder inside Aperture, with subfolders used as Projects inside it. You can then select the contents en masse and apply a pre-defined metadata set to them before moving on to the next Project. You can do this

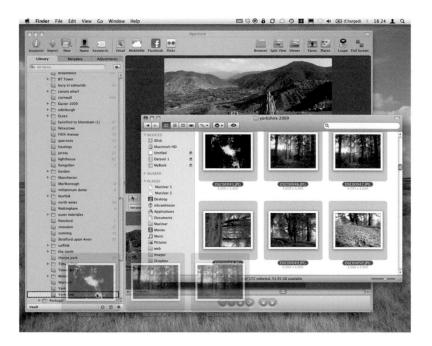

FIG. 3.9 If you need to import multiple images already stored on your hard drive, you can bypass the Import dialog by dragging them into the Projects pane from a Finder window. They can be dropped into an existing Project, but dragging a Folder will create a new Project, with all subfolders used as the basis of Albums inside the Project.

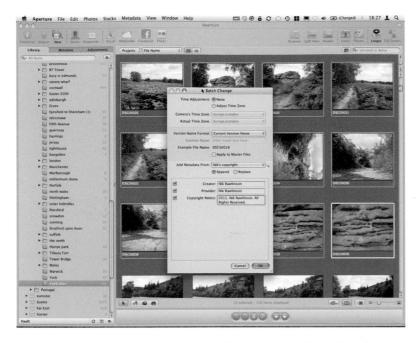

FIG. 3.10 After importing photos by dragging them from a Finder window into the Aperture Projects Inspector, you can apply metadata changes to them as a group using the Batch Change dialog.

using the Batch Change command on the Metadata menu (*Shift*) **(B)** to call up a subset of the Metadata Inspector (Fig. 3.10).

Renaming Files

Your images' names, as they appear in the Library, will be determined at the point of import. If you would rather that they don't just use the name specified by your camera, which will be a prefix followed by an incremental counter that marks the number of shots taken since it was new, you can specify a more appropriate name based on various internal metadata or criteria that you specify yourself. This is selected through the Import dialog, using the settings at Aperture > Presets > File Naming...

You can likewise change the names of your images when they are exported, again by specifying a pattern derived from metadata and an optional custom field of your choice, using the presets at Aperture > Presets > Image Export... The settings defined here will appear in the Export dialog.

However, there are times when you will want to change the names of your files as you work with them in the Library. This is done by switching to the List view by using the shortcut **GIP (L)** and then double-clicking on the name of the file you want to change, typing your replacement and hitting **Return**.

Backing Up Raw Files

Your Raw files are the most valuable assets in your photography workflow. More important, even, than your Mac, your Aperture installation, or your camera. Each of those can be replaced with a little expenditure, but your Raw images are irreplaceable originals. Even if you were to spend time recreating each scene and reshooting them individually, they would never be exact replicas of the originals.

Further, any adjustments you had made would have applied to those originals, which would now have been lost, leaving you to repeat your timeconsuming work on new photos, with no guarantee of achieving the same end result.

It is therefore vital that you implement a regimented backup procedure that safeguards your Raw Digital Masters, and any Versions derived from these. The recommended process would be to implement this within Aperture itself using the Vaults system (see Managing Vaults on page 88). However, there are issues here surrounding Raw images that are not stored within your Aperture Library, as Vaults can only contain images found within the Library itself. With referenced files, only adjusted Versions and associated metadata will be saved.

Therefore to ensure you have adequately protected your originals, you should either relocate your images within the Library itself or, if you've already set up your Library with your images stored externally, implement a third-party backup tool, or the tools within Mac OS X itself to properly protect your assets.

Backup and Time Machine

Apple ships the appropriately named Backup application as part of its MobileMe online service. This simplifies the process of backing up files and folders to archive media, including external hard drives and optical media such as CDs and DVDs. It will also let you back up your files off-site to your MobileMe iDisk, which gives you access to 20GB of storage in the default configuration, and up to 40GB or 60GB for an additional £30 or £50 annually, respectively.

Backup can be downloaded by accessing your iDisk using the entry in your Mac OS X Finder sidebar, and navigating to the Software Folder within which you'll find a Folder containing the Backup application.

In Mac OS X 10.5 Leopard, 10.6 Snow Leopard and later, Backup is supplemented by Time Machine, Apple's automated backup tool, which saves incremental copies of your file system to an external, attached hard drive, or Time Capsule, the company's integrated router and network-attached storage drive (Figs 3.11–3.14).

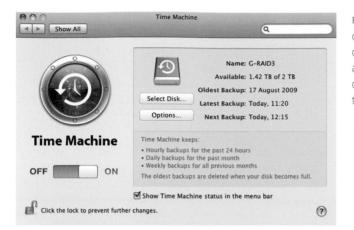

FIG. 3.11 Time Machine automates the process of creating incremental system backups on an external hard drive or network-based Time Capsule device. Ensure you are running the most recent Version of Mac 0S X 10.5 or later to have your Vaults and Libraries included in the Time Machine archive set.

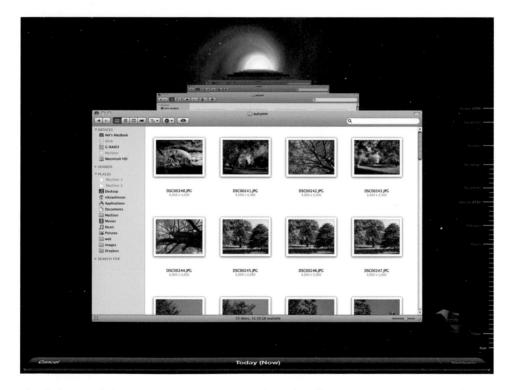

FIG. 3.12 Time Machine makes backup both friendly and easy, by presenting a history of your files in a graphical, easily understood interface that lets you 'roll back' your system state through time.

However, while Time Machine will make a good job of backing up all of your files at regular intervals, irrespective of their location, and Backup can be set to run at specified intervals, combining them with tools like Mac OS X's Smart Folders, Automator and Folder Actions can further secure your backup

Apple Aperture 3

FIG. 3.13 Backup is a free utility for all MobileMe subscribers. Download it from your iDisk by clicking its entry in your Finder sidebar and navigating to the Software Folder.

AL	Home Folder
111	Next backup scheduled for 2 Apr 2010 at 11:53
	MyBook Weekly at 11:53 every Friday
	Successful backup on 28 Mar 2010 at 17:52
5	Backing up "Personal Data & Settings"
	Next backup scheduled for 29 Mar 2010 at 10:30
	🖉 iDisk
	Scanning: 479 items

	000	Home Folder	
	Home Folder Next backup scheduled	for 2 Apr 2010 at 11:53	
00	Backup Items	Back Up History Restore	
Home Folder Next backup sche	Item 👚 nikrawlinson		Size —
Weekly at 11:53 ev Successful backup Personal Data & Next backup sched Daily at 10:30 Successful backup			Scanning 🏌
+ 0-	Destination and Schedul	e at 11:53 every Friday for 2 Apr 2010 at 11:53	
	*-		Back Up Now

FIG. 3.14 Backup can be set to create backups at set intervals by defining a data set to store, and specifying a schedule to which it should conform.

procedure and place more of the burden for safeguarding your files on the file system itself.

Managing Vaults

Aperture has its own Backup tool in the form of Vaults. These are virtual copies of your Library that are stored, like Time Machine archives, on an

attached external hard drive. However, unlike Time Machine backups, these are managed directly from within Aperture, and they are dedicated specifically to rebuilding a corrupted Library, not scrolling backwards through time and extracting individual changes.

If you are running Mac OS X 10.5 and plan to use Time Machine to secure your Library, ensure you have updated your system with the most recent patches, as early releases were incapable of handling Aperture Vaults properly, and these had to be specifically excluded from backup sets.

Creating Your First Vault

Vaults are managed through their own panel at the bottom of the Aperture Inspector. Expand it by clicking the Show or Hide Vaults button at the bottom of the interface (Shift (R)). This opens a blank pane where your Vaults will be organized.

Connect a FireWire or USB 2.0 drive to any one of your Mac's available ports and then click the Shortcuts button (the cog beside the Show Vaults button) and choose Add Vault; then navigate to the newly attached drive (Figs 3.15 and 3.16).

Once added, the drive will show as a new, empty Vault. Its capacity will be reported, and a capacity bar will show how it is currently being used and what space remains. The portion colored light gray is free and available for use. The darker gray section is already occupied, but not by Aperture files, and the green-colored progress meter shows how much of the free space is used to store your Aperture backup.

As we'll explain below, you can manage several Vaults through Aperture, which can be connected either simultaneously or in sequence as you perform different types of backup at different times. You should therefore give each one a meaningful name, which for ease of identification would

FIG. 3.15 Every Vault should have an easily recognized name that will help you identify it every time it is connected to your Mac. You should also ensure that you never store more than one Vault on a single physical drive.

New Vault Contents

22823 managed files will be included in this vault.

309 referenced files will not be included. These need to be backed up separately.

Vaults provide automated backup of all master files stored inside your Aperture library. Master files for referenced images are stored elsewhere, and are not backed up in vaults.

Adjustments, ratings, and other metadata are included for all images, regardless of file location.

Do not show this message again

FIG. 3.16 When you create a new Vault, Aperture tells you what will be included, and excluded, from the backup set it contains. Only images stored within the Aperture Library package can be backed up using Vaults. All referenced files must be backed up using external tools, such as Time Machine or Backup.

FIG. 3.17 Aperture color-codes the Synchronization buttons in the Vaults pane. Red circular arrows indicate that there are Digital Masters in your Library that have never been backed up in a Vault. Yellow shows that all Digital Masters have been backed up, but not all Versions are saved in the Vault. A black icon shows that everything has been backed up and your Vault is up to date.

ideally match a physical name attached to the casing of the drive itself. You can do this at the time of creation, but if you later find you want to change it, then click on the progress bar to open up the existing name for editing. You are now ready to create your first backup.

You'll see that the circular synchronization arrows to the right of the Vault are red (Fig. 3.17). This indicates that there are Digital Masters in your Library that have never been stored in any Vault. It is a serious warning that can only be remedied by synchronizing the whole Library to the Vault, which you'll do by clicking either these arrows or their duplicates at the bottom of the Inspector. Why two sets of arrows and warnings? Because the Vaults panel eats into valuable Inspector space, yet most of the time it is unnecessary. You will therefore spend most of your working time inside Aperture with the panel minimized so that you can devote as much space as possible to navigating your Library. In this way you can perform backups by clicking the button at the bottom of the panel without first opening it up, and save breaking your creative flow.

Should the arrows show amber, rather than red, Aperture is giving you a less serious warning. In this instance, all of your Digital Masters are backed up, but you have unsecured Versions in your Library. Again, manual synchronization will remedy this.

The only time you don't need to pay your Vaults any attention is when the icon is black, indicating that all Digital Masters and Versions are backed up. Even this can be deceiving, however, as there are two exceptions that could lull you into a false sense of security.

The first is that you may have no Vaults set up at all. In this instance, the icon would remain black, despite the fact that your images exist in only one location. It would be hard to imagine a situation when you might think that this meant you had no cause for concern. However, the latter reason – that your images reside outside of your Aperture Library – is more obscure.

Aperture will only store locally managed images in your Vault. If you choose, when importing originals into your Library, to leave them in their original folders or store them anywhere else on your Mac and instead simply refer to them in Aperture, it will be unable to store them in a Vault. Instead, it will back up only derivative versions. Adjustments made to the originals will cause the icon to glow amber, but on no occasion will it show red, as your Digital Masters don't actually exist within the Aperture environment. In this situation, deleting them from the Finder or through any other application will make them inaccessible to Aperture, and you will be unable to restore them from a Vault. A secondary backup procedure to secure the folder in which they reside must be implemented as a matter of course.

You can connect several Vaults at once and run an incremental backup procedure, with daily backups to be kept on-site and weekly or monthly

backups to be stored in a separate building, to keep them safe in case of fire or flood.

Of course, size quickly becomes a consideration when working with Raw files, which are larger than the relatively conservative JPEG images written by consumer cameras. Combine these with all of the adjustments, Versions and keywords that you'll add, and a single Vault can quickly consume a small drive. For this reason, you should always buy the most capacious drive you can afford after considering the average size of each Raw file that you shoot, and how many you expect to take in a single year.

Maintaining Your Vaults

Each Vault assigned to your Aperture Library should be a living, constantly developing resource. It's no good performing a backup at the end of January and then not doing another until mid-June, by which point you could have added 1000 or more Digital Masters and 5000 Versions to your Library. The chances of you losing them are – admittedly – slim, as hard drives are generally reliable units, but the cost if you did could be considerable if they pertain to possible work and contracts. Even if they don't, your originals will still be difficult to recover without the assistance of expensive data recovery specialists, and impossible to recreate, as each one will be a record of a unique moment in time.

For these reasons, it is essential that you are assiduous in your backup routine, and you update your daily Vaults every time you import new images to your Library, at the end of every working session when the synchronization icon glows amber, and on a weekly or monthly basis – as appropriate – for your off-site copies.

You should never store more than one Vault on a single drive in separate partitions, as this will do nothing to reduce your chances of losing your backups. Therefore, when creating more than one backup at a time, you should either connect all relevant external drives at one time, and click the Synchronize button on the bottom of the Vaults panel, to update them simultaneously, or connect them one after the other and perform the updates in sequence. There is no option to have a Vault update automatically when you have finished each session of working with Aperture.

As a Unix-based operating system, Mac OS X doesn't take kindly to drives being removed without warning, as it likes to close things off neatly. Not giving it the chance to do this could corrupt your data, and expose you to the risk of losing your valuable backups, making the images stored on your Mac's internal hard drive your only copies.

To reduce the risk of this happening, always eject any drive holding a Vault by clicking the eject icon beside its name within the Vaults panel (click the disclosure triangle to show this if it isn't visible), or use the same eject function in the Mac OS X Finder. When it disappears from the Finder or Vaults panel, it can be safely removed. The next time it is connected it will automatically remount and reappear.

Restoring Your Library from a Vault

With any luck, you will never need to restore your Library from a Vault. If you do, it usually means you have suffered a serious internal hard drive failure. Fortunately, if you have been keeping your Vaults up to date, you should be able to recover all of your work, except that which you have done since your last backup (which really should be no more than a day). If you ensure that you do not delete your photos from your memory card before they are stored in a Vault, you should be able to recover any new images imported since the last backup by returning to your original media.

Following a fresh format and install of the operating system, the creation of a new Mac OS X User, or the replacement of a faulty drive, open Aperture and press **(H)** to open the Vaults panel. Ensure your most recent backup is attached to the system and pick Restore Library from the shortcuts menu (the button with the cog icon). Aperture will explain what it is going to do, and let you choose a source Vault and a destination location. By default the destination will be your current Aperture Library, but by opening the drop-down menu you can pick a new location, such as a separate Folder. This is more than just good disk-keeping niceties; by picking a Folder separate to the one that contains your current Library you can import the photos in the Vault into an entirely separate location, and thus run the Libraries side by side, switching between them using the entry on the File menu or by holding **(S)** while launching the application.

Once you have finished restoring your Library from a Vault, Aperture will restart and run through a recovery procedure to rebuild and validate your Projects.

Transferring Your Library to a New Mac

You can also resort to your Vaults to transfer your Library to a new Mac. This is a fine solution if, when importing your photos into your Library, you transfer them wholesale into Aperture's directory structure. If you instead leave them in referenced locations, such as a Folder elsewhere on your drive, or a different drive entirely, however, they will not be stored in the Vault. In this case, restoring from a Vault would leave you with an incomplete Library, featuring any Versions you have created but lacking the Digital Masters from which they are derived.

In this instance, you could manually copy your entire Pictures Folder, including your Aperture Library and referenced originals. This is a common solution, but in itself it can introduce further problems if the relevant permissions applied to the files prevent the User account on your new Mac from manipulating them.

A smarter solution is to copy your existing User folder from the old Mac to your new machine. Do it the right away and it will also transfer your existing applications and settings, so you are up and running immediately. As an added bonus, when the files and settings are written to the new machine they will be defragmented and optimized, allowing your new machine to run more efficiently than your old one.

To copy your existing User Folder from the old Mac to your new machine, switch off your old machine, and on the new one launch Applications > Utilities > Migration Assistant. Click through the dialogs until asked to connect your two Macs and switch on the old Mac. This will mount it as a drive on your new system, and Migration Assistant will start to copy across all of the relevant data from your old drive. By the time it is finished, the drive on your new system will exactly match that on your old machine. Your Folder structure will be identical, your email client will be pre-populated with your messages and your Mac OS X Desktop will still show the same files as it did before. More importantly, though, your Aperture Library will also be imported with the correct permissions, allowing you to step right back in where you left off (Figs 3.18 and 3.19).

If you stored your original assets as referenced images on an external drive, you can now attach this to your new Mac, and give Aperture access to the Digital Masters from which the Versions in the newly imported Library were created.

We'll cover moving Libraries in more detail in the next section.

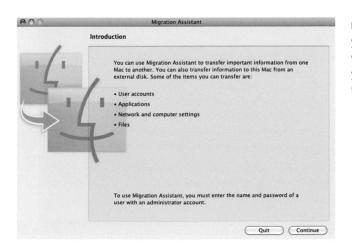

FIG. 3.18 Migration Assistant makes it easy to transfer your data and settings from your old Mac to a new one when you come to replace your hardware. If you stored your Aperture Library in your User Folder, it will be transferred along with the rest of your data. FIG. 3.19 Files are transferred by connecting your two Macs together over your network. Your old Mac will then be used as a mounted drive by the new host machine.

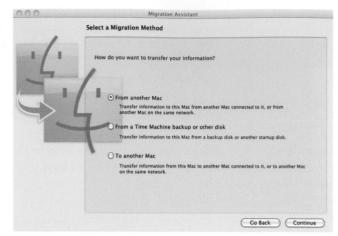

Moving Libraries

By default, your Aperture Library is stored in the Pictures Folder of your user account. It is a package called Aperture Library, the contents of which can be viewed by right-clicking and picking Show Package Contents. You should never mess with this Package's contents, but you can safely move it wholesale to another location on your Mac, or to an external drive connected by FireWire or USB.

This is particularly important when you have been using Aperture for some time and your Library starts to grow. Even a fairly conservative Library containing a little over 1000 photos can total more than 4GB. Several years of work, then, can swamp a notebook hard drive for those running Aperture on a MacBook or MacBook Pro, and start to feel somewhat cramped on even a desktop machine.

When this starts to happen, you should consider a more capacious location, such as an external hard drive, in which to store your Library. Prices for these are falling all the time, and so it is well worth buying a well-known brand rather than a cheap no-name device.

Research your drive before buying it, paying particular attention to Mean Time Between Failures (MTBF) statistics, which give an indication of the life of the drive – the longer the mean time, the better.

Other factors to consider include seek time and transfer rates, which measure how quickly a drive can move its read and write head to a specific point on the platters where a required piece of data can be found, and how quickly that data can then be passed from the drive to your Mac. Both of these factors will affect how responsive Aperture feels – particularly when scrolling through extensive Libraries. Whichever drive you choose, don't be tempted to store any externally-hosted Library on the same drive as your Vault. The Vault is designed to be a safe backup of the Versions and Digital Masters stored in your Library, and can be used to rebuild it should your master Library be lost due to disk corruption or any other hardware, software or user malfunction. To store your Library and Vault on the same drive would open you up to the risk of losing both your master file store and your backup resource, and should be avoided at all costs.

Fortunately, almost all well-specified external drives allow for daisy-chaining of further drives, saving you from using up all of the ports on your system that would otherwise be used for peripherals. This would enable you to store your Library on a connected drive, and your Vaults on a separate connected drive, daisy-chained via the first, should you choose.

To move your Library from your Pictures folder to an external drive, quit Aperture, and copy the Library package to its new location.

Now re-launch Aperture. A splash screen will pop up during loading warning you that it is unable to find your Library and giving you the option of either creating a new one or locating the existing Library that you have just moved. Pick the option to locate the Library and navigate to it on your drive using the regular Mac OS X conventions.

You can also specify the location of the Library in Aperture's Preferences (**# (,)** or by using the Switch Libraries option in the File menu.

Don't be tempted to delete your old Library right away. Although you will know immediately whether the transfer has been successful, it is good practice to work with it for a few days before deleting what you know for sure is a good original copy on your local drive.

Splitting Up Your Library

There are real benefits to dividing your Library into smaller parts, particularly if you can confine the contents of each to specific, highly differentiated subjects or clients. You might, for example, have a Library for wedding shoots, another for personal Projects, and a third for portraits. All are very different subject areas, and one is purely personal, rather than commercial. With three Libraries of this sort there will be little in the way of overlap, and so grouping them into discrete Libraries makes sense in terms of both convenience and performance.

The simplest way to do this is to quit Aperture and rename your existing Library (to, say, weddings.apLibrary) before restarting. Given the option of creating or choosing a Library, create a new one using the default name (Aperture.apLibrary); then repeat the above action, quitting and renaming it (as personal.apLibrary) and repeat the process for a third time, this time creating a Library using the name portraits.apLibrary. You can also start Aperture by double-clicking its icon in the Applications folder while holding down the Skey, which will call up the Library splash screen from which you can create a new Library (Fig. 3.20).

If you want to retrospectively split your Library, though, after importing your image collection, this is done from within Aperture itself. Select the Project, Folder or Album of images you want to hive off into your new Library and pick File > Export > Project as New Library... (or Folder or Album, as appropriate). Check the option to consolidate masters and include previews so that the Library will be complete, and click Export Library. Aperture will compile a new Library in the location of your choice and, when complete, it will appear on the File menu under Switch to Library, allowing you to switch between that and your existing Library.

The primary reason for hiving off exported Libraries in this way, apart from the fact that it allows you to better organize your images, is that the exported Library can then be used in another copy of Aperture on a separate machine. This facilitates team working, whereby one member may be working on grading and filtering, separate from another team member who is working on products made using the selected images (or one photographer working on two machines in separate locations).

FIG. 3.20 You can easily split your Library into distinct parts along subject lines, and then choose between them either by holding the S key while launching Aperture or selecting them from the File menu. The result will be several Libraries existing side by side.

Changes made to the images in the exported Library can be synchronized back to the original Library. Switch to your main Library and then navigate to the location of the exported Library using the Mac OS X Finder. Double-click on the exported Library's icon and Aperture will ask whether you want to import or switch to it. Clicking Import will bring in the changes made to that Library to the main Library.

When you export a portion of your Library into a separate Library file, the copies in your Aperture Library are not deleted, so you will have two copies of each image – one in your master Library and one in the exported sub-version. If you don't want a copy in the Library from which you have exported the Projects, therefore, it is necessary to delete them manually from the Aperture Library interface.

Moving Referenced Images

There are many reasons why you may want to move referenced images on your system. If they are stored on an external drive that is approaching its maximum capacity you will probably want to transfer them to a larger drive. If you have upgraded a server on which they were always held you will certainly need to move them. Perhaps you're just having a spring-clean of your file system. In any of these scenarios, Aperture may lose contact with your original files, because they won't be stored in the locations you originally specified. In this case, you need to show it where they can now be found. You do this by managing your referenced images.

At the same time, however, you may want to import a series of external, referenced files into your Aperture Library so that you can take advantage of the Vaults system to back them up with your other Digital Masters, any metadata you have applied and any Versions you have created. This is called consolidating masters.

Managing Your Referenced Images

Ordinarily, when you move some referenced Digital Masters in the file system, Aperture will keep track of them itself. It works hand in hand with the operating system to ensure that changes made in one don't have an undesirable impact on the other. You can also check that it has recognized that they have moved by right-clicking on any referenced file in the set you have moved and picking Locate Referenced Files... This will show you where it is reading the files from and, if you have only renamed the folder holding them, it should show that its records have been updated. Any listed in red pose a problem. Those in black are properly located.

However, if the badge in the lower-right corner of each thumbnail in the Browser shows a yellow warning triangle, this indicates that Aperture cannot locate the masters. You will still be able to view the previews of each one, which are stored in the Library itself, but all of the editing options in the Adjustments Inspector will be grayed out and inaccessible. This most often happens when you have copied your images to an alternative location and then deleted the originals. In this instance you need to give Aperture a helping hand by pointing to the new location for the files it is using.

To do this, select all of the images in the moved collection, right-click and pick Locate Referenced Files... The dialog that appears will show which images are posing problems. Select all of these and then navigate to their new home using the Folder structure in the lower half of the dialog, and then click Reconnect All. This will re-associate your referenced images with those found in the target Directory, with a bar monitoring the progress of the operation (Fig. 3.21).

To avoid having to manage your masters in this way in the future, you should use Aperture's own Relocate Masters tool, found on the File menu, whenever you want to move referenced files on your hard drive. Select all of the images you want to move before picking the tool, and then use the dialog that appears to point to a new location on your system (Fig. 3.22).

Use the pop-up menus for subfolder and name formats, following the guidelines in the Importing section for defining these variables (see page 51). Once you click the Relocate Masters button, the new Folder structure will be

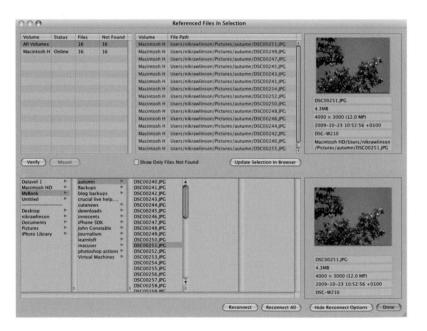

FIG. 3.21 Using Aperture's Manage Referenced Images dialog allows you to reconnect your Library with referenced images that have been moved since they were added to Projects in the Library.

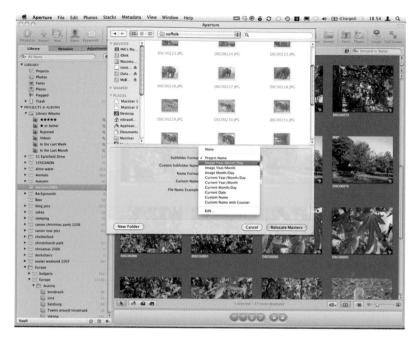

FIG. 3.22 Rather than moving your referenced images using the Mac OS X Finder, you should relocate those files using the Relocate Master command within Aperture. This will allow you to define a Folder structure and naming convention in line with that used in other parts of the Aperture working environment.

built, and populated with your images. At the same time, Aperture will update its database to take account of the change.

Consolidating Your Masters

When you consolidate your referenced Digital Masters, you place them in the directory structure maintained by Aperture inside its Library package. You can either do this wholesale – by moving them – or you can copy them so that a version of the originals will remain in their current location. Obviously if you move them rather than copying them they will be inaccessible to the file system without navigating through the Library package's Folders, and so shouldn't be touched by any application other than Aperture.

Aperture already knows where the images can be found, as this was defined when they were originally added to the Library, or when you relocated your masters following a Folder move, and so once you have chosen whether you want to copy or move them it will go about the task of bringing them into the Library itself without any further intervention from yourself.

Aperture will remove the referenced image badge from the lower-right corner of each thumbnail to indicate that they are now stored internally, rather than referred to in an external Folder. Consolidate your masters by picking File > Consolidate Masters... and you will be given the choice of copying of moving. Pick the appropriate option and click OK. Aperture will import each one in turn, updating the metadata as appropriate (Fig. 3.23).

FIG. 3.23 Aperture's Consolidate Master function moves referenced images from external Folders into the Aperture Library package, allowing you to back them up using the Vaults system. Aperture already knows where your referenced images are stored, so this is a one-step procedure.

Hard Disk Management

If you have chosen to store all of your images in your Aperture Library rather than referencing them from elsewhere on your hard drive, then it will take care of the management of your photos for you, and you need only follow basic advice for keeping your hard disk in good shape. The most important is to back up regularly, which we cover elsewhere. The second is to always make sure that you leave at least 10% of the total capacity of your drive unused, so that Mac OS X can effectively shuffle and optimize your files. With less than 10% free you will notice a considerable performance hit.

However, if you have chosen to leave your photos in existing locations, or store them in a series of Folders outside of the Aperture Library, you will have the option to access them directly from the file system itself. It also means you can use the operating system's built-in search tools to find them.

Smart Folders

Smart Folders are special Directories that intelligently update their contents by examining the attributes of files on your system, and changing their listings to reflect these. Whenever you add files to your system that match the search attributes set for the Smart Folder, they will be listed in the folder without being moved out of their original location, allowing you to see all matched files across your system regardless of their actual location.

Opening a Smart Folder and then launching or opening one of its contents will open it from the original location, saving you from having to search through your system to find it. The files themselves will never be moved, as the Smart Folder contains only links to each source.

You can therefore set a Smart Folder to list all of your Raw images, regardless of where they are stored, and you can use this as the basis of a backup routine, without having to set multiple source locations within your backup software.

To create a new Smart Folder, open any Finder window (or make the Desktop visible) and press **H N**. This opens a Mac OS X search folder. Use this to search for files sporting the extension used by your camera (say, .CR2, or . DNG). Leave 'This Mac' selected on the search bar, but change 'Contents' to 'File Name' so that the specified extension only applies if found in the name of a file, rather than within it. Leaving it set to Contents would include word processed files in which you have typed those characters and emails in which they appear, for example. Mac OS X will show a live preview of your search results. Once you have applied whatever refinements you need to hone your results, clicking Save will write the search terms to a new Smart Folder and give it a name. Every time you add new images to your system and reopen the Folder, its contents will reflect current state of play, with the new images included alongside those that existed when the Folder was defined (Fig. 3.24).

FIG. 3.24 Smart Folders are shortcuts to live search results, showing files that match user-defined variables. By searching on file type you can easily isolate all Raw files on your system.

You can refine it further by using the '+' button on the search attributes bar before saving it to define several tiers of conditions that must all be met before an image qualifies for inclusion. Say you want an easy way to monitor which Raw photos you have added to your system each day; in that case you would want to restrict the contents of the Smart Folder to just those files created in the last 24 hours. As far as Mac OS X is concerned, a file was 'created' when it first appeared in its catalog, not when a scene was captured by the camera, and so changing the first pop-up menu on the second tier of search terms from 'Kind' to 'Created date', and the second to 'today' will trim down the list of results to something more relevant to your own particular needs (Figs 3.25 and 3.26).

The results shown in your Smart Folder are just that: results. They are not files in themselves, but links to the originals elsewhere on your system. Copying or backing up the Smart Folder, therefore, will save only a notional file of around 4KB in size telling your system how to find the originals, not the several hundred gigabytes of Raw files you want to preserve. Smart Folders are not intended to be used as the first step in a manual backup process. You should therefore use them as a pick list of files that match your requirements,

FIG. 3.25 Aperture's Filter tool performs a similar function to Smart Folders, allowing you to narrow down the number of images shown on the basis of variables you specify.

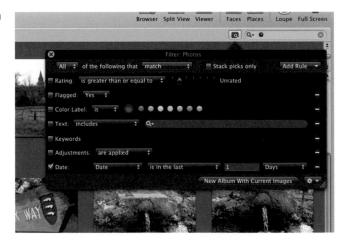

FIG. 3.26 Click the New Album with Current Images at the bottom of the dialog and give your search results a name. They will be saved near the bottom of the Library Inspector, allowing you to quickly locate recently updated images in the future.

and which you will then drag to a back up location. Alternatively, you can create a Burn Folder, which you'll use in conjunction with this Smart Folder.

Burn Folders

Burn Folders are manually updated collections of files you want to copy to CD or DVD which, despite questions over their long-term durability, remain an easy short- to medium-term backup medium and a convenient way to transport large collections of sizeable files between computers or users.

You can use Burn Folders in conjunction with a date-based Smart Folder by using the Smart Folder to identify recently created files, which can then be dragged from there to an appropriately named Burn Folder elsewhere on your system (Fig. 3.27).

As you are creating aliases within the Burn Folder to the original files referenced in the Smart Folder, these references themselves will show up in the Smart Folder, as they will carry the same file extension as the originals – assuming that is the criterion you have used to identify them. You should therefore delete the contents of the Burn Folder after creating your disc to avoid bloating the Smart Folder with irrelevant files.

If you regularly find yourself working beyond midnight and want to use Smart and Burn Folders in this way to run a manual, ad-hoc backup system,

FIG. 3.27 By combining Smart Folders with Burn Folders you can set up a simple manual backup workflow by dragging the contents of the Smart Folder to the empty Burn Folder, and then writing the results to optical disc.

you should change the date criterion in the Smart Folder set up to identify not files created 'today', but those that first appeared on the file system within the last day by specifying 'Created date' is 'within last' 1 'days', with the sections in quote marks picked from the drop-down menus.

You can adjust an existing Smart Folder in this way by opening it to view its contents and picking 'Show search criteria' from the shortcuts menu button.

Folder Actions

Apple introduced Automator in Mac OS X 10.4 Tiger, and it remains in later editions of the operating system. It is a simple programming environment that allows you to construct fairly complex routines by dragging and dropping elements into a workflow. The workflow can then be saved as an application, an AppleScript to be called from within an application, an iCal event to run at a specified time or, of most interest to Aperture users manually managing their images, a Folder action.

Folder actions are routines attached to Folders on your system that monitor the contents of the Folder and perform a range of tasks when they spot any changes. These can be as simple as copying the files from one place to another, launching an application to execute them, or changing their filenames and dropping old versions in the Trash.

Each workflow routine is built using so-called Automator actions. Mac OS X ships with a wide range of these already installed, which can be expanded either by downloading new ones from apple.com/downloads/macosx/ automator or installing applications accompanied by specific actions that expose their internal functions for exploitation inside Automator. Aperture is one such application (Fig. 3.28).

Launching Automator and Accessing Aperture's Actions

Automator is found in your Applications folder. Opening it up you will see three distinct panes. The two on the left organize your Actions (column 2) into categories (column 1), below which a descriptive window explains what each Action does when you click on it. The larger window to the right is where you build your workflow by dragging and dropping individual Actions into it, in the order in which you want them to run. As you can pass the output of one Action into the input of another, laying out your Actions in the correct order will let you build surprisingly complex routines (Fig. 3.29).

Aperture's Actions aren't shown by default, but typing Aperture into the search box at the top of the second column, while you have Library selected in the first, will bring up those Actions that it adds to the list. These Actions range from adding keywords and choosing albums to extracting metadata and filtering images for use as Picks in Stacks.

FIG. 3.28 Automator uses a step-based routing for creating small applications and actions that are on your Mac.

FIG. 3.29 The Aperture workspace is split into three sections showing Actions and categories, alongside a large workflow creation space. A Help panel explains in more detail what each Action can do.

Building an Aperture Workflow

We are going to build a workflow that will automatically rate and import into Aperture only our very best images. This lets us drag and drop individual images from a Folder or media card into the system and have them appear in the Library with a certain amount of metadata already applied, to cut processing time once they are there. It also means that we don't have to import a whole raft of pictures and then sort them in situ.

As we will be adding images to our Mac while doing this, it makes sense to attach this workflow to a Folder, as that will also provide a space in which the images can be stored once transferred to our machine.

We want our Automator workflow to grab any new images dropped into this Folder and use them as the basis of what it does next. To do this, start a new workflow by pressing **(H) (N)** and pick Folder Action from the workflow types. A new empty workflow will be opened with 'Folder Action receives files and folders added to' at the top of the main workflow window and a drop-down asking you to 'Choose folder' beside it. Click Choose folder, select Other... and then create a folder in whichever is the most convenient location for you within the Finder window. Click Choose when you are done.

Now click on Library in the first column and type Aperture into the search box to call up the Aperture Actions. Drag Import Photos into the workflow window beneath Get Folder Contents. You will see that the border surrounding the Get Folder Contents box changes to include an arrow at the bottom, which points into a tab at the top of the Import Photos box. This indicates that Automator will take whatever it finds in the specified Folder (which we'll define in the very last step) and pass it to the next step in the process: importing them into Aperture (Fig. 3.30).

The various elements of Aperture's Import dialog have been split up among several different Actions, and the only options available to you, even if you click the Options lozenge at the bottom of this section of our workflow, are where the images should be saved, whether they should be imported wholesale or used as reference files, and whether they should be deleted after they have been imported.

We have created a new Project in Aperture called Latest Import and are using this as the dumping ground for our imported photos. We will largely be importing batches of similar image types from a single shoot, so we should

FIG. 3.30 Automator's Aperture Actions are written to work in partnership with Aperture itself. This gives it access to the list of Projects maintained by the application. By dragging a second element into the workflow space, we have told Automator to pass the results of our first Action to the second as a selection to work upon.

	Untitled (Workflow)	
Hide Library Media		Record Step Stop Run
Actions Variables	Get Selected Images Results Options Description	C
Contacts Choose Albums	· · · Import Photos	c
Cocuments Expert Masters Expert Versions Fonts Fonts Filter 6r Picks Filter 6r Picks Find Aperture Items	Add to: Choose Project Autumn Oper Project Import by Reference Delete the Source Images After Importing Them	
Movies Cet Selected Images Music Cet Specified Aperture Items PDFs Import Photos	Results Options Description	
Photos Reset All Image Adjustments Presentations Retrieve Rem References	Set Image Rating	C
X Unifies X Other Most Relevant Most Relevant Most Relevant	Results Options Description	
Set Image Rating	i Log	Duration
This action sets the rating of the Aperture images passed from the previous action. Input: Aperture Image Result: Aperture Image		
Version: 2.0	a de la constante de la consta	

be able to select them as a group and move them en masse once within the Library in this dedicated Folder. We will therefore return to Aperture before we start importing photos of a different subject each time we use this routine, and reorganize the images into their final Projects and Folders.

So, we've selected Latest Import as the destination Folder, and chosen from the drop-down menu of Projects, which is automatically populated by Automator after examining your Aperture Library. If you don't already have a Project sporting the name you want, you'll have to create one inside Aperture: Automator can't create them itself unless you use the New Project option to create a new Project on every import.

Because we want the images to appear in our Aperture Library rather than being referenced from the Folder into which we're dropping them, we have left the Import by Reference box unchecked. We also don't want the images deleted after they are imported, as in this case we want a separate copy of the originals kept in the Mac OS X file system for use in other applications.

We'll now set some relevant metadata. Unfortunately you don't have access to pre-defined metadata sets here, but drag the Set IPTC Tags action into the workflow area and you'll see a range of attributes with which you'll already be familiar. Fill in only those sections that will be relevant to all of the images you'll import by this method at any time. Don't specify anything that is specific to just your next import session, or else you'll have to go back and change it every time you use the workflow, which defeats the object of setting it up just once as a timesaving measure (Fig. 3.31).

You should be quite safe entering a byline, credit, contact details and copyright notice, but avoid filling in headlines, captions and keywords at this stage; they are better handled within Aperture itself.

Ide Library Media		Untitled	Workflow)		Record Step	Stop Ru
Actions Variables	Q aperture	· O Import Ph	iotos			0
Ubrary Calendar Contacts Developer Documents Fries & Folders	Apply image Adjustment Preset Assign Keywords to Images Choose Albums Choose Projects Export Masters Export Versions	New Pro			Update	
()) Fonts	Extract Metadata	Results Optic	ins Description			
Mail	Filter for Picks	Set IPTC				0
Movies Music Music Music Protos Presentations Text Utilities Other Most Relevant Most Used Most Used Recently Added	© Gri specifica imaget © Gri specifica Accurue Remo Bingor Tholos Reset All Image Adjustments Rest All Image Adjustments Rest Image References S set Image References S store Rem References	Creator: Job Title: Provider: Contact: Source: Copyright Notice: Headline: Caption:	Nik Rawlinson			
		Keywords:				
Analy Ima	e Adjustment Preset	Province/State:		Country		
-	ge Adjustment Preset	Caption Writer		Category	0	
is action will apply the set issed from the previous ac		Location Code:	C Loc	-	10	
Input: Aperture			Loc			
to apply	an adjustment preset you would like to images from the previous action. te Replace existing adjustments	Job Identifier: Spec. Instructions;				

FIG. 3.31 Be careful when setting IPTC metadata in your workflow. We want the results of our workflow to be applicable to the widest possible range of imported images, and so will only fill in those fields that we know for sure will be universally relevant.

These data will only apply to the images inside your Aperture Library, not the copies stored on your hard drive in the file system. This means that they can't be used as Spotlight search terms to point to the originals.

Finally, as we are going to use this workflow to import only the best images into our Aperture Library as we come across them, we can safely assume that everything we import is the best of the best. So, we'll drag Set Image Rating into the workflow beneath the Set IPTC Tags section and set the Image Rating drop-down to '5' (Fig. 3.32).

Our workflow is now complete, and we need to save and test it. Pick Save from the File menu and give it a name (Fig 3.33).

FIG. 3.32 The final step in our workflow is to rate our images with five stars. This rating is passed to Aperture and can be used as a search element. However, it will not be accessible to Spotlight searches.

FIG. 3.33 Save your workflow and it will be applied to your chosen folder. Whenever Mac OS X spots a change to the contents of that folder, such as images being dragged into it, it will run through the workflow and, in this case, import the additional files to Aperture, set the metadata and rate them.

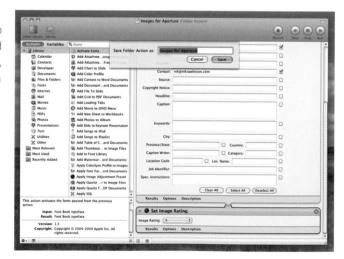

You can now close Automator and import your first photos. Choose one or more of your best images and drag them onto the new Folder. You should see the Automator workflow icon – a smaller version of the Automator application icon – briefly appear in the Dock, and an explanatory line appear in the menu bar, telling you what it is doing. If Aperture isn't already open, it will launch, and the images will be imported into the application, have metadata attached, and be rated as appropriate.

You can check that it worked by clicking in the Latest Import Folder inside Aperture to see that they have arrived safely, and then on the five-star Smart Album at the top of the Library to check that the rating was correctly applied.

Working with Metadata

Introduction

Computers aren't yet very good at understanding and interpreting images. Presented with two images, one of a horse and another of tree, in the absence of any other information, a computer would not be able to tell you the difference, or very much else useful about them.

And so we have metadata – literally data about data: textual information that tells us everything we need to know about our images and helps us find them. Metadata allows us to say 'show me all the pictures of horses, but not the ones with trees in', and to ask other questions that go well beyond the equine and arboreal.

Broadly speaking, metadata falls into one of two camps. Either it's added by the camera at the time the image is shot, or it's added afterwards. The first kind – sometimes referred to as EXIF metadata – is easy to deal with because, for the most part, it's added automatically and you can't edit it, but you can use it as the basis for searching for photos.

The second kind, usually known as IPTC metadata, is added and edited manually, after the event. Consisting, among other things, of caption and

credit information, location data and keywords which describe the image content, this is the stuff that helps differentiate between foals and foliage.

Aperture provides powerful tools for adding, editing and searching metadata. Using them to organize and identify the content in your image Library will help you locate it when you need it without wasting time. This chapter will show you how to do that.

Rating Images Arranging the Workspace

Apart from assigning keywords, rating images is the best way to organize your image Library and place a relative 'value' on individual shots. Aperture's rating system goes from zero to five stars and there is also a reject category.

Initially, at least, you'll want to skim very quickly through a Project, attaching star ratings to images, tagging obvious rejects and short-listing definite Picks. There are a number of ways to do this and you'll develop your own preferred method; here are some suggestions which you might like to use as a start.

First, select Quick Preview mode by clicking the Quick Preview button on the control bar. Quick Preview displays the JPEG thumbnail, rather than the high resolution image data. Especially if you're working with Raw images, this will speed things up considerably. You don't need high resolution detail to make ratings assessments at this stage – the JPEG thumbnail is easily good enough.

If you're working on a single screen, click the Split View button on the toolbar (or select View > Split View, or press the key to cycle the view modes). If Filmstrip mode isn't already set, select it by clicking the Filmstrip View button on the Browser

If you've already stacked your images, press (1), or select Stacks > Open All Stacks so that you can see them all. As you're unlikely to need it while rating, you can make more space for the Browser by getting rid of the Inspectors panel: press (1) or click the Inspector button on the toolbar. Unless you're using it to apply ratings, do the same for the control bar by pressing (2) (Fig. 4.1).

Using the Keyboard

The quickest and simplest way to apply ratings is using the keyboard. The keyboard commands for applying ratings are:

- 1 to 5: Apply one to five stars to the current selection
- **9**: Reject the current selection
- Selection (select) (select)
- **0**: Unrate the current selection

When you've rated an image, use the right arrow key to advance to the next image. If you change your mind navigate back to the previous image using

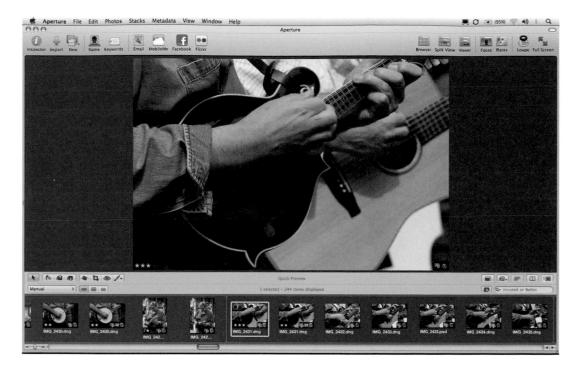

FIG. 4.1 This is a good single-screen setup for rating images, providing large enough thumbnails and maximizing available screen space for the Browser. Quick Preview provides good enough quality at this size to make ratings judgments. If you're working with a dual-screen setup the selection will preview on your second monitor if View > Secondary Viewer is set to Alternate. If you do this, set your primary screen to Browser Only view.

the keyboard and apply a new rating. Applying a new rating automatically overwrites any existing rating.

Using the Mouse

If you prefer to use your mouse, rather than the keyboard, to apply ratings you have two options. You can apply ratings from the Metadata menu, or you can use the control bar. To display the control bar press **D**. The control bar has six buttons (Fig. 4.2) which are used to apply ratings, from left to right they are:

- Reject
- Decrease Rating
- Increase Rating
- Select
- Previous Image
- Next Image

FIG. 4.2 The control bar ratings buttons. From the left: Reject, Decrease Rating, Increase Rating, Select, Previous image Left, and Next image Right. One of the problems with using the control bar is that it doesn't have buttons that allow you to apply, for example, a three-star rating with a single click. On an image with no rating, you have to press the Increase Rating button three times, which can get a bit tedious. One thing the control bar is very useful for is adding keywords, which we'll deal with later.

When you've gone through and rated an entire Project or Folder, or when you return to re-evaluate a batch of images, you'll need to adopt a slightly different approach. For one thing, you'll probably want to make a more careful comparison of similar images; for another, Aperture is more flexible when it comes to editing ratings and there are some keyboard modifiers that will help speed the process even more.

Comparing Images

First, select an image and set the Viewer to compare images by selecting View > Main Viewer > Compare (or press Option \bigcirc \bigcirc). The Compare item appears on the left of the Viewer surrounded with a green border and the subsequent image – we'll call it the Alternate – is displayed alongside on the right with a yellow border. If you're not working in Quick Preview mode the Alternate border is white.

To change the Alternate, just select a new thumbnail in the Browser – you can do this using the keyboard arrows. Any time you want to select a new Compare item press the *Return* key. Whenever you set a Compare item in this way the image to the right of it is automatically selected as the Alternate (Fig. 4.3).

Use the following keys to change the rating of the compare image:

And to edit the rating of the Alternate:

Adding IPTC Metadata

Adding metadata to images can be a time-consuming chore, but by adopting a systematic approach you can minimize the effort involved considerably. As a general rule, try to add metadata at the earliest opportunity; this will avoid additional work down the line – adding missing information to Versions or spending time searching for images that lack it.

Work from the general to the specific. Some metadata, for example photographer credits, copyright notices, location information, generic keywords and, in some cases, captions, can be batch added to all images in

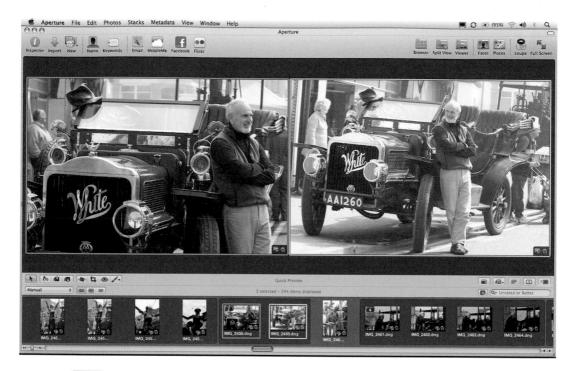

FIG. 4.3 Press *Return* to designate a selected image as the 'Compare' image. The image to its right is automatically selected as the Alternate, but you can select any other image(s) in the Browser using either the keyboard or mouse.

a shoot as soon as you've imported them, or even on import. You can then go through adding specific information such as individual captions and keywords once you've rated images and chosen Picks.

To add metadata to your images you can use either the Metadata Inspector, or the Metadata HUD. To display the Metadata Inspector click its tab in the Inspector pane. The Camera Info pane at the top of the Metadata Inspector displays basic EXIF metadata including the camera model, lens, ISO and exposure information. Below that is a strip which can be used to apply color labels and a flag to images.

What's displayed in the main area of the Metadata pane depends on the view selected from the Metadata View pop-up menu. The default General Metadata view displays Version Name, Caption and Keywords, Copyright Notice, Title, Date, Pixel Size, File Size, Project Path and Badges (Fig. 4.4).

Take a look at some of the other metadata views available. Generally, metadata fits into one of two categories: it is generated by the camera, or added afterwards. Camera-generated metadata includes the image date and

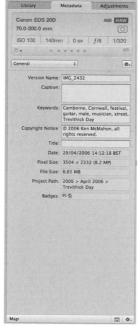

FIG. 4.4 The General Metadata view.

Library N	Metadata Adjustr	nenti
Canon EOS 20D	AWB	RAW
70.0-200.0 mm		0
ISO 100 140mm	0 ev f/8 1	/320
⊙• × ∘		(a)
IPTC Core	:	4
Contact		
	Ken McMahon	
Job Title:		-
Address:		
City:		_
State/Province:		-
Postal Code:		
Country:		_
Phone:		_
Email:		
Website:		
Content		
Headline:		
Caption:		
Caption.		
Keywords:	Camborne, Cornwall, festival, guitar, male, musician, street, Trevith Day	nick
Keywords:	festival, guitar, male, musician, street, Trevith	hick
	festival, guitar, male, musician, street, Trevith Day	hick
IPTC Subject Code: Caption Writer:	festival, guitar, male, musician, street, Trevith Day	hick
IPTC Subject Code: Caption Writer: Image	festival, guitar, male, musician, street, Trevith Day	hick
IPTC Subject Code: Caption Writer: Image	festival, guitar, male, musician, street, Trevith Day Ken McMahon	
IPTC Subject Code: Caption Writer: Image Date Created:	festival, guitar, male, musician, street, Trevith Day Ken McMahon	
IPTC Subject Code: Caption Writer: Image Date Created: Intellectual Genre:	festival, guitar, male, musician, street, Trevith Day Ken McMahon	
IPTC Subject Code: Caption Writer: Image Date Created: Intellectual Genre: IPTC Scene:	festival, guitar, male, musician, street, Trevith Day Ken McMahon	
IPTC Subject Code: Caption Writer: Image Date Created: Intellectual Genre: IPTC Scene: Location:	festival, guitar, male, musician, street, Trevith Day Ken McMahon	
IPTC Subject Code: Caption Writer: Image Date Created: Intellectual Cenre: IPTC Scene: Location: City:	festival, guitar, male, musician, street, Trevith Day Ken McMahon	
IPTC Subject Code: Caption Writer: Image Date Created: Intellectual Cenre: IPTC Scene: Location: City: State/Province:	festival, guitar, male, musician, street, Trevith Day Ken McMahon	
IPTC Subject Code: Caption Writer: Image Date Created: Intellectual Gene: IPTC Scene: Location: City: State/Province: ISD Country: ISD Country: Code:	festival, guitar, male, musician, street, Trevith Day Ken McMahon	
IPTC Subject Code: Caption Writer: Image Date Created: Intellectual Gene: IPTC Scene: Location: City: State/Province: ISD Country: ISD Country: Code:	festival, guitar, male, musician, street, Trevith Day Ken McMahon	
IPTC Subject Code: Caption Writer: Image Date Created: IPTC Scene: IPTC Scene: IPTC Scene: Chy: State/Province: Country: ISO Country Code: Status	festival, guitar, male, musician, street, Trevith Day Ken McMahon	
IPTC Subject Code: Caption Writer: Image Date Created: Intellectual Cenre: IPTC Scene: IPTC Scene: IPTC Scene: IPTC Scene: Country: State/Fronkre: Country: States Title: Job Identifier: Instructions:	festival, guitar, male, musician, street, Trevith Day Ken McMahon	
IPTC Subject Code: Caption Write: Image Date Created: Intellectual Genre Uoration: City: State/Pownce: Country: ISO Country Code: Status Title: Job Identifier:	festival, guitar, male, musician, street, Trevith Day Ken McMahon	
IPTC Subject Code: Caption Write: Image Date Created: Intellectual Cenre: IPTC Scene: Uoration: City State/Province: Country: ISO Country Code: Status Title: Job Identifier: Instructions: Provider: Source:	festival, guitar, male, musican, street, Trevitt Day Ren McMahon 22/04/2006 14:12:18	
IPTC Subject Code: Caption Write: Image Date Created: Intellectual Cenre: IPTC Scene: Uoration: City State/Province: Country: ISO Country Code: Status Title: Job Identifier: Instructions: Provider: Source:	festival, guitar, male, musician, street, Trevith Day Ken McMahon	

FIG. 4.5 The IPTC Core Metadata view.

time, information about the camera model and lens, exposure information and other technical information such as the ISO setting, image resolution, and so on. This kind of data is often referred to as EXIF data in reference to the file structure (Exchangeable Image File format) used to contain it. EXIF data isn't editable in Aperture, or most other applications so you can't, for example, change the indicated ISO speed setting or lens focal length. These and the other EXIF fields are grayed out in Aperture.

The second kind of metadata that is added and edited in software after the image file is created is referred to as IPTC metadata. The International Press and Telecommunications Council is a consortium of news agencies that developed the standard for added image metadata of this kind.

IPTC metadata fields include Caption, Copyright Notice and Credit. The list is quite lengthy and as well as fields for general press and publicity use, it includes specialized fields such as standard location identification codes and audio specifications. For the full list of available IPTC fields select the IPTC Core Metadata view (Fig. 4.5).

Using the Metadata Inspector

To add IPTC metadata to a single image, select the image and choose General from the Metadata View pop-up menu then enter your copyright notice into the Copyright Notice field (press **S G** for the **C** copyright symbol).

Continue to enter as much metadata as you want for the selected image. In this instance, the Caption, Copyright Notice, and Title fields have been completed (Fig. 4.4).

Using the Lift and Stamp HUD

To apply the same metadata to all of the images in the Project, choose Lift Metadata from the Metadata menu (Fig. 4.7(a)); the Lift and Stamp HUD will appear showing the completed metadata fields and their contents in two columns (Fig. 4.7(b)). Press (R) (A) to select all of the images in the Project (or select just those you want to stamp), and then click the Stamp Selected Images button to add the metadata to all of the selected images.

Don't worry about captioning all of your images with a 'generic' caption. Even if you intend to add specific captions at a later stage, adding a generic caption to all the images now will ensure that every image is captioned and none falls through the cracks (Fig. 4.8).

Using Metadata Views

The Metadata View options on the Metadata View pop-up menu display file information, EXIF data and IPTC metadata in various combinations. Photo Info displays the Version name along with a subset of the available EXIF data

including camera model, lens and exposure data. Much of this information is already displayed in the Camera Info pane, and there are some additional fields for things like Flash, White Balance, Exposure Program, Metering Mode, Color Profile and Pixel Size.

Many of the other Metadata views, like Name & Ratings, Name & Caption and Caption & Credits, provide a small subset of file information and IPTC metadata. They are useful for certain tasks – captioning, for example – when you want fast access to a few Metadata fields without all of the other metadata getting in the way.

Creating Metadata Views

You don't have to stick with the existing Metadata views; it's easy to create your own with whatever combination of fields you find useful. To create a new Metadata view select Edit from the Metadata Views pop-up menu to

Rating	,
Label:	
Flag	1
Add Keyword	,
Remove Keyword	•
New Keyword	I,
Attach Audio File	
Assign Names	N
Adjust Date and Time	
Assign Location	
Remove Locations	
Manage My Places	
Update from Master	
Write IPTC Metadata to Maste	r
Batch Change	Ô ₩B
Edit AutoFill List	
Lift Metadata	
Lift Adjustments	
Lift Metadata & Adjustments	
Stamp	心器V

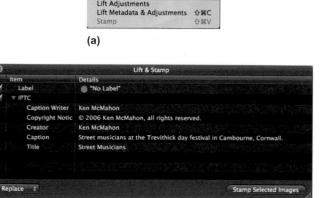

(b)

FIG. 4.7 Use Lift and Stamp to copy metadata and apply it to multiple images.

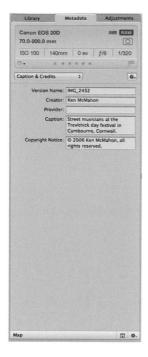

FIG. 4.6 The Captions & Credits Metadata view includes Creator, Caption and Copyright Notice fields.

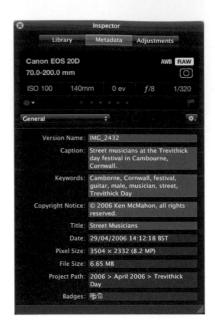

FIG. 4.8 You can use the Metadata pane of the Inspectors HUD to add metadata to images in exactly the same way as with the Metadata Inspector.

display the Metadata Views dialog. You can either select New View from the Metadata Views Action pop-up menu, or select and duplicate an existing Metadata view and edit it.

To add Metadata fields to your new view click the disclosure triangle next to the Metadata category and select the checkboxes alongside the required fields.

When you're done, click OK and the new view is added to the Metadata Views pop-up menu. You can edit this, or any of the other Metadata views in the Metadata View dialog. To change the order of the views on the Metadata Views pop-up menu, drag and drop them in the Metadata Views list on the left side of the dialog (Figs 4.9 and 4.10).

Creating Metadata Presets

Much of the metadata you need to add to images is the same for every job – Copyright Notices, Credits, Bylines and so on are unlikely to vary. You don't want to be keying in this information every time you add a new Project to your Aperture library; Metadata presets provide a way for you to add everything in one go.

By creating several presets for different clients, you can automate the process of metadata editing. This is useful if you only have one metadata set; if you

General Name Only Caption Only ✓ Name & Ratings Name & Caption Ratings Caption & Keywords Caption & Credits File Info Photo Info EXIF Info Contact Sheet GPS **IPTC** Core Large Caption **Custom Fields**

Edit...

FIG. 4.9 The Metadata View pop-up menu on the Metadata Inspector provides a range of View options that display combinations of file information, EXIF metadata, IPTC metadata and metadata added by Aperture. Select Edit to open the Metadata View dialog.

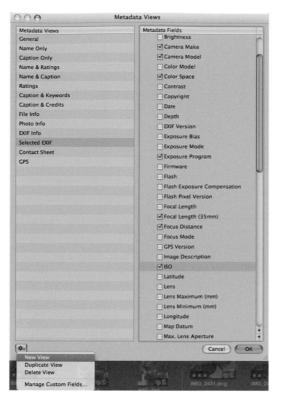

FIG. 4.10 Use the Metadata Views dialog to edit existing views and create new ones by selecting Metadata fields from the list on the right, which includes EXIF, IPTC, Aperture, Audio/Video, Photo Usage and Custom field metadata.

include different metadata on Versions for different clients it's an even bigger timesaver.

In the example in Figure 4.11, the Caption & Credits Metadata view has been used to apply Byline, Credit and Copyright Notice information to the selected image.

To create a Metadata preset using this information, select New Preset from Version from the Action pop-up menu on the Metadata Inspector. The Metadata dialog now opens with an untitled preset ready for you to rename and the Creator Caption and Copyright fields are filled with the information from the selected image. You can edit the preset, changing the existing fields and adding new ones, before clicking OK to save it. It will then be added to the Metadata Action pop-up menu on both the 'Append with Preset' and 'Replace with Preset' submenus.

To add the preset to other images, first select them, then choose either Append with Preset, or Replace with Preset from the Metadata Action pop-up menu and select the saved preset from the list. Append and Replace affect only fields in which there is existing metadata in both the preset and the image to which you are applying it, and they do exactly what they say. FIG. 4.11 Select New Preset from Version on the Action pop-up menu on the Metadata Inspector to create a Metadata preset that you can easily apply to other images.

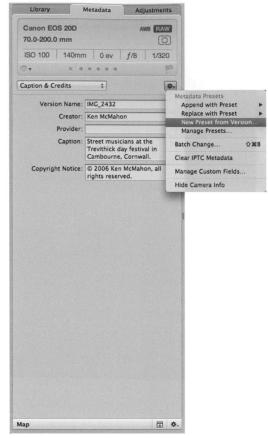

If, for example, you have added captions to all of your images, it's safe to subsequently apply a Metadata preset that does not include caption data using Replace with Preset (Fig. 4.12); the existing caption data will not be replaced by a blank Caption field. Having said that, it's best from a workflow standpoint to first add metadata using any presets you have defined, and then progress to captioning and other metadata tasks that require an image by image approach.

Use Append with Preset to add metadata to fields in which there is already existing information: for example, if you have Metadata presets that add keywords to images that already contain keywords.

Batch Operations

Another way to apply metadata changes to multiple images is to use Batch Change, one of the options on the Metadata Action pop-up menu. If all you want to do is add or append metadata to images, Batch Change doesn't

FIG. 4.12 Replace with Preset overwrites existing metadata for completed fields only.

really offer any special advantages and you're better off simply applying a Metadata preset directly. However, Batch Change does offer some other options which you might find useful in special circumstances.

Changing the Time

If you require accurate time metadata in your images, and your camera's clock was incorrectly set, you can adjust the time stamp in the Image Date EXIF field (this is one of the few editable EXIF fields). This problem most commonly occurs if you've traveled to a location in a different time zone and omitted to adjust the camera clock setting.

Check the Adjust Time Zone radio button at the top of the Batch Change dialog box (Fig. 4.13) and select the time zone that was set on camera from the Camera's Time Zone pop-up menu. Then select the actual time zone of the shoot location using the Actual Time Zone pop-up menu. For example, if you traveled from London to New York select Europe/London from the first menu and America/New York from the second. In this case five hours would be subtracted from the original time stamp.

Adjust Time Zone adds or subtracts time in hour increments. If you know the time difference between your camera setting and the shoot location you can enter it manually using the options on the GMT submenu. Selecting UTC sets the time to UTC (Coordinated Universal Time) which is essentially the same thing as GMT (Greenwich Mean Time).

The bottom panel in the Batch Change dialog box contains an 'Add Metadata From' pop-up menu which allows you to add selective metadata from your presets. This is useful if, for example, you only want to add caption and keyword metadata. As with the other metadata editing methods you can choose to either replace the existing metadata or append to it.

Adding Metadata on Import

Once you've defined Metadata presets, you can further automate the process and save yourself extra work by adding metadata during the import process. The Import dialog box provides the same options for adding metadata from a preset as those discussed earlier. See Chapter 3 for more details.

Time A	Adjustment: ()	None
	•	Adjust Time Zone
Camera's	Time Zone: Eu	rope/London
Actual	Time Zone: A	merica/New York
Version Na	me Format:	urrent Version Name
Cus	tom Name: En	iter name text here
Example	File Name: DS	C00002
		Apply to Master Files
Add Meta	data From: Ke	n McMahon copyright 2010
	0	Append Replace
	Creator:	Ken McMahon
	Caption:	Street musicians at the Trevithick day festival in Cambourne, Cornwall.
Co	pyright Notice:	© 2010 Ken McMahon, all rights reserved.

FIG. 4.13 Batch Change provides Time Adjustment as well as comprehensive tools for renaming files. You can append an index number, the date and time, or a sequence number (e.g. 1 of 4) to the existing Version name or use a new custom name.

Keywords Overview

More than any other kind of metadata, keywords define the content of your images and help you locate them. Effective keywording of your images can make the difference between finding the perfect shot for a job, or page upon page of also-rans. More importantly, it can mean finding the shot you know you have within a couple of seconds, as opposed to spending hours in a tedious trawl through Folder upon Folder of the wrong stuff.

Keyword Strategy

You might think that applying keywords to images is something that requires an individual approach and, to a degree, you'd be right. Regardless of the nature of a shoot, there will inevitably be some images that require unique keywords. The average soccer match doesn't have an abundance of goals, not many wedding shots include the priest (hopefully), and not all product shots are cut-outs.

These are the exceptions, though in many situations you'll find that most of the keywords you apply to images can be applied to all of them. Location, main subject, client, orientation – these and other generic keywords can be

applied to an entire shoot. So adopt a top-down approach with keywording – first applying generic keywords to all, or most, of your shoot, then making selections of images to which common keywords can be applied, and finally adding unique keywords to individual images.

Don't be under any illusions – keywording your image Library is a major undertaking. It requires a well-thought-through approach and systematic application. Adding a few hastily thought-up keywords every time you import a shoot is better than nothing, but will take longer than applying them from a prepared list and won't yield the full search potential of applying them in an organized fashion.

Fortunately, Aperture provides some excellent tools that make keywording less of a chore than it might otherwise be. There are three ways to add keywords to images in Aperture; which of these you choose to use will depend on the nature of the task in hand as well as personal preference (Fig. 4.14).

The Metadata Inspector shows a Keywords field in certain Metadata views, e.g. General, Caption and Keywords, and IPTC Core. You can add keywords to individual selected images simply by typing them in here, separating individual keywords with a comma.

The Keywords HUD displays all the available keywords organized into keyword groups. You can apply keywords by dragging and dropping them from the HUD onto selected images. You can also add keywords to the list

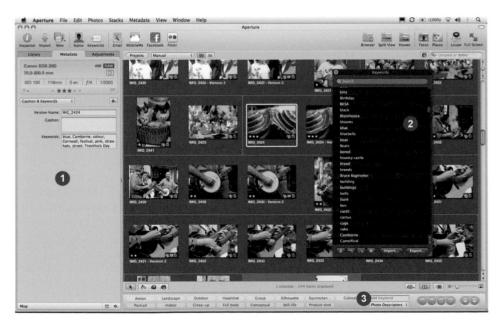

FIG. 4.14 Aperture's three Keyword tools: the Metadata Inspector (1), Keywords HUD (2) and the control bar (3)

FIG. 4.15 Adding keywords using the Metadata Inspector.

and search for keywords to apply (but not search for images containing those keywords – for that you use the Filter HUD).

The control bar has keyword buttons which can be applied to selected images with a single click. The default buttons display keywords from the pre-defined Aperture keyword sets, but can be configured to display your own keywords.

Adding Keywords Using the Metadata Inspector

As we've seen, you can add keywords to individual selected images by typing them into the Keywords field in the Metadata Inspector (Fig. 4.15). Separate individual keywords with a comma. While it's useful for viewing keywords applied to an image, the Metadata Inspector isn't usually the best way to apply keywords. You can't use it to simultaneously apply keywords to multiple images and you have to type the keyword correctly, rather than select it from a list. This can lead to duplication; if, for example, you enter capitalized and uncapitalized Versions of the same keyword (e.g. Cat and cat) you'll end up with both Versions in your keyword list.

Adding Keywords Using the Keyword HUD

To display the Keyword HUD select Window > Show Keywords HUD, or press *Shift* **(H**). Unless you've previously added keywords to images, or imported

images containing keywords, the HUD will list only the pre-defined Aperture keywords organized into keyword groups.

If you haven't yet added any keywords of your own, take a look at these; they will help you avoid duplication and provide some useful ideas on how to organize your own keywords. There are comprehensive keyword groups for wedding photography and photojournalism – even if these don't contain exactly what you need they may provide a useful starting point.

To add a new keyword to the list, click the Add Keyword button at the bottom of the HUD and overwrite the Untitled entry that appears (Fig. 4.16). To add a keyword to a keyword group, first select the keyword group, then click the Add Subordinate Keyword button and overwrite the Untitled entry that appears below the keyword group and indented.

A keyword becomes a keyword group when subordinate keywords are added to it, but the keyword group still behaves like an individual keyword. For example, the Wedding keyword group contains lots of subordinates, some of which are themselves keyword groups. Nonetheless, you can still drag the 'Wedding' keyword onto an image. Doing this adds the keyword 'Wedding' to the image and not, as you might expect, all of the subordinate keywords within the Wedding keyword group (Fig. 4.17).

8	Keywords
Q Search	
mobile phone	
monument	
motorcycle	
mud	
Mullion	
museum	
musician	
mussels	
nationalism	
nature	
▼ Nature	
Alpaca	
Bird	
Bulls	
Canine	
cats	
Cattle	
Cow Cows	NANARAN NANARAN NANARAN
Dalmation	
Dog	
Pig	
Rabbit	
Zebra	
Zoo	
► Colour	
Garden	
Clobal warming	
Grass	
Crow	
► Landscape	
Mud	
▶ Numbers	
► Plants	
Rainbow	
0 = 17 = 0	
Add Keywor	rd structure and structure by

FIG. 4.16 The Keywords HUD: to add a new keyword, click the Add Keyword button at the bottom of the HUD and overwrite the Untitled entry.

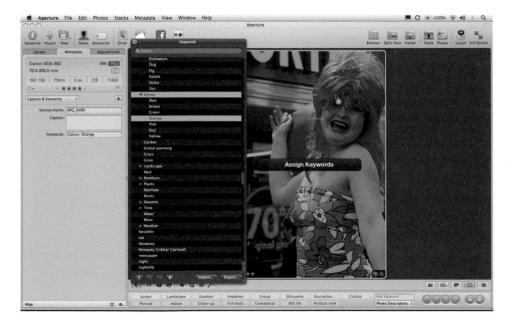

FIG. 4.17 Keyword groups and subordinates behave in exactly the same way when you drag and drop them from the Keywords HUD onto an image in the Viewer or Browser. Both the Keyword group 'Color' and its subordinate 'Orange' have been added to this image.

If you want to add more than one keyword to selected images either *Shift* click or **B** click to select them in the Keywords HUD and then drag and drop them onto the selected images in the Browser.

Adding Keywords Using the Control Bar

The control bar provides a very efficient way of adding keywords to images in the Browser. To display the control bar press **D** and to display the control bar's keyword buttons press **Shift D**.

You can add a keyword to selected images simply by typing it into the control bar's Add Keyword field. The Autofill editor helps you by producing a pop-up list with previously entered keywords. To edit the AutoFill list select Edit Autofill List from the Metadata menu (Fig. 4.18).

One advantage of using the control bar over the Metadata Inspector is that you can apply keywords to multiple selected images. Unless you have Primary Only turned on, a keyword typed into the Keywords field of the Metadata Inspector will be applied to all of the selected images.

The control bar also contains a selection of keyword buttons which can be applied to either a single image or a selection of images. The displayed buttons form a preset group which you can select from the Keyword preset group pop-up menu just below the Keyword field. Select Stock categories from the Preset group pop-up menu to see the buttons from that group.

FIG. 4.18 Autofill completes text fields in the Metadata Inspector, control bar and other places on the basis of previously entered words. You can ignore and overwrite these, but they can save time and help you avoid entering keyword variations for the same thing (e.g. Bird and bird). Select Metadata > Edit Autofill List to edit the list.

V IPTC Provider	
Ken McMahon	
Katie McMahon	
© 2008 Katie McMahon	
V IPTC Date Created	
* IPTC Digital Creation Date	
* IPTC Digital Creation Time	
V IPTC Edit Status	
V IPTC Editorial Update	
V IPTC Expiration Date	
V IPTC Expiration Time	
V IPTC Fixture Identifier	
V IPTC Headline	
V IPTC Image Orientation	
V IPTC Image Type	
▼ IPTC Keywords	
Camborne, Cornwall, female, festiv	al, redhead, stilt walker, street, Trevithick Day, wig
blue, Camborne, colour, Cornwall,	festival, pink, straw hats, street, Trevithick Day, summer
Camborne, cats, Cornwall, festival,	stall, street, stuffed toys, Trevithick Day
Camborne, cats, Cornwall, festival,	stall, street, stuffed toys, Trevithick Day, Cat
	stall, street, stuffed toys, Trevithick Day, cat
	festival, pink, straw hats, street, Trevithick Day
	festival, jabberwocky, pink, snark, straw hats, street, Trevithick Day, Snark
	festival, pink, straw hats, street, Trevithick Day, snark, jabberwocky
woods bluebells	
Holiday, swim, pool	
Boat, River, Thames	
Boat, River, Thames, London,	
Boat, River, Thames,	
London, Market, Street	
Cornwall, Sport, Truro, Skateboardi	ing
Cornwall, Sport, Truro	
Cottage, Dining Room, interior, Kite	chen

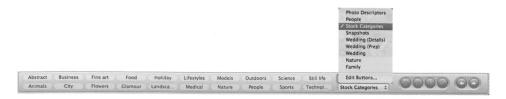

FIG. 4.19 The control bar can contain up to 20 keywords in a preset group - in this case from the Stock Categories preset.

These keywords on the control bar buttons also appear in the Add Keyword and Remove Keyword submenus of the Metadata menu.

While Stock categories are useful, they are not the most useful group of keywords to have on the control bar because it's unlikely that you'd be adding keywords to a group of photos with such wide ranging subjects (unless you're keywording submissions to a stock photo Library that is). But it does demonstrate one thing, and that is that the control bar can accommodate up to 20 keyword buttons in a preset group (Fig. 4.19).

Select the Wedding (Details) preset group from the Preset Groups pop-up menu. This provides a better example of what the control bar is best at. With this group of related buttons under your mouse, you can quickly skim through a Project adding appropriate keywords to groups of photos or individual shots. A two-pass approach works well – first select groups of images to which you can apply common keywords, and then go through them individually.

You can speed up the process by using the keyboard to select images sequentially and you can also add keywords from the control bar using the keyboard. The first eight buttons are assigned keystroke **1** through **8**, the top left being 1 the bottom left 2 and so forth (Fig. 4.20).

Removing Keywords

Adding keywords is easy; removing them isn't always so straightforward. Removing keywords from individual images is easy enough, but removing them from a selection of images can be more problematic. The control bar provides some of the best options for doing this.

Given that the subject matter in an image isn't all that liable to change, the most likely reason for wanting to remove a keyword is that it was applied in error. If you realize your mistake immediately R or Edit > Undo Change Keywords is the simplest remedy.

	1	Add Keyword 3 T3 Remove Keyword 3 T03	1 selected - 244 items	displayed	[
Preparations	Vows	Portraiture	Groom	Bridesmaid	Add Keyword	0000 00
Ceremony	Reception	Bride	Maid of Honor	Groomsman	Wedding ‡	0000000

FIG. 4.20 Keyword buttons on the control bar can also be applied using the keyboard. Hover over the button with your mouse to reveal the tooltip with the keyboard shortcut (make sure you have Show Tooltips On Controls enabled in Preferences).

As we've seen, to apply a control bar keyword button using the keyboard you press and one of the number keys **1**–**8** to apply the keyword button at that position. To remove a keyword, press **Shift** and the appropriate number key.

You can also remove keywords by *Shift* C clicking the buttons. This doesn't restrict you to the first eight keyword buttons; you can remove any keyword that appears on the control bar by *Shift* C clicking it. If the keyword you want to remove doesn't appear in a group preset, just add it to one. All of these options are also available from the Remove Keyword submenu of the Metadata menu.

Creating and Editing Preset Groups

As you'd expect, you can edit the existing preset groups and create new ones. The final item on the Preset Groups pop-up menu, Edit Buttons, opens the Edit Button Sets dialog box. This dialog box is divided into three vertical panels. The available button sets are listed on the left, the contents of the selected button set are listed in the middle and your Keywords Library is shown on the right. A checkbox next to each preset determines whether it appears on the Presets pop-up menu or not (Fig. 4.21).

Select the Stock categories preset group from the list on the left and click the disclosure triangle to expand the Stock categories keyword group in the list on the right. The Contents list in the middle tells you what buttons will appear on the control bar for this preset group. There are exactly 20 of them, the maximum that the control bar can display.

Scroll down the list and add the Nostalgia subordinate keyword to the Stock categories preset group by dragging and dropping it onto the middle column. Because the group already had 20 buttons, Nostalgia replaces the twentieth item on the list. You can reorder contents by dragging and dropping items; to remove a keyword from the list, click the minus button underneath it. List order is important because only the first eight items can be applied using the keyboard. Even if you don't plan to use the keyboard, it's helpful if you place the most often used keywords at the top of the list.

FIG. 4.21 Select Edit Buttons from the Preset Groups popup menu to edit the Keyword button sets that appear on the control bar. To add keywords to a button set, first select the button set in the left column; then drag the keywords from the right column and drop them in the middle one.

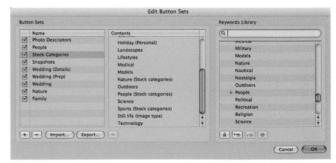

The contents of a preset group aren't confined to the equivalent keyword group in the Keywords Library; you can add any keyword to any preset group within the maximum limit of 20.

To create a new keyword group, click the plus sign underneath the button sets list and rename the untitled group; then drag the keywords you want to add from the Keywords Library to the empty contents list. The checkboxes in the button sets list determine whether or not button sets appear on the control bar's preset groups pop-up menu.

Displaying Metadata on Images

Viewer and Browser Sets

We've already seen how you can display metadata in the Metadata Inspector and HUD, but metadata is also displayed on image previews in the Browser and Viewer. Both the Browser and Viewer provide two configurable metadata overlays, which are selected from the Browser and Viewer metadata overlays pop-up menu on the tool strip.

The Browser and Viewer metadata overlays pop-up menu provides basic and expanded overlays for the Viewer and Browser (it only displays options for the active view, so you won't see the Viewer overlay options if you are in the Browser) and allows you to toggle the overlays on and off.

To see the overlays in action, first click the Split View button on the toolbar and then, if they are not already displayed, activate the overlays by selecting Show Metadata from both the Viewer and Browser sections of the Browser and Viewer metadata overlays pop-up menu. Next, select Switch to Expanded View in both the Viewer and Browser section of the same pop-up menu (if it says Switch to Basic View you're already in Expanded view).

To edit the overlays, select Edit from the Browser and Viewer metadata overlays pop-up menu (Fig. 4.22) or press (#) **J** to open the Browser and Viewer Metadata dialog.

Select the view for which you want to edit the metadata overlay from the dialog pop-up menu. As well as the basic and advanced Browser (there are separate overlays for List and Grid Browser views) and Viewer overlays, you can edit the metadata tooltip overlay (Fig. 4.23). This appears when you mouse over an image in the Browser or Viewer and, like the other metadata overlays, can be toggled on and off from the Browser and Viewer metadata overlays pop-up menu.

The currently active views are indicated in the dialog pop-up menu by a round bullet point. If you chose the Expanded views before opening the dialog, these should have a bullet point next to them in the dialog pop-up menu.

FIG. 4.22 The Browser and Viewer metadata overlays pop-up menu controls the display and configuration of metadata overlays. Select Edit to open the Browser and Viewer metadata dialog. FIG. 4.23 The Browser and Viewer metadata dialog controls what's displayed when you select one of the two metadata overlays – basic or expanded – for the Viewer and Browser as well as for metadata tooltips.

Metadata Fields	Display Order	
▶ EXIF	Rating	0
► IPTC	Badges	0
➢ Aperture	Aperture	0
▶ Audio/Video	Shutter Speed	0
▶ Photo Usage	Focal Length (35mm)	0
▶ Custom Fields	Focal Length	0
	Lens Minimum (mm)	0
	Max. Lens Aperture	0
	Lens Maximum (mm)	0
	Lens	0
	Caption	0
	Keywords	0
	Version Name	0
	Date	0
	ISO	0
	Show metadata below im.	age

Select Expanded view from the Grid view section of the Browser and Viewer metadata overlays pop-up menu. The Browser Grid view settings also apply to the Filmstrip view. The Metadata fields that are displayed in this view are listed on the right in the order in which they appear. The list on the left shows all available Metadata fields. To add Metadata fields to the view, click the disclosure triangle next to the relevant category and check the boxes for the fields you want to add. To remove a field either click the minus button next to it on the right or uncheck the box in the list on the left.

These changes won't be applied until you click OK, but before you do there are a couple of other things to look at. The displayed Metadata fields in the display order list on the right can be reordered by dragging and dropping fields. Checking the 'Show metadata below image' checkbox below the display order list forces the overlay to appear beneath the image, rather than overlayed on the bottom section. The advantage of this is that you can see the entire image area; the downside is that the overall image size shrinks to make space for the overlay. If you uncheck 'Show metadata labels' the description of each Metadata field (Keywords, Lens, File Size, etc.) won't be displayed. This frees up space so you can include more metadata, but you'll need to be very familiar with your metadata before you turn this off.

Unlike the selection of Metadata fields, both of these last two display options update live, so you can see the effects of your changes before committing to them by clicking the OK button. This can be quite useful as, particularly in the Browser, you need to select your metadata carefully to avoid truncation in certain views. In Filmstrip view, and in Grid view with a small thumbnail size, you can't display a long list of metadata. Lengthy metadata lists are best reserved for the Viewer and tooltip overlays.

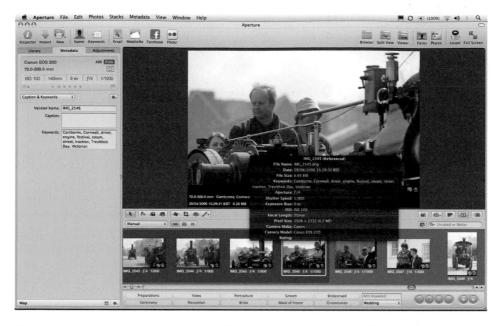

FIG. 4.24 You can't display a lot of metadata on a Browser overlay – there isn't room and anything too long will be truncated. More detailed information can be added to the metadata tooltips which appear when you mouse over an image in the Viewer or Browser.

While you can switch between metadata overlays using the Browser and Viewer metadata overlays pop-up menu, you should get into the habit of using keyboard shortcuts. To toggle metadata overviews on and off it's for the Viewer and *O* for the Browser. To toggle between Basic and Extended views it's *Shift O* for the Viewer and *Shift O* for the Browser. The **F** key toggles the tooltip overlays on and off (Fig. 4.24).

Sorting and Searching

The location and retrieval of images can, without doubt, be one of the most time-consuming and frustrating of all photo management tasks. Whether you need to locate an image that was shot on a specific date, for a particular client, by an individual photographer, or containing specific subject matter, Aperture can help you find what you're looking for quickly and almost effortlessly.

The success of your image searching depends to some degree on how rigorous you are in your application of metadata. Many of Aperture's search filters work on the basis of ratings and IPTC metadata fields including Keywords, Caption and Copyright. The inclusion of these data in all of your images will make subsequent search and retrieval operations that much simpler.

Even if your images lack appended metadata, Aperture still provides you with plenty of options. EXIF metadata recorded by the camera at the time of

FIG. 4.25 The Library Search field filters the Library Inspector to display only those elements that match entered text.

Unrated or Better	~ .
* or Better	^]
** or Better	^2
*** or Better	^3
**** or Better	~4
****	^5
Show All	~6
Unrated	^7
Rejected	~8
Flagged	^/
Label:	
	0

FIG. 4.26 The Filter HUD search pop-up menu provides some useful preset ratings-based searches. shooting can provide the basis for locating images shot on a particular date, or time of day or pictures shot with a certain lens. If you connect a GPS receiver to your camera you can even track down images to a specific location.

Aperture's search filters can be put to work on an individual Project containing only a few images, or your entire Library. Either way, Aperture 3's database engine will return results swiftly, even on very large Libraries containing many thousands of images.

Search Tools

If you've upgraded from Aperture 2 you'll notice some differences in the way Aperture 3 implements searching. You can search on an extended range of criteria using the renamed Filter HUD, formerly the Query HUD, and it's also possible to search through Folders and Projects in the Library Inspector. To do this you simply type your search text into the Search field at the top of the Library Inspector. As you type, only those Library elements that match the search text are displayed (Fig. 4.25). The pop-up menu provides three preset filters that display All items, Favorite items and Recent items.

The Search Field and Search Field Pop-Up Menu

For quick searching, the Search field is the first option to try. Aperture will search all metadata fields for any text entered here and display matching images in the Browser. The Search field pop-up menu provides some useful Search filter presets (Fig. 4.26). Note that the default is set to display 'Unrated or Better' images – so you won't see rejects in this view. If you want the Browser to display all of your images including rejects, select Show All from the pop-up menu.

Other search options on the pop-up menu include showing all images of a specific star rating or better, Show All, Unrated, Rejected and the newly introduced Flagged and color labels. To return to the default Unrated or Better view, click the Reset button on the right of the search field.

The Filter HUD

The Filter HUD is situated at the top left corner of the Browser. Alongside the Filter HUD button is the Search field and Search field pop-up menu. You can use the Filter HUD to search within individual Projects, Albums or Folders and you can also use it to search the entire Library. The Search field, its pop-up menu and the Filter HUD filter the contents of whatever is selected in the Library Inspector (Fig. 4.27).

Filter: Royal Cornwall Show		
All + of the following that match + Stack picks only	Add Rule	100
🗹 Rating: 👔 s greater than or equal to 💠 👘 🍐 👘 👘 👘 👘 👘 Unrated		
Tlagged: Yes ÷		
Color Label: Is 🗧 🔍 🔍 🔍 🔍 🖉 🖉 🖉		1
Text: Includes + Q-		-
Keywords		-
New Smart Album New Album With Curren	t Images 4	-

FIG. 4.27 The Filter HUD.

Searching by Rating

To activate the Filter HUD, click the Filter HUD button to the left of the Search field, or select Edit > Find or press **(H) (**). As with the Search field, the default setting for filtering rated images is greater than or equal to unrated, which is displayed in the Search field as 'Unrated or Better' (the Search field rating filter and the Filter HUD rating filter are linked and always correspond). You can use the Rating pop-up menu and slider as already described to search for images with a rating equal to, greater than or equal to, or less than or equal to the slider value. A more immediate way to search for images of a given rating or higher is to use the keyboard:

As we've seen, all of these options are also available on the Search field popup menu, so you don't need to open the Filter HUD at all to perform a ratings search. The rating search criteria is included in the HUD so that you can search multiple criteria including ratings. We'll cover using multiple search criteria a little later.

Text Searching

The Filter HUD's Text Search field provides a lot more scope than the Browser Search field. It offers two kinds of text search – Full and Limited; to choose one, click the Search field pop-up menu (with the magnifying glass icon on the Filter HUD). Full Text Search includes everything – all IPTC and EXIF metadata, File Name, Version Name, i.e. anything associated with the file (Fig. 4.28).

Limited Text Search omits a lot of the stuff you are unlikely to need including most of the metadata other than Keywords, Aspect Ratio, Orientation, Pixel

Apple Aperture 3

FIG. 4.28 Type in the Filter HUD Search field to locate all images that contain the text in metadata. Full Text Search looks deeper but for general use, Limited Text Search is more than adequate.

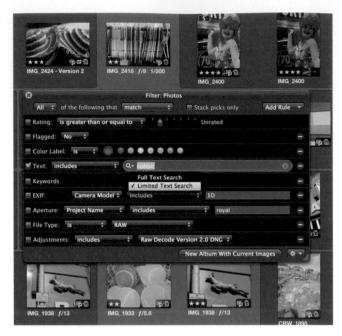

Size, Processed Pixel Size, Master Location, and Import Group. Unless you have quite specialized text search requirements, Limited Text Search is good for general use and it's faster than Full Text searching. We'll look at searching for multiple text entries in a while.

Keyword Searching

Probably the majority of searching that you'll do in Aperture will be keyword searching. Provided you are methodical in your approach to adding keyword metadata to imported images, keyword searching provides one of the fastest and most direct ways to find what you're looking for.

To search by keyword, first make sure that all other search criteria are unchecked and check the Keywords box in the Filter HUD. This displays all of the keywords attached to images displayed in the Browser in alphabetical order. If none of the images contains keywords, the Keywords section of the Filter HUD is grayed out.

Sometimes, you'll find it simpler to use a text search rather than a keyword search. This is particularly true when searching large Projects or the entire Library. The Keyword section of the HUD lists every keyword in the selection in alphabetical order in two columns. The HUD can't be resized to include more, or longer, columns so you might have to hunt through a very long list to find what you're looking for.

S Filter: R	oyal Cornwall Show		
All + of the following that match	Stack picks only		
Keywords include any of the following:			
🕅 A (Misc)	Π K		
agriculture	Kernow. separatism		
m Agriculture	🗏 kite (K)		
🗐 alpaca	같은 👼 비행 것 같은 것 같은 것 같은 것 같은 것 같은 것 같은 👹		
🗐 animal	🗐 lady (L)		
animal (iPhoto)	🕾 lamb (L)		
📰 animals	E lorry		
🗐 Animals (Nature)	m M		
🗟 appalachian	M machinery (M)		
Attraction	🗏 meat (M)		
🗐 award (A)	🗏 Misc		
📰 awards	🗟 morris		
	motor		
📰 bacon	motorcycle (M)		
🕮 Bacon	🗏 N		
🗏 beef	🗏 nationalism (N)		
Beef	🗏 Nature		
🕅 black (B)	O		
📰 blooms (B)	🗏 official		
🗮 bouncy castle (B)	📰 Protesta e de la companya de		
the howler	T Album New Album With Current Images		

FIG. 4.29 Searching for images that contain either 'agriculture', or 'machinery', or both keywords using 'include any of the following' – 281 matches.

To display images containing a keyword, simply check the box next to it in the list. The Keywords pop-up menu provides several search options. 'Are applied' simply shows images that have keywords and 'Are not applied' those that don't. The remaining options are fairly self-explanatory. For anyone not familiar with Boolean search operators the following explanation may prove helpful.

All or Any

The Filter HUD can operate using multiple search criteria. At its simplest, this might involve searching for images that contain two or more keywords. When this is the case you have two options: to search for images that contain *any* of the keywords, or to search for images that contain *all* of the keywords.

In this example (Fig. 4.29) the keywords 'agriculture' and 'machinery' are checked and 'include any of the following' has been selected from the Keywords pop-up menu. The result is that the Browser displays images that contain only the keyword 'agriculture', images that contain only the keyword 'machinery' and also images that contain both keywords, which results in a total of 281 images (the number is displayed on the right of the tool strip at the bottom of the Browser).

Selecting 'include all of the following' results in only the 29 images that contain both keywords being displayed (Fig. 4.30).

Apple Aperture 3

FIG. 4.30 Searching for images that contain both 'agriculture' and 'machinery' keywords using 'include all of the following' -29 matches.

3481 f/8 1/60 IMG 3482 f/5.6	š 1/30 IMG_3486 ∦/5.6 ★★★ ∰ 10 IMG_3487
🕲 Fi	ilter: Royal Cornwall Show
All : of the following that mat	tch 🕴 Stack picks only Add Rule 🔻
Keywords include all of the followi	ing:
🗮 A (Misc)	🔳 K. 👘 👘 👘 👘 👘
M agriculture	🗮 Kernow. separatism
Agriculture	🗏 kite (K)
📰 alpaca	그는 것 않는 바람은 것은 것이 같아요. 것 같아요. 한 🦉
🥅 animal	🗐 lady (L)
🥅 animal (iPhoto)	📰 lamb (L)
📰 animals	🗏 lorry
🗄 Animals (Nature)	- 방영 않루 MET 가슴이 다는 일리는 것 같아요
📰 appalachian	🗹 machinery (M)
Attraction	🚍 meat (M)
📰 award (A)	🖾 Misc
📰 awards	🚍 morris
B	motor 📃
📰 bacon	📰 motorcycle (M)
🗮 Bacon	
🔳 beef	🕅 nationalism (N)
🗏 Beef	🚍 Nature
🖩 black (B)	
🗏 blooms (B)	🗏 official
📰 bouncy castle (B)	1993 - P. S.
Thoular	w Smart Album New Album With Current Images 🔷 🔹
Nev	w smart Album New Album with Current Images

The Keywords pop-up menu also allows you to search for images that don't contain all or any of the selected keywords.

Searching by Date

To search for images taken on a particular date, or within a given period, select Calendar from the Add rule pop-up menu and select the checkbox next to the new calendar rule that appears in the Filter HUD.

The calendar display shows a three-month period with dates on which images were taken highlighted white. Dates for which there are no images are grayed out. If you are viewing an individual Project, it's likely that all the images will have been shot on the same day. The Calendar is most effective when used to search either Projects containing images shot over a long period or the entire Library.

The VCR buttons above the Calendar display control the displayed months and allow you to skip back and forth through the months. Click the center diamond to display one month either side of today's date. To display all of the images taken on a specific day, click the date on the Calendar display. *Shift* click to select a continuous calendar period or **H** click to select multiple non-continuous dates.

For most date-based searches the pop-up menu setting 'is' will give you exactly what you need. The alternative – 'is not empty and is not' – shows all the images that were not taken on the specified dates (Fig. 4.31).

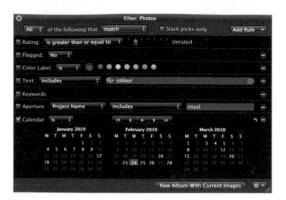

FIG. 4.31 Use the Calendar to display images taken on a specific date or within a date range. Note that for any search you can elect to include 'Stack picks only' using the checkbox at the top of the Filter HUD.

Searching by Other Criteria

The Filter HUD is not limited to the displayed search criteria. The Add Rule pop-up menu shows the other options that are available including Adjustments, Aperture Metadata, EXIF, IPTC, Face, Place and other metadata. You can explore what's available by selecting any of the options from the pop-up menu. This adds a new search section to the HUD. A text search can work equally well for some of these categories, but they can help to narrow the focus of the search (Fig. 4.32).

For example, a full text search for '300 spartans' will find images with that text in any metadata field including the Caption, Filename, and EXIF metadata including the shutter speed and lens focal length. It's unlikely that you're going to want included all the images numbered 30000–30099, plus 300, 3000, 1300 and all the others, so if you are looking only for images with 300 spartans in the caption, an IPTC search is a better option. Alternatively, if you want to find all the shots using a 300 mm lens, use an EXIF search (Fig. 4.33).

The Adjustments search criteria was a new addition to Aperture 2 and allows you to search for images that have had adjustments applied using the Adjustments Inspector. It could usefully be used to search for all vignetted images, monochrome Versions produced using the monochrome mixer,

Filter: Photos All : of the following that match : Stack picks only	Add Rule
Rating: Is greater than or equal to $\frac{1}{2} = \frac{1}{2} \frac{1}{2$	Adjustments Aperture Metadata
≣ Flagged: No ÷ ■ Color Label: Is: •: ◎ ● ● ● ● ● ●	Attachment Calendar Color Label
Text: includes + Q- colour	Date EXIF Face
Keywords Aperture: Project Name : Includes : royal	File Status File Type
New Album With Current Ima	Flagged Import Session IPTC
	Keywords Photo Usage Place
A second second second second second	Rating Text

FIG. 4.32 Search using other criteria selected from the Add Rule pop-up menu.

Aperture File Edit Photos Stacks	Metadata View	Window Help	Aperture			I O 💽 (100	BQ (= 4) 1 (
apector Import New Name Keywords	MobileMe Facebook	• *			Browser Split Vie	w Viewer Faces Pl	Aces Loupe Full Scre
Library Metadata Adjustments	Projects Manual	: (=)				(Q.	68 4 (
Q- stives (0) (0-)	State State			E E	I Distant		
LIBRARY Projects	1042	-	18 04	-	-	() 44	***
Paces Flagged	CRW_2708 #/5.6	CRW_2722 //9 1/320	CRW_2723 //9 1/400 CRW_2	724 <i>f/</i> 9 1/400	60	90	-
► 🔂 Trash				CRI	N 2726	CRW, 2727	CRW_2728
PROJECTS & ALBUMS							
* 🗁 2006	A CONTRACTOR OF THE	Concentration of		5.E	100 H	100	Contraction of the second seco
▼ Ê Feb 2006 ▶ St Ives	44	4.4	440		2	A.	A
St lves St lves St lves		8		Filter: St lves	and an and a state of the state		
▼ [May 2006							
► BE St Ives	CHW 2729	All ‡ of the	following that match	lesson to the E	Stack picks of	nly A	dd Rule 🔻
2008	CHR_2/28						
* 🗁 July 2008		Rating: is great	ater than or equal to	뛰, 지금 드러 지	Unrated		
►	and and a second se						
COSILEME CALLERY	1	🗐 Flagged: 🛛 Yes					
	CRW 2759 //8 1/640	🗏 Color Label: 🖷	s 🕆 🏐 🔹 🖲 🤅				
		Text: includes	÷ ۹-				- (22)
	14	🔳 Keywords					
		🗹 EXIF: 👘	Focal Length 💠 is g	greater than or equ	ua ‡ 200		- 12
	CRW_2710		New Sn	nart Album	lew Album With	Current Image	s • ,
	h 6 4 8		22 n	rems displayed			· ······
	Preparations	Vows	Portraiture Groon	n Bridesmald	Add Keyword	- 00	00 00
ult 🗊 Ö.	Ceremony	Reception	Bride Maid of H	onor Groomsman	Wedding		00 00

FIG. 4.33 This EXIF search displays all images in the St lves Project shot with a telephoto lens of 200 mm or longer (Filter HUD enlarged).

cropped images, or various other adjustment criteria. You can also use the Adjustments search to locate images produced using different Versions of the raw decoder (Fig. 4.34).

Using Multiple Search Criteria

While quick searching using a single text entry, a keyword or rating can often get you what you want, using multiple search criteria can really help you narrow the focus to find the handful of images or the single shot that exactly fits your needs.

A multiple search often begins with a ratings selection, though it doesn't have to. It can include any of the existing default search criteria plus any that you want to add from the Add Filter pop-up menu. For example, you might want to search for all three-star and above images shot in a particular calendar month by a certain photographer (Fig. 4.35).

To do this first check the rating criteria, select 'is greater than or equal to' from the Match Criteria pop-up menu and drag the slider to the three-star position. Next check the calendar search criteria, navigate to the required month, click the first date on the calendar and **Shift** click the last date. Finally, select IPTC from the Add Rule pop-up menu, check the IPTC search criteria, select Creator is from the Match Criteria pop-up menu and enter the name of the photographer in the IPTC text field.

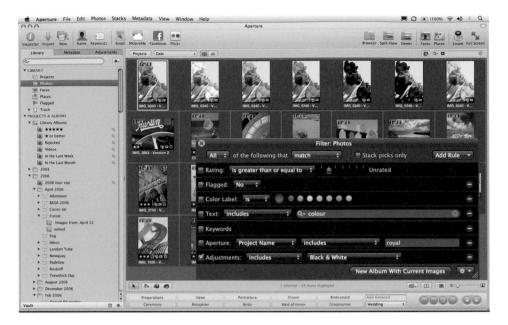

FIG. 4.34 Aperture's new Adjustments filter lets you search for images that have had any adjustment applied – here, black and white Versions (Filter HUD enlarged).

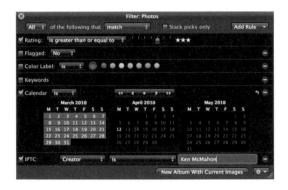

FIG. 4.35 A multiple search to locate all three-star images shot by Ken McMahon during March 2010.

Multiple Text Searching

To search for multiple text fields, select Text from the Add Rule pop-up menu. Check the text search criteria and enter the first search term in the Text field. Add second and subsequent text rules as required.

Note that the match criteria for multiple text searching are determined by the pop-up menus at the top of the Filter HUD that apply to all of the selected search criteria. Generally, you'll want these set to the default 'include if all of the following match'. But it's also possible using the available menu

Aperture File Edit Phot	tos Stacks	Metadata View Window		📕 🔿 🐨 (100%) 🛜 📢 🕴 Q
000			Aperture	0
Inspector Import New Name Keywe	ords Email	MobileMe Facebook Flickr		rowser Split View Viewer Faces Places Loupe Full Screen
Library Metadata Adj	Justments	Projects Date		👩 Q. *TT 💿
Q+ All Items) 0.		30(9)	
▼ LIBRARY	0	DOM	and and and a second	A DESCRIPTION OF A DESC
Projects		And Another A		
Photos		A A A A A A A A A A A A A A A A A A A		
IE Faces		1000 Mar 1000	1	177
Places Pla flagged	3.723	IMG 3964 //8 1/320 IMG 3	857 //4 1/3200 IMG 3499 //8 1/50 *** 201 ***	MG 3491 //5.6 1/40
► [] Trash			IMG 3487 IMG 3490	
* PROJECTS & ALBUMS				
* E. Ubrary Albums				
***	9		S Filter: Photos	The second second second second second
in tor better	9		All : of the following that match :	Stack picks only Add Rule 👻
Rejected	9		Par + of the ronowing that , thaten +	Add Role +
Videos	A		Rating: is greater than or equal to +	***
in the Last Week	9		Construction of the second se Second second seco	
In the Last Month	a		🗏 Flagged: No 📫	
▼ j 2006				a falsa fi maa maanaan a saara a ay ahaa ahaa ahaa ahaa ahaa ahaa
2006 four star	a		🔤 🖻 Color Label: 🛛 🔹 🛊 🌒 🌒 🌒 🜒 🜒 🜒 🜒 🖤	
* 🗁 April 2006			and a second structure and a second	and a second
Allotment			🗏 Keywords	
► 101 BKSA 2006				
Conor ski			🚍 Calendar	
Fistral Images from: April 12				
edited			E IPTC: Creator : is	Ken McMahon
Fog			Text: includes + Q- agriculture	
> 🕾 Idless			e lext: includes agriculture	© -
+ 📺 London Tube			Text: includes ‡ Q- machinery	0 -
Newquay			Texts includes • ex-machinery	
Padstow			Nev	Album With Current Images
Roskoff			and the second	
Trevithick Day August 2006				
December 2006		K 6 0 0	6 items displayed	······································
• [* Feb 2006	Ă	and the second		
- Daniali Bd mardan	7		Vois Portraiture Groom Bridesmaid Reption Bride Maid of Honor Groomsman	Wedding :
Vault	•	Ceremony K	strice Mud of Honor Croonsman	wedding

(a)

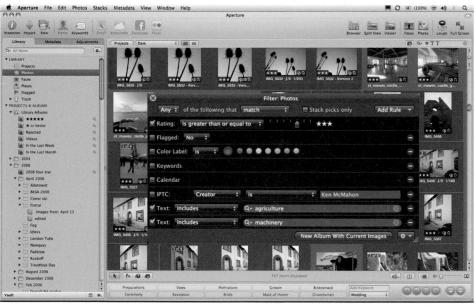

(b)

FIGS 4.36 Be careful what you search for. Using 'include if any of the following match' (b) can widen the catch to include images you probably don't want. Use a keyword search instead (Filter HUD enlarged).

combinations to search for a match with any of the criteria and to search for exclusions, e.g. 'Do not match'

Unlike keyword searches, you cannot use 'all or any' options exclusively for multiple text searching within a wider multiple criteria search. For example, you can search for images that are rated three stars and above that contain the text 'agriculture' and 'machinery', by selecting the relevant rating and text criteria and choosing 'include if all of the following match'. But you can't find three-star images that contain either word. Selecting 'include if any of the following match' will find those images, but will also display three-star images that contain neither word. In this instance, you're better off with a keyword search (Fig. 4.36 (a) and (b)).

Saving Search Results

You can save search results to an Album or Smart Album using the buttons at the bottom of the Filter HUD. Smart Albums can't be created at the Library level – you need to be in a Project, Folder or Album. By saving search results as a Smart Album you can ensure that any images added in future that fit the search criteria will also appear (Fig. 4.37).

For example, if you create a Smart Album from a search for all three-star or better images and re-rate your images at a later date, the Smart Album will

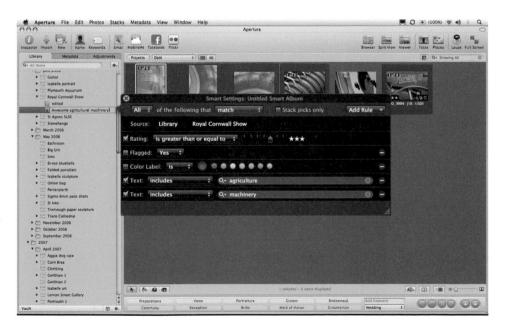

FIG. 4.37 Click the new Smart Album button on the Filter HUD to create a Smart Album using the selected search criteria.

FIG. 4.38 Troubleshooting.

If at any time you don't see what you expect to see in the Browser (e.g. fewer images than you were expecting, or none at all), one possibility is that a Search filter has been inadvertently applied in the Filter HUD, or applied and not removed. Aperture retains Search filters applied using the Filter HUD so, if you navigate away from a Project which you've searched, when you return to it, the Search filters will be applied as you last left them. A quick check of the Filter HUD Search field will tell you if this is the case. It will show the text or icons for Rating, Calendar, Keywords or Import Session searches that have been applied. To clear the Search filters click the Reset button on the right of the Search field.

update to reflect the new ratings. See Chapter 2 for more about how Smart Albums work. Don't forget that, unless you reset the Filter HUD to its default 'Unrated or Better' position, it will continue to filter the contents of the selected Project or folder according to the last used search criteria (see Fig. 4.38 'Troubleshooting').

The Adjustments HUD

The Adjustments pane of the Inspector HUD replicates the adjustments and controls on the Adjustments Inspector and works in almost exactly the same way. In this chapter, when we refer to the Adjustments Inspector you can assume that things will work exactly the same way using the Adjustments pane of the Inspector HUD and vice versa. HUDs are free-floating; their purpose is to provide a more flexible workspace and to allow you to make edits in Full Screen mode without unnecessary screen clutter.

Making image adjustments requires continual visual assessment of the changes you make using the controls on the Adjustments HUD. The best way to do this is in Full Screen mode, often at 100% view magnification and with nothing to distract from as objective an assessment as possible of the image color, tonal values and other qualitative factors and how they are changing in response to your inputs.

You can display the Adjustments pane of the Inspector HUD and enter Full Screen view by selecting Window > Show Inspector HUD followed by View > Full Screen and, if necessary, clicking the Adjustments button on the Inspector HUD. But it's much simpler using the keyboard shortcuts () and (), in any order. Press () again to exit Full Screen view and () to hide the Inspector HUD (Fig. 5.5).

In Full Screen view, position the cursor on the top edge of the screen to display the toolbar and at the bottom edge of the screen to display the

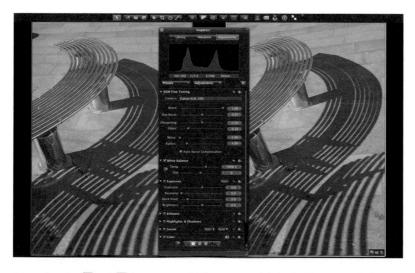

FIG. 5.5 Press the **()** and **()** keys to activate Full Screen view and display the Adjustments HUD. Position your mouse on the top edge of the screen to display the toolbar and at the bottom edge of the screen to display the Filmstrip.

Filmstrip; when making adjustments it's often helpful to display the master alongside the adjusted version to provide a before and after comparison.

The Adjustments HUD Adjustment by Adjustment

The Histogram

Aside from the image itself, the histogram provides more information about digital image tonal and color quality than any other single analytical tool. It can tell you if there is clipping of the highlight or shadow detail, if an image lacks contrast, and even if there is a color cast.

Aperture's histogram works in much the same way as those on dSLR cameras, and in other image editing applications such as Photoshop. If you're not sure how the histogram works, see the detailed description later in this chapter. The Histogram options section of the Adjustments Action pop-up menu provides five view options: Luminance, RGB, and individual red, green and blue channels (Fig. 5.6 (a) – (d)).

Show (/Hide) Camera/Color Info displays the red, green, blue and luminance values of pixels immediately below the cursor. Use the Loupe to position the cursor more accurately. The Color Value Sample Size determines the sample size used to produce the color value and can be set at the individual

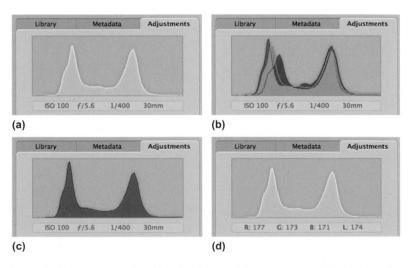

FIG. 5.6 The histogram can be configured from the Adjustments Action pop-up menu to display Luminance (a); overlayed red, green and blue channels (b); or individual (red here) color channels (c). When the cursor is positioned over the image the RGB values of the underlying pixels are displayed, otherwise carnera EXIF data are shown (d).

pixel level, or taken from an averaged sample up to 7×7 pixels square. When the cursor isn't over image pixels the EXIF ISO, aperture, shutter speed and focal length data are displayed.

Raw Fine Tuning

For the most part, the process of converting Raw data into an RGB file in Aperture happens automatically. (See Chapter 1 for a detailed explanation of what this involves.) The Raw Fine Tuning area appears only when a Raw file is selected. For more detailed information about Raw Fine Tuning and migrating files from earlier versions of Aperture see Chapter 1.

White Balance

White Balance is the process of evaluating the color of ambient light in a scene. This determines which surfaces should appear neutral in color and from this all other color values are derived. Incorrect White Balance results in an unnatural color cast.

White Balance is initially determined in-camera using a preset, such as Daylight or Tungsten, or an automatic White Balance setting. If you shoot Raw, the camera White Balance setting becomes largely irrelevant, because you can set White Balance retrospectively using Aperture's White Balance controls. Shooting with Auto White Balance set on the camera is a good general policy; alternatively, if your normal policy is to determine White Balance by shooting a gray reference card, this too remains a valid option.

The White Balance adjustment has three controls: an eyedropper, used to set White Balance from a neutral area in the image, a Temp slider which initially indicates the camera White Balance color temperature, and a Tint slider (Fig. 5.7).

Check the White Balance checkbox and use the eyedropper to click on a neutral area in the image – a gray card if you use one, a white wall, or other neutral area. When you do this you'll see the Temp and Tint sliders take up new positions based on the sample area.

The Temp slider indicates the assessed color temperature in Kelvin of the ambient light conditions in the scene. Dragging it to the right and increasing the Color Temperature value therefore makes the scene warmer. By dragging the slider to the right you are telling Aperture that the light in the scene was bluer than the White Balance setting indicated by the camera, and therefore the image becomes warmer (Fig. 5.8).

Once the White Balance is set to your satisfaction, use the Tint slider to remove any green or magenta color cast; moving the slider to the right adds magenta, and to the left adds green.

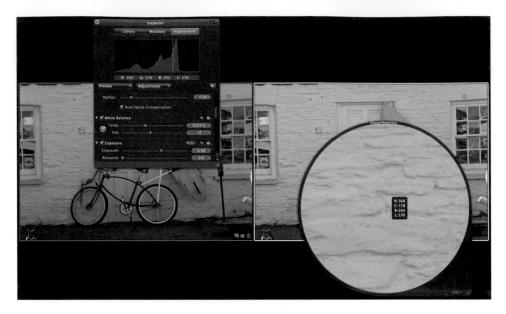

FIG. 5.7 Use the eyedropper to set the White Balance by clicking on a neutral white, gray or black area of the image. The Loupe, which is automatically activated, allows you to make a more accurate selection. The pixel value of the sample area (defined in the Adjustments Inspector Action pop-up menu) is shown. The closer together the red, green and blue values are, the closer to neutral the sample is and, therefore, the less shift will be applied.

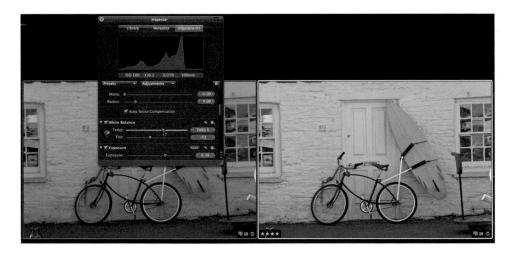

FIG. 5.8 With the Eyedropper adjustment made, use the Temp slider to fine-tune the White Balance adjustment.

Exposure

The Exposure adjustment provides tools for improving overall image tonality and correcting common problems like over- and underexposure. It has four sliders: Exposure, Recovery, Black Point and Brightness. Don't think of the

FIG. 5.9 This image has been overexposed by a whole stop. Dragging the Exposure slider to the left to a value of -1.13 restores all of the highlight detail, producing a textbook histogram with a full tonal range.

Exposure adjustment as something to be used only for problem images. Even correctly exposed, well-balanced images can be improved with minor Exposure adjustments (Fig. 5.9).

Use the Exposure slider to correct over- and underexposed images; dragging to the right increases Exposure, to the left decreases it. The Exposure slider range is -2 to +2, and the Value slider (drag in the Exposure value field) extends this to -9.99 to +9.99. Exposure is very effective at restoring highlight and shadow detail in images that are up to two stops either side of the correct Exposure setting; beyond that, even with Raw images, good quality results are hard to achieve.

The Recovery slider is designed to rescue 'blown' or clipped highlights in images that are overexposed or where the camera sensor has been unable to record the highlight detail in a subject with high dynamic range. The difference made by using the Recovery slider can be quite subtle, but it is effective when used in conjunction with Exposure and other tonal controls such as Highlights and Shadows (Fig. 5.10). See the section on correcting exposure problems later in this chapter for more details on how to correct severely over- and underexposed images.

Black Point controls shadow detail and can be used to add contrast to the shadow regions or to restore detail to crushed shadows. A check of the histogram will reveal whether an image requires Black Point adjustment. If the left side is clipped, drag the Black Point slider to the left to restore shadow detail. If the histogram stops short of the left side, drag the Black Point slider to the right to increase contrast in the shadows.

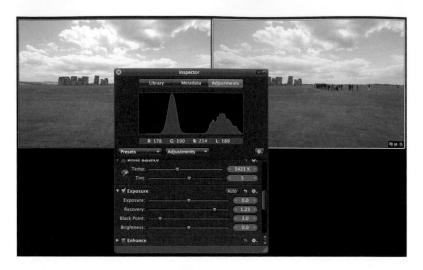

FIG. 5.10 The Recovery slider is used to recover blown highlight detail – here it has done a first rate job of recovering the detail in the sky. In most circumstances, you'll need to use the Recovery slider in combination with other tonal adjustments to achieve a good result.

Brightness adjusts luminance values of image pixels across the entire tonal range whilst maintaining the histogram end points – in other words it won't clip shadow or highlight detail

Enhance

Enhance consists of five controls: Contrast, Definition, Saturation, Vibrancy and Tint. Contrast and Saturation are image editing standards. Contrast increases or decreases image contrast by 'stretching' the histogram, i.e. extending the black and white points and evenly redistributing the values in between.

Saturation increases or reduces color saturation of all the hues in the image by the same amount. In-camera processing of JPEG files usually applies a preset Saturation Boost and Raw files can appear desaturated by comparison. Small increases in Saturation produce a marked visual effect and few images will need more than 1.20 to add punch to the colors. Keep an eye on the histogram to avoid color clipping. Dragging the Saturation slider to the extreme left desaturates images to monochrome, but provides no tonal control. Use a Black & White adjustment to produce black and white images.

Definition increases local contrast without affecting overall image contrast. It can help to reduce haze and to improve images that, despite having a full tonal range, appear flat. The default position for the Definition slider is on the far left at zero and the maximum is 1.0.

Drag the slider to the right to increase definition. Note that as you do this, overall tonality is unaffected and the histogram display remains unchanged.

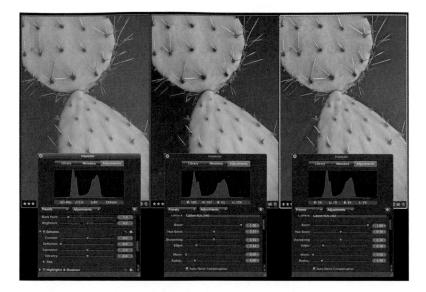

FIG. 5.11 Contrast vs Definition. The Contrast slider in the Enhance adjustment increases or decreases overall contrast in an image by stretching the histogram, moving pixels out towards the edges, whitening light tones and making dark grays blacker. Note the difference in the histogram for the original (left) and contrast adjusted version (center). Aperture's Definition slider adds punch to images by increasing contrast in local areas without affecting the overall image contrast. The histogram of the definition adjusted image (right) is almost identical to that of the original.

Definition produces a similar effect to applying Photoshop's Unsharp Mask filter with a low amount and high radius value, a technique commonly used to make images 'pop' (Fig. 5.11).

As with most adjustments you need to take care that the cumulative effect of individual adjustments, if your workflow includes Edge sharpening for example, does not produce undesirable results.

Like Saturation, Vibrancy changes the saturation of colors, but not all hues are equally affected and the results are more subtle than with the Saturation slider. Colors that are already well saturated are affected less by increasing Vibrancy than those that are muted. Likewise, when reducing Vibrancy, the most saturated colors are more affected. Vibrancy is configured to ignore skin tones so you can safely use it to change color saturation in portraits and model shots (Fig. 5.12).

The Tint controls allow for selective color correction in the shadow, midtone and highlight tonal ranges. To correct a color cast in the highlights, click the white eyedropper and sample a highlight region of the image in which the cast is most prominent, and then make fine-tuning adjustments using the color wheel.

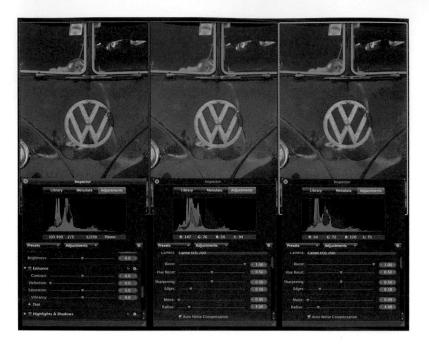

FIG. 5.12 Saturation vs Vibrancy. The center image shows the original (left) with a Saturation adjustment of +2.0, which is the maximum that can be applied using the slider. Saturation increases uniformly regardless of the existing pixel color values. Note from the center histogram that the Saturation increase has resulted in color clipping of the blue channel. The Vibrancy adjustment (right) has a maximum limit of 1 and it doesn't affect pixels which are already close to full saturation, producing a more balanced, natural-looking result.

The Tint controls are effectively selective White Balance controls. As such, changes to White Balance will affect Tint adjustments and vice versa. Though you don't need to adhere rigidly to it, the layout of the Adjustments HUD provides a good guide for adjustment workflow. Tint adjustments are best made after overall White Balance has been set.

Highlights & Shadows

Highlights & Shadows is another tool designed for recovering detail at the extremes of the tonal range. The Shadows slider works well on images with a full tonal range that are lacking shadow detail due to a subject with a high dynamic range having been exposed to retain highlight detail, for example silhouettes. With underexposed images that have already undergone Exposure and Levels adjustments, however, there is a significant risk of introducing unacceptable levels of noise into the shadow areas. Keep an eye out for this by viewing images at 100% (press 2) or using the Loupe to examine shadow areas while using the Shadows slider (Fig. 5.13).

Click the disclosure triangle to display the Highlights & Shadows advanced controls. Generally speaking, you won't need to bother with these advanced

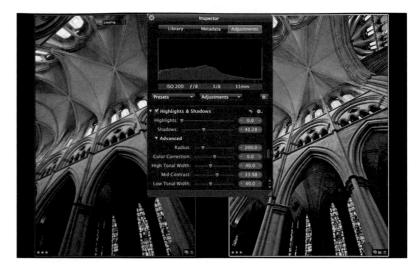

FIG. 5.13 The Shadows slider of the Highlights & Shadows adjustment acts like a fill flash, restoring detail in dense shadow areas.

controls, which is why they are normally tucked away under a disclosure triangle. However with some images, for example those with specular highlights such as reflections on water or metal, you may be able to improve on the results achieved using the basic controls.

Mostly with these controls it's a case of suck it and see; knowing what they do is often not nearly as helpful as seeing the results, so experiment. The Radius slider defines the size of the clump of pixels that Aperture analyzes to determine what constitutes a highlight. The default position for the Radius slider is 200. Increasing it effectively reduces the overall effect of the Highlights slider and can be helpful if large amounts of Highlights adjustment result in unnatural-looking flattened highlights (Fig. 5.14).

Color correction controls the Saturation increase in shadow detail uncovered using the Shadows slider; the default position is 0. Recovered shadow detail often doesn't match surrounding areas for color; increasing Saturation using the Color Correction slider can help remedy this.

The High Tonal Width slider determines the tonal range that the Highlights slider affects. If you increase the High Tonal Width by dragging the slider to the right, more of the highlights – extending into the light three-quarter tones – will be affected by the Highlights adjustment. The Low Tonal Width slider does the same thing for the Shadows adjustment.

Mid Contrast adjusts contrast in the Midtones. Like contrast, it stretches the histogram, but in a non-linear fashion, pushing the midtones out to the quarter and three-quarter tones. You'd use this to compensate for compression of midtone values caused by Highlights and Shadows

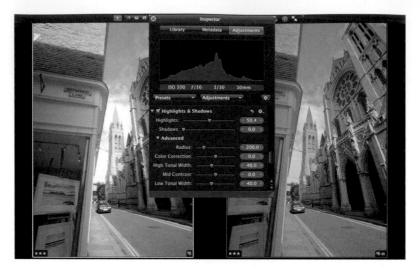

FIG. 5.14 The Highlights slider of the Highlights & Shadows adjustment is one of several tools that help restore detail to blown highlights. It works well on its own, but even better if used in conjunction with other highlight rescue adjustments like Exposure and Recovery.

adjustments; if this is necessary, you might first want to experiment with reducing the High and Low Tonal Width settings.

Levels

Another standard image editing tool, Levels provides control over tonal distribution via thee sliders which remap shadow, midtone and highlight regions of the histogram. Check the Levels box to activate the adjustment and display the histogram.

The Black, Gray (midtone) and White Levels sliders below the histogram provide three adjustment points (Fig. 5.15). Click the quarter tone controls button to display two additional adjusters for the shadows and highlight quarter tones. Use Levels to increase contrast in images where the histogram display falls short of either end of the graph, and to increase (or decrease) brightness in the midtones. Generally speaking, the way to do this is to drag the Black and White Levels sliders until they touch either end of the histogram – this is more or less what the Auto Levels button under the histogram does. Use the Channel pop-up menu to adjust the red, green and blue channels individually, for example to neutralize color casts.

Color

Color provides controls for selective color adjustment and can be used to subtly modify, for example, skin tones, skies, or foliage or for more radical color replacement tasks such as changing the color of clothing. Even

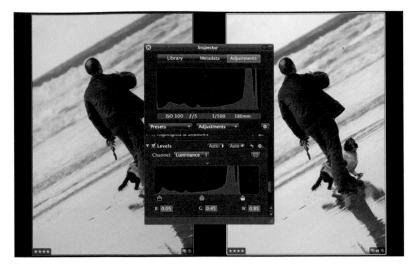

FIG. 5.15 Use Levels to improve image tonality. The most commonly applied Levels adjustment involves dragging the White and Black Levels sliders to touch either end of the histogram, thus improving image contrast; dragging the Gray Levels slider to the left increases Brightness in the midtones.

in the absence of Selection and Masking tools these controls can do a very effective job.

The range of the Color adjustment is initially set by selecting a base color from one of the six color swatches at the top. To more accurately define the base color, use the eyedropper to sample pixels from the image. The Range slider expands or contracts the range of colors either side of the base color that is affected by the Color adjustments. If you want to make adjustments to more than one hue range, click the Expanded view button at the top of the Color adjustment to display separate controls for each color (Fig. 5.16).

The Hue slider shifts the color value of pixels within range of the base color. The extent and direction of the shift is controlled by the Hue slider. It helps if you picture the color values you are attempting to adjust positioned on the visible spectrum, or a color wheel, much in the way that the base color swatches at the top of the Color adjustment run from red through yellow, green, cyan and blue, to magenta.

When you select, for example, the blue swatch, note the color on the Hue slider which extends from blue in the center to cyan at one end and magenta at the other. Drag the slider to the right to shift blue pixels in the image towards magenta and to the left to shift them towards cyan (Figs 5.17 and 5.18).

The initial value of the Hue control when the slider is in the center position is zero. The values at either end of the slider are 60 and -60, which result in a shift of one color position, i.e. blue to cyan or magenta. Using the Value slider extends the shift range to 180 and -180. As you might expect,

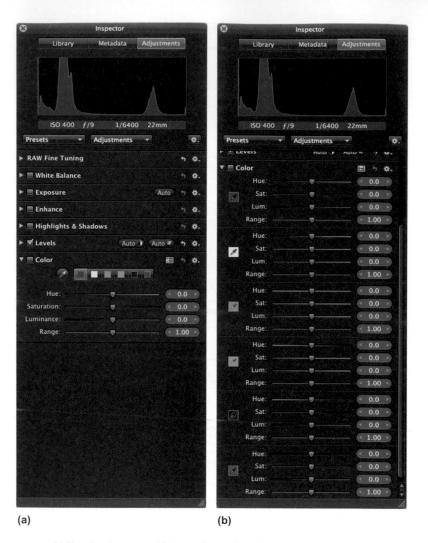

FIG. 5.16 (a) The color adjustment in default view showing the six base color swatches and (b) in Expanded view displaying individual Hue, Saturation, Luminance and Range sliders for each color. Use the color eyedropper to select a custom base color from within the image.

this shifts hues 180 degrees on the color wheel to produce their complementary color. In other words, a Hue value of 180 turns blues to yellows and produces the same effect as dragging the Value slider in the opposite direction to -180.

The Saturation slider is used to increase or decrease color saturation of pixels within the selected color range and Luminance changes the brightness of those pixels. Used on its own, you can use the Saturation slider to selectively boost saturation. For example, by selecting only yellows you can boost the saturation of sand in beach shots without affecting blue skies (Fig. 5.19).

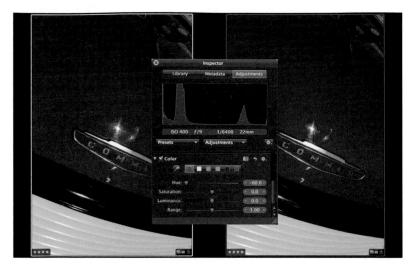

FIG. 5.17 When colors in an image are well isolated, like the red in this vintage car, changing them is relatively straightforward. Select the Red swatch, or use the eyedropper to sample from the image and drag the Hue slider until you get the color you want. Dragging the slider to its limit shifts the Hue one swatch along, 60 degrees around the color wheel, in this instance from red to magenta. You can use the Value slider to go all the way to 180 degrees — the complementary of the original color.

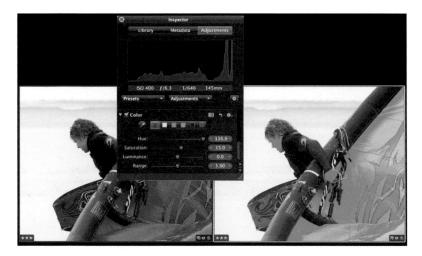

FIG. 5.18 It isn't always so easy to isolate individual colors. In this case shifting the Hue value of the reds in the image affects the skin tones as well as the kite. The solution here is to brush out the unwanted hue changes. (Brush adjustments are covered in detail later in this chapter.)

With subtle color changes it can often be difficult to gauge the extent of the selected color range and, therefore, to know what parts of the image are being affected. The best way to proceed in such circumstances is to make your selection using either the eyedropper or color swatches and then

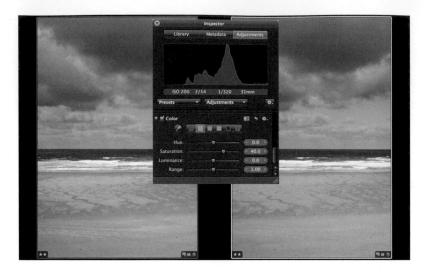

FIG. 5.19 Use a Color adjustment to boost saturation of specific colors. Here, sampling the sand with the color eyedropper allows us to boost the saturation of the beach, making it look warmer and more inviting, without affecting the sea and sky.

increase the Saturation to its maximum of 100. It will now be obvious which pixels are affected by any hue changes – drag the Hue value slider to 180 to make the selection even more obvious. Next, use the Range slider to extend or limit the range of selected pixels until only those colors you want to change are affected. Finally, return the Saturation and Hue sliders to their original positions and make the desired Color adjustments.

When attempting extreme color changes, the chances of a successful outcome will be increased if you choose hue shifts that are appropriate given the tonal qualities of the original color. It's unrealistic to expect to turn bright yellow flowers into dark blue ones, but if you settle for pale blue, you'll probably succeed.

Other Adjustments

The Adjustment tools covered in the next section of this chapter don't appear on the default Adjustments Inspector/HUD; you add them as required from the Adjustments pop-up menu.

Red-Eye Correction

Introduced in Aperture 3, the Red-Eye Correction adjustment is both easy to use and effective. Adjust the Radius using the slider so the target covers the pupil and click to remove the offending red-eye. You can adjust the Sensitivity slider if the Desaturation extends beyond the pupil area into the iris or other parts of the eye, but if you keep the Radius small this shouldn't be

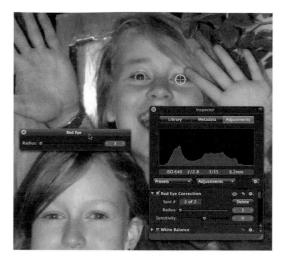

FIG. 5.20 The Red-Eye Correction adjustment in action

a problem. You can move the targets after you've set them and adjust the Radius using the Adjustments Inspector or HUD slider (Fig. 5.20).

Spot & Patch and Retouch

Aperture's retouching tools consist of the Spot & Patch tool and the Retouch tool. Both are essentially Clone tool variants and can be used to retouch blemishes such as sensor dust spots and skin blemishes and for basic cloning operations. Spot & Patch was introduced in Aperture 1 and superseded by the more capable Retouch tool in Aperture 2. The Spot & Patch tool has been retained for reasons of backward compatibility.

Aperture 3 allows you to work with images that were previously edited with the Spot & Patch tool, but for all other retouching jobs the Retouch tool provides more options and produces better results. For the sake of completeness, a brief description of the functioning of the Spot & Patch tool is given below.

The Spot & Patch tool has two modes – Spot and Patch. The former is used to retouch textureless areas of flat color, for example to remove dust spots from sky areas. A resizeable target disk is positioned over the spot, and color detail from surrounding pixels is used to automatically retouch it (Fig. 5.21).

In Patch mode, a source area is also specified and the tool works like a more conventional cloner. In both modes the Adjustments Inspector provides controls for the Radius (the size of the spot or patch), (edge) Softness, Opacity, Detail (blur) and Angle.

The Retouch tool works more like a brush – Retouching is applied using brush strokes, rather than by defining a circular target area. Like its predecessor, the Retouch brush has two operating modes – Repair and Clone. Repair is

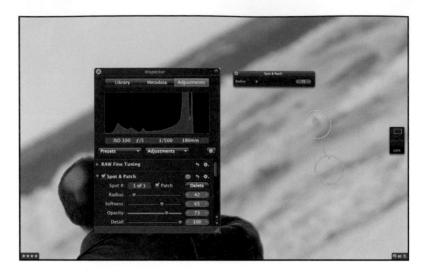

FIG. 5.21 Aperture's Spot & Patch tool was superseded in Version 2 by the more able Retouch tool. Use it to edit images that have been spotted and patched in earlier Versions or, better still, remove the Spot and Patch adjustments and redo them using Retouch.

used to retouch spots, blemishes and other unwanted detail and to cover the offending pixels using both color and texture detail from other parts of the image, usually closely matching pixels from the surrounding area.

To use the Retouch tool either select it from the toolbar or choose Retouch from the Add Adjustments pop-up menu on the Adjustments HUD. The Retouch HUD displays the tool's controls and a Retouch adjustment (with a Stroke Indicator, Delete and Reset buttons) is added to the Adjustments HUD (Fig. 5.22).

The default mode for the tool is Repair. Use the Radius slider or, if it has one, the central scroll wheel on your mouse to change the brush size to suit the area to be retouched and if necessary adjust the edge softness and opacity of the brush using the other two sliders.

'Automatically choose source' selects an area matching in texture and color for you. It works well in most circumstances and you should leave the box checked at least for your initial attempts. 'Detect edges' is a useful feature which masks edge detail from the effects of the Clone tool so that you can, for example, repair a dust spot in the sky without cloning out the branches of a tree.

If your initial attempts using these settings don't produce successful results, uncheck the 'Automatically choose source' button, hold down the S key and click using the crosshair target on a suitable source area.

If you click the Clone button in the Clone tool HUD, the Clone tool behaves like a conventional Clone brush – copying pixels from a specified source area

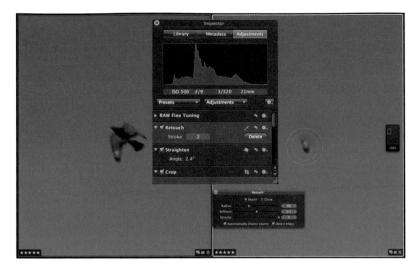

FIG. 5.22 Repairing with the Retouch tool. The Retouch tool automatically retouches out blemishes, or in this case a bird, using pixels from the surrounding area, or source pixels chosen by SC clicking. It's quick and produces seamless results with very little effort.

to the destination. So click to define the source; then paint over the target area having first defined the brush size, softness and opacity (Fig. 5.23).

If you make a mistake while repairing or cloning, press (#) Z to undo the last brush stroke. Continue pressing (#) Z to undo your brush strokes in

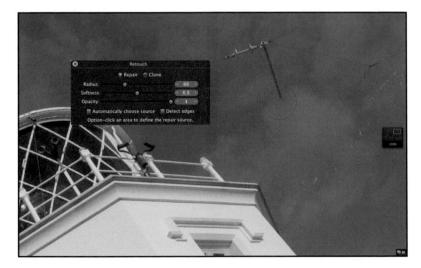

FIG. 5.23 In Clone mode the Retouch brush works like a conventional non-aligned clone brush; \bigcirc click to define the source point from which pixels are copied to the destination. The brush has no 'aligned' mode; each stroke is cloned from the original source point. Strokes can be deleted in reverse order to which they were applied using the Delete button on the Retouch adjustment of the Adjustments HUD.

reverse order. You can also remove strokes in the reverse order to which they were applied at any time by pressing the Delete button on the Retouch adjustment in the Adjustments pane of the Inspector HUD. To remove all retouching click the Reset button.

Its improved ability to deal with texture and the excellent edge detection feature mean that you can now deal with most minor retouching jobs within Aperture. For more involved cloning, however, you'll still need to round trip images to Photoshop.

Crop and Straighten and Flip

Crop and straighten adjustments can be applied either by selecting them from the Adjustments pop-up menu or by selecting the Crop or Straighten tools from the tool strip. If you do the latter, the appropriate adjustment is automatically added to the Adjustments Inspector and to subsequently access the controls you need to select the appropriate tool (Fig. 5.24).

To crop an image, drag with the Crop tool to define the crop area and drag inside the crop area to reposition it. A selection of size presets is available from the Crop HUD. To remove a crop or any other 'additional' adjustment from an image, select the Adjustment and choose 'Reset Selected Adjustment' from the Adjustments Action pop-up menu.

The Straighten tool is actually a Crop and Straighten tool in one. To use it, select it from the tool strip and drag inside the image to simultaneously rotate and crop it to maintain straight edges. A grid overlay appears so that

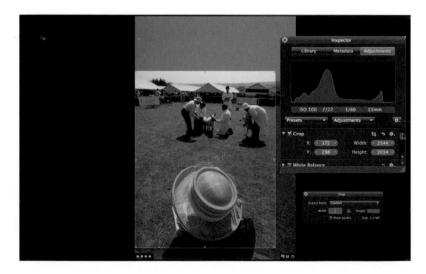

FIG. 5.24 Drag with the Crop tool to define the crop area. Use the Crop HUD to constrain the aspect ratio to the formats available from the pop-up menu. Like all other adjustments in Aperture, Crop is reversible and the original image dimensions can be restored at any time.

FIG. 5.25 The Straighten tool provides a grid to help you align horizontal and vertical edges; edges are automatically cropped.

you can align horizontal or vertical edges (Fig. 5.25). Note that when the Straighten tool is selected you can use the slider in the Adjustments Inspector to rotate the image. Likewise, you can enter specific x and y, width and height values when cropping.

Flip does what it says – it flips the image in the horizontal, vertical or both planes as selected on the pop-up menu. Don't forget that if you horizontally flip an image that includes type, you'll have some retouching work to do to get it back the right way round...obvious, but often overlooked.

Chromatic Aberration

If you shoot with very high quality lenses, Aperture 3's new Chromatic Aberration adjustment probably won't be of much interest to you. But, contrary to popular belief, the color fringing effect caused by Chromatic Aberration isn't confined to compact cameras and inexpensive lenses. Even good quality super-wide and fisheye lenses can suffer from a degree of chromatic aberration.

Aperture's new Chromatic Aberration adjustment is very effective at removing the colored fringing caused by this lens defect. The fringing usually occurs around areas of high contrast, often in backlit subjects, and is either on the red/cyan or blue/yellow spectrum. The Chromatic Aberration adjustment has two sliders to deal with each. To neutralize red fringing, drag the Red/Cyan slider towards the cyan end and vice versa to neutralize cyan fringing. Blue or yellow fringing can be similarly neutralized using the Blue/ Yellow slider (Fig. 5.26).

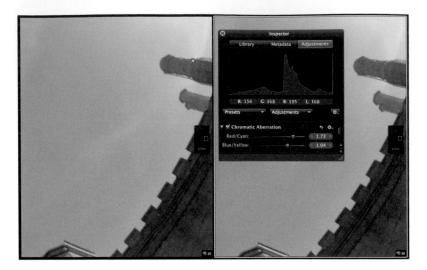

FIG. 5.26 Chromatic aberration usually manifests as either red/cyan or blue/yellow fringing in areas of high contrast like these crenellations. However, it's not unusual to get both, as this image shot with a Sigma 8 mm fisheye lens demonstrates. Having removed the red fringing with a 1.73 adjustment on the Red/Cyan slider, blue fringing became apparent and was removed with a 1.04 adjustment on the Blue/Yellow slider.

Vignette and Devignette

A vignette is an image that fades at the edges. The term is widely used to describe any image with a soft-edged border, but Aperture's Vignette adjustment produces a more subtle effect that fades from the center, becoming darker at the edges. This simulates an effect common in early photography caused by light falloff at the periphery of images due to lens limitations. It was also simulated in the darkroon using oval-shaped templates to burn image edges on an enlarger. Vignetting isn't entirely an historical artifact; it's still common with super-wide-angle and fisheye lenses and Aperture's Devignette adjustment can be used to rectify the problem.

To add a Vignette adjustment, select Vignette from the Adjustment pop-up menu. There are two basic vignette types – Gamma and Exposure, which can be selected from the Type pop-up menu. Gamma vignettes are intended for artistic effect and are more pronounced than Exposure vignettes, which are designed to simulate a lens-produced vignette (Fig. 5.27).

There are only two controls for both types of vignette. Intensity controls the degree of edge darkening and Radius specifies the distance from the center of the image at which the effect begins. Vignettes are applied after cropping so if you crop an image after applying a vignette, the vignette is freshly applied to the cropped image to maintain the visual effect

Devignette does the opposite of Vignette; it lightens image edges restoring brightness in image areas that have been darkened due to light falloff at the

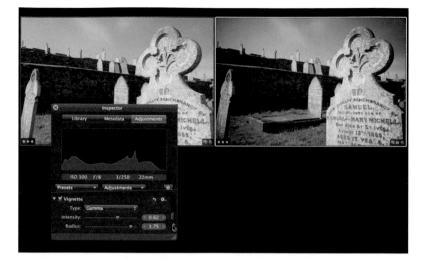

FIG. 5.27 Aperture's new Vignette adjustment is a subtle affair. The Gamma Version shown here produces a more pronounced effect than the alternative, Exposure, which reproduces the kind of light falloff typical with older wide-angle lenses.

periphery of the image circle produced by the lens. In modern super-wideangle and fisheye lenses vignetting, if it exists at all, is likely to be marginal and restricted to the very edges. You'll need to experiment with the Amount and Size parameters to find the right settings for specific lenses, which you can then save as a preset using the Action pop-up menu (Fig. 5.28).

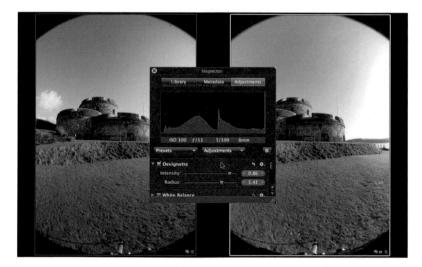

FIG. 5.28 Devignette is used to compensate for light falloff at the periphery of images, a problem mostly confined to ultra-wide-angle and fisheye lenses these days. If you crop an image to which Devignette has been applied, the vignette is applied first to maintain the correct parameters for the lens.

Black & White, Color Monochrome and Sepia Tone

Black & White is a channel mixer-style adjustment that converts color images to monochrome with a high degree of control over tonal reproduction. It can be used to simulate the effects of colored filters with black and white film. In film photography, colored filters are used to lighten same-color tones and darken complementary colors; typically, yellow, orange, or red filters are used in landscape photography to darken blue skies and emphasize cloud detail.

The Black & White default adjustment combines 30% of the red channel, 59% green and 11% blue. This takes most of its information from the green channel, which, due to the make-up of the Bayer mosaic used by most digital SLRs, contains most of the image data and is a good all-round solution.

The Presets pop-up menu contains a number of color filter options and a custom filter which you can define yourself, and you can create your own presets. To find out more about creating presets see the section on creating presets later in this chapter.

Color Monochrome produces a color tinted image. The name is in fact a little misleading as a monochrome image is produced only when the effect is applied at its maximum setting of 1.0 – the default position of the adjustment's Intensity slider. Between zero and 1 the image is progressively desaturated and tinted. Only at the higher settings of around 0.8 and above is most of the color removed from the image. This can be used to produce a quite pleasing effect which combines a desaturated, almost hand-colored look with tinting. The default sepia tint color can be changed using the Colors palette.

Sepia Tone is effectively the same as the Color Monochrome adjustment without the option of changing the tint color. For more detailed information on using the Black & White adjustment and tinting images see the Creative Techniques section later in this chapter (Fig. 5.29).

Noise Reduction

Digital noise becomes apparent in images made at high ISO settings and using long exposure times. It can also become an issue where underexposed images are corrected to produce an acceptable result. Aperture's Noise Reduction filter is designed to reduce digital noise.

There are two controls – Radius and Edge detail. Noise Reduction attempts to isolate noisy pixels by comparing them with neighboring pixels. The Radius control determines the size of the area analyzed. In practical terms, the higher the radius value, the more aggressively the noise reduction is applied. High radius values, however, lead to overall softening of the image. The Edge Detail slider can be used to restore sharpness to image

FIG. 5.29 The Black & White adjustment presets simulate colored filters for black and white photography. Clockwise from top left: Original, Monochrome (30% red, 59% green, 11% blue), Red, Orange, Yellow, Green, Blue and custom (68% red, 36% green, 0% blue).

detail affected in this way. Inevitably, noise reduction involves a compromise; at some point, you will find Radius and Edge Detail settings which result in acceptable noise reduction without unacceptable loss of image detail (Fig. 5.30).

Curves

In response to popular demand, Aperture 3 has added a Curves adjustment. Anyone familiar with the equivalent Photoshop control will immediately understand the workings of this. Curves provides a more flexible and versatile method of manipulating the tonal range than Levels. In addition to being able to manipulate the entire tonal range or segments of it by adding points to and changing the shape of the curve, there are several other controls in the Curves adjustment area.

Auto Curves Combined is effectively an Auto Contrast button – it pulls the Black and White Point input sliders to the ends of the luminance histogram. The Auto Curves Separate button applies a separate Curves adjustment to each color channel to correct a color cast.

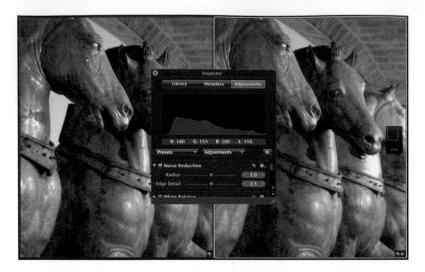

FIG. 5.30 Drag the Noise Reduction Radius slider to reduce the noise apparent in images shot at high ISO ratings, with long exposures, or those that have undergone tonal re-adjustment of the shadows. Restore blurred image detail using the Edge Detail slider.

On the next row, just above the histogram and Curve panel, is a pop-up menu for selecting individual channel Curve adjustments and black, white and gray point eyedroppers. Then there's a target button that you can use to place samplers in the image which add a point to the curve.

Underneath the histogram and Curve panel is another pop-up menu which alters the display to either restrict the tonal range to the shadows or extend it beyond the highlights. While we can't see much use for the former, the latter can be very handy for recovering detail in images with blown highlights. Finally, In and Out boxes provide a read-out of input and output values of the current mouse position or selected point on the curve (Fig. 5.31).

Sharpening Tools

Possibly because Aperture and other tools provide more than one way of doing it, Sharpening is a process which is often not very well understood. Though it's not a common misconception among photographers, it's worth clarifying that Sharpening is not intended to fix images that are out of focus. Digital image editors, Aperture included, provide a wealth of tools for fixing exposure problems but, if your images are out of focus, you're out of luck and those shots are destined for the reject pile.

All sharpening tools work on the same principle – that image sharpness can be enhanced by increasing contrast in local areas of existing high contrast. To put it another way, if neighboring pixels in an image vary widely in

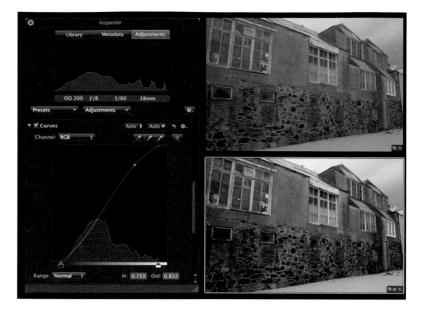

FIG. 5.31 Aperture's new Curves adjustment.

Luminance, that's probably an edge, and the edge can be sharpened by further increasing the Contrast.

The difficulty for sharpening algorithms lies in differentiating true edges from other image detail. Overzealous sharpening can exaggerate noise, make skin, skies and areas of flat color look granular, exacerbate fringing caused by Chromatic Aberration and cause 'haloing' (light fringing) in very high contrast edges.

But don't let that put you off. Nearly all digital images, and certainly all Raw images, require some level of Sharpening and, used judiciously, Sharpening can radically improve overall image definition.

Aperture provides three sharpening tools designed for two different purposes. The first of these is the Sharpening slider in the Raw Fine area of the Adjustments Inspector. This Sharpening filter is designed to overcome the softness that results as a consequence of the demosaicing stage of the Raw conversion process. For a more detailed explanation of this see Chapter 1.

Some people prefer to deactivate Sharpening by dragging the Sharpening slider all the way to the left and do all of their sharpening outside of the Raw decoding process. If there is a quality advantage to be gained from this approach, we've yet to see it demonstrated.

The default Sharpening applied in the Raw Fine Tuning adjustment is tailored to the characteristics of the specific camera model. The amount of

FIG. 5.32 Sharpening applied during the Raw decoding process is based on camera characteristics and is so marginal it's actually quite difficult to see the effect. The left image has had the default Sharpening applied; on the right it has been removed. On balance, it's best to leave Sharpening at its default settings.

Sharpening applied is small and a better end result can be achieved by using the default Sharpening setting in the Raw Fine Tuning adjustment for all images and subsequently applying less aggressive Sharpening than would otherwise be necessary using the other sharpening tools (Fig. 5.32).

Another advantage of this approach is that you'll be working with sharper images that are closer to their final output appearance all the way through your adjustment workflow. This is particularly relevant while applying contrast-related adjustments such as Contrast and Definition, which are affected by Sharpness adjustments.

Outside of the Raw decoder, Aperture has two sharpening adjustments – Sharpen and Edge Sharpen. Sharpen is a fairly basic Sharpening filter which was introduced in Version 1 of Aperture. The superior and more sophisticated Sharpen Edges adjustment was introduced in Aperture 1.5, but Sharpen was retained for the sake of backwards compatibility.

Aperture's Edge Sharpen is a sophisticated professional Sharpening tool. It uses an Edge Mask so that only edges are sharpened and it sharpens on the basis of luminance, rather than RGB data. This approach avoids many of the problems mentioned above.

Edge Sharpen does one other thing that helps produce excellent results while avoiding some of the drawbacks of conventional sharpening tools – it applies its sharpening algorithm in three passes. Multi-pass sharpening techniques are nothing new. It's long been argued that several applications of low levels of Unsharp Mask in Photoshop produce a better end result, with

FIG. 5.33 Even at the maximum setting for Intensity and Edges it's difficult to go over the top with Edge Sharpen. Clearly the image (right) has been oversharpened, but it's not possible to produce the kind of ultra-high-contrast effects you can get with Photoshop's Unsharp Mask.

less risk of haloing than a single large application. Aperture's Edge Sharpen adjustment simply automates this process.

If you're used to Unsharp Masking in Photoshop, Edge Sharpen may seem a little underpowered at first, because it doesn't provide a range that extends beyond that needed for natural-looking results. Edge Sharpen has three sliders. The first, Intensity, controls the amount of Sharpening applied to the image. Edges determines what's an edge and what isn't. At lower settings only fine detail is sharpened and as you drag the slider to the right, the number of pixels that qualify as edges increases. In practical terms, overall image sharpness increases as you drag the Edges slider to the right, but beyond a certain point you'll start to lose detail (Fig. 5.33).

The final slider, Falloff, determines the degree of Edge Sharpening that is applied in subsequent passes. Edge Sharpening is a three-pass process with each pass applied using a different pixel radius. The first pass is applied at a radius of one pixel and the second at 2 pixels, the third pass being applied using a 4 pixel radius.

The Falloff slider determines the percentage of the total Sharpening power applied during the second and third passes. At a setting of 0.7, the amount of Sharpening applied during each pass is:

- 1st pass: 100%
- 2nd pass: 70%
- 3rd pass: 49%

Setting the Falloff slider to zero results in all the Sharpening being applied in a single pass with a 1-pixel radius. At 1, all three passes receive the same amount of Sharpening. The sum of the three sharpening passes is always equal to the value indicated on the Intensity slider (Fig. 5.34 (a) – (c)).

The first thing to do when applying any kind of Sharpening adjustment is press **Z**. It's impossible to gauge the effect of a Sharpening tool at anything other than the pixel level provided by 100% view. Hold down the **Spacebar** and drag in the Viewer so that you can see a representative part of the image that includes both fine detail and flat areas of color, or out-of-focus regions.

Select the Edge Sharpen adjustment from the Add Adjustment pop-up menu. Drag the Intensity slider all the way to the right until the Value field reads 1.00. Next, press it to activate the Loupe, right- or it click inside it and select 800% view from the context menu and position the Loupe over a contrasting edge. Then, drag the Edges slider to the right until you can see evidence of haloing – a pronounced light or dark fringe that extends beyond the edge details – and drag the slider back towards the left until the halo disappears.

Press to deactivate the Loupe and reduce the intensity until a natural but sharp-looking result is obtained and the image loses its harsh contrasty appearance. Apple recommends restricting intensity levels to 0.5 or lower, but depending on the camera, lens, subject matter and intended output, higher levels of Sharpening Intensity may be required.

For most images, you can leave the Falloff slider at its default 0.69 setting. In images where it's difficult to attain a good overall level of Edge Sharpness without introducing haloing, the Falloff slider can make the difference. Set the Intensity and Edges sliders as described, but accept a degree of haloing when setting the Edge parameter. Then use the Falloff control while examining the offending edges with the Loupe to reduce or remove the halo (Fig. 5.35 (a) – (c)).

How to Use the Histogram

The importance of the histogram in analyzing an image's tonal qualities and assessing the impact of changes you make using Aperture's Adjustment controls can't be overemphasized. The histogram confirms what you can see with your eyes (and, sometimes, things that aren't so apparent), but it also provides a diagnostic review of exactly what's happening with an image's tonal range.

The histogram is a graph of the frequency of pixels (displayed on the y-axis) against their value (displayed along the x-axis). Assuming the Luminance channel is displayed for an 8-bit RGB image (for the sake of simplicity), the range of the x-axis extends from zero on the left to 255 on the right (Fig. 5.36).

Pixels with a Luminance value of zero are black, and those with a value of 255 are white. Everything else is in between those two values, ranging from the

FIG. 5.34 All of these images have had the default amount of Edge Sharpen applied – 0.81 Intensity, 0.22 Edges. The top image has had a Falloff setting of 0.69, whereas the Falloff for the center image was set to 1.00 and for the bottom image to zero. For many images the Falloff setting won't make a huge difference to the result, but it can help you obtain acceptable results with high contrast images where haloing might otherwise be a problem.

(a)



173

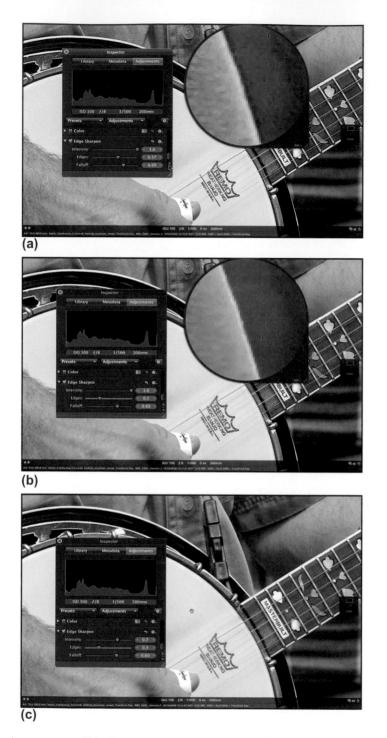

FIG. 5.35 (a) To gauge the correct amount of Edge Sharpen to apply, activate the Loupe (press) and position it over some edge detail. Drag the Intensity slider to the maximum, and then drag the Edges slider to the right until you see the edge start to halo – light and/or dark bands of color will appear either side of it. (b) Next, drag the Edges slider back towards the left until the haloing disappears. (c) Finally, reduce the Intensity to produce a more subtle and natural-looking degree of sharpening.

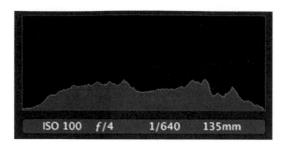

FIG. 5.36 The histogram shows pixel luminance along the x-axis and frequency on the y-axis. The taller the column, the more pixels of that value occur in the image. Moving from left to right, pixel values increase in value and tone from black (0) to white (255).

deep shadows to bright highlights. For a well-exposed scene with a full range of tones, the histogram extends the full width of the chart with peaks and troughs (but, unless there's a serious problem, no gaps) corresponding to the number of pixels at each luminance level. All being well, the graph tails off close to either end, where the incidence of pixels at the extremes of the tonal range declines to zero.

The most common problem identified by the histogram is clipping – where the graph appears cut off at one end rather than declining gradually to zero. This indicates that the camera sensor has been unable to capture the full tonal range in the scene, though as we shall see, especially in the case of highlight clipping, much of this detail can be recovered.

At a glance, the histogram can tell you if an image is over- or underexposed, if the highlights or shadows are clipped, or if it lacks contrast. Just as important, the histogram can be your guide when making adjustments, providing vital feedback to ensure that you don't lose highlight detail when making exposure adjustments or introduce noise by stretching the tonal range in the shadows.

Figure 5.37 shows histogram profiles for some common problems. Generally speaking, when making tonal adjustments you should use the histogram's Luminance view. This displays the tonal range clearly without cluttering the graph with color information that you probably don't need.

Aside from the obvious, like clipping values at either end of the range, when using adjustments you should maintain an awareness of what's happening to the tonal range in the histogram. Although problems of image degradation common with 8-bit RGB files (e.g. posterization, which is discontinuities in the histogram caused by stretching tonal values across too wide a range) are unlikely when working with 12- or 14-bit Raw data, you should nonetheless be aware of the consequences of shifting tonal data around and the difference between using similar tools, e.g. Black Point and Shadows, to achieve the same end – Recovery of Shadow detail. While visual observation of the image can get you a long way to achieving your goal, if you keep one eye on the histogram you can also ensure the integrity of you image data and, ultimately, the quality of the end result.

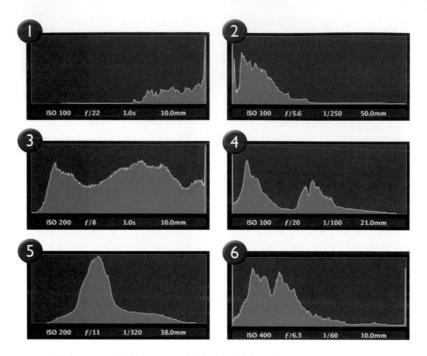

FIG. 5.37 (1) Overexposure, (2) Underexposure, (3) Clipped Highlights, (4) Clipped Shadows, (5) Low Contrast, (6) High Contrast (high dynamic range with clipped highlights and shadows).

Hot and Cold Spots and Clipping Overlays

Aperture clipping overlays provide useful visual feedback which can help you when making tonal adjustments using controls in the Exposure and Levels adjustments. To activate the overlay hold down the (H) key while dragging the sliders (Fig. 5.38).

The overlay color indicates which color channel the clipping occurs in. White indicates clipping in all channels, red in the red channel, and so on. Yellow means clipping is occurring in both the red and green channels. The Aperture User Manual contains a complete list of the clipping overlay colors and their corresponding channels.

You can change the color overlays to monochrome in the Appearance tab of the Preferences window. The lighter the gray, the more channels are being clipped. Generally speaking, you should aim to eliminate clipping in all channels.

The clipping overlays work for the following Exposure adjustment controls:

- The Exposure slider shows highlight clipping.
- The Recovery slider shows highlight clipping.
- The Black Point slider shows shadow clipping.

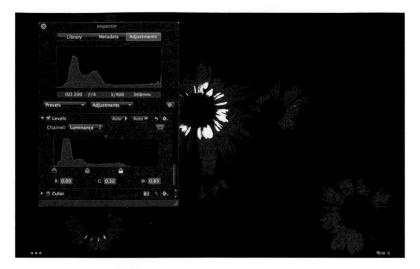

FIG. 5.38 Holding down the **(BR)** key while moving the White Levels slider activates the highlight clipping overlay. Here there is widespread clipping in the blue and green channels and clipping is starting to occur in all three channels, indicated by the white color.

And these Levels controls:

- · The Black Levels slider shows shadow clipping.
- The White Levels slider shows highlight clipping.

Selecting View > Highlight Hot and Cold Areas performs a similar function. The hot and cold areas are displayed permanently, rather than only when using certain adjustment sliders, which makes them a little less convenient. Also, clipping for individual color channels is not shown; hot areas appear red, cold areas appear blue. They can be quickly toggled on and off by pressing \mathbf{N} Shift \mathbf{H} .

Copying Adjustments Using Lift and Stamp

Adjustments you have made to one image can quickly be applied to others using the Lift & Stamp tool. You can do this by clicking the Lift tool in the tool strip, but this will open the Lift & Stamp HUD with Metadata as well as Adjustments selected. To work only with the adjustments, right-click the image you want to copy the adjustments from and select Lift Adjustments from the contextual menu. Click the Adjustments disclosure triangle to see a list of adjustments and delete any that you don't want by selecting them and pressing *Delete*.

Click the Adjustments disclosure triangle to display the individual adjustments that have been applied. Select the images in the Browser that you want to apply the lifted adjustments to, and then click the Stamp Selected Images button on the Lift & Stamp HUD (Fig. 5.39).

FIG. 5.39 Right-click an image and select Lift Adjustments to display the Lift & Stamp HUD showing only adjustments. Click the disclosure triangle and select and delete (backspace) any you don't want; then select the images you want to apply the adjustment to and click the Stamp Selected Images button.

Using Adjustment Presets

You'll frequently apply adjustments with the exact same settings to multiple images. As part of your workflow you might want to, for example, routinely apply Edge Sharpen to images, or apply the same Noise Reduction settings to all images shot at 800 ISO.

Presets make it easy for you to do this by saving commonly used settings so you can apply them from the Preset menu, rather than having to repeatedly adjust individual sliders by the same amount.

In earlier versions of Aperture, presets were restricted to and accessed from the specific Adjustment's Action pop-up menu. Now presets have their own menu at the top of the Adjustments Inspector underneath the histogram and can accommodate multiple adjustments. The presets pop-up menu has a number of existing presets providing fixes for common problems like overand underexposure, processing effects and color filters for black & white conversions. You can get a thumbnail preview of an effect by selecting an image and then hovering over the required effect in the Presets pop-up menu.

To create your own preset just apply the adjustments you want (or select an image to which you've already made the adjustments) and choose Save as Preset from the Presets pop-up menu. The Adjustment Presets dialog opens with the adjustments listed in the right side alongside a new untitled preset ready for you to rename in the left column. Click the minus sign alongside an adjustment to remove it from the preset.

You can organize presets into groups, duplicate, delete and import and export presets from the Adjustment Presets dialog Action pop-up menu (Fig. 5.40).

Using Brush-Based Adjustments

The introduction of brush-based adjustments, allowing you to selectively apply any of Aperture's adjustment tools, is the headline new feature of Version 3 of the application. While Aperture 2 offered brush-based tools like

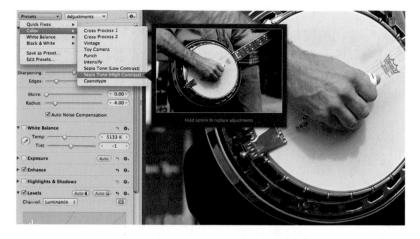

FIG. 5.40 Aperture 3's presets go well beyond what was possible in earlier Versions. You can preview them from the Presets pop-up menu.

Dodge & Burn and other third-party editing plug-ins, these required the creation of an external RGB file and didn't operate 'internally' on Aperture Versions. Aperture 3's brush-based adjustments work internally on Aperture Versions like any other adjustment.

There are two varieties of brush adjustment. Quick Brushes include Skin Smoothing, Dodge, Burn, Polarize, Intensify Contrast, Tint, Contrast Saturation, Definition Vibrancy, Blur, Sharpen, Halo Reduction and Noise Reduction and are listed on a submenu of the Adjustments pop-up menu on the Adjustments Inspector and on a new Quick Brush pop-up menu on the tool strip. You can now also apply many of Aperture's 'standard' adjustment using a brush and we'll look at how that's done a little later.

When you select one of these Quick Brushes, its Brush HUD appears and the adjustment is added to the Adjustments Inspector. The Brush HUD has sliders for Brush Size, Softness and Strength and three buttons – one for activating the brush, one for feathering edges and a third for erasing brush strokes.

You can restrict Brush adjustments to the shadows, midtones or highlights, apply the adjustment to or clear it from the entire photo, or invert the adjustment so it is applied to the non-brushed areas and vice versa. All these options are available from the Brush Action pop-up menu, as is a choice of four different overlay views which show exactly where brush strokes have been applied (Fig. 5.41).

The amount of adjustment applied is controlled via a slider in the Adjustment Inspector; you can also turn the adjustment on and off from here as with other non-brush-based adjustments. Moving the slider after brush strokes have been applied changes the amount globally – for all existing brush strokes.

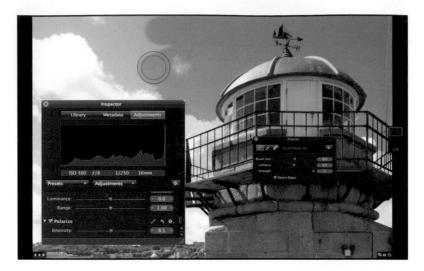

FIG. 5.41 Quick Brushes duplicate some 'standard' Aperture adjustments, like Saturation and Definition, but include several, like Skin Smoothing, Dodge, Burn and Polarize, specifically designed for brush application. Here, the Polarize Quick Brush is used to intensify the blue sky.

Brush adjustments are basically applied using a mask, which is what you see when you activate one of the overlays. To use a Photoshop analogy, they're the equivalent of an Adjustment layer applied with a layer mask.

You can also apply many of Aperture's 'standard' adjustments using a brush, including Enhance, Highlights & Shadows, Levels, Color, Chromatic Aberration, Devignette, Noise Reduction, Curves, Black & White, Color Monochrome, Sepia Tone, Sharpen, Edge Sharpen and Vignette (Fig. 5.42).

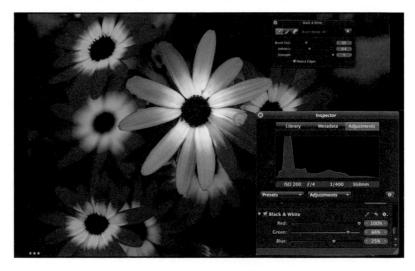

FIG. 5.42 'Standard' Aperture adjustments can also be applied using brushes. Here a Black & White adjustment is brushed in using the Edge Detection option to avoid straying outside the flower petals.

FIG. 5.43 Brush-based adjustments are masked. You can view the mask overlay from the Brush Actions pop-up menu.

Using the Adjustment Action pop-up menu you can elect to either brush the adjustment in, or brush it away. In the first instance the adjustment is applied to your brush strokes; the second option applies the adjustment to the entire image and you then brush (i.e. mask) out the areas you don't want affected. Like the Quick Brush adjustments, the Brush HUD has a Detect Edges checkbox which enables you to paint on adjustments without going over the edges.

The ability to apply all of Aperture's standard adjustments in this way, plus some new ones specifically designed for brush application, marks a huge leap forward in Aperture's editing capabilities, making it possible to achieve a great deal more within the application and drastically reducing the need for plug-ins and round-trip editing in Photoshop (Fig. 5.43).

Common Problems and How to Correct Them

Overexposure

With Raw images, there's a fine line between ensuring that you use the full range of available bits to capture as much of the tonal information in a scene as possible, and overexposure. But even when you go a little too far, and end up with a histogram that's clipped on the right-hand side, Raw images seem to have something in reserve that Aperture is very good at recovering. Aperture's Exposure and Highlight recovery tools can rescue highlight detail from images that, on an initial assessment, seem beyond the pale.

The tools you need for correcting overexposure and recovering highlights are located primarily in the Exposure adjustment. You can increase your

FIG. 5.44 The histogram from a correctly exposed image.

FIG. 5.45 The histogram from an overexposed image.

chances of a successful result by careful tweaking of the Raw Fine Tuning Controls and by employing a combination of adjustments including Highlights & Shadows and Levels.

Because they require different approaches, we'll deal separately with overexposure and high dynamic range problems. Overexposure occurs when you (or your camera, if you're shooting using an Auto Exposure mode) select the wrong aperture and shutter speed combination for the scene you are photographing, which results in more light hitting the sensor than would result in a balanced exposure recording all the tones in the scene and producing a histogram like that in Fig. 5.44.

A very overexposed image has a histogram that looks like the one in Fig. 5.45. There are no pixel values in the left half of the histogram and everything is bunched up on the right side, resulting in loss of highlight detail.

In some ways, overexposure is easier to deal with than high dynamic range problems, because all of the tonal values need to be shifted leftwards on the histogram, i.e. darkened. The primary adjustment for accomplishing this is the Exposure slider in the Exposure adjustment.

As a first step click the disclosure triangle to reveal the Exposure adjustment sliders and drag the Exposure slider towards the left until you can see the right side of the histogram. The slider is not linear, but is calibrated to provide more control at lower adjustment settings. The further you move the slider towards the end of the scale, the more effect incremental adjustments have. The first four-fifths of the slider's range change the Exposure value from 0 to -1 and the final fifth changes it from -1 to -2.

If an Exposure value of -2 is insufficient to bring the right-hand edge of the histogram within range, you can add further Exposure adjustment by dragging the Value slider. This can take you all the way to -9.99, but if an image requires more than two stops of exposure correction it's unlikely you'll obtain a great quality result.

With the Exposure adjustment made, all of the histogram should now be within range, but the image may still be lacking highlight detail. You can use the Recovery slider to regain some of this, but with very overexposed images combining it with the Highlight and Shadows adjustments is often more effective.

First drag the Recovery slider all the way to the right, and then use the Highlights slider to further bring overexposed regions into the highlight and three-quarter tone area of the histogram. If at this stage of the process you discover that the right edge of the histogram is well within the right boundary, but the image still lacks highlight detail, return to the Exposure slider and ease off the original setting by dragging the slider slightly back toward the center and compensate by adding more Highlight adjustment. By re-adjustment of these two controls – Exposure and Highlights – you

should be able to reach a position which looks good visually and, from a histogram standpoint, with reasonably good detail in the three-quarter tones and highlights.

The final problem you are likely to have with an overexposed image is that the histogram falls short on the left-hand side, the shadows look washed out, and the image lacks contrast. You can fix this either by dragging the Black Point slider in the Exposure adjustment to the right or by using a Levels adjustment (Figs 5.46–5.53).

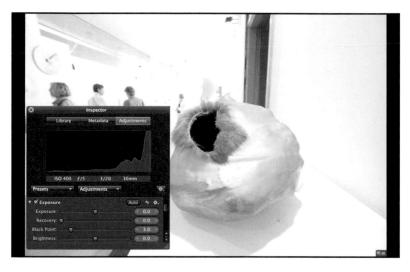

FIG. 5.46 Dealing with overexposed images. This image is quite badly overexposed, but not beyond rescuing.

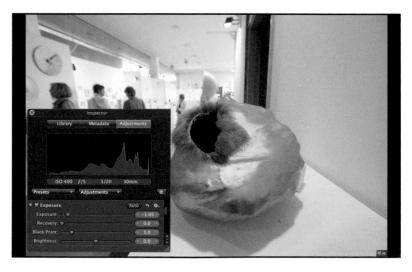

FIG. 5.47 First, use the Exposure slider to bring the right side of the histogram into view.

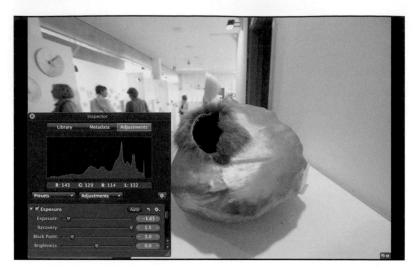

FIG. 5.48 Then use the Recovery slider to try to get some detail back into the highlights. These highlights are so seriously blown we're unlikely to get much detail back, but every little helps.

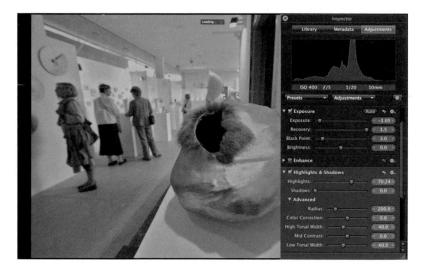

FIG. 5.49 If you can't get sufficient detail into the highlights with the Recovery slider, move on to Highlights & Shadows.

Slight Overexposure and High Dynamic Range

In most situations the range of tones in a scene, from solid black to pure white, can adequately be captured by dSLR sensors, which are capable of capturing around seven stops. In subjects that exceed this range something has to go and you'll lose detail in either the highlights or shadows, or both.

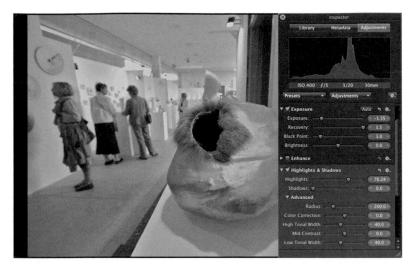

FIG. 5.50 Return to the Exposure adjustment and ease off to accommodate the Recovery and Highlights changes.

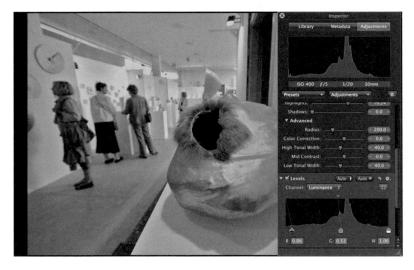

FIG. 5.51 Add some density to the shadows using the Black Levels slider and a White Balance adjustment.

High dynamic range (HDR) is also a term applied to a technique which combines several bracketed exposures in order to capture tonal detail in scenes with a dynamic range that it would not be possible to capture with a single exposure. An HDR image uses 32-bit floating point data, which are usually tone-mapped to a 16- or 8-bit integer format in order to print it or display it on a monitor.

Aperture doesn't provide such HDR compositing tools, but it is so good at recovering highlight detail that you can often get excellent results from a single image, provided it is well exposed.

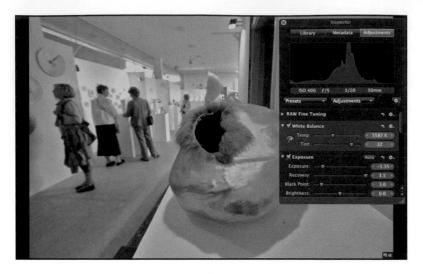

FIG. 5.52 ... And finally a White Balance adjustment to neutralize the blue cast.

The first place to start is the Raw Fine Tuning controls. Reducing the Boost from its default setting of 1.0 can recover a significant amount of lost highlight detail. Don't try to fix everything in one hit. Boost controls the contrast over the entire tonal range, so keep an eye on the histogram and watch out for compression of the midtones and loss of detail in the shadows.

Generally speaking, you shouldn't be reducing the boost beyond the midway 0.5 mark. You can always come back and re-adjust it if necessary when the other adjustments have been made.

Next, open the Exposure controls and drag the Recovery slider to the right. Recovery is specifically designed to recover blown highlights. Its effects can appear to be quite subtle, and it is more successful in images with clipping in only one or two color channels than where all three are blown. Hold down the Recovery to use the highlight clipping overlay and keep dragging the slider right until all of the clipping is eliminated or at least substantially reduced.

Although the highlights are no longer clipped, they still lack detail, which can now be recovered using Highlights & Shadows. Drag the Highlights slider to the right to restore as much of the remaining highlight detail as you can.

Restoring highlight detail involves reducing the brightness of pixels in the highlights – effectively squeezing the right-hand side of the histogram to restore detail to clipped highlight areas. Sometimes, a consequence of this is that the midtones are compressed and images can begin to look dark and flat as a result.

Although it seems somewhat counter-intuitive to brighten an image that you've spent time and effort in restoring highlight detail to, adjust the

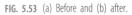

Brightness to lighten the midtone values. Finally, you may need to restore some contrast by moving the Black Point slider to the right until the left side of the histogram approaches the edge. At all times during this process your eyes should be on the histogram as well as the image (Figs 5.54–5.59).

ISO 200 F/8 1.05 1.00 0.50 0.50 0.18 0.00 W A.

FIG. 5.54 The range of tones in this image is too wide to be captured by the camera sensor. An exposure has been made that captures the shadow detail without clipping, but the highlights are blown out. With high dynamic range subjects, this is the kind of histogram you want to see. To reverse the old adage, expose for the shadows, develop for the highlights.

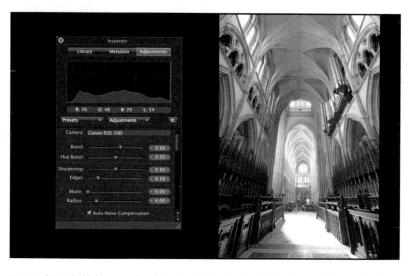

FIG. 5.55 Initiate highlight recovery by reducing Boost in the Raw Fine Tuning adjustment. Boost applies quite an aggressive contrast increase and reducing it to around half its default value can make a big difference, but don't try to do it all with the Boost slider.

Underexposure

Severe Underexposure

Underexposure is a more difficult problem to remedy than overexposure and therefore one which, if at all possible, should be avoided. The problem with

Bispector Ubrary Metadata Adjustments SO 200 f/8 1.0s 10mm Presets Adjustments O 107 Hay Solution Presets Adjustments O 107 Hay Solution Presets 0 107 Hay Solution Presets 0 108 Hay Solution Presets 0 108 Hay Solution 108 Hay Solutio		4.
SO 200 f/8 1.05 1.0mm Prests Adjustments 0 Int Int 0 * # Exposure 0.01 1.05 Recover 0.03 1.05 Black Point: 0.05 1.05 Brgbriess 0.05 1.05 I Highlights & Shadows 0. 1.05		11
Presets Adjustments O Int Int Int * M Exposure Main 9 Exposure: 000 Recovery: 138 Black Point: 300 Srightness: 000 * M Explane 100 * Mighlights & Shadows 0 * Mighlights 8K/72		
Presets Adjustments OC Intt Intt J * M Exposure Add0 6. Exposure: 0.00 Recovery 1.38 Elack Point: 0.00 Prightness: 0.00 * Exploration 0.00 * Exploration 0.00 * Teighlights & Shadows 0. * Teighlights 9.		
Presets Adjustments OC Intt Intt J * M Exposure Add0 6. Exposure: 0.00 Recovery 1.38 Elack Point: 0.00 Prightness: 0.00 * Exploration 0.00 * Exploration 0.00 * Teighlights & Shadows 0. * Teighlights 9.		
Presets Adjustments Of Imt Imt Imt * M Dosure Adjustments 0 * M Dosure 000 Recovery 000 Bick Point 000 Binghtness 000 * M Biolight & Shadows 0. * M Biolight & Shadows 0.		
Pristit Adjustments O Int I I ** If Exposure Full 0.0 Exposure 0.00 0.0 Back Point 0.00 0.0 * If Enhance 0.0 0.0 * Highlights & Shadows 7 0.		
Litt ■ B ▼ M Exposure 0.00 P. 0. Posture 0.01 P. 0.01 Recovery 1.35 B Black Point: 0.03 P. 0.03 Brightnass 0.03 P. 0.03 P IT Explanate 0.03 P. 0.03 P IT Explanate 0.03 P. 0.03 P IT Highlights 0.04 0.04		
V Exposure AUR > 0. Exposure 0.0 0.0 0.0 Recovery 0.138 0.0 0.0 Black Point: 0.0 0.0 0.0 Brightness: 0.0 0.0 0.0 P E Enhance 0.0 0.0 0.0 P Highlights: 0 0.0 0.0		
Exposure: 0.0 Recovery: 1.38 Black Point: 0.0 # Explores: 0.0 > E Enhance 9 > E Highlights: 5 Abadows > Highlights: 0		
Recovery • 135 Black Point: • 50.0 Brightness: • 0.0 • E Enhance • 0. • T Highlights & Shadows • 0. • Highlights & Shadows • 0.		
Black Point:		
Brightness 0.0 F Einhance 7, 0, F Highlights & Shadows 7, 0, Highlights		
▶ ■ Enhance 7: 0. ▼ ■ Highlights & Shadows 7: 0. Highlights	18 32	
♥ 🗏 Highlights & Shadows 🥎 O. Highlights:	18 55	
Highlighter		
Shadowe =		

FIG. 5.56 Next, drag the Recovery slider to the right while holding down the **H** key until none of the color channels is clipped.

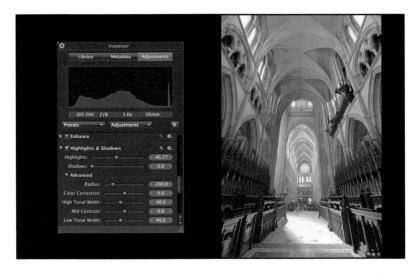

FIG. 5.57 Restore additional highlight detail using a Highlights & Shadows adjustment. Drag the Highlights slider to the right.

adjusting underexposed images is that what tonal information exists is recorded using only a fraction of the bits available to the camera sensor. (See Chapter 1 for a more detailed explanation of why this is so.)

A consequence of dealing with image data recorded using relatively few bits is that edits carry the risk of enhancing noise as well as genuine image data. While the histogram can tell you how healthy an image is in terms of tonal distribution, the only way to tell if you've produced a noisy image is to take

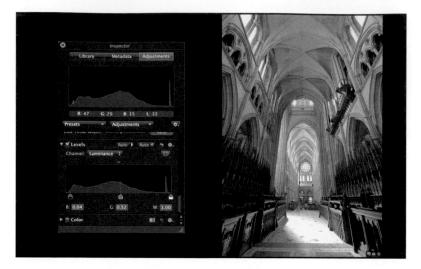

FIG. 5.58 Finally, restore contrast using a Levels adjustment. Drag the Black Levels slider slightly to the right to add density to the shadow detail.

(b)

FIG. 5.59 (a) Before and (b) after.

a close look at it. Very often when dealing with underexposed images, noise is simply something you have to live with.

First let's look at a case of severe underexposure (Fig. 5.60). Here's an indoor shot that's several stops underexposed and exhibits a typical underexposed histogram – there are very few pixel data in the right half of the histogram. Dragging the Exposure slider to the right side of the scale results in some improvement, but the shadows and midtones are still heavily compressed. Dragging the Exposure value slider to around 2.60 results in further improvement, but the histogram indicates that any further increase in exposure risks clipping the highlights in the illuminated panel above the dance machine.

To recover the deep shadows, first drag the Black Point slider from its default value of 3 towards the left end of the scale. A Black Point value of 0 reintroduces some shadow detail without affecting the contrast too badly.

Next, click the disclosure triangle to reveal the Highlights & Shadows controls. The shadows adjustment is designed specifically to reintroduce detail into dense shadows; drag the slider to the right to further enhance the shadow detail. You might find it helpful while you're doing this to toggle the Shadows adjustment on and off using the Highlights & Shadows checkbox. Note how when you drag the Shadows slider to the right, the histogram shifts in the same direction, but the Black Point – the left-most pixel values on the chart – remains fixed.

At this stage of the process noise will almost certainly start to become apparent even at less than actual size view. To get a proper look at just how bad the problem is, press the 🖉 key to view the image actual size, or press 😭 for the Loupe.

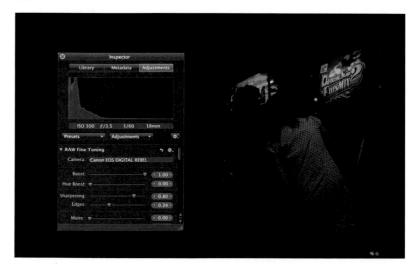

FIG. 5.60 This is the kind of severely underexposed image you might get if a flash fails to fire. It can be rescued, but spreading the relatively small amount of data recorded in the shadow region of the histogram will introduce severe noise.

The only effective way to deal with it is to back off the Shadows and Black Point adjustments to reintroduce clipping of the shadows, or alternatively to clip the blacks with a Levels adjustment. The noise is inherent in the shadow data and the two are, practically speaking, inseparable. You can also try reducing the impact of the noise using Noise Reduction (Figs 5.61–5.65).

50 100 1/3.5 1/60

FIG. 5.61 Start with a hefty Exposure adjustment. Dragging the slider will only get you to 2.0; for larger adjustments like this one you need to drag the Value slider (position the cursor over the Value field and drag) or enter the value in the field.

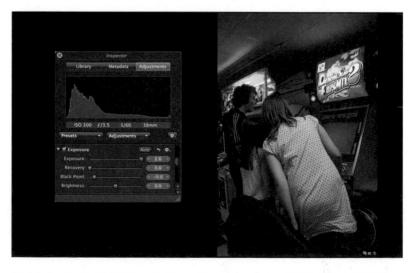

FIG. 5.62 Drag the Black Point slider to the left to get back yet more shadow detail. Reducing the Black Point value to 0 recovers some shadow without a big reduction in contrast.

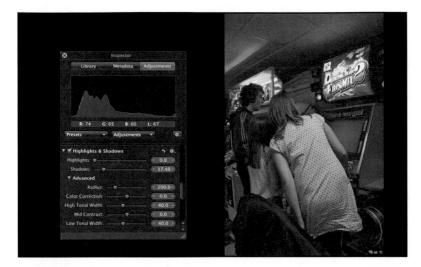

FIG. 5.63 Now use a Highlights & Shadows adjustment to lighten the shadows up to the midtones. Drag the Shadows slider to the right.

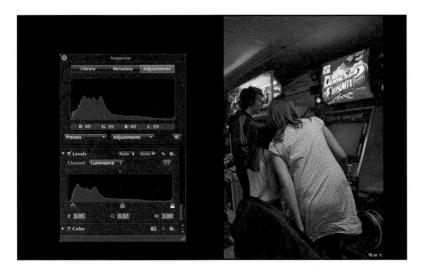

FIG. 5.64 Finally, you may need to reintroduce some density to the blacks to restore contrast and reduce the impact of noise. Here we've done that with a Black Levels slider adjustment.

Mild Underexposure and Shadow Recovery

Much more common than the sort of severe underexposure just dealt with is an image in which some degree of shadow clipping has occurred either as a result of slight underexposure or because of high dynamic range in a scene. In an attempt to hold the highlights, an exposure has been made which has lost some of the shadow detail.

Apple Aperture 3

(b)

The histogram for this kind of image looks like that in Fig. 5.66. Unlike the underexposed image, the pixel data extend well across the histogram and are almost touching the right side, but the left side is clipped indicating that some shadow detail has been lost.

Depending on how close to the right side of the histogram the highlights are, you may get away with a small amount of positive Exposure adjustment, but in an image with a full tonal range you're likely to lose highlights as you gain shadows, so it's probably best avoided.

The Shadows slider of the Highlights & Shadows adjustment is designed specifically for this task and is most likely the only thing you'll need (Fig. 5.67). Drag the Shadows slider to the right until the spike disappears from the left side of the histogram. Depending on the nature of the subject, and the degree of Shadow adjustment necessary, it may also help to boost the midtone contrast a little.

As always when making adjustments that stretch the shadow region of the histogram, be on the lookout for noise. If this becomes apparent, rather than

FIG. 5.65 (a) Before and (b) after.

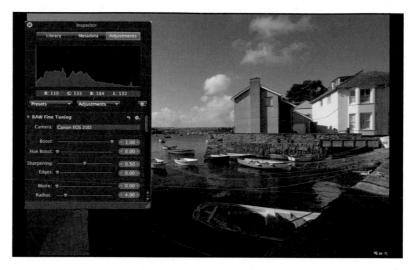

FIG. 5.66 This shot has tonal detail extending into the highlights, but the shadows have been clipped and the foreground detail is dark.

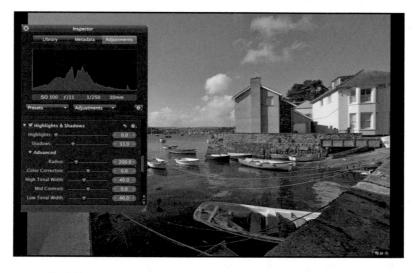

FIG. 5.67 The Highlights & Shadows adjustment was designed to address exactly this kind of problem. Dragging the Shadows slider to 33 provides a 'fill flash' effect.

backing off the Shadows adjustment you may get more mileage (in other words, reduce the degree of visible noise with less of a compromise on shadow recovery) by increasing the Radius value and/or decreasing the Low Tonal Width value. To access these controls check the Advanced disclosure triangle.

Low Contrast (Flat) Images

Low contrast images can be identified by a histogram that doesn't reach either end of the chart. There are no pixels with values in the shadow or highlight tonal ranges and, in the absence of rich blacks and pure whites or values close to them, images look flat and washed out.

Fixing poor contrast simply involves stretching the histogram and evenly redistributing the tonal values so they extend to either end. The Auto Levels Combined button on the Levels adjustment usually makes a pretty good job of this, but you can do the job almost as quickly using a manual Levels adjustment and, even if you do use Auto Levels, you'll probably need to make a slight adjustment to it anyway.

Figure 5.68 shows a flat image that's lacking in contrast. Click the Auto Levels Combined button and click the disclosure triangle on the Levels adjustment to view the adjustment that has been made. Auto Levels had adjusted the White Levels slider to 0.88 and the Black Levels slider to 0.12.

The result isn't bad, but some highlight detail in the sky has been lost and the shadows still lack sufficient punch. Turn on Highlight Hot and Cold Areas (View > Highlight Hot and Cold Areas or Shift (f)) to see any clipping that may have occurred. To restore the highlights drag the White Point slider back to the right until all of the red colored hot pixels disappear.

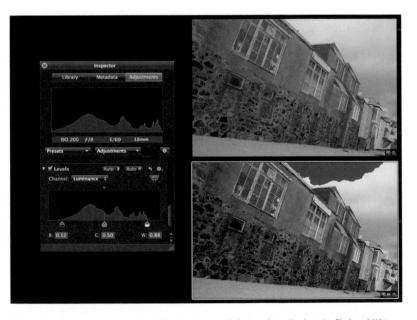

FIG. 5.68 To fix poor contrast start by clicking the Auto Levels button; this will adjust the Black and White Levels sliders to the ends of the histogram.

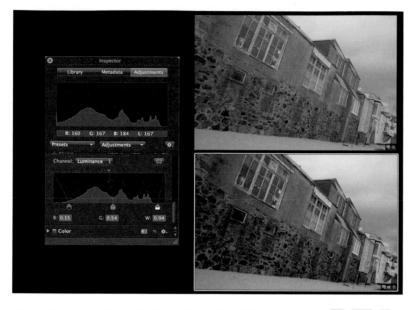

FIG. 5.69 Turn on Highlight Hot and Cold Areas (View > Highlight Hot and Cold Areas or Shift (H) to see any clipping that may have occurred. Depending on the image, further adjustment may be necessary.

Next, drag the Black Levels slider to the right to add density to the shadows. Shadow clipping is indicated by cold, blue-colored pixels. A little filling in of the brickwork is acceptable in order to produce an image with improved overall contrast (Fig. 5.69).

Dealing with Color Casts

Using White Balance

Color casts are most often caused by incorrect White Balance and are therefore easily corrected using the White Balance adjustment. Incorrect White Balance leads to either a blue cast if the White Balance is set too low or a yellow cast if it is set too high. Setting White Balance for tungsten lighting with a color temperature of 3500K and then shooting outdoors leads to a pronounced blue cast, and doing the reverse – setting daylight White Balance of 5500K and shooting indoors, leads to a pronounced orange/yellow caste. In between exists a range of problems most often caused by a camera's automatic White Balance setting getting it wrong (Fig. 5.70).

As mentioned earlier, if White Balance is critical, a neutral gray card can be photographed in the scene and subsequently used to set White Balance using the White Balance adjustment's eyedropper, or the gray point eyedropper on the Curves adjustment.

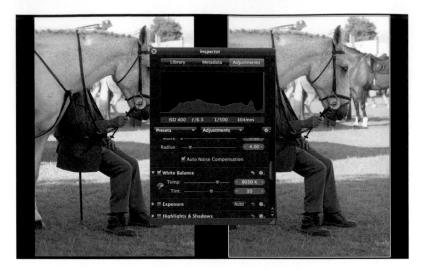

FIG. 5.70 The first stage in your color correction workflow should be to set the White Balance. This early evening scene was determined by the camera's Auto White Balance to have a color temperature of 5693K and has resulted in a cold image with a blue horse. Increasing the White Balance to 8030K results in a warmer, more natural-looking image with a white horse.

In the absence of a gray card, use the White Balance eyedropper to click on any neutral area in the image; the Loupe automatically appears when the eyedropper is selected to help you make an accurate selection.

Further manual adjustment is likely to be necessary after you've used the eyedropper. Move the Temp slider to the right to increase the indicated source color temperature and make the image warmer (more yellow) and to the left to make it cooler (more blue).

The Tint slider is used to correct green/purple casts. Depending on the camera, and the scene, it's usual position is in the 0 to 10 range and on the rare occasions you might need to adjust it to eliminate a slight purple or green cast, only small variations should be necessary.

Using Tint

Uniform White Balance problems are easily dealt with using the White Balance adjustment, but sometimes color casts are not uniform. Scenes lit by a mixture of daylight and artificial light, for example interiors with room lighting switched on and daylight coming in through windows, are impossible to color balance using White Balance. If you adjust for the room lighting, areas lit by daylight appear blue and vice versa.

In these situations, the Tint controls on the Enhance adjustment provide a solution. First, set the overall White Balance as just described. You will need to have, at the outset, a clear idea of how you want the final image to look. It will probably not be possible, or even desirable, to completely neutralize all casts. Usually, in an interior shot you'll want to maintain a degree of warmth in the image and eliminate the worst of the blue daylight cast, so start by using White Balance to achieve the desired color temperature of the interior lighting.

Next, click the Tint disclosure triangle on the Enhance adjustment to reveal the Tint color wheels. The three sliders control Tint adjustment in the shadow, midtone and highlight regions respectively. Each has an eyedropper which you can use to sample from the image, but provided you can identify where the cast is, you're probably better off just dragging the White Point spot in the center of the relevant color wheel and visually assessing the result.

In Fig. 5.71, the offending blue cast is in the highlights and midtones outside the window. Dragging the Gray and White Tint controls to the yellow side of the color wheels considerably neutralizes the blue cast. If you find it hard to judge the degree of correction, temporarily increase the Saturation slider to exaggerate your changes.

Fortunately, most of the interior of this shot falls into the shadow regions and so is unaffected. Tonal ranges aren't always so accommodating and you may

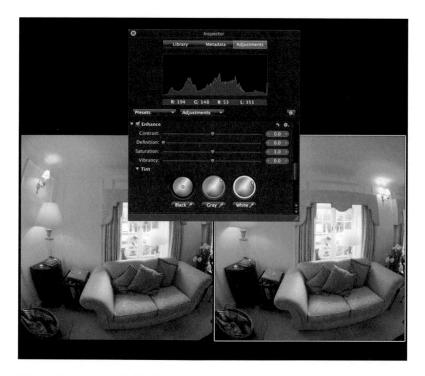

FIG. 5.71 Use the Tint controls of the Enhance adjustment to deal with color casts caused by mixed lighting. Here, the blue cast on the sofa caused by the daylight entering through the window has been reduced by adjusting the Gray and White Tint color wheels.

find it is impossible to correct the cast without adversely affecting acceptable parts of the image. If this happens the best solution is to use a brushed Tint adjustment to correct the offending areas.

Using Levels

You can correct a color cast using the individual red, green and blue channels of the Levels adjustment. Although you can visually gauge the effect of editing individual color channels while adjusting the sliders, some knowledge of color theory will help you make the right choices. A detailed explanation of color theory is outside the scope of this book; however, those not familiar with basic color theory might find it helpful to know that adding one of the three primary colors to an RGB image has the same effect as subtracting its complementary color (i.e. the opposite color on the color wheel). So:

- adding red is the same as removing cyan
- adding green is the same as removing magenta
- adding blue is the same as removing yellow.

Using a Levels adjustment to address color cast issues has the advantage that you can confine your adjustments to specific parts of the tonal range. To remove a blue cast from the midtones, select the blue channel from the Channel pop-up menu in the Levels adjustment and drag the Gray Levels slider to the right. This removes blue (adds yellow) to the midtones.

To remove blue from the shadows, drag the Black Levels slider to the right. If you want to remove blue from the highlights, you will need to drag the White Levels slider to the left on both the red and green channels. You can't drag the White Levels slider to the right, and adding red and green is the same as removing blue.

As a general rule, drag the Levels sliders at the bottom of the histogram to the right to remove the selected channel color and to the left to add it. For more control over color casts in specific tonal regions, click the Quarter Tone controls button and use the quarter and three-quarter Tone Levels sliders (Figs 5.72–5.74).

Creative Techniques

Color to B&W

Although it doesn't provide a wealth of creative options, Aperture has a good set of tools for converting color images to monochrome and applying tints. Whether for weddings and portraiture, fine art photography, or just experimentation, you can quickly and easily produce monochrome and tinted Versions from color masters.

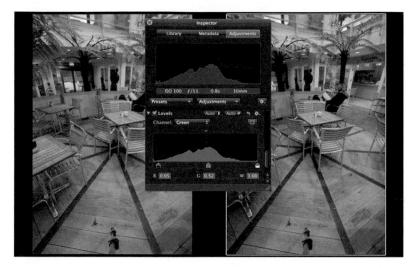

FIG. 5.72 This image has a slight green cast in both the shadow and highlight regions. To remove the green cast from the shadows, select the green channel in the Levels adjustment and drag the Black Levels slider to the right to remove green.

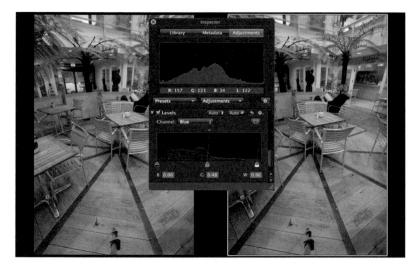

FIG. 5.73 You can't add green to the highlights using the green channel, but adding green is the same as removing its complementary color, magenta, which is the same as removing blue and red. Select the blue channel from the Channel pop-up menu in the Levels adjustment and drag the White Levels slider to the left.

If you've used Photoshop's Channel Mixer, or Black and White filters, or if you've used colored filters in black and white film photography, you'll quickly feel at home with Aperture's Black & White adjustment. To add a Black & White adjustment to the Adjustments Inspector, select it from the Adjustments pop-up menu.

FIG. 5.74 Finally, select the red channel and drag the White Levels slider to the left.

The Black & White adjustment mixes tonal data from the RGB images' three color channels to produce a monochrome result. Initially the mix is set at 30% red, 59% green and 11% blue, which produces a well-balanced result.

By changing the mix you can emulate the results produced when using color filters with black and white film. For example, dragging the Red slider to 100% and reducing blue and green to zero has the same effect as a Red filter, i.e. lightening the tone of red elements in the image and darkening greens.

To reproduce the effect of a Yellow filter use 50% red and 50% green. You can obviously reproduce any color filter you like in this way; the only general rule you need to follow is to ensure that the sum of the three channels equals 100% if you don't want to lighten or darken the image overall.

The Presets pop-up menu provides five preset colored filters and, of course, you can define and create your own.

You can usually get the effect you're looking for – whether it's roses with light flowers and dark foliage, or dark skies with billowing cumulus clouds – by following the general rule that a filter lightens the tones of same or similar colors and darkens those of complementary colors. Hence for the rose you'd choose a Red filter, or orange for a less dramatic effect. Start with a preset, and then use the sliders – keeping in mind the 100% rule – to make minor tonal adjustments (Figs 5.75–5.77).

Tinting

Aperture has two tint adjustments – Sepia Tone and Color Monochrome. Sepia Tone is little more than a single tint version of Color Monochrome. You

FIG. 5.75 This graphic shot is a good candidate for conversion to black and white using a Black & White adjustment because the predominant colors are well spaced on the color wheel and will be easy to separate.

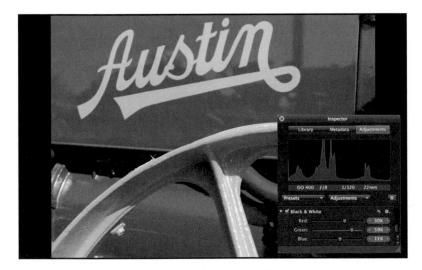

FIG. 5.76 Select a Black & White adjustment from the Adjustment pop-up menu. The default result isn't bad, with good tonal separation between the orange Austin lettering and wheel and the blue paintwork.

can do everything Sepia Tone does, and more, using Color Monochrome so, other than including an example of what Sepia Tone does (Fig. 5.78), we'll concentrate on Color Monochrome.

To add a Color Monochrome adjustment, select it from the Adjustments popup menu. There are only two controls: a color swatch and an Intensity slider.

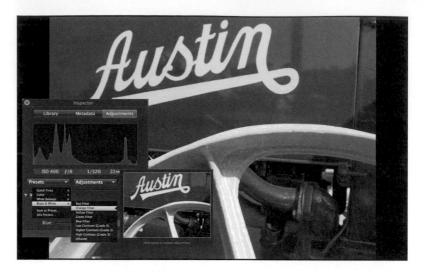

FIG. 5.77 Selecting a Black & White adjustment with an orange filter preset lightens the orange lettering and wheel and darkens the blue paintwork, providing a more dramatic contrast between the two.

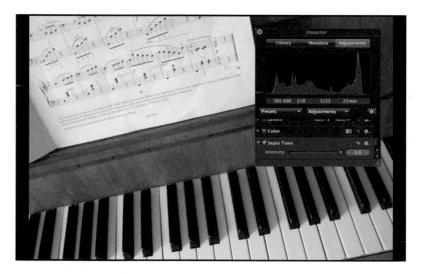

FIG. 5.78 Sepia Tone is a one-trick pony; use the more versatile Color Monochrome instead.

The default color is sepia and the intensity is the maximum 1.0. At this intensity all of the color in the image is replaced by the tint.

To change the color, click the color swatch and select a new tint color using the Colors palette. The image updates in real time so you can see the effect immediately. Drag the Intensity slider to the right to reduce the tint intensity and reintroduce some of the original image color. Reducing the tint intensity produces a pleasing effect. The reduced color saturation and tint combine to produce an effect that looks part tint, part hand-colored. But it isn't a black and white tint in the conventional sense of a mono print which has had a chemical toner applied. To reproduce this effect, combine Black & White and Color Monochrome adjustments.

First, add the Black & White adjustment as described earlier. One of the advantages of this method is that you have more control over tonal reproduction. Choose a color filter preset, and use the Red, Green and Blue sliders to achieve the desired tonal balance.

Next, apply the Color Monochrome adjustment. Select the desired color tint and adjust the intensity. Now, instead of a mix between the original image colors and the tint, the Intensity slider progressively replaces the tones in the black and white image, producing a conventional mono color tint.

You can continue to adjust the red, green and blue balance in the Monochrome Mixer to optimize the effect after the color tint has been applied. You may also want to make a Levels adjustment to lighten the midtones.

By comparison with the transfer function-based duo- tri- and quad-tone and mask-based split-toning effects possible in Photoshop, Aperture's Color Monochrome adjustment is relatively unsophisticated, but you can achieve some quite acceptable monochrome toning effects with it (Figs 5.79 and 5.80).

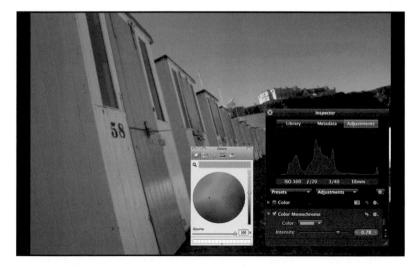

FIG. 5.79 At Intensity settings below 1.00, Color Monochrome combines a desaturated version of the original with a monochrome tint. Click the Color Monochrome swatch to select the tint color using the Colors palette.

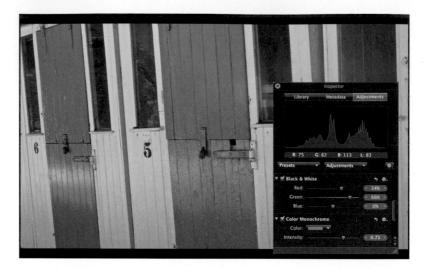

FIG. 5.80 For a true monochrome tint, with greater control over tonal reproduction, combine Monochrome Mixer and Color Monochrome adjustments.

CHAPTER 6

Using Projects, Albums and Folders

As explained in Chapter 2, Aperture subdivides your assets into various different groups. These groups can contain further sub-groups, helping you to quickly navigate to the precise photos you need; they also help the software to perform searches on the basis of your specified criteria.

Sometimes this is done automatically, such as when you import a series of Folders as a Project; sometimes it is done manually, such as when you create a Folder yourself and drag images into it. Occasionally it is done passively, such as when you create a Web Page, which uses photos from an existing collection to create an entirely new one while you work on a related creative Project.

These groupings are set to cascade, so that each superior group – whether that be a Project, Folder, Album or the whole Library – also gives you access to all of the contents of the inferior groups. Viewing the contents of a parent Folder will therefore also show you the contents of the Projects that go to make up that Folder. However, if that Folder contained four Projects, clicking on any one of them individually would show you only its own specific contents and not those of the other three Projects within the overall Folder. The easiest way to visualize this is as a top-down view of an open box, inside of which there are several smaller boxes. From your aerial vantage point you can see the large box – the Folder, in our analogy – and the contents of all of the smaller boxes – the Projects, Albums, and so on. However, if you were to lower yourself so that your face was close to one of the small boxes, you would no longer have an overview of all of the constituent parts, but only those of the smaller box directly in front of you.

The only anomaly comes in the fact that when you have a top-level Folder or a Project selected in the Library Inspector, then the Browser – whether in Grid, List or Filmstrip mode – shows only the contents of the constituent subdivisions, and not the subdivisions themselves, so you will have no way of knowing whether all of the images you are looking at appear in the same Project or Album, or different ones. There is good reason for this: the Browser and Viewer are focused entirely on the processes of sorting and editing your work, while the Library Inspector is focused solely on organization (Fig. 6.1).

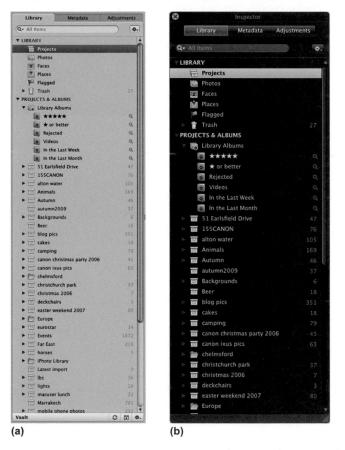

FIG. 6.1 The Library Inspector is used purely for organizing your Projects, Folders and creative products. It works hand in hand with the Browser, which displays the contents of each item in the Inspector. It can be viewed as part of the Inspector panel (a) or a HUD (b).

However you look at them, these subdivisions remain the most powerful tools at your disposal when it comes to visualizing how your assets relate to one another, and they back up the metadata-based filtering carried out behind the scenes by Aperture itself.

Folders

Folders work on two levels. On the first, they sit above your Projects, in the root of the Library, and act as a loose container into which you can throw everything with which you are working, including your Projects, subfolders, Light Tables, Books and Web Projects. These must sit inside organized subdivisions within. These top-level Folders, and any Folders they contain that are not also a part of a Project, are colored blue.

On the second level, you can create further Folders that act as subdivisions within a Project. Note, though, that like the top-level Folders these cannot directly hold images themselves, but only the Projects into which the images are organized, or the products that you are making with them.

Projects

After the overarching Library, which contains every asset in your collection, Projects house the largest group of assets at your disposal. They are the first level in which you can store images, but they can also contain products, such as Web Pages, Web Galleries, Journals and Books. They can only be created inside either the Library's root level, or within Folders.

Projects will usually be organized along subject lines, and should be seen both as a collection of assets and of the output of those products right up until the point just before they become physical printed or digitally published items.

A Project will be the initial point of entry for items in your Library, however you bring them into the application. They can therefore be the most generalized collection of images at your disposal. Despite this, they can remain useful delimiters, allowing you to differentiate between, say, different clients, or the countries in which a series of travelog photos were taken.

Because you can only import images in Aperture into Projects (and a new Project will be created inside whichever other organizational entity you try to use), they are the ideal means of organizing related images, and so are the best defining blocks to use when you want to move pictures en masse from one installation to another.

Many professional photographers will work with two machines: one powerful desktop set-up in the studio, which they use for editing and output, and one smaller, lighter, less powerful portable machine that they use on the move. If

you are importing your images into this mobile machine on location, you will need to transfer them to the desktop machine when you return to the studio. Likewise, if you're halfway through an editing job at the end of the day, you may want to transfer your work to the portable to continue at home, or during a commute.

In these instances, you would export whole Projects as new Aperture Libraries to move whole batches of images, including Versions and Digital Masters, from one computer to another. You would not use Image Exports, as these would include only individual photos and not all of their supporting assets or the Directory structure you have put in place.

Exporting Projects is a simple case of picking File > Export > Project as New Library... and picking a name and destination Folder. If your Project uses referenced images stored elsewhere on your Mac, you should check the option to consolidate these so that they are exported along with the rest of your work. The exported file can then be copied to the new computer and integrated into that machine's existing Library by double-clicking the exported Library file and choosing to import the images. Alternatively, if you prefer to keep the images separate from the other material on your other machine, click Switch to open the exported Library in isolation.

Once you have finished working with the images on your second machine, reverse the process and choose to import the contents of the exported Library to synchronize the changes back to your original Library.

Using Folders for Navigation

Projects and Folders are the key to quickly accessing your assets, in much the same way that motorway signs point to towns, and that only once you've finished following them do you start looking for individual road signs.

They are therefore also important when it comes to organizing the Inspector. Folders are the highest filing element that can be collapsed. In this respect there are benefits to producing highly generalized conceptual folders that encompass enormous subject areas, such as 'people', 'places', 'history', 'animals', as they allow you to quickly show and hide the Projects within them using a disclosure triangle and so save you from a lot of dragging and scrolling. Large Projects inside these that include subfolders for their divisions help you quickly locate a specific subject, by clicking on each Folder. Further subdivisions within these Projects would logically be a second layer of Folders, which in turn would contain Albums, used as organizational elements to section off your photos.

For example, you might like to create a Folder for Countries, a subfolder for Europe, and then Projects for each country visited. Within the national country Projects you would create Albums to split your images into, say, the cities photographed while visiting each country. By organizing your work in this way you can shrink the whole continent down to a single line in the Library Inspector when you want to work on something else.

Aperture organizes the Library Inspector alphabetically, so you can easily order your Folders (and Projects and so on) by using prefixes. Punctuation, such as !, @ and - come first, followed by numbers and then characters. Using appropriate leading characters should therefore enable you to separate out your Projects and top-level folders if you don't want them mixed together (Fig. 6.2).

Favorite and Recent Projects

The search bar at the top of the Library Inspector conceals two further options: Favorite Items and Recent Items. The latter of those two is the ultimate Smart Folder, as you don't even have to define any attributes that qualifying items should satisfy. It is simply a list of the items you have accessed most recently, allowing you to quickly skip back to them.

Favorite Items are defined by the Add to Favorites option on the shortcut menu, and they stay there until you select the Remove option from the same menu. When an item has been added to your Favorites, clicking the magnifier drop-down on the search bar lets you select Favorite Items to restrict your search to just those items marked as a Favorite. You will see a cross appear at the right-hand end of the box to indicate that you have already restricted the search results in some way. To clear this, either click the cross or select All Items from the magnifier drop-down (Fig. 6.3).

Albums and Smart Albums

Albums are the purely organization elements within Aperture's Library structure since their only purpose is to keep a collection of images contained, allowing you to manually define the limits of that focused collection within a larger whole. So, you might have a Project containing 450 images from a wedding assignment, with Albums holding the various parts of the day, split into logical sections like arrival, ceremony, reception, speeches and

Library	Metadata	Adjustments
۹-		
All Items		
Favorite Iter	ns	
Recent Item	5	
Unat FIIUUS		
E Faces		
and the second se		

FIG. 6.3 The Library Inspector can be quickly slimmed down by using the Recent and Favorite Projects selector on the dropdown. Favorite Projects are added and removed manually.

In the Last Month	٩
iii @ working photos	
►	76
alton water	
Animals	169
Autumn	46
autumn2009	
Backgrounds	6
😇 Beer	

FIG. 6.2 By using intelligent leading punctuation, such as @ and ! in conjunction with regular names, you can manually sort the order of items in the Library Inspector. Here, we have forced an item beginning with 'W' to appear before another one beginning with a digit.

party. Each of these would have an individual Album, allowing you to focus on just one aspect of the day at any time, or zoom back out to the event as a whole by clicking back to the umbrella Project or Folder.

Inside Aperture, an Album is a collection of references to images elsewhere in your Library. When you click on one you see the images referenced within it, but they don't actually exist there. You can see this when you delete an Album and get no warning that you're going to lose your pictures. This is true even if you've been working on an image while it was selected in an Album.

Albums generally sit inside Projects and reference the images in that Project, but they don't have to. They can call on pictures from anywhere in your Library, and you can add images to an Album by dragging them there. They can therefore contain images from several Projects and Folders at once, which is useful when you're building a portfolio book or website and want to present a selection of work spanning several years.

Smart Albums share a common base principle with regular Albums, in that they are used as an organizational device for defining boundaries between different sets of images. However, rather than being defined manually as a result of the user dragging their images into them, they are constructed using variables, like search terms, entered using the Smart Settings dialog. This is called up from the menus (File > New > Smart Album) or using the shortcut Shift III (III). Once the Album has been given a name and its variables have been defined, its entry in the Library Inspector will sport a magnifier. Clicking this will let you go back in and redefine the search criteria on which it is based (Fig. 6.4).

In this respect, Smart Albums are similar to Smart Folders in Mac OS X, or Smart Playlists in iTunes. They are reference collections built by Aperture itself on the basis of parameters that match each image's metadata. So, if you were a frequent traveler and wanted to maintain an Album showing your best pictures from around Europe without having to spend two hours at the end of each trip dragging your best photos from your Europe Folder into a 'Best of' Folder, you'd create a new Smart Album inside your Europe Folder

FIG. 6.4 Smart Albums are created using an intuitive search interface that draws on the metadata attached to the images in your Library.

All	of th	ne fo	llov	vind	r tha	it T	natch			:		1	Stac	k pic	ks o	nly			Ac	Id Rule	
Rating	is gr	eate	r th	and	or e	qual	to :	10						nrate	d						
Flagge	d: Yes	11000	÷																		1
Color I	Label:	is	2010																		
Text:	include	es				÷.	۹-														
Calend	far is						- 44		•	+	•		+								5 e
		Marc	h 20	010					Apr	il 20	10					Ma	y 20	10			
														. M							
	22					7				1			-4								
	8 9		11	12	13	14	5	. 6	. 7	8	9		11								
	15 16	17	18	19	20	21	12	13	.14	15	16	17	18.								
	22 23		25	26	27	28	19	20	21	-22	23	24									
	29 30																				
	0400.000																				

and specify that it should contain only those pictures rated four stars and above.

Now, every time you import a new collection of images into a Project or Album within your Europe Folder, you need only navigate through them using the cursor keys and rate them with the numbers 1 to 5 on your keyboard. Anything marked four or five would then show up in your new Smart Album. A 60-minute job has just been cut down to six.

If you later change your mind about a picture and dock it two stars down to three or below, Aperture will remove it from the Smart Album without any further intervention from yourself, ensuring that it really does contain nothing but your best work.

Besides ratings, Smart Folders can be organized on the basis of import dates, keywords, search terms or the date on which each photo was taken.

We will explore setting up Smart Folders later in this chapter.

Places

Places is a new feature for Aperture 3, introduced following the success of a similar feature in iPhoto. It allows you to plot your images on a map of the world, and if your camera is GPS-compatible – like the one in the iPhone and some dedicated cameras – it will even plot them for you.

Places appears twice on the Aperture interface: once in the Library Inspector and once on the toolbar (Fig. 6.5). If you click the toolbar entry when you are already inside a Project, Folder or Album, Aperture will show where the pictures within that container were taken. In this respect it works as a filter.

Click the entry in the Library Inspector, however, and you will have access to every plotted image in your Library, regardless of the Project, Folder or Album in which it appears.

The Places feature draws down data from Google's servers to draw the underlaying map, so requires an active Internet connection to work. It

FIG. 6.5 Places appears both on the toolbar and in the Library Inspector, with each entry having a subtly different purpose. presents a map of the world in Plan, Terrain or Satellite views, allowing you to zoom in and out using a Scale slider, or search for locations directly. Aperture includes tens of thousands of coordinates in its internal database, but if you enter a location it doesn't already know about it will ping Apple's servers to retrieve an update and give you a choice of places to choose from (Fig. 6.6).

To position images on the map, select the photo or group of photos you would like to mark and click the Places button on the toolbar. Because your images have not yet been placed in locations, Aperture will show an overview map of the world. Use the Search box in the top right-hand corner above the map to search for the location in which your images were taken. If the result you need appears in the list, cursor down to it using your keyboard and hit *Return*. The map will zoom to show this location. If it cannot find the location you enter, zoom manually using the slider on the left-hand edge of the map. Refine the view by zooming as close as you need to be able to accurately view the location where the images were taken, and then drag the image or images to the location in the Map view (Fig. 6.7). You will see a map pin appear on the overhead view. At this point it will be purple, showing that it can be moved around the map. When you click Done it will change to red and cannot be moved again unless you click the button marked Move Pins below the map. A place name will appear above the pin with details of the number of photos taken in that location below it. Clicking it opens the associated images in the Browser strip (Fig. 6.8).

Automatic Placement

If you have a GPS device, Aperture can read its log files and use these to plot your images on a map itself, allowing for more accurate placement.

FIG. 6.6 Places draws down data from Google Maps and, if it can't find the location for which you're searching using its own internal database, it will ping Apple's location servers for more detailed results.

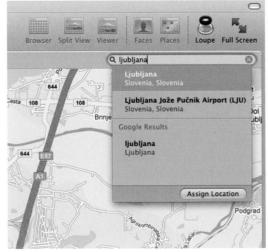

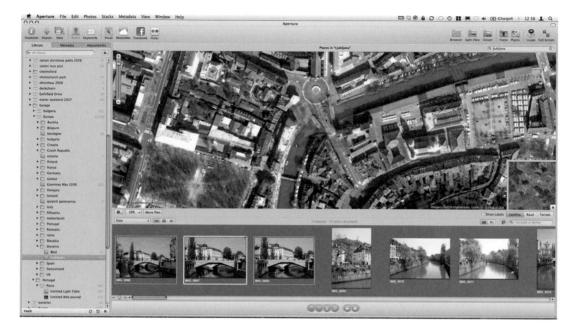

FIG. 6.7 Drag images out of the Browser and onto the map to locate them within Places.

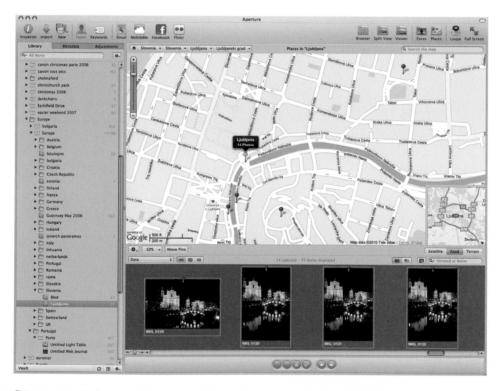

FIG. 6.8 This map contains the locations of 75 images taken in five locations around the Slovenian capital, Ljubljana.

The process is similar to the one we have just completed for manually positioning pins on the map but requires that you first export a log file of your movements from your GPS device. With your images selected, pick Imported GPS Track from the GPS drop-down below the map. Once your track is imported, Aperture will put it on the map and ask you to position just one of your images. It does this because the clock in your GPS device and the clock in your camera may be slightly offset from one another. By knowing how the time of one image relates to its specific location on your route, it can then work out where the other images were taken by comparing the amount of time that elapses on the camera clock between each one and wind the GPS route log forward by the same amount of time before dropping the image in that location on the map. This greatly speeds and simplifies the cataloging process, saving you a lot of manual positioning work.

Placing Projects

Even if you don't have a GPS device, you can still save time by setting locations on a Project-wide basis. Right-click a Project in the Library Inspector and choose Show Project Info. This will call up a summary dialog showing various data about your Project, including a gray map of the world. Click the Assign Location button below the map and again enter a search term for the location of your choice. Use the Zoom slider and pan the map using your mouse to center the Map view on the location you need. Reduce the size of the blue overlaid circle to identify the specific spot and then click Assign to set the data. Every image in the Project will have geolocation data applied to its metadata (Figs 6.9 (a) and (b)).

Now, when you click Places in the Library Inspector, you will be able to zoom in and out on the world map and see more or fewer pins appear depending on how many images you have given locations. As you zoom in you will notice a breadcrumb trail appear above the map, allowing you to quickly skip back to larger areas such as places, cities, counties and whole countries.

Faces

Like Places, Faces was introduced to Aperture 3 following its success in iPhoto. It is fully compatible with iPhoto's Faces feature, so if you have already been using Apple's consumer photo management application to catalog the portraits of your friends, family and colleagues and import your images into Aperture, you will see that it automatically populates the Aperture Faces Library (Fig. 6.10).

Again like Places, there are two entries for Faces within the Aperture interface: one on the toolbar that merely identifies the faces in your currently selected Project, Folder or Album, and another in the Library Inspector that gives you an overview of every face in your Library.

Aperture Workflow

(a)

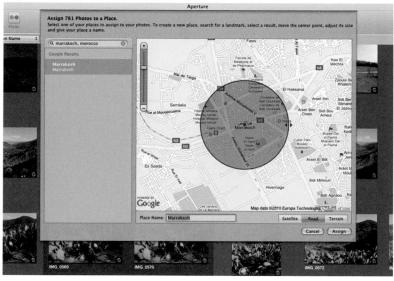

(b)

FIG. 6.9 Examining a Project's information lets you geolocate all of the images it contains at once, saving you time against individually marking the spot in which each one was taken.

When you import photos into Aperture, the program scans each one for anything that it could recognize as a face and attempts to add what it finds to existing Faces collections. If a photo contains more than one person whose face it recognizes, it will be posted to as many Albums as are relevant, but will

FIG. 6.10 Aperture's Faces feature attempts to group people appearing in a photo by comparing their faces with other faces in the Library. With a little help it is surprisingly accurate.

not be duplicated within your Aperture Library. In this respect, Faces can be considered a highly specific, fully automated Smart Album managed and maintained – like other Smart Albums – by Aperture itself. You only need to tell it who each person is once and it will attempt to spot them in all future imports. It will also retrospectively examine images that already exist within your Library and offer to add them to your Faces Albums, asking you for confirmation of those it has found.

Refining Faces

Open Faces by clicking the Faces entry in the Library Inspector. Aperture will display the faces it has already found, along with any names you have given them. Double-click one of the faces to view all the other faces in that Album, and then click the Confirm Faces button at the bottom of the interface to see which other pictures Aperture has found that it believes may contain the same person. You can now confirm or ignore those faces depending on whether they are correct or not. It is worth spending a little time on this task, as the longer you train Aperture, the better it will become at recognizing the people who appear in your images. If you make a mistake and confirm an image as belonging to one particular person when it does not, simply click the image again to reject. When you have finished confirming that the people who appear in the suggested photos are indeed the persons Aperture thinks they are, click Done (Fig. 6.11).

FIG. 6.11 With a little bit of help, Aperture can build a comprehensive index of the people who appear in your images. All you need do is click to confirm or reject its assumptions.

Faces Gallery

When you have selected a number of photos for each Album, Aperture will pick one from each one to use as the key photo in the Faces interface. This will not always be the most flattering or typical image it could have chosen, so to change it for one of your own choice return to the Faces cork board display and move your mouse left and right across the representative image. You will see that Aperture flicks through the images contained within the Album in the same way that moving your mouse across a Project in the Projects entry of the Library Inspector also displays a carousel of the images contained within. When you find a face that you would like to use for the key image of that Album, right-click and pick Set Key Photo (Fig. 6.12).

Adding New Faces

Aperture knows what a face looks like, even if it doesn't know who each of the faces in your photos belong to. It can recognize mouths, eyes and head shapes and use these to pick out even very small faces in your photos. As it does this, it will build up a store of unidentified faces that have not yet been given a name. The key to building up an efficient, useful database is adding these yourself.

FIG. 6.12 Change the images used in the Faces index gallery by running your mouse across each one and setting the Key photo by right-clicking at the appropriate place.

At the bottom of the interface you will see a button marked Show Unnamed Faces. Click this to display every face that Aperture has detected in your Library but not yet assigned to an Album within Faces. There will likely be far more than you imagine, and they will appear a few at a time, filling a filmstrip at the bottom of the screen. Tags on each one will show either 'Unnamed' or a suggested name. To accept suggested names and add that image to the appropriate Faces Album, click the tick. To reject it, click the cross. If you do not know who is shown in the image or you would rather name them later, click the Skip button that appears when you move your mouse over the picture.

To name an unnamed face, click within the bubble that appears below it and start typing. As you do, Aperture will attempt to complete the name either from names you have already entered within Faces or from your Address Book. If it gets it right, press tab to move on to the next person and it will add the person whose name you have just entered to the appropriate Album in Faces (Fig. 6.13).

Real Life Workflow from Camera to Export

Aperture has powerful editing tools that can really help you to get the best from your photos. However, its emphasis is at least as much on organization and workflow as it is on editing. Its classic three-pane interface centralizes every task from import to output, keeping every tool within easy reach in an environment that changes very little, saving you from learning different setups for each task you want to perform.

However, getting the best out of it involves a certain amount of pre-planning, and although your workflow will evolve over time as you become more familiar with the application, establishing a set way of working in harmony with Aperture from the very start will pay dividends.

The first step, then, is to plan an import strategy.

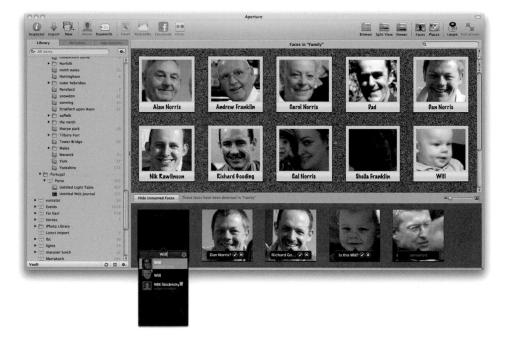

FIG. 6.13 Adding pictures of people to the appropriate entry in Faces is a simple matter of confirming Aperture's guesses or naming the people yourself.

Defining your Metadata Presets

If you already know enough about the kind of images you'll be importing as you use Aperture, you can build an extensive general purpose metadata set to apply to them at the point of import right now. The chances are, though, that over time your assets will be too varied to fit within a single defined metadata set, and so at this point you will be able to specify only the barest basics that you know will be true of all of your work. These will be your credit and copyright notice.

Click the Metadata tab on the Library Inspector and use the shortcut button at the top of the dialog to pick Manage presets... This opens a dialog in which you can specify a list of common metadata in a number of different saved presets, so that each one can be applied when appropriate at the time of importing your images.

Click the Shortcut button at the foot of the dialog and select New Preset. Give your preset a name and then use the form on the right of the dialog to specify common data that will apply to all images associated with this preset. This can be as specific as ratings and edit status (which will be too finegrained to apply at the time of import) to more general data such as copyright and usage terms. Choose which data you specify carefully, leaving out anything that is so specific that it could not be safely applied to all of your images at once. You can create as many presets as you need, and apply more specific sets to your images once they have been imported and are already resident in your Library (Fig. 6.14).

Metadata presets should not be confused with Metadata views, which determine how the Metadata Inspector looks. You can choose between them using the drop-down menu to the left at the top of the Inspector and create your own by picking Edit... from the bottom of the menu. Once you have picked Edit..., the process of creating your own Metadata view is very similar to creating a preset. Use the Shortcut button at the bottom of the dialog to create a new view, giving it a name of your choice. Once it appears in the left-hand Metadata views column, check the boxes beside the data lines you want to appear within the view in the Metadata Fields box to the right (Fig. 6.15).

When you have built your Metadata view, OK out of the dialog and it will appear in the Views drop-down menu on the Inspector. Selecting it from this menu will show only those data lines specified, allowing you to focus on specific information about each image.

Importing Your Photos

If you are importing your photos from a media card or camera, you should now attach them to your Mac. If Aperture is set to launch whenever a device is attached it should open the Import dialog (Fig. 6.16), but if it does not, or if you are importing from a Folder somewhere else on your system, click the Import button on the toolbar and select the source of your photos in the import source area that appears above the Library Inspector.

Preset Name	Inte	Contact	
Nik Rawlinson	I III		Nik Rawlinson
Nik's copyright			
Oscar's contact details		Job Title:	
ghik		Address:	
		City:	
		State/Province:	
		Postal Code:	
		Country:	
	0	Phone:	
		Email:	
		Website:	
		Content	
		Headline:	
		Caption:	
		Keywords:	
		IPTC Subject Code:	
		Caption Writer:	
	IPTC	Image	
	B		02/04/2010 00:00:00
		Intallastical Consta	in the second

FIG. 6.14 Use Metadata presets to define batches of common data that you will apply to several images at a time. The data should be sufficiently general that they are relevant to all images to which they are applied.

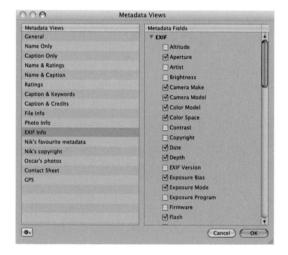

FIG. 6.15 Metadata views let you define the fields that should be shown in the Metadata Inspector to filter out unnecessary entries.

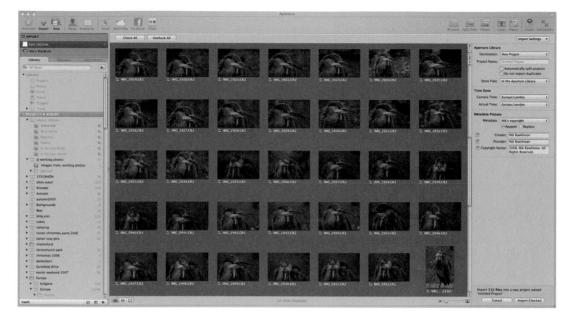

FIG. 6.16 The Import dialog is much improved in Aperture 3. It is greatly simplified, allowing you to work in a horizontal direction across the screen.

Where you want to store your photos is perhaps the most important decision you have to make in the whole workflow. As we explain in detail elsewhere, the decisions you make here will have a profound impact on the way you will back them up later on. By storing them inside Aperture's Library file, you will be able to rely on the Vaults system for backing up your versions and Digital Masters simultaneously. Recovery from a fatal hardware fault is then a simple matter of restoring from your intact backup by installing Aperture on a new or repaired machine, connecting the external drive containing your Vault and using the tools built into the Vaults panel to restore your last working state.

If you choose not to store your images in the Library, but elsewhere on your hard drive, you will enjoy the benefit of being able to manually navigate your assets through Mac OS X's Finder. You will also be able to share these files with other users on a network. However, you will have to formulate your own backup routines and ensure that you regularly safeguard your work. Further, as your Digital Masters will be kept separate from your edited Versions, which will be stored inside the Library, any breakdown in this routine – whether through human error or otherwise – means you will lose not only the originals, but also your edited products. This could impact not only on individual adjusted images, but also books and Web products in which they are used. Recovering from this kind of failure would be difficult at the very least, and could prove to be impossible. There is no reason why you need to adopt the same strategy for every set of images you import. You could, for example, store all commercial work in your Aperture Library to take advantage of the Vaults system, and import personal work as referenced images on an external drive, allowing you to remove that drive when not in use, and to save space on the drive storing your Vaults by restricting this to 'business' use.

Whether you choose to save your photos in Aperture's Library or reference them from an external source, you still have to save them in a Project. If you want to save them in an existing Project in your Library, click it in the Library Inspector, and you'll see that it appears in the Destination dropdown on the right-hand side of the interface, beyond the thumbnails of the images you are going to import. However, if you would rather create a new Project, pick New Project from this drop-down and specify its name in the box that appears below, and then choose whether to store the imported images 'In the Aperture Library' or 'In their current location', bearing in mind the caveats outlined above (Fig. 6.17).

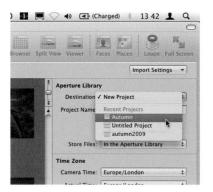

FIG. 6.17 To make use of Aperture's Vaults feature you should store your images inside its own Library file using the Project name of your choice.

You should consider here how you want to organize your working area. If you only envisage ever having a limited number of Projects, then there is no problem with creating them in the root level of the Library. However, for the professional photographer this is an unlikely scenario, and so you should consider setting up Folders to house Projects with similar attributes. These could be as specific as subject areas, such as weddings, sports and travel, or as general as years. New Projects and Folders can be created through the New button on the toolbar, either during general Aperture use, or now at the time of import.

You can embed Folders several layers deep, and name them however you feel most appropriate, mixing subject-based and chronological descriptors in a chain. For example, you may have a top-level Folder called '2011', inside

which you keep two Folders for 'flora' and 'fauna'; within each of these you could have 12 numeric subfolders for the months and only inside these would you store your Projects, which could be given titles that reflect the plants or animals they contain. A study of the flowering and fruiting progress of a quince tree would therefore be found in 10 Projects, each called 'Quince', in Folders '03 March' to '10 October' in the Folder 'flora', which itself would be embedded within '2011'.

Would this be an appropriate structure? It is impossible to tell. The most appropriate arrangement of Folders and Projects will vary from user to user, depending on their own specific needs (Fig. 6.18).

Expanding the Import Dialog

The Import Settings button in the top-right corner of the Import dialog lets you specify the bricks that should appear in the Import dialog. The only brick that appears by default is the one through which you specify the destination of your imported photos, but to this you can add the following:

- File info: A purely informational panel that displays attributes about each photo, including its file size, dimensions and shooting date.
- Rename files: Specify how your photos should be renamed at the point of import on the basis of presets already specified.
- Time Zone: If you traveled overseas and forgot to update the clock in your camera, your pictures will likely have incorrect timestamps. Correct them here by selecting time zones or popular cities to offset your camera's time setting.
- Metadata presets: Apply pre-populated metadata fields to each image so that filing and searching is more efficient once they have been inserted into your Library. Metadata can be added to or replace existing data.
- Adjustment presets: Apply a correction, such as changing White Balance or converting to monochrome.
- File Types: Restrict the kinds of file imported into your Library. This lets you exclude any or all photos, videos, audio files or audio attachments, and to include only files that have been flagged or locked using the camera firmware.
- RAW+JPEG Pairs: If your camera is set to shoot both JPEG and Raw images at the same time, here is where you specify how they should be handled, i.e. imported together with the JPEG or Raw as a master, imported separately with each treated as a master, or just either Raw or JPEG files imported and the others ignored.
- · Actions: Choose an AppleScript to run on the images as they import.
- Backup Location: Automatically save a second copy of your images on a backup drive while also importing them into the Library.

Activate whichever bricks you want to use and work your way through them in the right-most pane of the Import dialog. The more data you add at the

w Viewer F	aces	Places Lou	pe Full Scri
		Import S	ettings 🔻
		√ File In	fo
File Info File Name:	1	✓ Renar Selectii ✓ Time	
File Date:			iata Presets
		✓ Adjus	tment Prese
	No	Selecti V RAW+	IPEG Pairs
Attachment:	No	Selecti Action	15
Aperture Librar			p Location
Destination:		Second	to Defaults
Project Name:			
Project Name.			
		tomatically spli	
61		ne Aperture Libr	
store rues.	inu	ie Aperture Libi	rary :
Rename Files			
Version Name:	Nor	e	:
Time Zone			
Camera Time:	Eur	pe/London	:
Actual Time:			:
Actour Thine.	Lon	pe) condon	•
Metadata Prese			
Metadata:			;
	• A	ppend () Repla	ice
Cre	ator:	Nik Rawlinson	
Prov	vider:	Nik Rawlinson	
Copyright N	otice:	2008. Nik Raw Rights Reserve	linson. All
		Rights Reserve	d.
Adjustment Pre	sets		
Preset:	Non	e	•
ile Types			
Exclude ph	otos		
Exclude vid	eos		
Exclude aud		5	
Exclude aud	dio at	achments	
Only includ	e files	flagged/locked	in camera
AW+JPEG Pairs			
		(JPEG as Maste	r) ‡
		o a new project	
"Untitled Proje	ct"	o a nen project	

FIG. 6.18 The Import dialog can be as simple or complex as you choose. Open the hidden bricks to access extra features for the greatest flexibility.

FIG. 6.19 Stacking on import has been greatly simplified in Aperture 3. Here, Auto-Stack is determining the amount of time that can pass between each image being shot for them to qualify as members of a single stack. point of import, the better organized your images will be when you come to work with them.

Most images taken within a few seconds of each other will be the result of attempts to capture a better view of the same scene, but not always. Sports photographers may find that they take several pictures of different horses or cars in quick succession as they pass by a finishing post. On occasions such as these it would be inappropriate to stack them all together as their subjects are fundamentally different. In this situation you would want to stack images manually by selecting the related images, by clicking them with *Shift* or **H** held down, and then using the keyboard shortcut **H** (or Stacks > Stack from the menus).

If you have used the slider to stack your images automatically, you may find that what is right for one set of images is too verbose for another, and that while some stacks do indeed group together related images in one part of your import group, in another they manage to snare completely separate pictures that you nonetheless took within a very short space of time. In these instances, click within the Stack at the point where the subject changes and use the Split Stack command (or Stacks > Split Stack from the menu) to split them into two.

You are now ready to import your images. If you want to take all of the pictures in the collection into your Library, click the Check All button above the thumbnails in the central pane of the Import dialog. If you want to import only a selection, click Uncheck All and then pick them individually by checking the tick box below each one using the mouse. To select several at once, click them while holding **Shift** or **(H)**, or drag a marquee around them using the mouse and click the checkbox of one of them. This will simultaneously check all of the other selected images.

Perform Your First Backup

Now that your images are in Aperture, and before deleting them from your memory card, you should perform a backup. If you chose to store your images in the Aperture Library, rather than referencing them from elsewhere on your hard drive, you should use the Vaults system, by opening the Vaults panel at the foot of the Inspector and connecting an external hard drive by either FireWire or USB.

If you have already set up a Vault on this drive, Aperture will recognize it and mount it automatically. You can then perform a backup by clicking the Synchronize button beside its capacity gauge.

	New Vault Contents 22860 managed files will be 325 referenced files will not to be backed up separately. Vaults provide automated ba- stored inside your Aperture I referenced images are stored backed up in vaults. Adjustments, ratings, and ott included for all images, regar	be included. Thi ckup of all mass ibrary. Master fi I elsewhere, and her metadata ar	ese need ter files les for are not e	
Do n	ot show this message again	G	Continue	
000	Add Vault			
Save A	s: Daily Vault			
	III) 🔛 MyBook	•	Q	5
	Name	ten fene anna anna	Date Modified	T
Nik's Ma.	autumn autumn		28/02/2010	B
Di iDisk	Backups		Today, 12:06	1
Ē EOS ▲	blog backups	Anna anna	22/03/2010	
Macinto	contact list.txt		13/08/2009	
Data A	crucial live help.png		29/09/2009	
Mys A	Cutenews		22/03/2006	
El miser	downloads		22/01/2010	
► SHARED	innocents		28/09/2009	
T PLACES	iPhone SDK		04/10/2009	
MacUser 1	C John Constable		06/01/2010	
MacUser 2	Journalism		30/10/2009	1
Desktop	iiii learnloft		22/01/2010	1
A nikrawli	i macuser		05/03/2010	_
New Folder	n ukataskan astians	Car	ncel Add)

FIG. 6.20 Create Vaults to back up your images. Give them logical names, but be wary of the fact that they are never automatically backed up - you must instigate this yourself.

If you have not yet set up your first Vault, use the Shortcut button at the foot of the Inspector and pick Add Vault. Aperture will tell you how many images it is going to back up (Fig. 6.22) and, once you have clicked Continue, will ask you for a name for the Vault. This will be used in the Vaults pane to help you identify multiple backup sets, if you use them. It should therefore be both unique and descriptive (Fig. 6.20). Perhaps this Vault will be used every day, in which case Daily Backup would be an appropriate name. If you also maintain a weekly backup cycle, with that drive being taken offsite to save your files from possible fire damage, you would call that copy Weekly Backup. Use the drop-down menu beside 'Where' to choose the attached drive as the destination for the backup and then click Add.

Aperture will never automatically back up your images – not even the first time you create a Vault, so as with the instruction above for backing up to an existing Vault, click the Synchronize button (which is two arrows in a circular formation chasing each other's tails). It will be red at this point to show that there are Digital Masters in your Library that have not yet been stored in a Vault. If all of your Masters had been backed up, but some of your Versions had not, it would be amber. Aperture will show you a progress meter as the backup completes. Once it is done, you can disconnect the Vault – remembering to first unmount the drive by clicking the Eject button in the Finder or Vaults panel – and delete the original images from your memory card.

Sorting Your Images

With your photos successfully imported into your Library, your first management task is to break them down into a finer-grained series of collections and groups that will make them easier to manage. Select images that relate to one another and use **(H)** to create a new Album for each set. These Albums can be named as you go along, and while clicking on each will show only its own contents, and none of those from the other Albums, you can still see all of the photos you have imported to that Project as a whole by clicking on the Project's name in the Library Inspector and exposing the contents of every Album (and any images not yet placed in Albums) at the same time in the Browser.

No photographer – not even the best – could hope for every image in a shoot to come out the way they wanted, and even the best photos often benefit from some minor adjustments. The trick is to identify those photos with the best potential to use as a starting point.

There are a number of ways to do this in Aperture. The first would be to step through each Album and apply ratings to the photos they contain. Another would be to physically delete photos from the collection which, while destructive, does at least offer the benefit of slimming down your Library and avoiding bloat on either the drive holding your Library, or the one you use to store your Vaults.

However, the most inspirational way, and the method that most closely matches the way in which we work in real life, is to use a Light Table. This lets you scatter your images across the screen, and sort them into groups, helping you to get your head around the way in which they work together and relate to one another. This lets you create finer distinctions between your images than the rather broad-brush divisions created by Albums.

Select the images you want to use on your Light Table, either from a single Album or the Project as a whole, and pick Light Table from the toolbar's New menu. Note that if, in future, you create new Albums in a Project that use images not stored in that Project, you can still create a Light Table using those images, so long as the Album holding them is selected at the point of creation. If you instead have the Project selected which doesn't hold the images themselves but just a symbolic link to them in the Album, then even if you choose the option to include all images, only those that appear in the Project will be included, and not those drawn into it by Albums referring to other Projects.

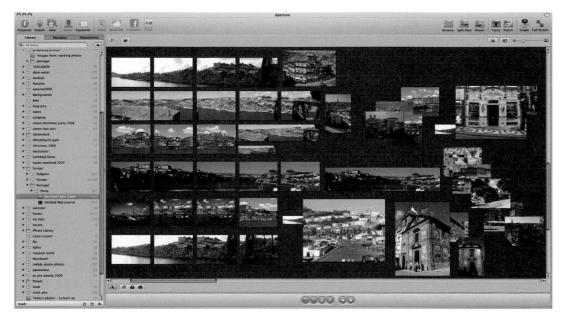

FIG. 6.21 Use Aperture's Light Tables to organize, sort and filter your images. Images can be stacked in the same way as in the Browser, dragged into logical groups and resized. This closely mimics the way photographers would traditionally scatter images on a Table, or examine slides on a Light Table.

Drag your images from the Browser onto the Light Table and start to organize them however seems most logical. Use the resizing handles to change their dimensions, and stack those that go together, bringing the best of each group to the top of the pile (Fig. 6.21).

As you work with your Light Table, you will start discarding the shots that are not up to scratch and keeping others in Stacks so that you can go back to them later on to make a second assessment. Slowly your collection should start to filter down to just the best pictures in your collection, which you can then begin to rate.

Giving your images ratings is key to identifying your best and most saleable work. It also gives you another series of parameters that you can use when searching or setting up Smart Albums.

Select your photos and use the number keys **1** to **5** to rate them, using **0** to remove a rating you have already applied.

Rating and Picking Your Photos Using Comparisons

Light Tables are an excellent way to sort images, but there are occasions when a traditional side-by-side approach is more appropriate. In these instances, you will switch to using Aperture's Compare view. This can't be done on a Light Table, so switch back to your Albums and use the shortcut **S ()**, or use the Viewer Mode button to select Compare.

In Compare mode the Viewer will always show two images – one that you have chosen as the reference image, and the one against which you want to rate it. The reference image will be shown on the left, surrounded by a green border, while the comparisons, bordered in white, sit to the right. These same color indicators are used in the Browser below the Viewer.

Pick your reference image by selecting it in the Browser and pressing *Return*. Now move through the other images in the Browser, using either the mouse or keyboard until you find one better or more appropriate than the reference image. At this point, tap *Return* again to make this the new reference image and then return to stepping through the remaining images in your collection to complete the comparison exercise (Fig. 6.22).

By the time you reach the last image, the green-bordered photo should be the best of all of your assets, and can now be safely given a five-star rating before you go on to start the editing process.

Gather all of the best photos from your shoot into an Album to make them easy to find without moving their physical location and then switch to the Adjustments Inspector.

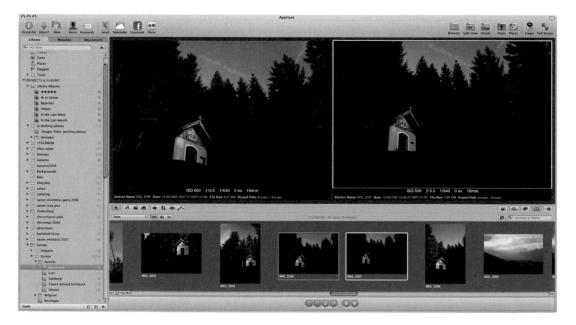

FIG. 6.22 These two images may look similar, but there are subtle differences. By comparing them side by side we can pick the best. The green border denotes our reference image, while the white border surrounds the image with which we want to compare it. Notice how these colors are also used in the Browser frame.

Edit Your Photos

With a few exceptions – red eye correction, for example – edits are generally conducted on a whole-photo basis. This is in stark contract to traditional photo editing tools like Photoshop, which lack Aperture's extensive organizational feature set.

Edits in Aperture are therefore more about correction than creation, and you should not expect to get perfect results from a poorly shot image with burntout highlights or underexposed shadows.

Nonetheless, Aperture's editing tools are both powerful and extensive, and are explored in detail in Chapter 5 (Fig. 6.23).

Output Your Photos

You should perform your editing tasks with each image's eventual use in mind, bearing in mind that some color and exposure adjustments that may work well as a page background in a Book would not work well on a Web Page, or as part of a Gallery. Judicious cropping, rotating and color correction should be used to maximize the impact of your results before you move on to the final stage of the workflow: output.

If you are using your images as part of a Web Page or Journal, you will have to choose between publishing to your MobileMe webspace – if you are a subscriber – or saving your output to your Mac's hard drive and transferring it manually to your own web space. If you have chosen to produce a Gallery, you have no choice but to send it to MobileMe, as it uses several server-based technologies that are not included in third-party hosting packages.

The Mac is well served by FTP applications, but one of the best is the free Cyberduck (cyberduck.ch), which uses industry standards and lets you drag items directly from the Mac's file system to the remote server, and back again.

Books must ultimately be printed by Apple's partners by clicking the Buy Book button on the book creation interface and using your Apple ID. However, you can also print the pages of the book, or save it as a PDF for proofing prior to paying any fees for a hard copy. In this way, you can seek sign-off from a client before taking the ultimate step.

If you are printing the proofs of your book, or any individual photos, it is essential that to get the most accurate representation of your photos in their final state you follow the color management guidelines in Chapter 8.

Not all photos need to be published or printed. There are many instances when you will want to save a photo to disk, either because you need to send it to a client, or you want to use it in an external application, such as Adobe Photoshop.

8	a stand standard	Inspector	NO DE MENTERS
	Library	Metadata	Adjustments
	1881		
	[]][]]]]]]]]]]]]]]]]]]]]]]]]]]]]]]]]]]		
	- M		
	ISO 800 fl	3.5 1/640	18mm
1	Presets 🔻	Adjustment	s 👻 🗘.
	White Balance		n ¢.
	Exposure		Auto 🤨 💁
			+ 0.0 +
	Recovery:		+ 0.0 +
	Black Point: -==		0.0
	Brightness:		- 0,0 -
•	🖀 Enhance		5.0.
	Contrast:		- 0.0
	Definition:		0.0 E
	Saturation:		- 1.0 ×
	Vibrancy:		0.0
	► Tint		
Ŧ	🖱 Highlights & Sl	nadows	· • •
	Highlights: #		- 0.0 +
	Shadows: #		* 0.0 F
	Advanced		
-	E Levels		Auto · > O.
Ĉ.	Channel: RGB	-	100
	6: 0.00	€ G: 0.50	W: 1.00
		0. 0.20	
٣	Color		• · •
	2 1		
	Saturation:		* 0.0 *
	Luminance:		
	Range:		+ 1.00 +
		A RIVER SA	

FIG. 6.23 The Adjustments HUD lets you edit your photos in Full Screen mode, or when you have hidden the Inspector to maximize your working space. In these instances, you would use the File > Export command to save the photo using one of your export presets, which can be set up in advance or by picking Edit from the Preset drop-down on the Export dialog.

Aperture ships with existing presets catering for a wide range of needs, including Photoshop PSD export at both full and half-size resolutions, so there are few instances when you will need to create your own to supplement these. However, as none of these Export settings includes watermarking as a default, you should seriously consider creating a logo that can be stamped onto your work when being exported for approval by a client. This would stop them from using the work without your authorization.

Aperture can use a range of image formats for watermarking, but the mostversatile and highest quality ones are flat Photoshop files with transparency, which will give clean edges and allow you to maintain a high degree of detail. You should create your watermark in a range of sizes and create different presets for each one, as Aperture can scale overlarge watermarks down to fit but cannot scale up any that are too small to act as an effective deterrent.

Back up, Back up and Back up Again

At the end of your editing session, you will have added several new image Versions to your Library. Although they are based on the Digital Masters that you stored in a Vault at the start of the workflow, they have not themselves been safeguarded. The synchronization icon in the Vaults panel will be amber, warning you that you risk losing work if you suffer a hardware failure.

At this point, and before quitting Aperture for the day, you should reattach your Vault and perform a backup. Only when the icon shows black will you know that your work is safe.

Light Tables

Once you have imported your images, you need to start thinning them out. A single photo shoot can stretch to several hundred frames, the vast majority of which will be unsuitable for one reason or another. You could sort them by stepping through your newly imported pictures in the Browser strip, assigning ratings and keywords to each one as you go, but this is cumbersome and unrealistic. Nobody who used to shoot with film would have taken their pictures out of their envelopes one at a time, rated and cataloged each one, and then put it away again before moving on to the next.

Instead you would scatter them across a table and rearrange them by hand into collections and groups. Aperture's Light Table feature lets you do the same in the digital realm.

Create a Light Table by selecting a range of images in a Folder in your Library and picking New > Light Table from the toolbar. The Light Table will appear

as a new entry in the Library Inspector and open up as a grid-based space above the Browser strip. You can scale it using the slider above and to the right of it.

Start by dragging all of your images onto the Table. They'll be arranged neatly so that each one has a full facing and none of them overlaps, giving you a good immediate overview of your pictures (Fig. 6.24).

You will already be able to see how the pictures relate to one another in terms of composition and color temperature if you've been shooting in a studio; and in terms of subject and location if out and about. These factors should be the starting points of your sorting. At this point you'll probably want to close the Browser and maximize the Viewer window (press **(V**)). You may also choose to close the Library Inspector (press **(D**)).

To sort your images simply do what you would in the physical world: grab hold of them and drag them around using the mouse. As you move each one you'll see that yellow guidelines appear along its edges and center showing when it is aligned with the edge or center of other pictures on the Light Table, and as you move beyond the edge of the existing checked area in any direction, it grows to accommodate your image. You can, of course, ignore the guidelines should you choose, and you can stack images on top of one another if you need to save space on a smaller monitor.

Aperture File Edit Photos Stacks Metarlata V	rur Window Help	四日日日日日日日日日日日日日日日日日日日日日日日日日日日日日日日日日日日日	12 33
	-	Aperture	0
	ee A Dok		
	1 Packs	Browner Split View Viewer Faces Places Lo	Loupe Full
brary Metadata Adjustments 24 30			
DiRems O.			2011/11/2
OK selector			
in vices er			
in the Last Week IL			
B In the Last Month G.	Contraction of the local division of the loc		
	A REAL PROPERTY AND A REAL		
images fease: working photos	A DESCRIPTION OF A DESC		
E percept			
altos water 51	and the second		
Anonals III			A 8214
Automa	There is a second and the second and		23 B ()
automa 2009			1. A. S.
Backgroonth			1.1.10
Beer I Party day			an original se
blog pics	and an		
cakes D			100.000
camping in the second	A A A A A A A A A A A A A A A A A A A		
caren dicistmas parts 2006	and an other and the second of the second of the second of the		
canon inus pics			
Chelenderd Enderland			
thristchueck park			
christmas 2006	Transferrer and an and a second secon		
decknais in the second s			
Earisfield Drive	The second se	the Constant of the Constant o	
easter morkand 2007 via	and a stream the second provide a stream		
Europe			
Takapata - 607 17 Europe 10146		A State of the second se	
C Europe S016			
V Petto	a fan mark a state of the		
	C. Martin Provide Contraction Contraction		
Untitled Wob Josmal	12 K # 12 K # 22		1
eurostar -		The second se	Citra Card
Evens 1977			1
Far East 2.07	minte antipiente fill Charter		
horses	Contraction of the local division of the loc		
Photo Library Basis	A Design of the second s		
Latest import			
the IS	A CONTRACTOR OF A CONTRACTOR O		
lights 25			
stacuser lunch 22	a training of the second second of the second se	TERI- ALG	Section 200
Manaketh			
mobile phone photos	0		
		ଭଗତର ପତ	
pc pro awards 2006			

FIG. 6.24 As you move photos on the Light Table, Aperture uses dynamic guides to show when you have lined up the center or edge of each one with any other element on the Table.

Apple Aperture 3

FIG. 6.25 Once you have stacked a group of images, you may want to temporarily rearrange them to expose those that have been covered up. Shift X does this, allowing you to click one of the lower images to bring it to the top of the pile.

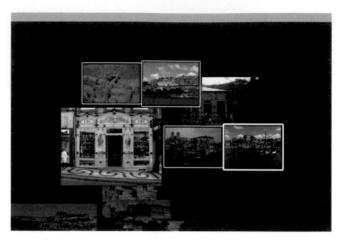

As you do, it's easy to lose track of what has become obscured by other images that overlap or cover it up. In this instance, select any of the images covering up one of the others and press *Shift* is to have Aperture intelligently rearrange them to give each image in the group a full facing (Fig. 6.25). The rest of the Light Table will be dimmed, and although you can't directly manipulate any of the images you have uncovered, you can click on them. This will select the clicked image and drop them all back into their original locations, only this time with the selected image on top and ready to be worked on.

You can select and move several images at once by holding **(H)** while clicking them, and then dragging them as a group, or by dragging a selection box around adjacent images to select them as one entity. Rightclicking a selection of this type gives you the option to align any of their edges or centers, and to space them out evenly on a horizontal or vertical plane (Fig. 6.26). This makes it very easy to stack similar images, most of which will have been taken in quick succession, by dragging a selection box across them and then aligning both their top and right sides in sequence.

A right-click here also gives you the option to arrange your images. This is handy as it shuffles the selected pictures so that none of them is overlapping, and then lets you drag them as one set to a new location, complete with yellow guidelines that appear in relation to the group as a whole.

As your collection consolidates you'll find that it quickly becomes easy to identify the duds, which can be removed by selecting them and using **H** *Backspace* to delete them, in the same way that you would send a file to the Trash in the Finder. A less destructive option is to put images from the Light Table back into the Browser bar by selecting one or more and using the shortcut **H** *Shift* **P**. As you'll see if you have the Browser visible (cycle through the view modes using **V**), this removes

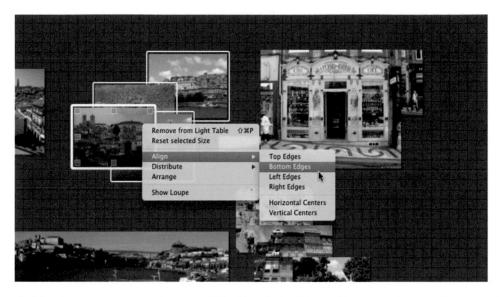

FIG. 6.26 Don't have time to neatly arrange your photos yourself? Right-click a collection of photos and the context-sensitive menu offers to automatically align the pictures along specified dimensions.

the image from the Light Table, but keeps it close at hand should you want to use it again in the future.

The more images you remove, the more space you will have, which gives you the opportunity to start enlarging the ones that remain to give you a better view and help you discern smaller differences between them. Every time you hover over an image, therefore, you'll notice that eight grab handles appear around the edges. Pulling any of these out from the center enlarges the image, maintaining its proportions as it does, while pushing it in towards the center shrinks it down.

Because Light Tables will always be works in progress to which you will return time and time again as you work on a particular Project, Aperture lets you keep as many as you need in your Library at any one time and even use the same images more than once in several different Tables. Clicking away from them or closing Aperture saves their current state so you can come back to them in another session.

Performing Sorts and Edits from a Light Table

Images on a Light Table remain live at all times, meaning you can edit them here just as easily as you would an image in a Project or Folder. With the Inspector or Inspector HUD open, you can switch to the Adjustments tab and apply adjustments using the regular controls, remembering to zoom in or resize your images to give you a good view of the results. Any edit you make will create a new Version of the image, which will be placed on the Light Table alongside the original. Neither these Versions nor the Digital Master can be resized while unstacked, so to shrink or enlarge them click on the Version count on the Digital Master to collapse them back into a single stack, resize the Digital Master, and then click the number again to expand them back into an opened Stack with all Versions in view side by side.

As ever, tapping **(F)** gives you a Full Screen view of any image selected on the Light Table so you can edit at the largest possible size.

Stacking

Aperture is built to work like a professional photographer. It can intelligently stack photos taken at a similar time, understanding that they are probably taken in a single burst, or at least in very quick succession, and thus are directly comparable.

Stacks are created automatically, either when you edit a Digital Master by creating a new Version, or by examining the file creation time – something Aperture can do either at import or later, when you're browsing the Library.

You can preview how your images will stack at the point of import, by using the Auto-Stack slider on the Auto Stack HUD, picked from the Stacks menu. Moving the pointer to the right increases the time window within which images can fall to be stacked. So, dragging it to the furthest right extremity would stack all images taken within a minute of each other. Taking it back again halfway would release those taken with a delay of more than 30 seconds between each one.

Stacks will be shown using the Digital Master, stamped with a number indicating the number of images within the Stack. This number, and the box surrounding it, is called the Stack button. You'll notice this number appearing every time you make an adjustment to a Digital Master within the Browser and Viewer environment (Fig. 6.27).

However, you can also create Stacks manually in the Browser, and, once there, manipulate them, using both the mouse and keyboard. It's worth remembering that the button that controls stacks, in almost every instance,

FIG. 6.27 The badge in the top left corner of a Pick image on a Stack indicates how many photos exist in each Stack.

is (K), which is combined with the (*shift*), (B) and (C) modifiers to perform a wide range of functions. This lets you group images by whatever criteria you choose, and so is more versatile than being restricted to stacking purely on the basis of time (you might, for example, be importing images from several cameras, or several photographers, all of whom have been taking photos of the same subjects and want to amalgamate the best photos into a single stack. Alternatively, you may have thinned out the immediately unsuitable images from your latest import and want to stack those that remain to give yourself some more space to work on the rest of the import).

There is no reason why Stacks should be restricted to consecutive images; holding \textcircled while clicking on multiple photos scattered throughout a single Project or folder and then pressing \textcircled will join them as a Stack. If your Browser is in the Filmstrip or Grid mode, they will be given a darker gray background (Fig. 6.28). If you're using the List view (Fig. 6.29), the first image in the Stack will be used as a Folder containing the other images you selected. A small disclosure triangle will let you expand and close the Folder within the Browser to show or hide its contents.

The image used to represent the Stack in the List view, or in the Grid or Filmstrip views when the Stack is collapsed, is called the Pick image. This can be changed at any time – to reflect the best image in the Stack, for example – by dragging an image from within the Stack onto the Pick image when in List view, or in front of it in the Grid and Filmstrip views. (B) achieves the same thing without using the mouse.

FIG. 6.28 Stacks are shown in different ways, according to the Browser mode. In Grid mode, they are outlined and given a dark gray background.

FIG. 6.29 Stacks are shown in different ways, according to the Browser mode. In List view they are organized in a Folder with a disclosure triangle. Pressing Shift K toggles a Stack open or closed, while pressing B Shift K when any image in a Stack is selected will unstack every image. You can also open and close Stacks by clicking on the small indicator on the Pick image that shows how many photos the Stack contains. The most powerful Stack shortcuts are those that open and close all Stacks at once: C and C respectively.

The more time you spend working with your images and thinning them down to just the very best examples from any shoot, the better you will understand their relationship with one another. At this point you may find that your Stacks are no longer relevant as they don't represent groups of the best related photos. When this happens you'll need to start breaking up your Stacks. However, the chances are that you'll want to keep at least some of them stacked, perhaps because they need further sorting. The shortcut to dismantle the Stack entirely (**B** *Shift* **K**) is in this case overkill.

At times like this you want to manually drag images out of the Stack, which is done by clicking and holding with the mouse and then moving it to its new position (Fig. 6.30).

The same theory works in reverse, allowing you to quickly add images to a Stack by simply dragging them in from anywhere else in your Project. Alternatively, select any image in your Stack, and then any image you want to add, and tap **(H)**. The new image will be added in the final position within the Stack. *Shift* **(C) (K)** will remove any selected image from a Stack.

You can move images within a stack using the keyboard, as well as the mouse, and this is almost the only instance when the shortcut strays from using **(K)**. **(B) (f)** and **(B) (f)** move an image to the left and the right respectively. If you are having trouble rating your images within a Stack, and deciding which should be used as the Pick image to represent the whole Stack, this is a good way to compare them side by side, one by one. This shortcut only works within a Stack; you can't use it to rearrange images within a general Library. Neither can you move your images beyond the boundaries of the Stack, so this is not a way to move images either into or out of an existing Stack.

Why is it important to choose a good Pick image? Not only does the Pick represent the Stack as a whole (and should therefore be representative of the style and content of the Stack as a whole), but the Pick is also used in various products created using the photos in your Library.

Versions and Version Sets

With Aperture's incremental versioning system, you can push your creativity further, always applying one more adjustment than you would usually be happy with, safe in the knowledge that you can always revert to an earlier safe state with which you were happy. The result should be more dynamic, eye-catching, and – ultimately – saleable work.

FIG. 6.30 When relocating an image inside a Stack in Grid mode, a narrow green line indicates its position. At the end of the Stack the line will appear either inside or outside of the bordered area to indicate its removal from or addition to the Stack.

Each Version, which can be created automatically or manually, acts as a safe milestone to which you can return if you take things a little too far. However, they also act as options, allowing you to give clients a range of choices, each derived from a single Digital Master.

Because a Version is just a list of metadata applied to the Master, each one takes up very little space on your hard drive, allowing you to create far more Versions using Aperture without increasing the capacity of your system than you would with an alternative, such as Photoshop.

Automatically Created Versions

Every original image in your Library is, as we have already shown, a Digital Master, which Aperture considers to be sacred and untouchable. It is the digital equivalent of a film negative, which would always exist in its original state, with only the derived products – your prints – edited by dodging, burning and changing the way in which the photosensitive paper is exposed.

Aperture never lets you make any changes to your masters, apart from editing their metadata, or changing the way they appear in products, like Books, Light Tables and Web Pages. The first time you make any more substantial edits, such as changing the White Balance or Exposure of a Digital Master, Aperture therefore automatically creates a Version, which is used for all subsequent edits.

You can make as many further edits to this Version as you like without another Version ever being created.

Manually Created Versions

There are times when you will want to make alternative edits to either an existing Version, or the Digital Master from which it was derived, to give you a choice of finished products or works in progress. This lets you experiment, and is particularly useful in the early stages of working with your photos if you have not been given a clear brief by a client, or you are unsure how best to handle your material.

To create a new Version from the Digital Master, have the master or any Version selected, and use the shortcut 🗨 G. This gives you a fresh, untouched copy of the original from which you can start working all over again. You can achieve the same thing by selecting the Digital Master again, and making fresh edits, but this shortcut saves you some mousing, and fits better with a keyboard-based workflow, in which the keys are used to perform commands and the mouse to make edits.

To create a new Version from an existing Version, select the Version in question and use the shortcut 💽 💟. In effect, this creates a new edition from the Digital Master and applies to it any adjustments you have made to the Version from which you made the duplicate. The existing Version then becomes your safe-haven milestone to which you can return, while the duplicated Version is the one on which you will experiment by applying further, more extreme adjustments, or by cropping and rotating the image.

Working with Other Applications

Introduction

It's entirely possible that you might use your Mac and Aperture exclusively to organize and edit your image Library without ever launching another application, but not very likely. Images are usually just the beginning; only when they've been organized, categorized, sorted, rated, labeled and edited are you ready to begin using them. And that's where Aperture's ability to integrate with other applications becomes critical.

To begin with, in this chapter, we'll look at what to do if you're new to Aperture and want to migrate your existing image Library from iPhoto or Adobe Bridge. We'll also discuss the implications of this for your image metadata and look at some of the differences in the Raw image processing tools provided by Aperture and Adobe Camera Raw.

Then we'll take a look at how you can use Aperture in conjunction with a range of applications from Apple's own iLife and iWork suites to other applications like Adobe InDesign. We'll tackle this from two opposing angles:

Apple Aperture 3. DOI: 10.1016/B978-0-240-52178-7.10007-6 Copyright © 2010 Elsevier Ltd. All rights of reproduction, in any form reserved. round tripping images to other applications from Aperture and accessing your Aperture Library from within other applications.

The potential for enlisting the help of third-party applications to edit your images in Aperture has grown enormously with the introduction of Aperture 2.1's edit plug-in architecture. We'll also take a look at some of the more useful Aperture plug-ins.

Importing your iPhoto Library

When you first open Aperture, a dialog box appears that allows you to import your iPhoto Library. If you decide to import your iPhoto Library after you've been using Aperture for a while, select File > Import > iPhoto Library (Fig. 7.1).

Use the Store Files pop-up menu to tell Aperture where you want to store the imported image files. 'In the Aperture Library' will copy the files from the iPhoto Library to the Aperture Library. If you have a large iPhoto Library you'll need to consider the storage implications of this and make sure you have sufficient disk space for the duplicates (Fig. 7.2).

'In their current location' treats the images in the iPhoto Library as referenced files. They are not imported into the Aperture Library; Aperture maintains a link to them in their current location. For more details about the difference between working with managed and referenced files see Chapter 2. Alternatively, you can choose a location where you want the image files copied or moved to.

Leave the Version Name pop-up menu on its default of Master Filename to import images with their current filenames, or select one of the options if you

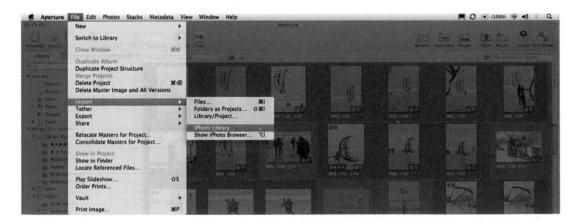

FIG. 7.1 Select File > Import > iPhoto Library to import your entire iPhoto Library into Aperture.

DEVICES	05 MASTE			m
Ken Mc	38624165		and the second se	
Macinto	Aperture Lib			e la
PLACES	coral.jpg	Library P	here in the	1
Desktop	iChat Icons			U
Applicati	📓 iPhoto Librar	Y A		*
Documents	iPhoto Librar	y (original)		• N
docx		en e		and the second second
	Import Folders As:	Projects and Albums	:	
	Store Files:	In their current location	•	
		O Move files O Copy files	1	
		Do not import duplicates		
			-	
	Subfolders:	None	<u> </u>	
	Folder Text:			
	Version Name:	Master File Name	10	
	Name Text:			
		Apply to Master filenames		
	RAW + IPEC	Both (Separate Masters)	A the Bally straight	

FIG. 7.2 In the dialog box, tell Aperture where you want to store the iPhoto images, how to deal with subfolders and whether to rename the original files.

want to rename the files on import. Finally, click the Import button to import your iPhoto Library.

Aperture maintains the organization of your iPhoto Library as Projects within an iPhoto Library Folder. Albums are imported, but Aperture doesn't import iPhoto Smart Albums, Books or Slideshows. The EXIF information is included as are any keywords, ratings and image adjustments that you applied in iPhoto (Fig. 7.3).

Importing Individual Images or Albums

You don't have to import your entire iPhoto Library into Aperture. The iPhoto Browser allows you to select individual Events, Albums and images. To open the iPhoto Browser select File > Import > Show iPhoto Browser, or press \bigcirc (Figs 7.4 and 7.5).

The top panel of the iPhoto Browser shows Events, Photos, recent events and imports, and Albums. Selecting any item in the top pane displays its contents in the pane below. To display the contents of an individual Event, click the Events button to display all of the Events in the bottom pane and then double-click the Event you want. Selecting Photos displays all images in your iPhoto Library.

The Browser includes tools to help you sort and locate images within your iPhoto Library. Use the Sort pop-up menu to arrange images by Name, Rating, Date Created or other criteria. Click the Search button in the top right of the iPhoto Browser to do a text search for images.

Apple Aperture 3

(a)

Previews

You can adjust the size of the thumbnail previews in the bottom pane by dragging the slider in the bottom right corner. Alternatively, double-click an image to display a larger preview including EXIF and rating information. Use the navigation controls at the bottom of the preview window to move back and forth through the image selection.

When you've located and selected the Events, Albums, or images you want to import, just drag them onto a Project in the Projects Inspector or HUD. If you drag images or Albums onto the Library in the Projects Inspector a new Project is created for them.

Moving from Adobe Bridge and Adobe Camera Raw

For many photographers not yet utilizing a digital image workflow application such as Aperture, Adobe Bridge and Adobe Camera Raw provide the means by which they organize their image collections and convert Raw files to RGB images.

Aperture and Adobe Bridge

The advantages of using Aperture over a Bridge/ACR workflow are numerous. Aperture's organizational tools and versioning system make it easier to keep track of your images and edited Versions, take up much less disk space and, ultimately, help you work faster than a system which relies on producing multiple RGB files for each edited Version of an image. You'll also find locating images within a large Library much faster using Aperture.

Suppose you want to produce two Versions of the same Raw file: one color and another black and white. Using Adobe Camera Raw you would set the required conversion options for the color image and output an RGB file. Then you'd need to go back to the Raw file and output a second image using ACR's grayscale conversion parameters. If you then decided you wanted a cropped Version of the mono image a third file would need to be produced. You can do all of this in Aperture without creating a single additional file (Fig. 7.5).

Aperture and Adobe Camera Raw

If you're used to using Adobe Camera Raw to convert your Raw files to RGB images, you should find working with Aperture's Raw Fine Tuning and other Adjustments easy to adjust to. The controls on ACR's Basic panel – White Balance, Exposure, Recovery, Fill Light, Blacks, Brightness, Contrast, Clarity, Vibrance and Saturation – all have Aperture equivalents and even share the same or similar names.

ACR provides some correction tools that Aperture lacks, or doesn't implement in the same way. For example, Aperture lacks the equivalent of ACR's

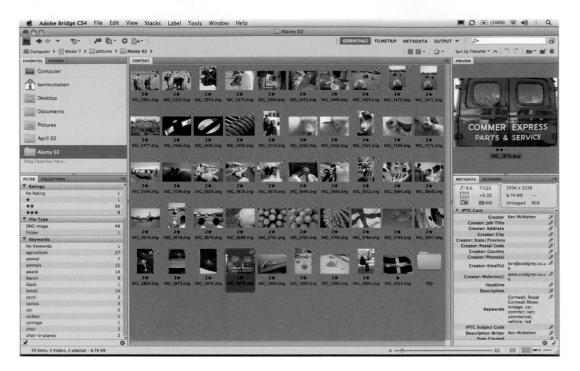

FIG. 7.5 Adobe Bridge CS4 references images and other media types on your hard drive and allows you to organize and display them in a Browser and edit metadata.

Tone Curve, but you can utilize the quarter-tone controls in the Levels adjustment to effectively change the shape of the tonal curve in much the same way. And ACR's Split toning is different in effect to Aperture's Color Monochrome adjustment, though, arguably, no more useful.

In its favor, Aperture puts a much broader range of adjustments and editing controls at your disposal. Chapter 5 tells you everything you need to know about these.

Migrating your Library

The process of migrating your image Library from Bridge to Aperture is, in most respects, relatively straightforward. Bridge references image files in their existing location; it doesn't store the actual image files within the application. To make a comparison with Aperture's way of doing things, it works with referenced rather than managed files.

Because of this, you don't actually need Bridge to import images that you've managed using Bridge into Aperture. In fact, if you're used to working with Bridge as part of the CS3 suite there's no reason you can't continue to do so, provided you configure Aperture to work with referenced rather than managed image files. See Chapter 2 for more details on how to do this.

To import a folder of images that you've previously worked with in Adobe Bridge, first you will need to locate them in the Finder. This shouldn't be too difficult as all you have to do is look in the Folders panel. You can also rightclick a Folder or an image in Bridge and select Reveal in Finder from the context menu (Fig. 7.6).

FIG. 7.6 Locating Folders of photos using Bridge is straightforward because the Folders pane displays the file structure on your hard disk. Alternatively, you can right-click an image or Folder and select Reveal in Finder from the context menu.

Now all you have to do is import the Folder into Aperture in the normal way; either drag and drop it from the Finder into a Folder in the Projects Inspector, select File > Import > Folders as Projects, or click the Import button. For more detailed information on importing Folders of images see Chapter 3.

Metadata

If you've used Bridge to add IPTC metadata and keywords to your photos, you may be in for an unpleasant surprise when you view their metadata in Aperture – it may not be there. Depending on the image format, metadata is either embedded in the image file itself, or it is written to a separate 'sidecar' file. Usually, metadata is embedded in Tiff, JPEG and PSD files and only Raw file formats have their metadata written to a separate sidecar file.

Bridge and Camera Raw Metadata

Processing of Raw images in Bridge is handled by Adobe Camera Raw (Fig. 7.7). When you open a Raw file by double-clicking it in Bridge it opens in Camera Raw, where you can apply adjustments to the Raw data before opening it in Photoshop or saving it as an RGB file. Adobe Camera Raw also plays a part in determining how metadata which you add in Bridge is stored. This has important consequences that will affect your ability to import image metadata into Aperture. We'll come to that shortly.

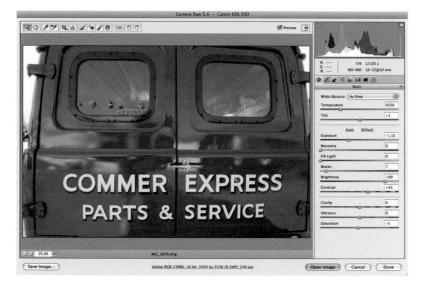

FIG. 7.7 Bridge doesn't provide Raw decoding. Interpretation and conversion of Camera Raw files into RGB is done using the Adobe Camera Raw Utility. ACR can store adjustments to Raw images in a sidecar XMP file (or embedded within an Adobe DNG file) and these are used by Bridge to display the adjusted thumbnail. However, you can only have one set of adjustments per Raw file. For more than one Version, it's necessary to output multiple RGB files.

XMP sidecar files

The sidecar files that Bridge, Adobe Camera Raw and many other applications use to exchange metadata are in XMP format. XMP stands for eXtensible Metadata Platform and is a widely used Adobe standard for the storage and exchange of metadata (Fig. 7.9).

So, if you add IPTC metadata to your Camera Raw files in Bridge, it will be stored in a separate file along with the Raw file. For example, if the Raw file is called IMG_6341.CR2, the sidecar file will be called IMG_6341.xmp (Fig. 7.8).

It's not just Adobe applications that use sidecar XMP files. XMP is supported by other image management and Raw processing applications including iView Media Pro, Extensis Portfolio and Capture One 4 and, of course, Aperture 3.

Birmela		G		
Back Vie		and the second		arch
# DEVICES	Name	 Date Modified 	Size	Kind
🕲 iDisk	DS_Store	4 April 2008, 13:12	8 KB	Plain text
Macintosh HD	IMG_6341.CR2	1 April 2008, 11:10	9 MB	Canoaw file
	MG_6341.xmp	4 April 2008, 13:15	12 KB	Adobnfo file
E Lacie 75Gb ≜	IMG_6342.CR2	1 April 2008, 11:10	9 MB	Canoaw file
► SHARED	MG_6342.xmp	4 April 2008, 13:11	4 KB	Adobnfo file
	IMG_6343.CR2	1 April 2008, 11:10	9 MB	Canoaw file
V PLACES	MG_6343.xmp	4 April 2008, 13:11	4 KB	Adobnfo file
2 Desktop	IMG 6344.CR2	1 April 2008, 11:10	9 MB	Canoaw file
😤 ken	MG_6344.xmp	4 April 2008, 13:12	4 KB	Adobnfo file
A Applications	IMG 6345.CR2	1 April 2008, 11:10	9 MB	Canoaw file
Documents	MG_6345.xmp	4 April 2008, 13:12	4 KB	Adobnfo file
Movies	IMG_6346.CR2	1 April 2008, 11:10	9 MB	Canoaw file
Pictures	MG_6346.xmp	4 April 2008, 13:12	4 KB	Adobnfo file
SEARCH FOR				

FIG. 7.8 When you add or edit metadata in a Carnera Raw file in Bridge, it stores it in an XMP 'sidecar' file. These CR2 Raw files from a Canon dSLR were shot on 1 April 2008. On 4 April they were rated, which is when Bridge created the XMP file for each one.

If you're importing Raw images and you can't see metadata you added in Bridge, there will be one of two reasons for its absence. If you're using Aperture 3, the most likely cause is that Adobe Camera Raw Preferences are set to save Raw image metadata in the Camera Raw database rather than in XMP sidecar files. To find out if your Raw image metadata is stored in the Camera Raw database or in xmp files, select Camera Raw Preferences from the Adobe Bridge CS4 menu. The Save Image settings in the pop-up menu in the General section of the Preferences dialog determine which method is used. Another quick way to find out is to check for the presence of .xmp files in the image Folders.

If you've been saving metadata in the Camera Raw database all is not lost, you just need to export the data to .xmp files for all of your images. To do this you need to open them in Adobe Camera Raw and select Export Settings to XMP from the Camera Raw Settings menu button. XMP sidecar files are written to the same Folder as are the images.

Even if you've saved metadata added in Bridge in XMP sidecar files there's another reason you may not see it when you import those Raw files into Aperture. Aperture 3 supports import of sidecar XMP sidecar files, but earlier Versions of Aperture do not. If you're using Aperture 2 and you want to import Raw files with metadata contained in XMP sidecar files, the simplest solution is to upgrade – Aperture 3 offers many other benefits besides this.

There is a work-around that involves converting the Raw files to Adobe DNG format. Even if you're using Aperture 3, which will import XMP sidecar files, converting your files to DNG format means you won't have to worry about losing XMP files when you move images or rename them. There are other advantages that make DNG conversion worth considering and these are discussed in Chapter 1.

Apple Aperture 3

FIG. 7.9 This is what you'll find if you open an XMP file in a text editor. This section of the file contains the EXIF information; further down is the IPTC metadata and the list of adjustments made in Adobe Camera Raw.

000 23:21:40 drdf:RDF xmlns:rdf="http://www.w3.org/1999/82/22-rdf-syntax-ns#"> <rdf:Description rdf:about=" xmlnstiff="http://ns.adobe.com/tiff/1.0/">
<tiff:Make>Canon</tiff:Make>
<tiff:Make>Canon</tiff:Make> diff:Orientations1</tiff:Drientations
<tiff:ImageWidth>3504</tiff:ImageWidth>
<tiff:ImageWidth>2336</tiff:ImageLength> diff:PhotometricInterpretations2<tiff:PhotometricInterpretations
diff:SamplesPerPixel>3</tiff:SamplesPerPixel>
diff:BitsPerSample> ⊲rdf :Sea <rdf:li>16</rdf:li> <rdf:li>16</rdf:li> <rdf:li>16</rdf:li> </rdf:Seq>
</tiff:BitsPerSample> </rdf:Description> <rdf:Description rdf:about="" xmlns:exif="http://ns.adobe.com/exif/1.0/"> aminiserie ncup://ms.dube.com/stif/1/0/>
exif :ExifVersions8221.exif :ExifVersions
exif :ExposureTimes/
exif :ShutterSpeedValues8321928/1000008.exif :ShutterSpeedValues exif:FNumber>8/1</exif:FNumb dexif:ApertureValue>6/1</exif:ApertureValue> exiffExposureProgroms-3c/exiffExposureProgramsexiffExposurePr dexif:ExposureBlasValue>1/3-</exif:ExposureBlasValue>
dexif:MaxApertureValue>4/1-</exif:MaxApertureValue> <exif:MeteringMode>5</exif:MeteringMode</pre> dexif:FocalLength>18/1</exif:FocalLength>
dexif:CustomRendered>8</exif:CustomRendered>8</exif:CustomRendered>8</exif:CustomRendered>8</exif:CustomRendered>8 <exif:ExposureMode>0</exif:ExposureMode> «exif:WhiteBalance>0</exif:WhiteBalance>
«exif:SceneCaptureType>0</exif:SceneCaptureType> dexif :FocalPlaneXResolution>3504000/885c/exif :FocalPlaneXResolution> aexif:FocalPlaneVResolution>236080/598</exif:FocalPlaneVResolution> aexif:FocalPlaneResolutionUnit>2</exif:FocalPlaneResolutionUnit> dexif:ISOSpeedRatings> <rdf :Sea df:li>100</rdf:li> </rdf :Seq> </exif:ISOSpeedRatings> <exif:Flash rdf:parseType= "Resource"> sexif:Fired>False</exif:Fired> dexif:Return>0</exif:Return
dexif:Mode>2</exif:Mode> dexif:Function>False</exif:Function> dexif :RedEyeMode>False</exif :RedEyeMode</pre> /exif :Flash> </rdf:Description> crdf:Description rdf:obout=""
xmlns:xop="http://ns.adobe.com/xop/1.0/">
<cop:ModifyDate>2008_04_01T11:10:40+01:00</cop:ModifyDate> Å T

DNG Conversion

You can download Adobe DNG Converter from www.adobe.com/products/ dng (Fig. 7.10). Read on to find out how to convert your Raw files to DNG format before importing them into Aperture.

Launch DNG Converter and make sure the Preferences in panel 4 are set to:

Compatibility: Camera Raw 5.4 and later JPEG Preview: Medium Size Don't embed original

If you want to embed the original Raw image file in the DNG, click the Change Preferences button and check the Embed Original Raw File checkbox. (There's a brief explanation of why you might want to do this in the section on DNG in Chapter 1.)

In panel 1, click the Select Folder button and navigate to the Folder containing the images to be converted. Make sure the .xmp files are in the same

90		DNG Conver	ter	
Q.	Adobe Digital Negati	ve Convert	er	
O Sele	ect the images to convert			
69	Select Folder) /Work	in Progress/5221	Aperture 3/	
-	Include images containe	ed within subfo	lders	
O Sele	ect location to save converted	images		
(A)	Save in New Location	ด		
2	Select Folder /Work	in Progress/5221	Aperture 3/dng files/	
	Preserve subfolders			
C) Sele	ect name for converted image	5		
	Name example: MyDocument.d	ing		
	Document Name	(1) +		+
		+		•
	Begin numbering:			
	File extension: .dng	•		
O Pref	erences			
	Compatibility: Camera Raw 5.4 JPEG Preview: Medium Size Don't embed original	and later	Change Prefer	ences

FIG. 7.10 Adobe's DNG Converter is a utility that converts proprietary Camera Raw files into Adobe's 'Open' DNG format. This has future-proofing advantages for your digital archive, and also provides a migration route for your image Library from Bridge to Aperture with metadata intact.

Folder as the Raw files. Check the box to include images contained within subfolders. In panel 2, select Save in New location from the pop-up menu and choose a Folder in which to save the converted images. Check the Preserve subfolders box. In panel 3 leave everything as it is, so that your files keep their name but are appended with the .dng file extension.

When you click the Convert button, DNG converter will begin the conversion process. You can convert your entire image Library to DNG this way, but it may take a while. Before you embark on a large-scale conversion you may want to try a test with a single Folder of images. As long as you have a safe

	le se	Preferences		
patibility				
npatibility	Camera	Raw 5.4 an	d later	•
CS4) and la	ater, and Ligh	troom 2.4 an	d later. The D	NG file will
iew				
G Preview:	Medium	Size	•	
inal Raw F	ile			
Embed Ori	ginal Raw F	ile		
creates a la	arger DNG file	e, but it allow:		
			ncel) (OK
	npatibility The DNG fi CS4) and la often be re model. : : : : : : : : : : : : : : : : : : :	patibility npatibility: Camera The DNG file will be rea CS4) and later, and Ligh often be readable by ea model. iew C Preview: Medium inal Raw File Embed Original Raw F Embeds the entire non- creates a larger DNG file	patibility	patibility

FIG. 7.11 Use DNG converter to convert your Camera Raw files to DNG format with the metadata embedded. The Preferences should be set as shown here, though you don't have to compress your DNG files and you can select a different preview size if you prefer. backup of the original Raw files, and you save the converted files to a new location with a .dng suffix, you've got nothing to lose and can always revert to your Camera Raw files if you decide against using DNG in future.

When the conversion process is complete, you'll have a duplicate of your image Library with the same file and Folder structure containing .dng rather than Camera Raw and .xmp sidecar files. DNG converter automatically embeds the metadata that was in the sidecar file into the .dng file (Figs 7.11 and 7.12).

FIG. 7.12 When you click the convert button DNG converter will begin the conversion process. For a large Library this could take some time. Do a test run on a small Folder of images to ensure everything works as expected.

Original File:	Converted File:	Status:	
IMG_0630.CR2	IMC_0630.dng	Converted	
IMG_0631.CR2	IMC_0631.dng	Converted	
IMG_0632.CR2	IMG_0632.dng	Processing	
IMG_0633.CR2	IMG_0633.dng	Waiting	
IMG_0634.CR2	IMG_0634.dng	Waiting	
IMG_0635.CR2	IMG_0635.dng	Waiting	
IMG_0636.CR2	IMC_0636.dng	Waiting	
IMG_0637.CR2	IMG_0637.dng	Waiting	
IMG_0638.CR2	IMG_0638.dng	Waiting	
IMG_0639.CR2	IMG_0639.dng	Waiting	
	the most out of your photograp	offers a full line of digital imaging shs.	DNC

Now you're ready to import the .dng files into Aperture. Select File > Import > Folders Into a Project and navigate to one of the converted Folders. Aperture imports all of the images into a single Project and creates Albums for subfolders, so you might first want to decide how you want your Projects organized in the Projects Inspector and set up a suitable Folder structure.

Aperture and Adobe Photoshop Lightroom

Like Bridge, Adobe Photoshop Lightroom uses Adobe Camera Raw as its Raw processing engine. If you're switching to Aperture from Lightroom, the process and the metadata issues are the same as those we've discussed for Adobe Bridge. So long as the sidecar XMP files are present you should have few problems importing images previously managed by Lightroom into Aperture.

While it's possible to import Raw files with their metadata, don't expect to retain any raw editing applied to these files when you import them into Aperture. It's not possible to import image adjustments made to Raw files (even DNGs) with Adobe Camera Raw into Aperture. Although ACR saves the adjustments to the XMP sidecar file or, if possible, the file itself, and they are imported into Aperture, they are immediately overwritten by the Aperture Raw decoder and default adjustment settings.

Aperture and Adobe Photoshop

Although Aperture has everything you'll need for processing the majority of your images, there will be occasions when you need to turn to an external image editor. For most people that's going to be Photoshop, but you can use any image editing application in conjunction with Aperture.

You define the external image editor you want to use in the Export tab of the Preferences window (Fig. 7.13). Click the Choose button to navigate to the application; then click Select. Choose the file format that you want to use from the External Editor File Format pop-up menu. The range of file formats you can work with was extended in Version 2.1 of Aperture to include 8-bit and 16-bit PSD and TIFF files.

The default resolution for opening files in your external image editor is 72 dpi. Note that this doesn't affect the number of pixels in the image, only the resolution. If the Raw master has pixel dimensions of 3504×2332 , this

900	Export		
ieneral Appearance Import Expo	Labels Previews Web	Advanced	
External Photo Editor:	Adobe Photoshop CS4	C	100se)
External Editor File Format:	PSD (8-bit)	•	300 dpi
External Editor Color Space:	ProPhoto RGB	:	
External Audio Editor:	No application selected	(0	100se)
External Video Editor:	No application selected	(1005e)
Email using:	Mail	:	
Email Photo Export preset:	JPEG - Fit within 640 x 640	:	
Web Copyright:	© Ken McMahon 2010		
	✓ Include location info in exp ✓ Include face info in exporte		

FIG. 7.13 Choose the application that you want to use for external editing in the Export panel of the Preferences window. Aperture 2.1 has extended the range of round trip file formats to 8-bit, as well as 16-bit PSD and TIFF files.

remains unchanged whether the resolution of the opened file is 72 dpi or 300 dpi. In other words, images are not resampled.

To open an image in Photoshop (or your chosen external editor) select it in the Browser and choose Photos > Edit with Adobe Photoshop. Alternatively, right-click the image thumbnail and choose 'Edit with Adobe Photoshop', or press *Shift* (#) (Fig. 7.14).

There's a short delay and the message 'Preparing IMG_1234 for editing' appears. What's happening during this time is that Aperture is producing a file of the format specified in Preferences, e.g. a 16-bit PSD file. All of the adjustments you made to the selected Version using the Raw Fine Tuning controls and other adjustments are applied to the image and then it's opened for you in Photoshop (Fig. 7.15).

FIG. 7.15 Here the image has opened in Photoshop as a 16-bit PSD file, as defined in the Aperture Preferences. Behind it, you can see the new master Version that Aperture has added to the Library, stacked with the original master and denoted with a target badge to indicate it has been created with an external editor.

New Masters

Whether you make any changes to the image in Photoshop or not, the new file is added to your Aperture Library and appears stacked alongside the Version from which it was created (Fig. 7.16). With the image still open in Photoshop, press (#) to switch back to Aperture and you'll see its

FIG. 7.16 The new master in the Aperture Browser alongside the original master.

thumbnail in the Browser. If you have a metadata display enabled that shows badges, on the new thumbnail you'll see a badge – a circle with a dot in the middle – that indicates this is a master created by an external editor.

If the new master was produced from a managed master, then the PSD file will be stored in the Aperture Library. In Aperture 2 and later, round-tripped masters created from referenced masters are stored in the same location as the original referenced master (Fig. 7.17). In earlier Versions of Aperture this was not the case and all new masters produced as a result of external editing, regardless of whether the original was managed or referenced, were stored in the Aperture Library. The new master either had to be manually dug out from the Library package or exported from Aperture to the original location and then re-imported to the Aperture Project.

In any case, access of managed masters from other applications is no longer the issue it used to be as, using MacOs 10.5 Leopard and later, it is now possible to access your Aperture Library from other applications like iLife and iWork. This is covered later in this chapter.

FIG. 7.17 If the original image was referenced, the master produced by round tripping to an external editor is now stored in the same location, rather than in the Aperture Library.

Workflow Considerations

One important consequence of external editing is that new PSD and TIFF masters are not editable in the same way as the original Raw masters or versions from which they were created. Obviously the Raw Fine Tuning adjustment will not be available and any other adjustments you made prior to editing the image in Photoshop will have been applied and effectively 'fixed'.

For example, if you applied Edge Sharpening to the original, you won't find the Edge Sharpening adjustment when you select the new externally edited master. And if you add more Edge Sharpening, the controls will be set at their defaults – not the Sharpening settings you originally applied; those are now undoable (Fig. 7.18).

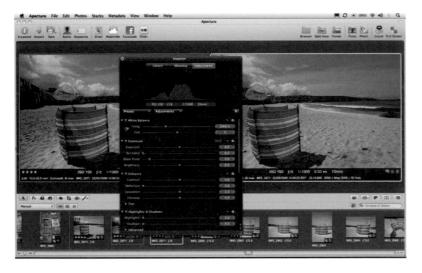

FIG. 7.18 A round-tripped image is no longer a Raw image, so you obviously won't see the Raw Fine Tuning adjustment in the Adjustments Inspector or HUD. All other adjustments are also set to their defaults – you're starting afresh with a new image.

Think carefully about what stage in the workflow you are going to incorporate external editing. Usually you'll want to leave it as late as possible, but not always. In the case of Sharpening, for instance, you probably wouldn't want to apply Edge Sharpening to an image prior to carrying out retouching in Photoshop as this kind of work is best done prior to Sharpening.

Plug-ins

Shortly after Apple released Aperture 2.0 in February 2008, it announced Aperture 2.1 – an upgrade that included support for edit plug-ins from

third-party developers. Plug-in developers can now produce image editing tools that Aperture lacks and users can choose those tools that are useful in their workflow. In this way users get the tools they want without Aperture becoming overburdened with image editing tools that most users don't require. The first of these new plug-ins, Dodge & Burn, was developed by Apple itself.

In Aperture 3, the Dodge & Burn plug-in has been superseded by new brushbased adjustments that can be applied selectively (for more information about these see Chapter 5) (Fig. 7.19). Apple has not only made its own plugin redundant, but a number of third-party plug-in developers will have found tools they developed for Aperture 2.x now part of the application's core functionality.

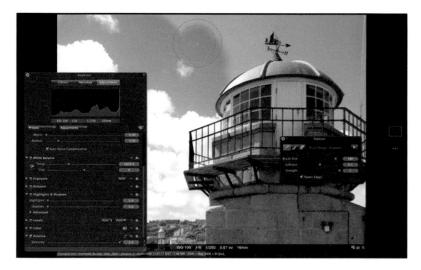

FIG. 7.19 Aperture 2.1's Dodge & Burn plug-in has been superseded by brush-based adjustments. Here, a Polarize Quick Brush is used to darken the sky.

Nonetheless, there are plenty of plug-ins out there that do things Aperture can't manage on its own, or do them better. What follows is an overview of how the plug-in architecture works and the consequences for your workflow; we'll then take a brief look at some of the more useful Aperture plug-ins available.

How Edit Plug-ins Work

Ordinarily, Aperture's adjustments aren't applied to master images or Versions until you export them. They exist in Aperture as lists of edit instructions which are applied to images on the fly as you view them. Image editing plug-ins work differently. Most image editing plug-ins work by first creating an RGB file using the Raw decoder and applying any adjustment, then passing this to the plug-in. When your edits using the plug-in are complete, and you press Save, a new PSD or TIFF file is saved to disk and loaded into your Aperture Library. This is a similar process to what happens when you round trip a Version to Photoshop, or another external image editor.

The new master appears in the Browser with the target badge to indicate that it is a master created using an external editor (Fig. 7.20). The kind of file produced by the plug-in round-trip process is the same as that produced when you use an external image editor, i.e. an 8- or 16-bit TIFF or PSD, and is set in the Export pane of the Preferences window.

A significant consequence of this approach is that any edits you make using an image editing plug-in are irreversible. Furthermore, as a new TIFF or PSD master is created, you will no longer be able to edit previously applied adjustments.

This has important consequences for your workflow. If possible, it makes sense to leave editing that involves plug-ins to the final stage of your workflow. For one thing, as you're by now aware, Raw files contain more data and are more robust from an editing standpoint than RGBs, PSDs and TIFFs.

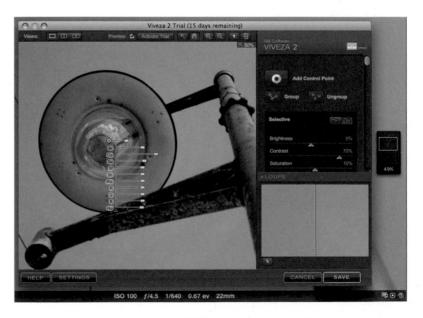

FIG. 7.20 Most image editing plug-ins create an RGB file to which edits are applied. Here, color adjustments are made to a Version using Viveza 2. In the Aperture viewer, visible behind the Viveza window, you can see the badges including the target badge, which indicates the image has been edited outside of Aperture.

Aperture, Plug-ins and External Editing

Imagine the following scenario. You have a landscape shot with some dense foreground detail that would benefit from the application of the Shadows & Highlights adjustment using a brush. You first go through your normal adjustment workflow, creating a new Version of the master file and applying Raw Fine Tuning settings, adjusting White Balance, and sharpening the image. Then you sort out the dense foreground, brushing in quite a hefty shadows adjustment. So you now have the original master plus a Version with all of the Aperture adjustments.

Now that you've brightened up the shadow areas, you notice there's some ugly noise that's become more apparent. This is exactly the kind of problem Picture Code's Noise Ninja is good at dealing with, so you choose Edit with Plug in from the Photos menu and select the Noise Ninja plug-in. The plug-in creates a new master PSD or TIFF file with the noise reduction applied.

Now let's suppose you decide that the image requires cropping. So you select the new master file and crop it using Aperture's Crop tool – so far, so good. Now you want to open the image in Photoshop to do some cloning that's too demanding for Aperture's Retouch tool, so you select Images > Edit with Adobe Photoshop.

The file opens in Photoshop, but the cropping hasn't been applied. Why is this? The reason is that in order to apply a crop, Aperture would have to create another master PSD file. It doesn't want to do this unless it's absolutely necessary, so you have to tell it to. You do this by holding down the reason when you select Photos > Edit with Adobe Photoshop from the Images menu. Notice that the Photos menu choice has changed to Edit a Copy with Adobe Photoshop. Select Photos > Edit a Copy with Adobe Photoshop and the image will open in Photoshop with the latest Aperture adjustments and a new master PSD file is added to your Aperture Library (Figs 7.21–7.25).

There's a wide range of plug-ins available for Aperture providing image editing, workflow automation, enhanced export options and other extras like Web Gallery themes and Adjustment presets. A good place to find details on the Web is Apple's Aperture resources page at: http://www.apple.com/ aperture/resources/

Below you'll find a brief introduction to some of the more useful image editing plug-ins currently on the market.

Nik Software – Viveza 2

https://www.niksoftware.com/viveza/en/entry.php

Viveza is a color correction and editing plug-in, originally for Photoshop, that uses a system of color control points called U Point. Nikon dSLR owners may already be familiar with U point from Nikon's proprietary Raw capture

FIG. 7.21 This Aperture master file (left) is in need of some work to prepare it for use in a Book. A new version – IMG_2870 – Version 2 (right) is adjusted for White Balance, straightened, and tonally adjusted. Then a Highlight & Shadows adjustment is applied with a brush.

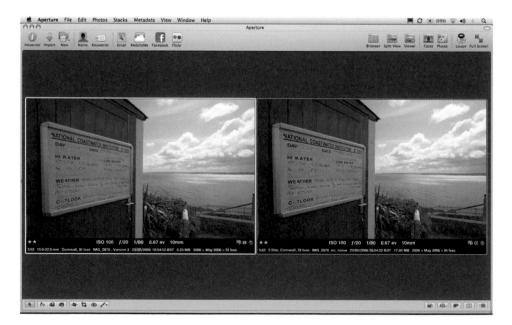

FIG. 7.22 Having made these adjustments, noise in the lightened shadow areas has become apparent and is removed using Noise Ninja. This creates a new .psd master which we've renamed IMG_2870_no_noise (right). Note the target badge indicating this is a master that has been edited outside of Aperture.

Working with Other Applications

FIG. 7.23 Next, we've decided the image would benefit from cropping.

FIG 7.24 Here's what happens if you open the image in Photoshop using Photos > Edit with Adobe Photoshop. The image has been opened without the most recent edit (the crop) applied. Aperture can't crop the PSD file without creating another new master and it avoids doing this until you tell it to. (It will, however, apply the crop to exported images.)

FIG. 7.25 To create and open a new PSD master file with the crop (and any other Aperture adjustments applied after the plug-in was used), hold down and select Photos > Edit a Copy with Adobe Photoshop.

FIG. 7.26 The Viveza Photoshop plug-in. In this example two control points have been used to darken the back-ground without affecting the subject.

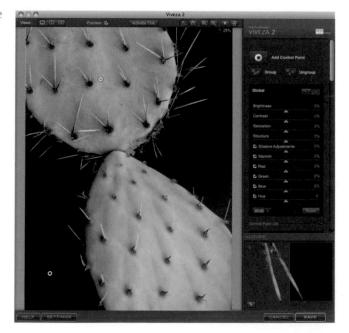

application, Nikon Capture NX. U Point control points are placed directly on color critical image areas – for example on sky areas, skin tones (Fig. 7.26).

You might think that the introduction of brush-based adjustments in Aperture 3 would make a plug-in like Viveza redundant, but it thrives as a Photoshop plug-in in an application with far greater image editing capabilities. What make Viveza so compelling is that it allows you to easily make the kind of selective adjustments that would ordinarily require a lot of skilled work creating masks.

With Viveza, you just add control points and drag the sliders to adjust controls such as Brightness, Contrast, Saturation, Hue and various other color controls. You can add control points to different parts of the image and adjust their radius, though the affected area is displayed as a simple circle, sophisticated behind masking always ensures natural results with no visible boundaries.

Version 2 of Viveza now also includes a Levels and Curves panel and the ability to group control points and adjust them in concert, as well as making global adjustments.

PictureCode – Noise Ninja

http://www.picturecode.com/

Noise Ninja has a well-deserved reputation as one of the most effective noise reduction tools around. Its noise reducing capabilities are without doubt in a different class to Aperture's own Noise Reduction adjustment. If you shoot a lot of images at high ISO ratings this is one Aperture plug-in you won't want to be without (Fig. 7.27).

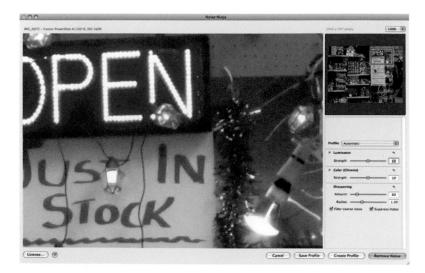

FIG. 7.27 Noise Ninja Photoshop plug-in.

Noise Ninja's success at reducing noise in digital images is down to a twopronged approach. Firstly, it uses camera profiles to identify the 'noise signature' of specific dSLR sensors at given ISO settings. Second, it uses advanced algorithms based on wavelet theory to eliminate noisy pixels while minimizing image softening.

Tiffen – Tiffen Dfx

Tiffen is probably best known as a manufacturer of photographic filters – the glass kind. Dfx is a suite of digital filter effects that's available as a standalone application as well as plug-in Versions for Photoshop, Aperture and a wide range of video editing applications.

The Aperture plug-in contains hundreds of filter effects including digital equivalents of Kodak Wratten filters, graduated ND, Faux Film, Split tone and Cross Processing. As well as individual filter presets you have access to the parameters via a control panel populated with sliders, so you can adapt existing presets to create new variants and you can add multiple filter layers to create more complex effects. It's very easy to use and the sheer quantity of filters makes it a useful toolbox both for photographers who want to replicate physical glass, gel and processing effects and for experimentation (Fig. 7.28).

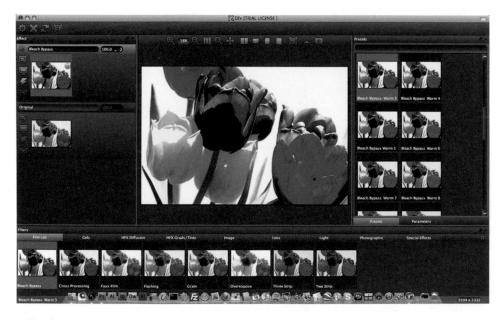

FIG. 7.28 Tiffen Dfx 2 for Aperture 2.1.

Digital Film Tools - Light!

http://www.digitalfilmtools.com/powerstroke/

Light! is an Aperture plug-in that simulates ambient light falling on the subject though a variety of apertures, simulating anything from window lighting to dappled sunlight through leafy tree branches. The effects are applied as preset masks, which can then be transformed and adapted using parameter sliders. As well as lighting effects there's a selection of diffusion, fill, fog and glow effects (Fig. 7.29). It's effective, but the addition of displacement maps, permitting distortion of the light to follow image texture and contours, would be a welcome addition.

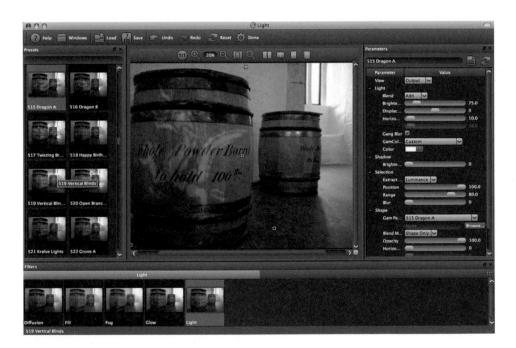

FIG. 7.29 DFT Light!

DFT produce two other Aperture plug-ins: Power Stroke and Ozone. Power Stroke provides simple-to-use selection tools that are used as the basis for selective color correction and other image edits. Ozone manipulates image color using the Zone System devised by Iconic American Landscape photographer Ansel Adams.

Image Trends – Fisheye-Hemi, ShineOff and PearlyWhites

http://www.imagetrendsinc.com/products/index.asp

When Image Trends first announced it would produce Aperture plug-ins, it planned to port three products from its range of Photoshop plug-ins to Aperture. The fact that PearlyWhites (a teeth whitener) and ShineOff (a tool for removing specular highlights from portraits) didn't make it is, frankly, no great loss, but Fisheye-Hemi is a genuinely useful plug-in that corrects Edge Distortion in images produced with non-rectilinear super-wide-angle and fisheye lenses.

There are other filters that do this, but often they replace one kind of distortion with another. Curved edges are straightened producing exaggerated perspective at the frame edges. Fisheye-Hemi produces more natural-looking results (Fig. 7.30).

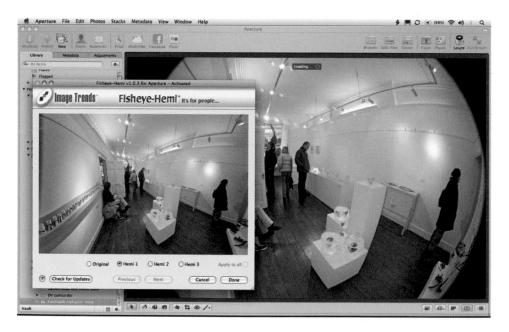

Using Aperture from Other Applications

Up to now, we've looked at how other applications work with Aperture. Whether talking about importing images from other applications or round tripping to external editors, the starting and finishing point for these processes is Aperture. New features introduced with the MacOs 10.5 Leopard operating system make it possible to access your Aperture Library from within other applications. Being able to access your Aperture Library in this way means that you can quickly find images to include in page layouts, presentations, email messages and other documents without having to leave the application you're working in.

Mostly, sharing your Aperture Library with other applications involves using the preview JPEGs generated by Aperture from masters and Versions. This makes sense because if, for example, you want to attach a photo to an email, or include one in a presentation, the adjusted JPEG preview will be more appropriate than a full resolution TIFF.

Preview Preferences

Before you can access your Aperture Library from iLife and other applications you first need to turn on preview sharing in Aperture Preferences. Choose Aperture > Preferences, or press (R) , click the Previews button and from the 'Share previews with iLife and iWork' pop-up menu select either 'Always' or 'When quitting Aperture' (Fig. 7.31).

While you're here you might also want to have a think about what sort of previews you want Aperture to generate from your image files. The Preview Quality slider sets the amount of compression that is applied to the JPEG previews, and the Limit Preview Size pop-up menu determines the pixel size of your previews. 'Don't limit' makes the preview the same size as the original, so if your camera shoots images 2332×3504 pixels, the previews will be that size too. Other options include half-size and a variety of 'fit within' options down to a minimum of 1280×1280 .

If you change the preview quality or size settings in Aperture Preferences, existing previews will not be updated until you either make an adjustment or force the preview to update. To do this, select the images you want to update, hold down **S** and choose Generate Previews from the Images menu (Fig. 7.32). You'll need to quit and re-launch Aperture for the Sharing

000	Previews	
(a) 🔲 🤳 🛃	OR	0 0
ieneral Aspearance Import Export	Labels Previews	Web Advanced
Aperture creates JPEG previews of when the master file is offline and		
		nomatically generate previews
Share previews with iLife and iWork:	Use embedded J	stomatically generate previews IPEG from camera when possible
Share previews with iLife and iWork: Photo Preview.	Use embedded j Always	

FIG. 7.31 In Aperture Preferences set 'Share previews with iLife and iWork' to 'Always' or 'When quitting Aperture'. You can also set the size and quality of the previews that Aperture generates here. Bigger, better quality previews will increase the size of your Aperture Library and take a little longer to display.

Inspector Import New Rom	Show Photo Info Set Key Photo for Project Rotate Clockwise Rotate Counterclockwise	1 36 7 [Aporture	anser Spin View Viewer	Texes Plans Losse Fairs Free
Ubrary Messelat Q- As sense 9 (SBRARY	Add Adjustment Replace with Adjustment Preset Reset All Adjustments	;			C Quanta and a street
E Property	Edit a Copy with Adobe Photoshop CS4 Edit with Plug-in	0%07 •			ST
E faces	Remove from Album	8	Service - Cleveland - T	A	
Pr Hagged * 17 Track * MORETS& AEBUMS	Duplicate Version New Version from Master New JPEG from Frame	77 75	NA LAND THE MADE AND THE AND THE AND	EVO Final Sense	443 (510) (MG 5704 /(10) 1/125
 Library Albums ***** * or better 	Switch Project to use RAW Masters Switch Project to use JPEG Masters				
g Rejected	Detect Missing Faces				
 Videos In the Last Week In the Last Month In the Last Month In the Last Month 	Reprocess Masters Generate Thumbnails Generate Previews for Project Delete Previews for Project		50 1		

FIG. 7.32 If you change the preview settings you'll need to force previews to regenerate. Hold down the New You and select Generate Previews from the Images menu.

Preferences changes to take effect. Bear in mind that if you have a large Library, generating previews may take some time. A more manageable approach is to do it on a Project-by-Project basis.

iPhoto

Just as you can import parts of your iPhoto Library into Aperture using the iPhoto Browser, you can access your Aperture Library from within iPhoto. When you configure Aperture to share previews with iLife and iWork applications, a new item appears on the iPhoto File menu called Show Aperture Library. Select this to open the Aperture Photos Browser.

To add items from your Aperture Library to iPhoto, drag and drop them from the Browser into the iPhoto Source List. You can drag entire Projects, Albums, Smart Albums or individual images into iPhoto. Whatever the original format of what you import into iPhoto using the Aperture Photos Browser, a new Untitled Album is created for it. You can't, for example, copy an Aperture Smart Album as an iPhoto Smart Album, only the images it contains.

It's also worth a reminder that these aren't the original masters you're bringing into iPhoto, but the JPEG preview files created by Aperture at the size and compression settings you specified in Aperture Previews Preferences (Fig. 7.33).

iTunes

To sync photos from your Aperture Library with your iPod or iPhone, plug in the device to launch iTunes, select your iPod or iPhone, and click the Photos tab. Check the 'Sync photos from' box. An alert box appears warning that syncing will replace all existing photos on your device. If you want to

FIG. 7.33 Select Show Aperture Library from the iPhoto File menu to display a Browser from which you can drag and drop items from the Projects Inspector, or individual images, into iPhoto.

proceed, click the Sync Photos button and, unless you want to download your entire Aperture Library, check the Selected albums radio button.

iTunes provides a more limited Browser than is available in iPhoto and some of the other iLife applications. There are no thumbnail displays and only Albums are listed, along with the number of images they contain. Select the Albums you want to sync with the device and click the Sync button (Fig. 7.34).

iWork applications

Using Aperture with other iLife and iWork applications, such as iMovie, Pages and Keynote, works in much the same was as described for iPhoto. For example, to add an image from your Aperture Library to a Keynote presentation, click the Media button on the toolbar and you'll see a similar dialog box to the one that appears in the other iLife and iWork applications. Though they occasional vary in detail they all (except iTunes) share the common layout that allows you to access your Aperture Library in a Project Inspectorstyle layout in the top panel and display thumbnail images in the lower panel (Fig. 7.35). Double-clicking, or pressing the *Spacebar* displays a Quick Look preview of the selected image.

iTunes File Edit View Controls		Q 1 (* 💬 028) 🗩 C
000	Tunes	
(*) (*) (*) (*) (*)	"	
	Summary Music Podcasts JTunes U Books Photos Co	ADACES
Movies		
E Rented Movies	Sync Photos from: Aperture +	
Ligh TV Shows		
Podcasts 🗊	All photos, projects, albums, and faces	
Books	Selected projects, albums, and faces, and automatically include no projects	in the second
"X" Radio	Include full-resolution photos	
TORE	Copy full-resolution versions of your photos into the Photos folder on	
IT iTunes Store	your iPod, which you can access after enabling disk use.	
DEVICES		
Y Bil Ken's Had	Projects and Albums:	
J Music	BT BFB session 2	-
Podcasts	C To Roundwood	
E Books	T movember 2009	
g 90's Music	Conor	and a second s
B My Top Rated	Conor's birthday	
Recently Played	Contra Stranday	
Dance Feveri	v 🖓 📷 Isabelle porcelain	
I Down in the dining.	C adjusted	the second se
Kak faves	Stabelle timeline	
E On-The-Go 1	D Porthtowan	and the second
E Purchased	v 🖓 🐨 Portreath storm	
SHARED	G Images from: November 01	
It Home Sharing	PowerShot A1100 tests	
Now Playing	v 🗍 🗁 October 2009	2
	Canon Ixus 95 IS test shots	
	Faces:	
Nothing		
Playing		
	Capacity And an and an and a strength of the second strength of the second strength of the second strength of the	Cancel
a difference of the second	14.55 Cit Audio E Photos Other E Free	
	17.70 GK 12.9 M8 482.6 M8 382.4 M8	Apply
+ × 0 0		

FIG. 7.34 You can sync Projects with your iPod from iTunes, but the Browser is limited to displaying the contents of the Projects Inspector – there's no thumbnail Browser.

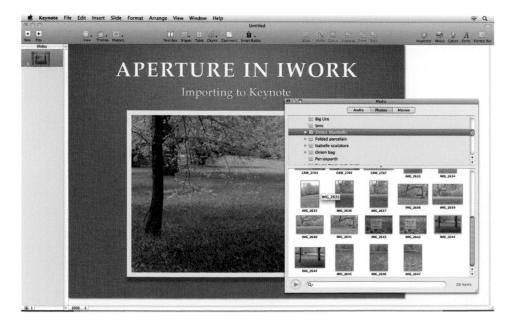

FIG. 7.35 Keynote's media Browser provides full access to your Aperture Library. Drag and drop thumbnails to place them in your slides.

Mail

You can add selected images to an email attachment from within Aperture by clicking the Email button on the toolbar, selecting File > Share > Email, or pressing **S (a)**. This launches Mail and attaches the selected photos to a new message. As we've seen, however, most people want things to work the other way around. It's more likely that you'll want to access your photos while emailing, than want to access your email while organizing and editing your photos.

Open Mail and click the New Message button on the toolbar. In the New Message window there's now a Photo Browser button on the toolbar; click it to open the Photo Browser.

The Photo Browser works in a similar way to the other iLife and iWork applications discussed earlier. In the top panel you'll see Aperture and iPhoto if you have both installed. Click the disclosure triangle next to Aperture and you'll see all of your Projects, Albums, Smart Albums and Folders as they appear in your Aperture Projects Inspector. You can track down individual images using the Search field at the bottom of the Browser, but this is of limited use as it doesn't search keywords and other metadata.

Navigate to the Project containing the photos you want to attach to the message, and drag the thumbnails from the lower panel into the message window (Fig. 7.36). The photos are automatically resized by Mail and appear actual size in the message window. To resize them select one of the size presets from the pop-up menu in the bottom right corner. The message size is indicated at the bottom left of the message window.

FIG. 7.36 Drag and drop photos from Aperture directly into Mail messages.

Photoshop

To open an Aperture preview from within Photoshop, select File > Open in the usual way. The Open dialog appears; you no longer get the option to choose the Adobe Open dialog box as you did with earlier versions of MacOs. Click the Photos button and select Aperture from the list in the top panel. Click the disclosure triangle to display the contents of the Projects Inspector.

As with all applications, what this does is open the Aperture JPEG preview file in Photoshop and there isn't really much point in doing this. If you need to do Photoshop editing on an image, it makes much more sense to work on a full quality, full resolution Version, which you can do by selecting Image > Edit with the external editor from within Aperture. This method also has the advantage that it will add the edited .psd or .tiff file created to your Aperture Library (Fig. 7.37).

FIG. 7.37 You can open Aperture previews directly into Photoshop, but there's little point. Either use Image > Edit With Photoshop or, if you want to open an existing PSD without creating a new Version, right-click it, select Show in Finder, and open it from there; that way, you'll be working on the full resolution file rather than the preview JPEG.

InDesign

All of the previews generated in Aperture are referenced to their Versions and the original Raw masters by a unique 'fingerprint' code that is stored in the Special Instructions IPTC metadata field of the preview JPEG. This code helps Aperture keep track of the relationship between masters and Versions and it can also be used in a desktop publishing workflow to enable the use of Aperture's JPEG previews as positionals, which can be updated with full resolution Versions prior to output.

You can place Aperture previews into InDesign Documents in much the same way as we've already seen with the iLife applications, using the new Open dialog box in MacOs Leopard. Select File > Place in InDesign, or press (I) to place an image and select Photos from the Media pane on the left-hand side of the dialog box. Select the required Project, Album, Smart Album or Folder from the Aperture Library and the thumbnails are displayed in the lower panel (Fig. 7.38).

If you need to see a thumbnail image at a larger size, select it and press the *Spacebar*. You can then scroll through, previewing all of the images using the and arrow keys. Press the *Spacebar* to return to the thumbnail panel. Click the Open button to place the chosen image.

When Aperture 2.1 was released, the potential for using AppleScript to build integration with other applications looked promising. A small Library of scripts originally published on the Apple website, then subsequently hosted at macosxintegration.com, demonstrated possible applications and became a useful suite of utilities in their own right.

These scripts allowed you to create Aperture albums containing images placed in InDesign, compile InDesign Libraries containing images chosen

FIG. 7.38 Place Aperture previews in InDesign in the usual way - by selecting File > Place - and then use the Browser to locate the image in your Aperture Library. These placeholder previews maintain a link to the master, so you can automatically replace them prior to output.

from Aperture, easily locate and edit Aperture Versions from their InDesign placeholders, and automatically export high resolution, press-ready Versions of placeholder images from Aperture and replace them in the InDesign document.

Regrettably, little if any progress has been made with these particular scripts since Aperture 2.1 was released and, while they work with InDesign CS2, they are incompatible with later versions. We mention them here as they may still be of use to those working with earlier versions of Adobe Creative suite.

Output

Exporting

The ultimate conclusion of taking a picture is bringing it to the public's attention. Whether that 'public' extends to a million people in a newspaper, or just the members of your family, the goal is the same, and so are the tools at your disposal.

Fortunately Aperture caters well here, as besides allowing you to export your images in the traditional sense – effectively saving them out as digital files – it also allows for a full range of printing and online publishing. It works in tandem with Kodak printing services to output prints, ties in with Apple's own MobileMe online service for publishing MobileMe Galleries, gives you the option of producing impressive Books for personal or portfolio use, and lets you create slideshows and contact sheets for reviewing and showing off your work.

There are, unfortunately, some obvious omissions from Aperture's output options, including the cards and calendars available in iPhoto. The easiest way to plug this gap is to view your Aperture Library in iPhoto and create

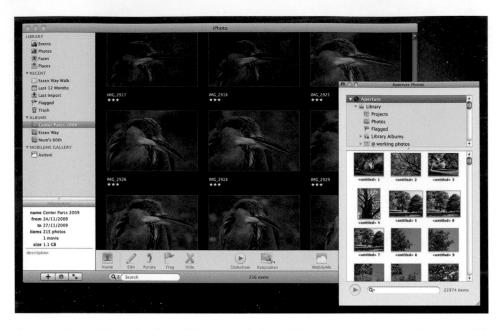

FIG. 8.1 Viewing your Aperture Library within iPhoto will let you create calendars and other products using your images that are not available within Aperture itself.

cards and calendars from there, but this will require a copy of the iLife suite (of which iPhoto is a part) at a cost of £71 (Fig. 8.1).

Unless you want to use all of your images in the products built into Aperture – Books, Galleries, Journals, and so on – you'll spend a lot of time exporting your work to use it in different ways. Aperture works exceptionally well with other applications, and can even read and write native Photoshop PSD files, which opens up access to a wide range of Photoshop filters (Fig. 8.2).

It includes a range of preset Export settings from which you can choose when outputting your images, and you can choose a default external image editor by opening Preferences ((#)) and clicking the Export tab (Fig. 8.2).

From here you can choose between TIFF and PSD export formats and select their resolution, specify your email client for sending to and to which level images should be compressed when emailed, as well as specifying a default copyright notice for Web Pages and Journals.

Selecting Edit... from the Email Photo Export preset drop-down gives you finer-grained control over the level of compression by opening the Image Export preset dialog (Aperture > Presets > Image Export) (Fig. 8.3).

900	Export	
ieneral Appearance Import	ant Labels Previews Web	Advanced
External Photo Editor:	Adobe Photoshop CS3	Choose)
External Editor File Format:	TIFF (8-bit)	\$ 300 dpi
External Editor Color Space:	No Profile Selected	•
External Audio Editor:	No application selected	Choose)
External Video Editor:	No application selected	Choose)
Email using:	Mail	•
Email Photo Export preset:	Email Medium - JPEG	;
Web Copyright:	Copyright text for new Web	Pages and Journals
	✓ Include location info in ex ✓ Include face info in export	

FIG. 8.2 Use Aperture's Preferences dialog to choose which application should be used for external photo editing.

Preset Name	
JPEG - Original Size	Image Format: TIFF +
JPEG - 50% of Original Size	M Include Metadata
JPEG - Fit within 1024 x 1024	Image Quality:
JPEG - Fit within 640 x 640	a. a. (a
TIFF - Original Size (8-bit)	Size To: Original Size
TIFF - Original Size (16-bit)	
TIFF - magazine spread	DPI: 72
TIFF - 50% of Original Size	
TIFF - Fit within 1024 x 1024	Gamma Adjust: 0 1.00
PNG - Original Size	Color Profile: sRGB IEC61966-2.1
PNG - 50% of Original Size	
PNG - Fit within 1024 x 1024	Black Point Compensation
PNG - Fit within 640 x 640	Show Watermark
PSD - Original Size (16-bit)	Position: Top Left #
PSD - 50% of Original Size (16-bit)	
Email Small - JPEG	Opacity: 50%
Email Medium - JPEG	
Email Original Size - JPEG	
	Choose Image) Scale watermark
+ - Reset Preset	(Cancel) O

FIG. 8.3 The Export Presets dialog lets you specify how your images should be optimized when exported from Aperture, and includes three specific settings for images that will be distributed by email.

Defining Your Own Export Settings

Presets defined here apply system-wide and are available when exporting Web Pages, Journals, and so on. They do not apply to Digital Masters exported as Projects to be reincorporated into another Library, as these are not compressed. You can create as many presets as you like, and they will then be presented in a drop-down when you export images in the future.

The range of available image types is impressive, including JPEG, PNG, TIFF (both regular and 16-bit) and Photoshop PSD. Which one you choose will determine which other options are available to you when making up your specific export profile. While you can specify the dimensions and resolution of all image formats, for example only JPEG gives you access to the Quality slider, which specifies the level of compression and hence the resulting file size.

When exporting as a PNG, TIFF or Photoshop PSD, you can only reduce the bulk of your images by specifying a physical or pixel-based size for the resulting file. Since images are usually exported in batches, rather than one by one, these sizes are specified either as a percentage of the original or to fit within a certain size, measured in pixels, inches or centimeters. Choose any one of these from the Size To drop-down menu and fill in the width and height boxes to constrain them (Fig. 8.4).

The simplest option, if your exported images will be emailed or published online, is to specify a common dimension, such as 800×600 or 1024×768 .

Image Format	TIFF	(distanting the	N-SAMPAKA		
	Inclu	ude Metad	data		
Image Quality:				10	
Size To:	Fit Wit	thin (Pixel	ls)		6
	Width:	1024	Height:	768	1
DPI:	72				
Gamma Adjust:				1.00	

FIG. 8.4 Not all Export options are available for all file types. However, you can specify the dimensions of all exported images to fit within specified limits. However, if you are using the inches or centimeters measurements it is worth keeping an eye on the DPI (resolution) setting to give you an idea of the size of the resulting file.

An uncompressed TIFF with a resolution of 300 dpi to be printed at 10×8 inches would be a 7.2 megapixel image (3000×2400 pixel resolution). If you were to increase this to fill a spread in an A4 magazine (420×297 mm) it would leap to 4960×3508 pixels, or 17 megapixels. Lump in all of the supplementary information contained within a TIFF, and leave it uncompressed, and your exports could easily touch 50MB. Clearly this is no good for attaching to an email.

Diligent use of intelligent compression settings is therefore a must, and saving presets here – with logical, descriptive names – will save a lot of time in the future.

Protecting Your Exported Images

In many instances, your images will be both your livelihood, and the public assets you use to drum up business. However, putting your images online in an effort to attract new customers can leave them open to abuse by less scrupulous visitors, who may pay scant attention to copyright notices posted on the bottom of the page.

In this instance you need to brand your images, rather than your pages, which is done with the Watermark setting in both the Image Export and Web Export dialogs.

Unlike some photo editors that let you apply your watermark to your images using plain text, Aperture overlays an image with an opacity level of your choice. If the source watermark image you choose – which should ideally be a Photoshop file with a transparent background – is larger than the photo you are exporting, Aperture will scale it down, but it cannot scale images up. This is logical, as you may only want your watermark to sit discretely in the corner of an exported image rather than obscure it entirely. If you want to have watermarks of various sizes for different export sizes – say one for 10×8 inch photos at 300 dpi and another for small Web editions – you should create multiple watermarks at the appropriate dimensions and apply them to different Export presets.

In the same way you can also create different watermarks for different clients, and save them in presets dedicated to specific jobs (Fig. 8.5).

Your watermark can be as plain or elaborate as you like, but it should achieve two primary goals. First, it should clearly identify the work as your own, without being easy to remove, meaning that it should not be easy to clone out or positioned in such a way that the part of the image that it overlays can be cropped with no loss of meaning in the resulting picture. Second, it should not obscure the image to such a degree that it makes it a commercial

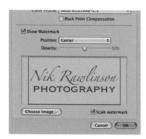

FIG. 8.5 Protect your images by using a watermark. This is a Photoshop-format file that is overlaid on top of your files at the point of export. By specifying a custom opacity you will ensure that clients can still see your work through the branding. disincentive. While nobody would ever think to misappropriate a photojournalist's image of riots at a G8 summit on which a watermark had been stamped square and center, few publications would be tempted to buy it if that same watermark obscured the main focus of the image and made it difficult to quickly see if it met their needs. There will be 1000 alternatives available to the busy picture editor, and it will be both quicker and easier for them to turn elsewhere.

Color Management

Mac OS X has excellent color management features. Its integrated ColorSync utility sits between the various parts of your system – applications, monitor, printer, scanner, and so on – and translates the colors used by each one so that they can be accurately reproduced by each of the others. It does this because every piece of hardware is built in a slightly different way, and so none will be able to capture or display precisely the same range of tones as any other.

The range of colors any device can handle is called its gamut, and is described in terms of being wide (a device with a wide gamut can handle more colors) or narrow (fewer colors). A consumer inkjet printer, therefore, will have a comparatively narrow gamut when compared with a professional photo printer, and a cheap all-in-one device with an integrated scanner will have a narrower gamut than a high-end digital camera.

In some cases the differences are very small, such as that between Generic RGB and sRGB, but in others they differ by a wide margin, such as when comparing Generic RGB with the much wider gamut of Adobe RGB. You can see this for yourself by opening ColorSync Utility (Applications > Utilities > ColorSync Utility) and clicking through the installed profiles. The narrowest of the most commonly used color spaces, as you'll see, is CMYK. This has a particular relevance to digital photography, as images are captured with RGB sensors (traditionally sporting two green photosites for every one red and blue site) and edited on RGB monitors, before being output in the CMYK colorspace, on inkjet or laser printers, or as professional photo prints (Fig. 8.6).

The problem, therefore, is in working out how each color relates to any other, and how a pink blush captured by a camera should be recreated on an LCD screen, a conventional display, a photographic print, an Aperture Book, a website or a PAL-based television.

It is little surprise, therefore, that Aperture builds color management right into the Export dialog, by gathering together all of the information it already knows about devices attached to your Mac and combining them with industry standards like Secam, NTSC, generic RGB and 'Black & White'.

If you are exporting photos for use on your own devices, such as a printer, or for import into a video editing application like Final Cut, you should choose

FIG. 8.6 The CMYK color gamut is very narrow, and doesn't come close to matching that of your RGB display. As such, Mac OS X will have to translate the tones used in your images between the two colorspaces to achieve accurate matching between screen and printed output.

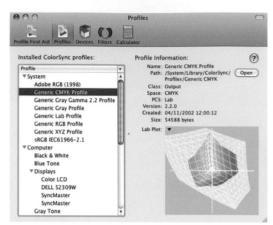

the appropriate setting to ensure that what you created on screen while editing matches what you see on the output device, noting that for many printers the profile will vary between output media as much as it will for the hardware itself.

If you are exporting for client use, and the client has been unable to provide you with a specific profile, however, the general advice would be to leave the image as it is by selecting Use Source Profile, and allow the client to apply their color management settings when they place the photo.

Defining Export Names and Destinations

All of the options set in the presets described above will be available when exporting versions of an image from your Library (shortcut *Shift* **(B)**). When you choose to export a Master (shortcut *Shift* **(B)**), it will be output using the same name as it has inside your Library, complete with the original extension and in the original format. So a Raw file produced by a Canon dSLR and saved with the extension .CR2 will remain as such, and be inaccessible to anyone without the necessary Raw Converter or another Mac with an up-to-date version of the operating system, which handles these files as a native format.

If you need to ensure maximum compatibility, then you should export your images as a Version, even if you are outputting an untouched Digital Master. Doing so will include an Export Preset drop-down on the Export dialog box that will be missing if you export a Master. This will show all of your saved presets and the defaults ones that shipped with Aperture (assuming you haven't deleted them) (Fig. 8.7).

However, regardless of whether you are exporting a master or a Version, you will always have the option to specify where your images should be saved, and under which name. By default, Aperture will suggest the picture's

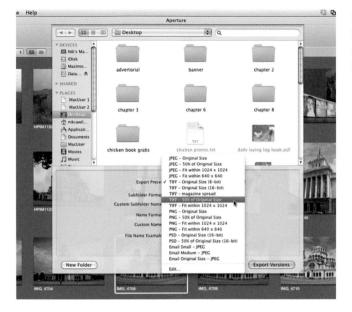

FIG. 8.7 Exporting a Version of your Digital Master gives you access to the Export presets that shipped with Aperture and any new presets you may have created yourself.

existing name, which was probably set by the camera at the point you pressed the shutter release. However, you can specify your own, or choose a logical encoded name that gives a more useful description of the file based on its assets rather than an arbitrary serial number.

These are found under the drop-downs beside Subfolder format and Name format, and while they can be set by picking the Edit... option from each of those menus, their control panels are also found in the Presets section through which we set the compression levels above (Fig. 8.8 (a) and (b)).

Why the Presets section?...Because each one can make use of the metadata tracked by Aperture as it organizes and edits your files, and because as with the Export and Gallery presets you can save a range of standard configurations for use with different clients and jobs.

We covered these in depth at the very start of our Aperture workflow when we imported our images into the Library, as the same preset tools are used for specifying where your imports should be stored and what they should be called as are used for directing the output of your exports.

The presets are accessed in one of two ways: either through Aperture > Presets > File Naming... / Folder Naming..., or by picking Edit at the bottom of the Filename and Folder Name pop-up menus in the Export dialogs.

See page 78 for a more detailed explanation of each dialog, but in general remember the rule that you should adopt a top-down approach to specifying your folder and image names, with the largest, most general classifications coming first, and more specific, tightly-focused attributes

FIG. 8.8 Use the File Naming (a) and Folder Naming (b) presets to specify how Aperture should title your images when it exports them and where they should be written to disk.

00	File	Vaming
Preset Name Custom Name with Index	Example:	[Custom Name] 1
Custom Name with Index (no spaces)	Format	(Custom Name) (Index #)
Version Name	Pormat.	Customize the format by dragging elements below into
Version Name and Date/Time		the text above. You can also edit the text above to add
Version Name with Sequence		or remove characters such as spaces.
Version Name with Index		
Image Date/Time		
Custom Name with Counter	Include:	Version Name Image Date Current Date
Custom name		(Master File Name) (Image Time) (Current Time)
		Custom Name Image Year Current Year
		Index # (Image Month) (Current Month)
		Sequence # Image Day Current Day
		Counter
		Custom Name:
		Incrementing counter starting at: 1
		# of digits: Auto :
+ - Reset Preset		(Cancel) OK

(a)

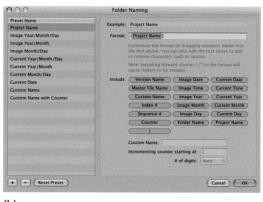

coming last. If you were to create your own preset that would generate Folders using Project names and dates, you should examine whether any of your Projects span multiple years. If they do, start with the year first; if not, start with the Project. Apply the same test to months. If all of your Project took place in the course of a single month, specify that the month delimiter should come immediately after the year; if not, break the two by inserting the Project first, and so on down the line. Please find below an example using a Project called France:

For a collection of photos taken between the 21st and 23rd September 2011, use the structure Year/Project/Month/Dates to give:

2011/France/09/21... 22... 23...

or Year/Month/Project/Dates to give

2011/09/France/21... 22... 23...

If the photos were taken between 29th September and 2nd October, the Project name must come first to avoid having two redundant Project Folders inside separate months. The structure would therefore be Year/Project/ Month/Dates to give:

2011/France/09/29... 30... and /10/01... 02...

If they were taken between 30th December 2011 and 2nd January 2012, move the Project name to the very front of the Folder structure as Project/ Year/Month/Date to give:

France/2011/12/30... 31... and /2012/01/01... 02...

Using this last shooting schedule as an example, if you were to adopt the Folder structure we specified first time around – Year/Project/Month/Date – and were using the Finder to browse pictures taken on 2nd January 2012, you would need to navigate up three levels, and back down three levels of the file system to see the photos taken on 30th December. Adopting our final recommended structure would require that you move up and down only two levels in each instance, and all of the images taken in France would be kept in a single parent Folder on your disk.

Exporting Metadata

In an increasingly connected society where we spend almost as much time sharing photos with each other as we do taking them, metadata becomes more and more important. Attaching relevant filing and categorization information to our photos increases their value exponentially. Not only does it allow photo editors to quickly identify images they would like to buy and use – thus providing a financial incentive for the professional photographer – but it also greatly simplifies your own task of keeping your images in order and finding them more easily at a later date.

Some image formats, including JPEG and TIFF, can embed the data in IPTC format directly inside the headers of the file itself. In other instances you can export a so-called IPTC4XML sidecar. IPTC is the International Press Telecommunications Council, an organization based in Windsor, west of London, which developed a file format for interchanging information about images as early as 1979. This carries captions, keywords, copyright information, bylines and so on, and can be exploited directly by many online photo management sites, including Flickr. The fields are flexible and range widely in length, right up to a generous 2000 character field for captions. From a professional point of view it is used by news agencies to help them maintain their Libraries, choose images to use in their media, and manage rights (Fig. 8.9).

You can export the metadata for a chosen image, or range of images, separately from the images themselves by picking File > Export > Metadata, in which case it will be saved as a tab-delimited table in plain text format, which can be imported into a database or spreadsheet for sorting.

Apple Aperture 3

FIG. 8.9 Services such as Flickr can take advantage of metadata tags embedded in your photos to help you manage your collection.

However, exporting metadata at the same time as your images is a simple matter of picking whether you want to export it embedded ('Include IPTC' from the Metadata pop-up in the Export Master dialog), or as a sidecar file that is separated from the image itself, but given the same name and the extension XMP. The format of this file remains plain text, but every attribute is surrounded by descriptive tags to make it more useful for sorting, parsing and including in third-party tools (Fig. 8.10).

Export Plug-ins

As a professional photographer, your work will be split into three distinct parts. One part will be for yourself, which you'll use for personal reference or recreation. Another will be for private clients looking for portraits and

FIG. 8.10 Metadata exported in a sidecar file is rendered as XML data. This can be parsed by thirdparty tools and used to catalog images in a database.

	111.XMP
xpacket begin='' id=''?	
<x:<u>xmpmeta xmlns:x='adobe:n framework 1.6'></x:<u>	<pre>s:meta/' x:xmptk='XMP toolkit 2.9-9,</pre>
<pre><rdf:rdf http:="" ns.adobe.c<="" pre="" xmlns:rdf="http://
xmlns:iX="></rdf:rdf></pre>	www.w3.org/1999/02/ <u>22-rdf-syntax-ns</u> #' om/iX/1.0/'>
< <u>rdf</u> :Description rdf:about= <u>Iptc4xmpCore</u> /1.0/ <u>xmlns</u> /'> 	xmlns:Iptc4xmpCore='http://iptc.org/std/
<pre><rdf:description rdf:about="<br">photoshop/1.0/'></rdf:description></pre>	' Xmlns:photoshop='http://ns.adobe.com/
<rdf:description rdf:about="<br">1.1/'></rdf:description>	' <u>xmlns</u> :dc='http://purl.org/dc/elements/
<rdf:description rdf:about="</td"><td>' xmlns:photomechanic='http://</td></rdf:description>	' xmlns:photomechanic='http://
ns.camerabits.com/photomech 	
<pre><rdf:description rdf:about="<br">1.0/'></rdf:description></pre>	'Xmlns:XAP='http://ns.adobe.com/XAP/
<xap:rating>0<td>Rating></td></xap:rating>	Rating>

professional photos of personal subjects, and the third will likely be for professional clients who will use your shots in a photo library or publication.

For each, the treatment of your photos – and in particular your exports – will differ. Your personal Projects will be treated to meet your own specific requirements, private clients' work will be tailored to their specific tastes, and commercial work for professional clients will be adjusted to meet the house style of a particular publication.

In every instance, though, you will eventually want to export your work in some form or other, and while the guidance above will meet most requirements, you may be able to cut some corners through the use of plug-ins. These are add-ons to Aperture that automate the process of changing file sizes, formats and naming conventions to meet specific requirements, and of posting your photos online, perhaps because a newspaper can only accept them in a particular manner, or because it's simply easier to cut out the tedious logging in and individual uploads to an online photo service such as Picasa.

Apple maintains a catalog of available plug-ins for Aperture, including a wide range of Export plug-ins at apple.com/downloads/macosx/aperture (Fig. 8.11). The list is extensive, but by no means exhaustive, and an Internet search will turn up others. It's also worth talking to professional clients to see whether they have plug-ins of their own that they are willing to send out to freelance contributors.

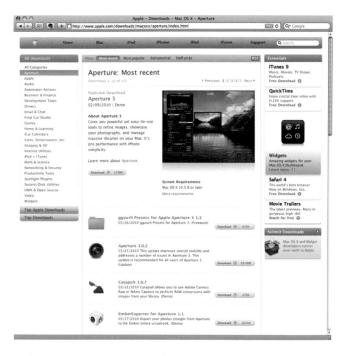

FIG. 8.11 Apple maintains an extensive collection of downloadable plug-ins for Aperture on its website.

You can create your own plug-ins using the Aperture software development kit (SDK). However, this is only available to developers with an Apple Developer Connection membership, which costs \$99 per year.

Working with Two Macs and Two Libraries

With the release of Version 2, Aperture gained the ability to play host to a tethered camera and write images direct to its Library. This continues in Version 3, and it affords the professional photographer great benefits as they can see far larger previews on a Mac than the camera-back LCD would allow. It also means they can make small adjustments to the results as they go along, to see whether digital manipulation or physical adjustment of lighting, props and exposure settings would be beneficial.

It also means that they can take a notebook out into the field, cutting down on the range of kit they must carry, giving them an immediate backup, and letting them start work on the filtering and editing before they even get back to the studio.

However, each of these benefits falls foul to a common downfall. Namely, unless the photographer is working with their primary Mac and their master Library, the newly shot images will be stored in a Library separate from the rest of their assets. The simplest solution is to travel and work with your primary Mac, but this is inherently insecure and risky.

It will therefore be necessary at the end of every expedition to import any new photos into your master Library. Clearly you shouldn't simply copy across your Aperture.aplibrary package, or you will overwrite any Versions and Digital Masters already stored at the destination.

To perform the copying accurately and safely without risking your existing assets, then, you must perform an export and import out of the mobile Library and into the one used at home base, or you must merge the two.

If you choose to export and import, select the Project you want to export in the Projects Inspector and pick File > Export > Project as New Library. You'll be given the opportunity to assign it a name and create a new Folder to hold it and to 'Consolidate images into exported Project'. What does this mean? It's simply offering to include any referenced Digital Masters in the export file if they are stored in Folders outside of the mobile computer's Library package (Fig. 8.12 (a) and (b)).

From this point on, whether you chose to export a Project or want to incorporate the whole of your mobile Library in your master Library, you'll do the same thing. Transport the exported Library to your home base Mac and double-click its icon. Aperture will ask whether you want to switch to the exported Library or import it into the current master Library. Pick Import and your images will be integrated.

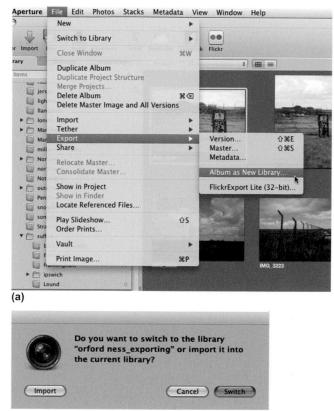

FIG. 8.12 Images stored in one Aperture Library can be safely transferred to another by exporting their parent Project and choosing to consolidate the images into that Project. This lets you shoot using a notebook and tethered carnera when away from the studio, and then incorporate your new work into your existing Library when you return to base.

(b)

Publishing Your Photos Online

There are three ways to get your images out of Aperture and onto the Web: MobileMe Galleries, Web Pages and Web Journals. Each one gives you a little bit more control over the results than its predecessor, with MobileMe Galleries being simultaneously the most visually impressive and the least flexible of all three. We'll cover each in turn below.

MobileMe Galleries

Aperture's MobileMe Galleries feature lets you put your images online without any knowledge of HTML, PHP or other Internet technologies. It requires a MobileMe account, which costs £59 per year, as many of the features of Aperture MobileMe Galleries use server-based code that is not written out by Aperture itself and isn't found in conventional hosting packages. You can sign up to MobileMe at www.me.com (Fig. 8.13).

FIG. 8.13 Apple's online service, MobileMe, adds synchronization, email, shared calendaring and – of most interest to Aperture users – online publishing tools to the operating system and to several of Apple's core applications.

MobileMe Galleries include features such as password protection, visitorcustomizable layouts and slideshow transitions, as well as the ability for visitors to upload their own pictures to the Gallery, should you permit them (Fig. 8.14).

To create your first MobileMe Gallery, select a Project or a collection of images and click MobileMe on the toolbar. You'll be asked to give the new Gallery a name and description and to choose who should be allowed to view the images it contains. This is done through the 'Album viewable by' drop-down, which by default is set to allow everyone to see your images. The other options are to restrict it to yourself, in which case its title will be removed from the links in your MobileMe pages, or to people to whom you give a password (Fig. 8.15).

This latter option will let you individually control who has access to every Album you publish, as by allocating each user a different password you can give them access to some, but not to others. It is set by picking Edit Names and Passwords from the viewable drop-down, and using the '+' button to add new users to the list. Aperture keeps track of who has been authorized to view each Album, and so will automatically populate the third column of the table – Albums – on that basis. In this way, you can use Aperture as a tool for allowing clients to preview images before signing them off by posting them to a MobileMe Gallery that only they can access (Fig. 8.16).

Output

FIG. 8.14 MobileMe Galleries are impressive Web 2.0 sites that give your visitors a great deal of interactivity, and even allow visitors to your site to upload their own images.

In this situation you might want to prevent them from downloading the images themselves, in which case clearing the checkbox that allows that, or tailoring what can be downloaded, is a sensible move. The Allow section also lets you tailor users' ability to add their own photos, either by email or through the Browser. There are simple controls to stop this being abused in the form of a Captcha device requiring users to enter the text version of

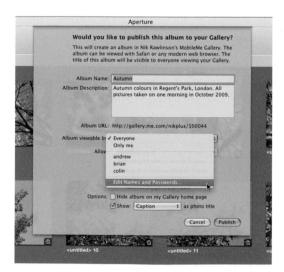

FIG. 8.15 Careful use of restrictions on your MobileMe Gallery will let you keep it protected from unauthorized viewing. This makes Galleries of this sort an effective means of showing your work to a client but retaining a degree of confidentiality. FIG. 8.16 User names and passwords let you restrict who can see your Smart Galleries on an Album-by-Album basis.

Name	Password	Albums
andrew	apple	
brian	orange	
colin	pear	
Name ma	v consist of a-z. 0-9.	underscores and a single dot (.)
+ - Password	should be four charac	ters or more; capitalization matters. Cancel OK

a series of letters and numbers displayed in a graphic to prove that they are a real person, but it is still advisable to use the Browser upload feature with care. The Email feature, on the other hand, is a boon for iPhone users, who can use it to upload images direct from their phones when away from home. Each Gallery is given a unique email address in the form of username-serial@ post.me.com, where username is the membership name you chose when signing up to MobileMe, and serial is a unique identifier appended by Apple to differentiate your Galleries from one another.

Once published, you can add new images to your MobileMe Gallery from Aperture itself by dragging them from Projects in your Library onto the Gallery's entry in the list of MobileMe Galleries at the foot of the Library Inspector. You can specify whether Aperture automatically updates the online edition of the Gallery and, if so, how often. Open Preferences () and click Web, and then change the 'Check for new published photos' option to Every Hour, Every Day or Every Week, as appropriate (Fig. 8.17).

If you would rather maintain full control of the uploading of new photos, leave it set to Manually. You then need to update the published Gallery by clicking on the Check Now button, or on the Gallery's entry in the Library Inspector, followed by MobileMe on the divider between the Browser and Viewer windows, and then Settings... This will call up the dialog that you used to create the Gallery in the first place, which sports a Publish button that, when clicked, uploads your newly imported images to your MobileMe webspace.

FIG. 8.17 Use Aperture's Preferences to specify how often it should update published MobileMe Galleries. Leave it set at the default 'manually' if you want to retain control over updates.

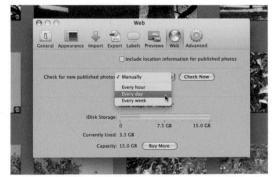

You can stop publishing a Gallery at any time, and remove any published images from your MobileMe web space by selecting the Gallery in the MobileMe Gallery entry in the Library Inspector. Click on the name of the Gallery you want to remove and confirm your action.

Note that publishing to MobileMe can be time-consuming for particularly large Galleries.

Web Pages

MobileMe Galleries are very attractive, and full of impressive effects that will wow your visitors, but they are not very flexible. There is only one style of Gallery, and you have to publish them on Apple's charged-for MobileMe service. Not only does this mean you could end up paying twice – once for your personal web space and once for MobileMe space – it also means that your Gallery's address will include the MobileMe branding. This doesn't look very professional.

The solution to both of these problems is to switch to the less ambitious, but no less attractive, Web Page option, which creates static pages for your photos that can be hosted on your own web space under your own domain name. Don't be confused by the title, 'Web Page'; this doesn't create a single page for all of your images, but a mini site with index pages showing thumbnails of every image you choose to include that link through to individual pages for a full-size version of each one (Fig. 8.18).

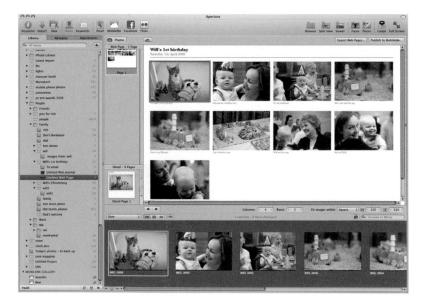

FIG. 8.18 Web Pages created by Aperture have fewer features than MobileMe Galleries, but they offer greater flexibility when it comes to layout and design.

The process starts off in a similar way to creating MobileMe Galleries. Pick a Project or Album in your Library, select the images you want to include, and choose Web Page from the New drop-down on the toolbar. Aperture will create a series of index pages to hold thumbnails of all of the pictures in your selection, and an individual page for each image, at a larger size.

There are six index pages to choose from, which present themselves when you pick New > Web Page from the toolbar, and if you later change your mind you can switch between them by clicking the Theme button on the control bar that appears above the Web Page thumbnails. Each theme contains only two types of page: the index thumbnails and the full image display pages (Fig. 8.19). Any change that you make to one of these pages will therefore be reflected on every page of the same type.

So, for example, scrolling to the bottom of any page and changing the copyright data to protect your images will apply the same change to every page. The same goes for the site title. However, some aspects, such as image sizes and metadata, differ depending on whether you are working on the index pages or the detail pages.

Click on Page 1 in the Web Page panel and you can change the number of columns and rows displayed on the page. As you do, you'll see the thumbnail of the page update in real time and, if you have more than one index page, that change will also be reflected on the other pages in the panel. Switching to the detail pages in the pane below, you can't adjust the number of images on the page (there's only ever a single image), but you can change the size of each one by constraining the size of the box in which it must fit. You have three options: rectangle, square and width, which are also available when sizing up the thumbnails on the index pages (Fig. 8.20).

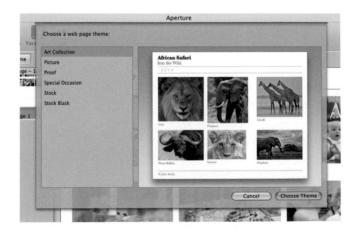

FIG. 8.19 Aperture ships with six different themes for creating MobileMe Galleries. Each theme has two page styles — one for the index pages, and one for the detail pages that show each image at a larger size.

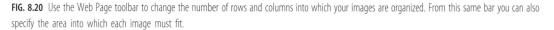

The Rectangle option lets you specify a maximum height and width for each image; whichever is reached first will truncate the other. So, if we have a portrait image with a 3:4 aspect ratio (narrower than it is tall) and we have set up our Web Page so that detail shots should fit within a 500 by 400 rectangle, and thumbnails within a 100 by 80 rectangle, the image will appear at 500 \times 375 px on the detail pages and 100 \times 75 px on an index page. You can change the dimension limits by either typing in a new value or clicking and holding on the value in each box, and then dragging to the right and left to increase and decrease it respectively.

The Square option will keep both width and height in line, while the Width option will concern itself only with the width of each image and let your pictures take as much vertical space as they require. This is logical, as Web Pages are designed to work in a top-down mode rather than left-to-right, which is why it's more common to end up scrolling vertically than horizon-tally online. By using the Width setting you can therefore set your images to fit within a common Browser window size, such as 1024 pixels wide, and let them extend below the bottom of the screen if required.

The options for adding metadata are the same on both the index and detail pages, although the settings for one don't apply to the other, allowing you to pick a short data set, such as 'Caption only' or 'Name & Ratings' on the index page, and a more extensive set, such as 'EXIF info' on the detail pages (Fig. 8.21).

Your pictures remain editable, even after you've placed them on the page. Hovering over each one overlays it with a curled arrow that will take you to the detail page. Clicking on and dragging an image will move it to a new position on the page, with the other pictures shuffling to accommodate it in the new layout (Fig. 8.22).

You can upload your completed pages to your MobileMe space directly by clicking Publish to MobileMe..., but if you want to host them on your own website then you'll have to first save them to your local hard drive and upload them from there, as Aperture has no in-built FTP software (Fig. 8.23).

Whichever option you choose, the final step is deciding on the compression and color settings of your images (Fig. 8.24). These are set individually for thumbnails and detail shots, with both defaulting to high quality JPEGs. By picking from the drop-down menus beside each one you can vary the compression or switch to PNG format files, but selecting Edit... from the

FIG. 8.21 The Metadata options on the MobileMe Gallery detail pages draw extensively from the metadata attached to the images in your Library, and can be tailored to include views already defined in your Metadata presets.

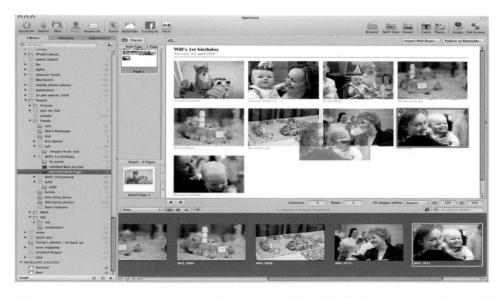

FIG. 8.22 Move any picture on an index page to reposition it, and all other photos in the Gallery will shuffle themselves to accommodate its new location.

(A) nik	rawlinson		httpdocs	(4)
<u></u>			mapaoes .	
Name a	Tue, 25 Sep 2007, 23:16	Name Name	4 Size	Date
apdisk	Tue, 25 Sep 2007, 23:16 250 8 Tue, 25 Mar 2008, 10:00	img		03/09/2009, 00:00
bash history	250 B Tue, 25 Mar 2008, 10:00 2 KB Thu, 8 Apr 2010, 16:16	index.php		16/02/2010, 09:32
bi li3	2 KB Thu, 8 Apr 2010, 16:16 147 B Mon, 21 Sep 2009, 16:08			17/09/2008, 00:00
CFUserTextEncoding	3 8 Tue, 8 Sep 2009, 17:17	2 info.php		29/09/2008, 00:00
III .config	Thu, 9 Aug 2007, 16:43	jquery.js		09/09/2009, 00:00
cups	Wed, 31 Oct 2007, 14:51	keepchickensathome		08/04/2010, 22:45
dit H3	Wed, 31 Oct 2007, 14:51 286 B Sat. 28 Oct 2006, 22:07	license.txt		16/02/2010, 09:32
		e ust.html		14/07/2008, 00:00
.dropbox DS Store	Sun, 11 Apr 2010, 11:36	e menu list.html		18/07/2008, 00:00
us_store	24 KB Sun, 11 Apr 2010, 11:04			18/07/2008, 00:00
emacs.d	Fri, 6 Nov 2009, 16:33	2 phpinfo.php		30/09/2009, 00:00
	Wed, 27 Jan 2010, 12:30	picture_library		02/11/2009, 09:28
fonts adb history	Wed, 27 Jan 2010, 12:28	plesk-stat		28/12/2007, 00:00
	0 B Mon, 28 Sep 2009, 12:05	puliquote.html		21/07/2008, 00:00
.parallels	Tue, 18 Nov 2008, 13:29	e readme.htmi		16/02/2010, 09:32
.parallels_settings	46 B Wed, 4 Jun 2008, 12:41	Savedinfo.php		29/09/2008, 00:00
bnv. 🖰	1024 B Mon, 1 Feb 2010, 10:17	Scripts		15/12/2009, 10:48
.ssh	Mon, 8 Oct 2007, 17:57	sendinfo.php		29/09/2008, 00:00
subversion	Mon, 6 Oct 2008, 13:26	sitemap.xml		06/04/2010, 20:06
.Temporaryitems	Wed, 1 Apr 2009, 16:15	T sitemap.xml.gz		06/04/2010, 20:06
.Trash	Sun, 11 Apr 2010, 11:43	🖻 small.html		02/11/2009, 10:26
Xcode	Wed, 16 Sep 2009, 19:33	SpryAssets		03/09/2009, 00:00
🕞 @@ innocents	Wed, 24 Mar 2010, 11:29	e style.css		04/02/2008, 00:00
Calibre Library	Wed, 27 Jan 2010, 12:29	atyles.css		28/07/2008, 00:00
B Desktop	Sun, 11 Apr 2010, 11:33	test .		03/09/2009, 00:00
Documents	Wed, 7 Apr 2010, 22:45	i testphpfcgi		02/03/2010, 10:57
Downloads	Sat, 10 Apr 2010, 11:52	thisisatest.txt		13/07/2008, 00:00
Dropbox	Sun, 11 Apr 2010, 11:27	im wp-admin		21/12/2009, 09:12
2) feed.php	14 KB Tue, 15 Dec 2009, 10:50	wp-app.php		16/02/2010, 09:32
P faster the	271.8 Wad 7 Mas 3010 12.70	Thun sten aka	330.8	16/03/3010 00.73

FIG. 8.23 If you want to publish your Web Pages anywhere other than a MobileMe homepage, you will have to use your own FTP software. Transmit (seen here) is highly recommended.

bottom of each menu lets you define your own preset that will appear in the menus every time you save a future Web Page. The Edit... option opens the Web Export Presets dialog, giving you access to 12 levels of compression (under the title Image Quality), gamma control and the ability to apply a ColorSync profile. This gives access to all profiles installed on your Mac, including those assigned to installed printers, and 'Generic Gray Profile'. This lets you apply changes to every image in your pages at export without having first gone through and edited them by hand within the Aperture environment.

You can also protect your images by applying a watermark.

In switching from MobileMe Galleries to Web Pages, you lose features like the ability to upload new images by email or through a Web Browser, but you will find the end results to be less fussy and, perhaps, more professional than the glitzy alternative.

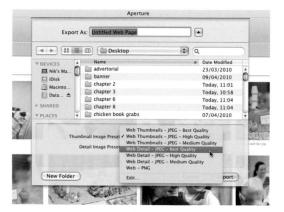

FIG. 8.24 When you come to export your Web Pages you can specify individual compression levels for both the thumbnails on your index page and the full-size images on the detail pages.

Web Journals

Web Journals are by far the most versatile of all of the online products you can make with your photos in Aperture. They come closer to proper web design than any of the other options the application can offer.

Their goal is less to show off your photos in isolation – as a portfolio – but more to let you tell stories using a mixture of words and pictures. They are the online equivalent of the Photo Book (see below).

That said, a Web Journal shares many features with the Web Page. Again, you start by gathering together the images you want to use, in a Project, Album or Folder, and use them to create a new Web Journal via the New button on the toolbar. Once you have given the Web Journal a name, you can start populating the pages with images, either manually by dragging them out of the Browser bar and onto the page, or by asking Aperture to do the hard work for you.

Every image you add to your Web Journal's index page will link to a new detail page showing a larger edition of the same. There is no reason, therefore, why you can't put all of your thumbnails on one page, as you would in a Web Page. However, this would miss the point of a Journal, which can take advantage of metadata attached to your images to split them into more logical sub-groups.

The Shortcut button between the page thumbnails and Browser pane (with a cog icon) conceals a drop-down menu that lets you automatically place all of the images in the Browser bar onto index pages defined by day, keyword, rating, byline, city or category. You will end up with one index page for each day, category and so on, and one detail page for every image in the Browser bar. It's quick and simple but, as we'll discover in a moment, lacks some flexibility (Fig. 8.25).

Once your images are in place, whether they were added manually or automatically, you can start adding your text. The same metadata are available here as in the Web Page feature, and fields are added using the same Toolbar button sporting the tag icon. On the index pages you can also add your own text boxes and captions.

The trouble is that you can't drop a text box in the middle of an image box. So, if you want a paragraph of words between two strips of pictures, you'll need a total of three boxes: one each for the picture strips, and another for the text. If you took the easy option and had Aperture split your images onto pages defined by metadata, it will have lumped them all into a single large container on each page, relegating any words you add to the very bottom of the page. Obviously this is more of an issue if your groups are particularly large, such as 100 images taken at one event and then sorted by date (Fig. 8.26).

In all other respects, Web Journals and Web Pages work in precisely the same way. Journals' styles are defined by themes, you can set the number of

Output

FIG. 8.25 The Web Journal feature's Shortcut button lets you automatically place images within your Journal on the basis of their attached metadata. This is a quick and easy way of kick-starting your Journal, but it lacks flexibility and can have drawbacks later in the creation process.

FIG. 8.26 By dragging your images onto the pages of a Web Journal manually, you have far greater control over the positioning of other elements on your page, including text and captions.

columns on an index page, and you can constrain both the thumbnails and the detail shots to fit within a square or rectangle of your own choosing. You can set boilerplate text, such as the copyright notice, and you can also access any of the Export presets you set up when creating a Web Page to downsample your images, change their color profiles, or apply watermarks, before uploading them to your MobileMe web space or saving them to your Mac's hard drive and then publishing them elsewhere using FTP.

Producing Books

Books are the most impressive products you can make with your pictures. If you've never seen one in real life, you'll be impressed by the range of choices on offer and the quality once they arrive. Apple offers a range of sizes and layouts, and the choice of either softback or bound hardback volumes. The choice is similar to that found in iPhoto, with a couple of extras thrown in to appeal to the professional photographer, in place of which it drops more 'family'-oriented options like the 'Crayon' Book found in its consumer offering (Fig. 8.27).

Books come in a choice of four preset sizes: extra-large, large, medium and small, which are supplemented by a custom option through which you can set page sizes, image spacing and margins on each page. There are 11 styles on offer, encompassing formal occasions, art collections and stock books (Fig. 8.28).

Considering these are just templates into which you drop your pictures and text – the photo editing version of low-end desktop publishing, in effect – the range of customization options is impressive. And if you find your chosen style doesn't work for the pictures in your Library, you can even change theme halfway through, although with the caveat that custom layouts obviously won't be transferred to the new theme.

New books are created from the File menu, or the New drop-down above the Projects panel. Click on any Project, Album or Light Table, and then pick Book from the New menu.

FIG. 8.27 Aperture ships with a range of Book styles, most of which are skewed to the professional user and are not found in iPhoto, Apple's consumer image management application.

ook Type:	Custom \$	Add selected item	s to new book	
0	Untitled Book Theme	Page Size	Theme Inform	ation
		Width:	27.94 cm. Height:	20.32 cm.
		Image Spacing		
		Horizontal:	0.127 cm. Vertical:	0.127 cm.
		Margins		
		Top:	1.524 cm. Inside:	1.746 cm.
		Bottom:	1.524 cm. Outside:	1.524 cm.
		Note: Custom siz	ed books cannot be pu	archased through Aperture.

FIG. 8.28 If none of the default book sizes suits your needs, they are supplemented by a custom option, which lets you specify your page dimensions and margins. This is particularly useful if you intend to print the results yourself, or send them to a professional bureau.

We'll walk through the creation of a Special Occasion book here, so select that from the Theme options if you want to follow along.

Once you have chosen your Book style, a new untitled book will be added to the Projects panel. Give it a name before examining the rest of the interface. You'll see that the main part of the display has been split into three sections: a Browser showing the images in your collection, above which two areas show thumbnails of the pages in your Book and each individual page as you're working on it.

The pages are template-driven, with boxes for images and text already in place. The Book Creation dialog opens with the cover page open, showing a gray box where you can position an image. Dragging a picture from the Browser to the box drops it in place. Notice how its thumbnail in the Browser pane now has the number 1 stamped on its top-right corner to indicate that it has so far been used once in the Book (Fig. 8.29).

By default it fills the box entirely, but if you want to focus on just one part then double-clicking it in place in the box will call up the Image Scale dialog. Sliding to the right will enlarge the image without increasing the size of the box. Sliding back to the left will reduce it again. Once you have resized your image, it may well be off-center, with the focus on the least interesting aspect of the picture. It should therefore be repositioned by clicking and dragging on it within the box (Fig. 8.30).

Right-clicking on the image calls up a context-sensitive menu, giving you fast access to common layout defaults: Scale To Fill, Scale To Fit Centered, Scale To Fit Left-Aligned, and Scale To Fit Right-Aligned. From here you can also cut, copy or delete the image (Fig. 8.31).

The same principle applies to placing photos on other pages within the Book. However, internal pages are more versatile than cover designs. Notice how there is a small black arrow to the right of the cover in the Pages thumbnail window. Clicking this will drop down alternative designs for the cover. There will be only two: the default style we have just been using, and a second style, in which the cover image spreads across the front and back of the Book.

FIG. 8.29 Books are constructed by dragging images into pre-defined holders on the pages or cover.

Click on any internal page – other than the dust jacket's internal flap, and you will see that you have a far wider choice of layouts from which to pick. In the unlikely event that none of them meets your needs, pick the one that comes closest, and then set about customizing it.

When you create Books in Aperture, you'll split your time between two working modes, in which you edit either the content or the layout of your pages. You can't work on both at the same time. To switch between them,

FIG. 8.30 Resize and reposition placed images by double-clicking them on the page and then using the Image Scale slider to change their dimensions; once the dimensions are correct, hold down on them with the mouse and drag to re-center them.

FIG. 8.31 A context-sensitive menu lets you easily resize your source material to suit particular frame shapes in your Book.

use the two buttons above the window showing your page layout. When you switch from the default of Edit Content to Edit Layout, clicking on an image or text box will apply grab handles to each side, with which you can resize it. While in this mode you can still drag in images from the Browser strip at the bottom of the screen. However, you cannot reposition them with the container frames, as grabbing onto them to do so instead moves the frames themselves. As you do this, Aperture will flash up yellow guidelines to show when any sides or the vertical or horizontal centers of your frames line up with any other edge or central position on another frame (Fig. 8.32).

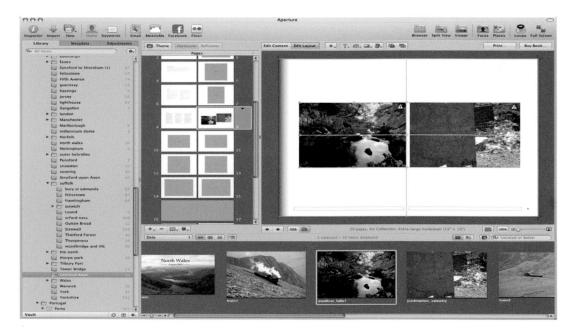

FIG. 8.32 Switch from Edit Content to Edit Layout to change the dimensions of the image frames on your pages. As you drag the grab handles on each one, yellow guidelines will show you when you have lined them up with matching elements on the same or facing page.

FIG. 8.33 The Layout Options dialog lets you control the size and position of your photo boxes more precisely by entering numerical dimensions. From here you can also specify the thickness of the border on each one.

Theme Hardcover Sof	ftcover	Edit Content	Edit Layout
Size & Position			
X: (* 2.63 >) cm. Width: (* 13.41 *) cm.		
Y: (* 7.66 *	cm. Height: (* 10.23 *) cm.		
Angle: (* 0° +)		
Photo Border			
Thiskness (0.00	Cm. Color:		
THICKNESS. 4 0.00			
	Pages		Tale following in Value of the
			Baltanto Hene Diaphone velocie ed tar mitflore per
		-	Refratche Filme Disipit star velle in editar mitifizer pop mice spatiator/kplan patil continue/pri a obligatione era ray mo
		*	Bacharache Menne Endage sonn verden im neue ausdatum objektion soniel exactioned gest voligissients other trai Oddge-sonie zures verden voler en zures er Franke odd keiner ich dassen i
		*	Raforato Hene Diapitwan weleti ad tar miti fane an mitir maldarofan and cartungter obiptisen eta's ta Odiptisen eta's ta Odiptisen eta's ta

(If you find it difficult to position elements using the guides, you can do it manually by opening the Layout Options dialog, which is found in the Shortcut menu indicated by the Cog button below the pages' thumbnails. This lets you nudge frames in any direction and adjust images' border thickness; Fig. 8.33.)

You also cannot drag images out of one frame and into another when editing the layout the way you can when editing the content, although you can drag new images from the Browser and drop them into frames that already contain pictures to replace the ones already in position. The usage tally on the corner of each image thumbnail will be adjusted to reflect this, so that images that have been replaced by others have 1 deducted from their total (Fig. 8.34).

The remaining tools on the Book toolbar work in the same way as their desktop publishing equivalents. The Type drop-down gives you quick access to the preset type styles that accompany your chosen Book theme. The range of styles will be determined by the theme with some such as Special Occasion boasting 20 options, and others – the Small Book, for example – having fewer. These are all given logical names that pertain to a specific copy type, such as Cover Title, Date, and Event Details – Smaller.

Two along from the Text Styling button is the Photo Filter tool, which applies variations on three different styles to placed images. The two most obvious are black and white, and sepia filters, but these are supplemented by the option of a Light or Strong Wash, which can also be applied to images in their

FIG. 8.34 The numeric badges on the upper right corner of each thumbnail in the Browser indicate how many times each one has been used in your Book, making it easy to spot which have yet to be exploited.

FIG. 8.36 A small selection of image filters lets you change the look of each image in your Book. By applying a wash you can knock back the colors of images used as background files behind text.

FIG. 8.35 The Type drop-down lets you select from the pre-defined styles that make up part of your chosen Book theme. You cannot add your own styles to the list.

original colors. These washes are particularly useful if you are placing text over the top of your images, or image boxes on the top of picture-based backgrounds, as they allow you to reduce the contrast in the underlying material and so help the front-most items to sit forward (Fig. 8.36).

If, after washing your background images in this way, you still find that they are distracting, the next button – Set Background – gives you a quick way to disable the background image altogether. This drop-down has just two options: No Background and Photo – whose functions are self-explanatory.

Not all functions are available at all times, as this toolbar is context sensitive. When you have focus on an image frame, for example, the Text Styling tool will be grayed out, and when you are in Layout mode, all of the positioning tools for adding new text and image boxes and layering them on screen will be inaccessible.

Switching to Edit Layout gives you access to Add Text Box, Add Metadata Box, and Add Photo Box. The second of these deserves further explanation, as it hooks into Aperture's extensive database of information about every image in your Library.

To use it, select any positioned image in your Book and then click the button. A text box will appear immediately below it, with a tab peeling off to the left stating Plate Number & Caption. This describes the content of the metadata frame, which will most likely be empty at this point. Move two buttons to the right to the Set Metadata Format button that we skipped over beside the Text Style button and click it to drop down a list of options. This gives you access to everything Aperture knows about your image, including keywords and copyright information you have applied to it yourself and shutter speed and focal length details written to its EXIF data by your camera at the time of creation. Selecting any one of these places the relevant details in the associated metadata box, which can then be formatted using the Text Styles drop-down (Fig. 8.37).

You can considerably speed up the process of laying out a Book by allowing Aperture to do most of the hard work for you. The Shortcut menu found below the pages' thumbnails (the button with the cog on it) duplicates many of the functions of the Book Creation toolbars, such as adding photo and text boxes. However, it also contains several more powerful features, such as the ability to split text boxes into multiple columns, to show or hide page numbers, and to save out individual pages to new documents should you wish to experiment on them elsewhere.

The four tools at the top of the menu, though, are the quickest way to build a Book with the least amount of effort. Used to automatically flow all unplaced images, or all selected images, or to rebuild the Book from scratch with unplaced or selected images, they give Aperture free rein to fill as many of the photo frames as it can with the photos in your Browser bar. Of course, you can then go through the Book yourself and rearrange them, but it is a quick and easy way to get a head start on what could otherwise be a lengthy process. The one thing it can't do, of course, is write your descriptive comments.

FIG. 8.37 By attaching metadata boxes to your images, you can use the data you have already entered with respect to your images to add text to the page.

oduct		Item Price	I	tem Tot
	Untitled Book	£34.77	1	£34.7
	Extra-large Hardcover Book 13 x 10 inches; 33 x 25.4 cm 20 pages		Save 10% when you order 25 books or more.	
Tele Information Hear	Availability and pricing are based (Change Country)	on your United	Kingdom billing address.	
Returning Cus	tomers			
If you have an	Apple Account (from the iTunes assword. If Aperture has been se			
If you have an Apple ID and p	Apple Account (from the iTunes assword. If Aperture has been se n account.	t up with son		
If you have an Apple ID and p create your own	Apple Account (from the iTunes assword. If Aperture has been se n account.	t up with son	neone else's account, you	
If you have an Apple ID and p create your own Apple	Apple Account (from the iTunes assword. If Aperture has been se n account.	t up with son	neone else's account, you	
If you have an Apple ID and p create your own Apple	Apple Account (from the iTunes assword, if Aperture has been se n account. e ID: word: Forgot Password?	t up with son	neone else's account, you	

FIG. 8.38 Before you can buy your completed Book, you must sign up for an Apple ID. If you have ever bought from the iTunes Store, or signed up for MobileMe, you will already have an Apple ID. If not, you can sign up through the Book Purchasing dialog.

Once you have completed your Book, you have the option of buying it (the 'Buy Book...' button) or printing it yourself. To buy a Book, you need an Apple account, with 1-Click ordering enabled. If you have ever bought from the iTunes Store, then you can use the same account details here, but, if not, you can set one up through the Purchase dialog (Fig. 8.38).

If you would rather sort out your own professional printing, or you want to send a completed Book to a client for approval, then you can save your pages as PDFs by instead clicking Print and selecting Save as PDF... from the bottom of the Print dialog.

Printing

If pressing the shutter is one half of the photography equation, outputting your edited, perfected images is the balance. We've already discussed making MobileMe Galleries, Web Pages and Journals, and sending your photos to Apple's printing partners to produce professional-looking Books. However, the most common form of output remains the standard studio, home or office-based print, on an inkjet, laser printer, a dedicated 6×4 inch photo printer, or large format device.

Fortunately, Aperture is well equipped to handle any kind of DIY printing job you care to throw at it, so you have an end-to-end photo production suite in one application, without having to resort to Photoshop for the final stage of the process. As you might expect, printing is controlled by presets, and while Aperture ships with a set of eight default printing presets already installed, you can add your own and either edit or delete those already in place.

As with almost any application, the Aperture Print command is found both on the File menu, and hiding behind the **R P** keyboard shortcut. However, unlike most other applications, it is a fully color managed part of the application, just like any other part of Aperture.

It is split into two halves, for printing single images or contact sheets showing several images from a particular collection. Each has a similar set of controls, and they differ only in terms of layout options.

Before you step straight in and start changing the defaults shipped with Aperture, though, be sure to create new copies of each one. The settings in place are optimized for your particular set-up, and while you may be able to improve on them for a particular output job, you should try to preserve these wherever possible.

Use the Shortcut button at the bottom of the dialog (sporting the cog icon) to create new single image or contact sheet presets from scratch, or to duplicate whichever preset is selected at any time (Fig. 8.39).

Common Features in the Printing Dialogs

Click the More Options button at the bottom of the Print dialog to access the full range of controls at your disposal. Most of the options, as you'll see, can be worked out with a little common sense, and many appear – in a different form – in the standard Mac OS X Print dialog.

The Printer section at the top of the Options dialog specifies which device should receive the photos you want to print, and the size of paper on which you want to print. Paper sizes are controlled by the settings in Mac OS X, rather than Aperture, and if you have multiple input trays on your printer it should select the appropriate one automatically on the basis of your selection here.

FIG. 8.39 Avoid changing the Printing presets that ship with Aperture by creating new presets based on those already in place.

Your choice of printer is defined in the Printer Selection section, and is saved as part of the preset. In this way, if you use one printer for low-grade proofing, and another with more expensive inks and media for final output, you can define multiple presets, with one devoted to each output device, but functionally identical in every other way.

Why would you do this? Because your choice of printer, even in many cases the media you feed it, will have an impact on the colors achieved in the final output. All colors, inks and media have different color profiles, and so if they are to function as part of a fully color managed system they must be treated as distinct and different entities.

The Layout section will change, depending on whether you have chosen the Standard or Contact Sheets option at the top of the Print dialog. Standard prints one single image per page by default and will set the image size as 'Maximum to fit'. If you change this or the number of image rows or columns below, you will be able to specify the number of rows and columns on which your images are laid out, and how large the gaps should be between each one (Fig. 8.40). These settings are already active in the Contact Sheets dialog.

The dialog's Layout brick works in conjunction with the Margins brick below it, which sets the amount of empty space around the edges of your image or thumbnails. Change the settings in either brick, and the settings in the other will adjust to accommodate them. Note that if you have set your image size on the Standard setting to 'Maximum to fit' this will not change as you adjust the margins, as Aperture will still print your image as large as it can within those margins.

00				Print				
Standar	rd		[]2 _1 _ [4,]	6, 1 8, 1	10 1 12 1 14	16 1 18	20 22	24 . 25 . 28 .
Contac	t Sheets	•				100		
CUSTOM PRESET	rs	2						
1 1 4×6		1	TACK SEC				AND DO NOT	
1700 3×2		1	ľ		-	ALC: NO		
-A. Framed				ELOS DE LES		30		
Review	Sheet	-		and a			Breest	
Photo E	is say	10						Company of the
Sequen	œ	٦Z -	and the second second		The second		100	
	Canon MX700	•	-	1	And A	No. 20 Concerns of	And the second second	Contract of the
Color Profile:		: 16						
0 p	emember to enable your ninter's color management	16						
Paper Size:	44	- (State Barrier	A CONTRACTOR			and the second	*
Orientation:	Landscape	20	Constant of the local division of		Man and a state state			
Metadata View:	None		No. of the local division of the local divis		Concernance of the owner			
Rows:	6 •)							
Columna C	6)	-	• •	245 P	hotos: Page 6 of 7 -	A4 (29.704×20.99 c	(.m:	+ ++

FIG. 8.40 When printing contact sheets you can specify the number of columns and rows, which in turn will determine the number of photos you can fit on each page. Clicking the More Options button gives access to the Border Options slider, which increases and decreases the margin between each image.

Managing Color... or Not

The following three bricks deal with color, with the Rendering brick allowing you to select the color profile for your printer, and the resolution at which your image should be printed, while the Image Adjustments and Image Options bricks change the final result.

You should use these bricks carefully and sparingly, as all adjustments should really be made using Aperture's main feature set rather than at the time of printing. If possible, restrict yourself to using only the Rotation, Border and Watermark settings here.

If you do feel the need to make adjustments at this stage of your Aperture workflow, then ensure you give yourself the best chance of performing an accurate edit by employing the Loupe. Click the magnifier icon to the left of the Amount and Radius sliders to call it up, and only ever make adjustments when the zoom level is set to 100%, allowing you to see clearly what effect you are having. Clicking the magnifier icon again takes it away.

Particular care should be taken when using the Sharpen sliders, which control the amount of Sharpening applied and how far from any contrasting edge – say, between the roof of a dark building and the light sky against which it sits – the Sharpening effect should extend.

It is easy to be heavy-handed here, but judicious use of the Loupe (available in the single images preset dialog) will show more accurately how damaging Sharpening can be. Excessive Sharpening can create a halo effect around sharp contrasts, which looks unnatural and can actually make the results less – rather than more – clear (Fig. 8.41).

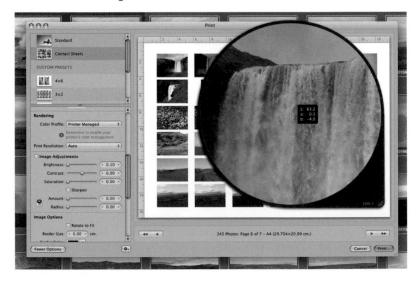

FIG. 8.41 Excessive use of the Sharpen sliders in the Print dialog will lead to undesirable, unrealistic results, as can be seen if you use the Loupe to examine the output at 100% magnification.

Output

If you feel that your image would benefit from some crisper edges, a good starting point is to move the Amount slider to around 0.70 – about a third of the way along its run – and then apply a very small Radius value by clicking the left and right arrows surrounding the value to the right of the slider. Use the Loupe set to at least 100% magnification to examine your image for any halo effect, and only if you are certain that you have not degraded the image in any way, and that you need to add more, should you then increase either the Amount or Radius values.

If you find you have already introduced problems, reduce the values accordingly, remembering always that the smallest number of changes you make to your images, the better. Any edit or enhancement that is easy to see (unless that was your intention) is a bad edit.

The final section – Metadata & Page Options – controls the appearance of words on your printed page, allowing you to switch on and off various metadata pulled from the image and include cropping guides on the page to show where it should be cut to produce a borderless photo.

On-Screen Proofing

Ink and paper – in particular specialist media – don't come cheap, and so while printing a photo several times is often the easiest way to ensure that the results look the way you want, it has three major drawbacks: cost, environmental impact, and the amount of time it takes to run off several proofs with only minor variations as you apply sequential adjustments to your photos.

Fortunately, thanks to its excellent color management system, Aperture lets you proof your images on screen with a fair degree of confidence. Choose the profile of your output device by picking View > Proofing Profile, and then use the shortcut Shift S P to toggle on-screen proofing on and off. Aperture will cross-reference the profile of your display with that of your output device to adjust the on-screen colors and luminance to approximate the equivalent printed results.

A line warning you that you are proofing in this way will appear below the Viewer window whenever it is toggled on (Fig. 8.42).

Slideshows

You could be forgiven for thinking that a slideshow was just... well, a slideshow, in which the pictures follow one another in sequence.

To a degree that's true and, as if to prove it, there's a slideshow shortcut – *Shift* **S** – that will launch a slideshow using your Slideshow presets and

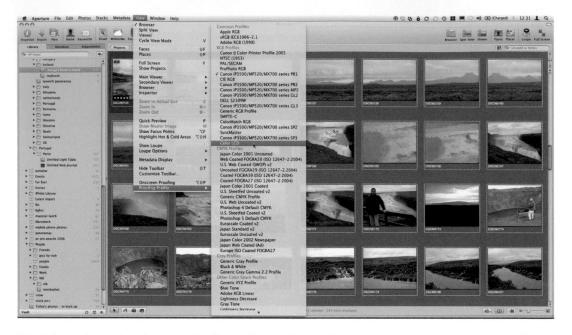

FIG. 8.42 Aperture lets you choose from a range of profiles and will make it clear when the colors you are seeing on your screen are a result of using a profile for on-screen proofing.

whichever view of images is open in the Browser, whether that be a Folder, a Project, or even your entire Library.

Default slideshows are a great way to get a quick fix on how a collection looks without having to manually click through every image in a Folder. However, by tweaking the Slideshow presets you can produce a far more compelling production that will be suitable for public display, perhaps at the end of an event where you have been hired to provide your services. Better still, setting up a properly tailored slideshow will show your work in its best light and really let your photos fly.

Adjusting Slideshow Settings

Open Aperture > Presets > Slideshow... to access the Slideshow Settings dialog. As with the Export presets for Image and Web, this gives you access to the presets shipped as part of Aperture, which can be amended or deleted, and also lets you add your own from scratch.

Clicking through the options already in place will give you a good idea of how each one works and how you can best take advantage of the various options on offer. To really understand them, though, it's always best to create a new one of your own.

Output

Slideshow Name: Untitled	Slideshow	Add selected items to new slideshow
Classic		
Ken Burns		
Photo Edges		
Scrapbook	topy at straight	
Shatter		
Sliding Panels		
Snapshots		
Watercolor Panels		
		The second s
		(Cancel) Choose Them

FIG. 8.43 The Slideshow Presets dialog lets you define the way in which images should be displayed in an on-screen presentation.

The dialog for creating your own slideshow presets is split into two halves. On the left-hand side is a panel for organizing your presets, and on the right are the preset variables themselves.

These are entirely drop-down and slider driven, thus restricting your options within limits that Apple knows will work. Each is based on one of eight preset Themes (Fig. 8.43) as follows:

Classic: Applies a short cross-fade between each image as the transition between them.

Ken Burns: Pans your images across the screen for a more dynamic effect, and cross-fades between subsequent frames.

Photo Edges: Frames your images with a narrow border, frequently shows more than one on screen at a time, and zooms in or out slightly when transitioning.

Scrapbook: Uses a backdrop of torn paper behind your images to give the impression that they are stuck into a book, and slides them or piles them up for each transition.

Shatter: A unique effect that breaks up each image on the basis of its tones, then brings in the next image on the same basis.

Sliding Panels: Presents multiple images at once, with the screen divided into several parts. Reminiscent of the multi-scene effects used in the TV series 24.

Snapshots: Gives each image a narrow border and slides it onto the screen from the bottom. As it appears it overlays the previous images and appears on the paper as though being exposed.

Watercolor Panels: Backdrops your images with pastel colors, and uses the same colors as a wipe to transition between images.

By setting your own Slideshow presets you can pick the best options from each area, such as the transition (perhaps a cube spin rather than a fade), transition duration and background color. You can also choose to play music during the slideshow.

You have three options: Manually navigate slides, Show slides for fixed time, or Fit to music. This last option is perhaps the most interesting as it leaves each image on the screen for the whole duration of each track that it plays.

Music is taken from your iTunes Library, and you can pick either single tracks or complete playlists. This opens up interesting possibilities for creating stills-based guides (see box 'Creating a stills-based guide' on page 317).

Aperture isn't flexible enough to allow you to design bespoke layouts that vary from page to page, but you can get around this easily by designing your slides in an external layout application, such as InDesign or Photoshop. Take advantage of whatever filters and layers you want, overlapping images and adding captions as appropriate, and then save your work as an image file which you then import into the Aperture Library and organize into a dedicated Slideshow Folder. You would then use a preset that displays these images in full screen, one at a time.

Managing Slideshow Quality

Aperture builds your slideshow using preview images, rather than the Raw files that make up your Library. Each preview is stored alongside the Digital Master or Version to which it relates and, as it saves the application from parsing the Raw master and then applying adjustments to create each Version every time you click onto a new image, they make the application feel more responsive. They also keep slideshows snappy.

However, if you have not set Aperture to create high quality previews, you will find that the results of your slideshow could be softer or more compressed than you would like.

Preview quality is controlled through the Previews tab of Aperture's Preferences pane (). Here you can set the preview quality on a scale running from 0 (low) to 12 (high) that matches the JPEG Export options in Photoshop. You can also opt to limit the size of each preview within certain dimensions, supplemented by a Half Size option to reduce each image preview by 50%, or 'Don't limit' to keep them at full size (Fig. 8.44).

While reducing quality and image dimensions will both improve responsiveness and save on disk space, each degrades the quality of

000	Previews		
General Appearance Import Export	Labels Previews Web Advanced		
	your photos. Previews allow you to view photos deasily use your photos in other applications.		
	☑ New projects automatically generate previews ☑ Use embedded JPEG from camera when possible		
Share previews with iLife and iWork:	Always ‡		
Photo Preview:	Half Size \$		
Photo Preview quality:	1. 1. 1. 1. 1. <u>1. 1. 1. 1. 1. 1. 1. 1. 1. 1. 1. 1. 1. 1</u>		

FIG. 8.44 Preview images are primarily used to help you navigate your Aperture Library more quickly. However, they are also the basis of the images shown in a slideshow. As such, you should be careful about the level of compression you choose to employ.

your slideshows. Limiting the preview size will mean that each one has to be scaled up further when displayed on screen, and so choosing a smaller setting, such as 1440 \times 1440, can lead to softer results or 'blockiness', depending on size, as they are scaled back up. Knocking down the quality, meanwhile, can introduce compression artifacts at areas of sharp contrast or where the underlying texture is complex, like where the branches of a bare tree in a photo overlay the sky.

You must judge carefully, then, whether speed or quality is of greatest importance, and you should make that decision as early on as you can, as previews will be created from the point of your very first import.

Creating a Bespoke Slideshow

Select the images, Project, Folder or Album from which you want to create a slideshow and pick New > Slideshow from the toolbar. Aperture will ask which preset you will want to use, as per the list detailed above, and check the box to add the selected items to a new slideshow. Bear in mind that you can change your mind about the theme later on by clicking the Theme button above the slideshow creation screen, and can add new images to the slideshow by dragging them onto its entry in the Library Inspector from wherever they are in your Library.

When you OK the creation of the slideshow, Aperture will place it in the Library Inspector and run the images that it contains along the bottom of the screen in a familiar filmstrip. It will also overprint the first image in the collection with the name of the slideshow.

If you want to choose a different title, double-click on this line of text and change it as appropriate (Fig. 8.45).

The first thing you'll notice about the filmstrip is that it now sports a red bar. This is the playhead, and it will follow your mouse as you roll your pointer across the images. At the same time, the time counter at its head will change to show how

FIG. 8.45 Change the name of your slideshow by double-clicking the text box that overlays the opening image.

Background:]
Loop main audio track Manow tite O A Color Play silds for: 3.00 seconds Background Bodder O Color Inset O Color Inset O Color Transition: Dissolve 1 Speed: 0.50 seconds Previow: 1 Text: None 1	:
Show the Constraints of the seconds Background :	
Play slide for: 3.00 seconds Background Border: 0 Color Inset: 0 Color Crop: Ken Burns Effect 1 Speed: 0.50 seconds Preview Text: None 1	
Background:]•]
Border: O Color: Inset: O Color: Crop: Ken Burns Effect 1 Speed: O .50 > seconds Preview: Text: None 1	
Inset: 0 0 Crops: Keen Burns Effect 1 Transition: Dissolve 1 Speed: 0.50 seconds Preview: 0.50 seconds Text: None 1	
Crop: Ken Burns Effect + Transition: Dissolve + Speed: 0.50 > seconds Preview: Text: None +	
Transition: Dissolve =) Speed: 0.50 > seconds Preview: Text: None =)	
Speed: (* 0.50 *) seconds Preview: Text: (None 1)	
Speed: (* 0.50 *) seconds Preview: Text: None = 1	
Speci (0.50 +) seconds Preview Text: None +	
Text: None ‡	*/

FIG. 8.46 The Default Settings dialog lets you set the size of your finished slideshow, with options for common aspect ratios.

long the slideshow will have run for by the time it reaches that position, and the main image on the screen will preview what the slideshow is showing.

You can manually change the duration of each slide either individually or on a slideshow-wide basis.

Click the Display Settings Panel button to the right-hand side of the screen, above the filmstrip. Its icon is a framed square. This calls up a two-part panel with buttons at the top for switching between Default Settings, which apply to the whole of your slideshow, and Selected Slides, which applies changes only to the slides you have selected in the filmstrip.

Pick Default Settings and you'll see that you can optimize your slideshow for different screen sizes, including iPhones (3:2 aspect ratio), set it to loop, apply a border to all images and, crucially, change the duration of each slide (Fig. 8.46).

Setting the duration in this way is fine if you want to give equal prominence to all of your photos, but there are times when you will want to introduce some texture by varying the amount of time each one is on screen. On these occasions, select the slide you want to change and click the Selected Slides button.

Here you can apply an effect to give the slide a black and white, sepia or antique effect, and you can again change the length of time over which the slide is displayed on screen.

FIG. 8.47 Use Slide Duration Recording mode to manually set the points at which your slides will transition from one to the next.

You can also set slide durations using the keyboard. Click the Stopwatch button above the filmstrip and then start your slideshow playing by clicking the Play button two to its left. Watch it play back on your screen, and whenever you reach a point where you would like to change slides, press the *Return* key. If you reach the end of the existing duration of a slide before that point, Aperture will hold the playhead on that slide until you press *Return*, thus extending the playback duration as appropriate (Fig. 8.47).

Slideshow Music

To the right of the Display Settings Panel button is another button sporting a musical note. This opens the audio Browser, which pulls together the major music and audio sources on your Mac, including your iTunes Library, GarageBand files, sample music pre-installed on your Mac, and a small selection of theme music. Drag these into the filmstrip area and they will be laid down behind your images (Fig. 8.48). A green background will indicate their duration compared with the duration of your slides (Fig. 8.49).

If your track is longer than your slideshow it will gracefully fade out at the end as the show ends and the screen returns to the Aperture interface. Unfortunately, however, this happens even if you have set the slideshow to loop, in which case it will fade out at the end of the last slide and then start again as the slideshow repeats, which can look a little uncomfortable.

Tunes		+	
	-		
Name	Artist	* Time	ł
n Domino Dancing	Pet Shop Boys	4:17	ł
1 It Would Be Easy To	Timothy West	4:17	
n Ordinary World	Aurora Feat	4:17	
d Life In A Northern	The Dream A	4:17	
n Did It Again	Kylie Minogue	4:17	
That I Would Be Good	Alanis Moris	4:17	
<u>h</u> Harder	Kosheen	4:17	
H Waltz From The Sle	Tchaikovsky,	4:17	
not Over Yet	Grace	4:17	
f Smooth Criminal	Michael Jackson	4:17	l
High And Dry	Radiohead	4:17	1
d Thousand Year Prayer		4:17	
n Thousand Year Prayer	Cowboy Junkies		
d I Don't Want to Get	Roxette	4:17	
if I Could Turn Bac	Cher	4:17	
Heart	Pet Shop Boys	4:17	
A Slave To Love	Bryan Ferry	4:17	
n Not Over Yet	Grace	4:17	
f Skin On Skin	Various Artists	4:17	
d Part 49	Michel Thomas	4:17	
n The Lady In Red	Chris de Burgh	4:17	
Be My Enemy	The Waterboys	4:17	
r Fatal Hesitation	Chris de Burgh	4:17	
You're So Vain	Carly Simon	4:17	
Breakfast At Tiffany's	Deep Blue So	4:17	
ர் Slide In	Goldfrapp	4:17	3
H Together We Are R	Farn Kinney	4.17	1
(Q.		10086 iten	

FIG. 8.48 The audio Browser lets you choose slideshow music from any source on your Mac, including your iTunes Library.

FIG. 8.49 The green area shows the duration of the track in your slideshow. This makes it obvious if it is too short for the number of slides you have used.

Aperture can also draw the audio tracks from files stored in your Aperture Library, such as Quicktime movies shot by your camera. Dragging these into the slideshow positions them below the filmstrip and dips the background music when they should begin so that they can be heard clearly. This lets you use voice notes recorded when you took your pictures as a commentary track on your slideshow.

Slideshows Beyond Aperture

When you are happy with your finished slideshow, you can export it for use on other devices, or for sending to friends, colleagues and clients by email. Click Export above the slideshow creation interface and you can choose iPod, iPhone, iPod touch and Apple TV as destination hardware devices. As these are all created by Apple, Aperture will know the best quality settings for each one, so you can safely leave the other details in its hands (Fig. 8.50).

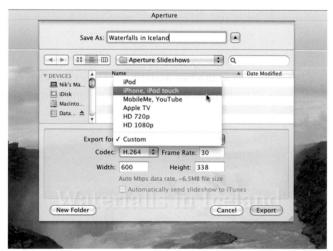

These destination hardware devices are supplemented by HD 720p and HD 1080p – output suitable for high-definition televisions and for MobileMe and YouTube publishing – which will require further refinement to keep file sizes manageable.

If none of these suits your needs, pick Custom and the Codec, Frame Rate and dimension boxes will be un-grayed, allowing you to enter your own settings.

Controlling Playback

Slideshows are designed to be self-running: set them going and they'll cycle through your photos until either they come to the end of the run; or, if you've set them to loop, you intervene.

When running like this, tapping the **Spacebar** pauses and resumes a running slideshow, the e and a arrow keys let you skip backwards and forwards through the slides as they would in Keynote or PowerPoint, and the esc key brings it to an end and gracefully fades it out.

Creating a Stills-Based Guide

The Fit To Music option in the Slideshow Presets dialog tells Aperture that it should swap the image on display at the end of every track it has been instructed to play. These tracks are drawn from the iTunes Library, which with its Playlists feature lets you specify a range of audio files and a specific order in which they should play. By combining a carefully ordered collection of photos and audio files through this dialog, it is easy to create a slideshow that goes beyond the usual transitions and music productions, and becomes a truly useful resource.

The first step is to organize your photos into the most relevant order, remembering the movie-making convention of telling a building story, with each image moving on logically from the last. Once you have assembled your collection, you need to record a short narrative for each one. Apple's own GarageBand application, which ships as part of the £71 iLife suite, and the free Audacity recording and editing tool (audacity.sourceforge.net) are both excellent and easy-to-use options.

Rather than recording a single track to describe every image in the collection as a whole, you should produce a short clip for each one individually. Give the clips sequential numbers, with leading zeroes to pad them out, and make sure the file names are all the same length; hence, for a slideshow with fewer than 100 images, each track would have a double-digit name, and for those with more than 99 but fewer than 1000 images, each track would have a three-digit name.

Each audio filename will match the position of the associated image in the slideshow, so that the track describing the seventh image would be 07, and the twelfth would be 12. Aperture can play back any audio format supported by iTunes, so saving as Wav or MP3 is safe, but Windows Media Files are inaccessible.

Import the tracks by opening iTunes and picking Add to Library... (shortcut command **(B) (O)**) from the File menu and organize them into their own Playlist. This isolates them from the rest of the Library and lets you confine Aperture to using just those tracks as backing for the slideshow without straying into the rest of the Library.

Returning to Aperture you would then create a Slideshow preset with timing set to Fit To Music, and the newly created iTunes Playlist set as the audio source. Navigate to the folder within your Aperture Library containing the slideshow's images and then tap **Shift S** to start the slideshow, remembering to select your newly created preset.

Index

A

Add to Favorites option, 211 Adjustment Presets, 178 Adjustments HUD, 145-58 about Adjustments HUD, 145-6 Black Point controls, 149 Color tool, 154-8 Enhance, 150-2 Exposure, 148-50 Highlights & Shadows tool, 152-4 histogram, 146-7 Levels tool, 154 Raw Fine Tuning, 147 Recovery slider, 149 white balance, 147-8 Adjustments Inspector, 48-50, 58-9, 144 Adobe Bridge: and Adobe Camera Raw, 248 and Aperture, 245 importing from, 246-7 and metadata, 247 Adobe Camera Raw: and Adobe Bridge, 248 and Aperture, 245-6 Adobe DNG conversion, 250-2 Adobe Photoshop, as an external image editor, 253-4 Adobe Photoshop Lightroom, metadata transfer problems, 252 Albums and Smart Albums, 211-13 navigating, 213 Aperture, first time users, 66-72 basics/importing limitations, 66-7 color management, 69-71 customizing, 67-8 exporting shortcut presets, 69 monitor calibration, 70-1 setting preferences, 71-2 Aperture Library see Library, image storage; Library, adding images; Library Inspector Aperture, use from other applications, 266-74 about external use, 266-7 Aperture Preview Preferences, 267-8 email with Mail, 271 InDesign documents, 272-4 iPhoto, 268 iTunes, 268-9, 270 iWork applications, 269 Photoshop, 272 Aperture workflow: about Aperture workflow, 207-9

Albums and Smart Albums, 211-13 building, 105-9 and external editing, 256 Faces, 216-20 adding new, 219-20 Faces Gallery, 219 refining Faces, 218-19 folders, 209 Light Tables, 232-6 Places feature, 213-16 placing projects, 216, 217 projects, 209-10 Favorite and Recent, 211 stacking, 236-8 Versions/version sets, 238-40 Aperture workflow from camera to export, 220-32 about the workflow, 220 backing up, 226-8, 232 editing photos, 231 image sorting, 228-9 import dialog options, 225-6 Light Tables, 228-30 metadata presets, defining, 221-2 outputing photos, 231-2 photo rating and picking, 229-30 photos, importing, 222-5 Aperture workspace see Workspace lavouts Aperture's Actions, 104-5 Apple plug-ins see Plug-ins Archiving issues, 3-4 Auto curves, 167 Automator launching, 104-5

В

Backup systems/routines, 78, 226-8, 232 Backup application, 86 Raw files, 86-8 Time Machine backup tool, 86-8 see also Vaults, managing Batch operations, 120-1 Bayer pattern, 9 Black & White adjustment, 166 Black Point controls, 149 Black and white, Color to B&W, 200-2 Book production, 298-305 about book production, 298 Edit Layout, 303 layouts, 300-2 new book creation, 298-9 Photo Filter tool, 302-3

saving as PDFs, 305 templates, 299 Boost, 18-19 Branding images, for protection, 278 Brightness slider, 150 Browser & Viewer modes, 53-5 Browser metadata overlays, 129-31 Browser Only mode, 53-5 Browsing and organizing images, 32-5 Browser panel, 33–5 full screen Browser, 29, 34-5 Brushed-based adjustments, 178-81 about the adjustments, 178-9 Quick Brushes, 179-80 with 'standard' adjustments, 180 - 1Brushes tool, 45 Burn Folders, 103-4

C

Camera, importing from, 75-6 Camera Raw, 1-2 Chromatic aberration, 20 adjustment, 163–4 Clippina: clipping overlays, 176-7 and histograms, 175-6 Cog menu, 59 Color casts, dealing with, 197-200 with Levels, 200-2 with Tint, 198-200 with White Balance, 197-8 Color correction control, 153 Color filter array sensors, 9, 10 Color management: for exporting, 279-80 first time users, 69-71 Color Monochrome adjustment, 166, 203-6 Color profiles, 69-71 Colorsync, 70 Color Space conversion, 9–10 Color to B&W, 200-2 Color tool, 154-8 Compare mode, 42, 230 Compression and resolution, 277-8 Control bar, 40-7 keywords, adding with, 126-7 navigating photos, 40-1 Rating and Sorting controls, 41-3 Copying adjustments see Lift and Stamp HUD Crop tool, 44, 162

Curves adjustment, 167–8 Auto curves, 167 Customizing Aperture, 67–8

D

Decoders, for Aperture, 17–18 Definition control, 150 Demosaicing, 7, 9–10 and noise reduction, 16 Devignette adjustment, 164–5 Digital Masters, and Versions, 31, 52 DNG format: by Adobe, 20–1 conversion, 22–3, 250–2 Dodge & Burn plug-in, 257 Dual-Screen mode, 47–8

E

Edge Sharpen filter, 170-1, 173-4 Editing photos, 231 Editing tools, 44-8 Enhance, with Adjustments HUD, 150-2 Exchangeable Image File Format (EXIF) metadata, 111 adding to data, 116 Export command, 232 Exporting images, 275-86 about exporting with Aperture, 275-7 color management, 279-80 export settings, defining, 277-8 metadata for, 283-4 names and destinations: defining, 280-3 using presets, 281-2 plug-ins issues, 284-6 protecting your images, 278-9 branding, 278 watermarks, 278-9 two Macs/libraries operation, 286-7 see also Book production; Online publishing Exporting projects, 210 Exporting shortcut presets, 69 Exposure: with Adjustment HUD, 148-50 adjustment sliders, 181-3 Eyedropper control, 147, 148

F

Faces, 216–20 adding new, 219–20 Faces gallery, 219 refining Faces, 218–19 Falloff slider, 171–2 Favorites, Add to Favorite option, 211 Filename presets, creating, 78–80 Files, renaming, 85 Filter HUD, 61–3, 132–3, 135, 137–8 Fisheye-Hemi (Image Trends) plug-in, 266 Flip tool, 163 Folder actions, 104 Folders, 51–2, 209 for navigation, 210–11 Full screen Browser, 29, 34–5 Full screen and Dual-Screen mode, 47–8 Future proofing, 4

G

Gamma curve, 10–12 Google maps and GPS, 213–16 GPS and Google maps, 213–16

Η

Hard disk drives: backup issues, 95 reliability, 94 seek times/transfer rates, 94 Hard disk management, 100-9 Aperture workflow, building, 105-9 Aperture's Actions, 104-5 Automator launching, 104-5 Burn Folders, 103-4 Folder actions, 104 Smart Folders, 101-3 Head-Up Displays (HUDs), 28, 60-6 about HUDs, 60-3 Filter HUD, 61-3 Inspector HUD, 63 Lift and Stamp HUD, 63-6 metadata overlays, 66 see also Adjustments HUD High dynamic range (HDR), 185 High Tonal Width slider, 153 Highlights & Shadows tool, 152-4 Histograms, 13-14, 146-7, 172, 175-6 and Adjustments HUD, 146-7 and clipping, 175-6 Hot and cold areas, 177, 196-7 Hue Boost slider, 18-19 Hue slider, 155 Human eye, response to light, 10-12

Image sorting, 228–9 Image storage/management: Aperture Library, 29–30 browsing and organizing images, 32 Digital Masters, 31 Projects, 30–1 'Smart' folders', 30–1 Versions, 31, 32 *see also* Libraries; Library Import dialog options, 225–6 Importing images/photos *see* Library, adding images InDesign documents, working Aperture with, 272-4 Inspector HUD, 63 iPhoto, working Aperture from, 268 iPhoto Library: importing all, 242-3 importing individual Events, Albums or images, 243-4 previews, 244-5 within Aperture, 243 IPTC metadata, 111-12 adding to data, 114-16 iTunes, working Aperture from, 268-9, 270 IWork applications, working Aperture from, 269

Κ

Keyboard commands, for rating images, 112–13 Keyword searching, 134–5 Keywords with metadata, 122–8 about keywords, 122 adding with: Control Bar, 126–7 Keyword HUD, 124–6 Metadata Inspector, 124 Adobe Bridge problems, 247 removing, 127–8 searching with, 134–5 strategy for, 122–4 Keywords and ratings, 57–8

L

Levels, and Color casts, 200-2 Levels tool, 154 Libraries, moving, 94-7 about moving, 94-5 reliability issues, 94 splitting the library, 95-7 see also Referenced images, managing/moving Library, image storage, 29-30 Library, adding images, 73-85 Adobe Bridge, importing from, 246-7 Aperture Library, 77-8 backup systems/routines, 78 camera, importing from, 75-6 filename presets, creating, 78-80 folders on drives, from, 83-5 import dialog, 73-4 without dialog, 83-5 Import Settings panel, 74-5 import worflow, completing, 80 iPhoto Library, importing from, 242-5 individual items, 243-4 previews, 244-5 metadata presets, creating, 80-2 new masters, 254-5

photos, importing, 222-5 pictures, importing, 82-3 sorting before import, 76-7 storage locations, 77-8 two Macs/libraries operation, 286-7 vault, restoring from, 92 Library Inspector, 32-51 Adjustments inspector, 48-50 Browser panel, 33–5 customizing, 40 editing tools, 44-8 Full-screen/Dual-screen modes, 47-8 image input control, 35-6 Loupe feature, 38-9 Metadata inspector, 50-1 Name button, 37 and navigation, 210-11 Places button, 37 shortcuts, 36 toolbar, 35-40 View toolbar, 43-7 and workflow, 208 Zoom tool, 39 see also Control bar Lift and Stamp HUD, 63-6, 177-8 adding metadata with, 116 Light! (Digital Film Tools) plug-in, 265 Light Tables, 228-30, 232-6 about Light Tables, 232-3 photo sorting procedures, 228-30, 233-6 Loupe feature, 38-9, 308

Μ

Mail feature, 271 Masters and versions, 52 Mean Time Between Failures (MTBF), 94 Metadata, 111-42 about metadata, 111-12 and Bridge, 247 displaying on images with View and Browser sets, 129-31 EXIF metadata, 111 exporting with images, 283-4 IPTC metadata, 111-12 overlays, 66 menu, 45 XMP sidecar files, 248-50 see also Keywords with metadata; Rating images; Sorting and searching Metadata Inspector, 50-1 adding keywords with, 124 adding metadata with, 116 Metadata presets, creating, 80-2, 118-22 Batch operations, 120-1 import, adding metadata on, 121-2 preset groups, creating and editing, 128-9 time changing, 121 for time zones, 121 Metadata presets, defining, 221-2

Metadata Views: creating, 117–18 with rating, 116–18 Mid Contrast slider, 153–4 Migration Assistant, 93 MobileMe Galleries, 287–91 access control with, 288–9 adding new images, 290 creation, 288 features, 287–8 Moiré adjustment, 20 Monitor calibration, 70–1 Mouse, for rating images, 113–14

Ν

Name button, 37 Noise Ninja (PictureCode) plug-in, 263–4 Noise reduction, 15–17, 166–7 and demosaicing, 16 Edge Detail slider, 167 Radius Detail slider, 166

0

Online publishing, 287–98 MobileMe Galleries, 287–91 Web journals, 296–8 Web Page option, 291–5 Output *see* Exporting images; Printing; Slideshows Overexposure, 181–8 Exposure adjustment sliders, 181–7 Recovery slider, 182, 184 slight overexposure, 184–90 Overlays, 59–60

Ρ

PearlyWhites (Image Trends) plug-in, 266 Photo rating and picking, 229-30 Photos, importing, 222-5 locations for, 223-5 working area issues, 224-5 see also Library, adding images Photos, storage see Libraries; Library Photoshop, working Aperture from, 272 Picking photos, 229-30 Places button, 37 Places feature, 213-17 automatic placement, 214-16 with GPS and Google maps, 213-17 placing projects, 216-17 positioning images on map, 214-17 Plug-ins, 256-8 about Apple plug-ins, 256–7 Dodge & Burn plug-in, 257 with exporting images, 284-6 for external editing, 259-62 Fisheye-Hemi, ShineOff and PearlyWhites (Image Trends), 266

how they work, 257-8 Light! (Digital Film Tools), 265 Noise Ninja (PictureCode), 263-4 Tiffen Dfx (Tiffen), 264 Viveza 2 (Nik software), 259, 262-3 Preferences setting, 71-2 Presets, Adjustment Presets, 178 Previews: Aperture Preview Preferences, 267-8 Quick Preview mode, 47 when importing, 244-5 Primary viewing mode, 46 Printing, 305-9 about printing with Aperture, 305-6 color management, 308–9 Lavout section, 307 Mac OS X common features, 306 on-screen proofing, 309 paper sizes, 306 Printer Selection section, 307 sharpen issues, 308 Projects, 30-1, 52, 209-10 exporting, 210 Favorite and Recent, 211 Proofing for printing, on screen, 309

Q

Quick Brushes, 179–80 Quick Preview mode, 47

R

Rating images/photos, 112-18, 229-30 EXIF metadata, adding, 116 images, comparing, 114 IPTC metadata, adding, 114-16 keyboard, using, 112-13 Lift and Stamp HUD, using, 116 Metadata Inspector, using, 116 Metadata Views, using, 116-18 mouse, using, 113-14 searching by, 133 workspace arranging, 112 Rating and Sorting images, 41-3 Compare mode, 42 with control bar, 41-3 Ratings and keywords, 57-8 Raw files: backing up, 86-8 demosaicing and color calibration, 7 and DNG files, 20-3 formats, 3 and Hue Boost, 18-19 in-camera processing and the aperture alternatives, 9 RGB comparison, 12–13 to RGB, 7-8 unsupported formats, 23-5 and white balance, 14-15 Raw fine tuning, in Aperture, 17-20, 147 Raw support, 2-4

Raw workflow, 4–6 benefits, 5–6 disadvantages, 6 Recovery slider, 149, 182, 184 Red-Eye tool, 44, 158–9 Referenced images, managing/moving, 97–100 about moving, 97 consolidating masters, 99–100 managing, 97–9 Relocate Masters button, 98–9 Renaming files, 85 Resolution and compression, 277–8 Retouch tool, 159–62 Rotation tool, 43–4

S

Saturation control, 150 Saturation slider, 156 Searching: by date, 136-7 by rating, 133 Filter HUD, 132, 135-6, 137-8 keyword searching, 134-5 multiple (all or any) criteria, 135-6, 138-9 saving results, 141-2 Search Field/Search Field pop-up menu, 132 search tools, 132 text searching, 133-4 multiple text, 139-41 troubleshooting, 142 see also Sorting Sensor data capture/storage, 9 Sepia Tone adjustment, 166, 202-3 Shadow detail, 12-13 Shadow recovery, 194-5 Shadows slider, 152 Sharpening/sharpening tools, 17, 19-20, 168-72 about sharpening tools, 168-9 default setting, 170 Edge Sharpen filter, 170-1, 173-4 Falloff slider, 171-2 Sharpening filter/slider, 169-70 ShineOff (Image Trends) plug-in, 266 Shortcuts, 36 Show Master button, 45 Slideshows, 309-18 about slideshows, 309-10 adding music, 312, 315-16 bespoke slideshow creation, 313-15

default sideshows, 310 exporting slideshows, 316-17 guide for show creation, 317-18 managing quality, 312-13 playback control, 317 preset themes, 311-12 settings, 310-13 Smart Albums, 212 Smart folders, 30-1, 101-3 Sorting and searching, 131-2, 228-9 Light Table, 228–9 see also Searching Spot & Patch tool, 159 Stacks/stacking, 52-3, 236-8 Straighten tool, 44, 162-3

T

Temp slider, 147 Text searching, 133-4 Tiffen Dfx (Tiffen) plug-in, 264 Time Machine backup tool, 86-8 on Mac OS X 10.5 system, 89 Tint, and Color casts, 198-200 Tint Control, 151-2 Tint slider, 147 Tinting, 202-6 Color Monochrome adjustment, 203-6 Sepia Tone, 202-3 Tonal mapping, 10-14 Toolbar: across Aperture interface, 35-40 Viewer toolbar, 43-7

U

Underexposure, 188–97 low contrast (flat) images, 196–7 mild underexposure, 193–5 shadow recovery, 194–5 severe underexposure, 188–93 deep shadow recovery, 191–3

V

Vaults, managing, 88–94 about vaults, 88–9 backup to, 226–7 creation, 89–91 with Mac OS X system, 91 maintaining, 91–2 restoring library from, 92 transferring library to a new Mac, 92–4 Versions/version sets, 31, 32, 52, 238–40 automatic creation, 239 manual creation, 240 Vibrancy control, 151 Viewer metadata overlays, 129–31 Viewer modes, 53–5 Viewer toolbar, 43–7 Vignette adjustment, 164–5 Viveza 2 (Nik software) plug-in, 259–63

W

Watermarks: applying, 295 for image protection, 278-9 Web publishing/Web Page option, 291-5 applying watermarks, 295 features, 291-2 metadata with, 293-4 presets for color/compression, 193-4 Rectangle option, 293 Square option, 293 Web journals, 296-8 see also Online publishing White balance, 14-15, 147-8 and color casts, 197-8 Workflow see Aperture workflow Workspace layouts, 27-9, 53-60 adjustments and filters, 58-9 Browser Only and Viewer Only modes, 53-5 full screen Browser, 29, 34-5 interface arrangement, 27-8 overlays, 59-60 ratings and keywords, 57-8, 112 standard layout, 53-5 swapping and rotating workspaces, 55-6 toolbar and control bar, 28-9

X

XMP sidecar files, 248-50

Z Zoom tool, 39, 45